HOPI PAINTING

HOPI PAINTING
THE WORLD OF THE HOPIS

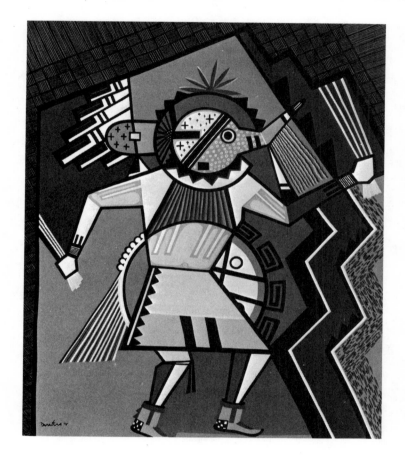

By Patricia Janis Broder

A BRANDYWINE PRESS BOOK
E. P. DUTTON
NEW YORK

Dedicated

To the Hopi People—
with Respect and Admiration

This book was edited and produced by
THE BRANDYWINE PRESS, INC.
Clarkson N. Potter, President

Design and Production by Helga Maass
Typography by David E. Seham Associates, Inc.

Published, 1978, in the United States by E. P. Dutton,
a Division of Sequoia-Elsevier Publishing Company, Inc.,
New York, and simultaneously in Canada by Clarke,
Irwin & Company Ltd., Toronto and Vancouver

For information contact: E. P. Dutton,
2 Park Avenue, New York, N.Y. 10016

Library of Congress Catalog Card Number: 78-68404
ISBN: 0-525-12711-9

10 9 8 7 6 5 4 3 2 1
First Edition

CONTENTS

Acknowledgments

I wish to thank the many individuals and institutions without whose help and cooperation my work would not have been possible:

The members of Artist Hopid—Mike Kabotie, Milland Lomakema, Terrance Talaswaima, Delbridge Honanie, and Neil David, Sr.—and Fred Kabotie and Otis Polelonema for their interpretations and explanations of their work.

Carl Schaefer Dentzel, Director of the Southwest Museum, Los Angeles, for his interest, cooperation, and help from the very beginning of my work.

The directors and staffs of libraries, museums, and universities throughout the United States for their historical and statistical information and photographs from their collection: William Stiles, Sr., Curator of Collections, The Heye Foundation, Museum of the American Indian, New York City; Alexander F. Draper, Administrator, The Heye Foundation, Museum of the American Indian, New York City; Sanda Alexandride, Secretary to the Photography Department, The Heye Foundation, Museum of the American Indian, New York City; Charles Daily, Director, Institute of American Indian Art Museum, Santa Fe, New Mexico; Richard Best, Director, The Thomas Gilcrease Institute of American History and Art, Tulsa, Oklahoma; Patrick T. Houlihan, Director, Heard Museum of Anthropology and Primitive Art, Phoenix, Arizona; Edna Robertson, Curator of Fine Arts Collection, Museum of New Mexico, Santa Fe, New Mexico; Betty Toulouse, Curator of Pottery Collection, Museum of New Mexico, Santa Fe, New Mexico; Harry King, Laboratory of Anthropology, Museum of New Mexico, Santa Fe, New Mexico; Edward B. Danson, President, Museum of Northern Arizona, Flagstaff, Arizona; Hermann K. Bleibtreu, Director, Museum of Northern Arizona, Flagstaff, Arizona; Barton Wright, Curator, Museum of Northern Arizona, Flagstaff, Arizona; Steven Williams, Director, Peabody Museum of Archaeology and Ethnology, Harvard University, Cambridge, Massachusetts; Lisa Kamisher, Curator and Assistant, Peabody Museum of Archaeology and Ethnology, Harvard University, Cambridge, Massachusetts.

The collectors of Hopi art for providing statistical data and photographs of their collections: James T. Bialac, Scottsdale, Arizona; John Cartwright, Santa Fe, New Mexico; Ed Comins, Phoenix, Arizona; Byron Harvey III, Phoenix, Arizona; Brian Hunter, Phoenix, Arizona; Renee Jacobs, West Orange, New Jersey; Rita Jacobs, West Orange, New Jersey; Dr. Maria Louise Koch, Cedar Grove, New Jersey; Mr. and Mrs. Gerald Peters, Santa Fe, New Mexico; Judith Rosenstock, Phoenix, Arizona; Wayne Sepuquatewa, Second Mesa, Arizona; and Nettie Wheeler, Muskogee, Oklahoma.

Ted Hill for his cooperation and excellent photography of Hopi art on the Hopi Reservation and in collections throughout Arizona.

Owen Seumptewa for his photography of the Cultural Center mural.

My husband, Stanley, my sons, Clifford and Peter, and my daughter, Helen, for their cooperation and assistance with my research and writing.

Patricia Janis Broder

Foreword

Recently the Southwest Museum in cooperation with a group of Hopi Indians presented *Two Days in the Continuous Journey of the Hopi to the Sun* at its Casa de Adobe in Los Angeles. The Hopi more than any other Indian culture in the American Southwest seem to identify themselves with the sun. Throughout the Western Hemisphere the ancient Americans were aware of the solar system. They had profound respect for what transpired in the heavens. Their greatest concern was, of course, reserved for the sun. Hence, many of the Pre-Columbian cultures, in what was to be known as the Americas, were often referred to as the Sun Kingdoms.

Astronomy and mathematics were remarkably advanced among many of the Indians in various parts of the Americas. The prehistoric Americans appeared to have made remarkable progress in those sciences as compared to many Europeans of the same time. It is generally accepted today that solar activity is responsible for the weather on earth. The mesa dwellers of the desert and semi-arid regions of the Southwest had perhaps more reason than any people to understand the nature and power of the sun. Consequently, it would seem only natural for them to associate themselves with the great Master of the Heavens.

Primitive people everywhere have generally called the sun a masculine force and its celestial companion the moon a feminine force. Therefore it is not unusual to have those great heavenly bodies referred to as Master Sun and Mistress Moon; the gold and the silver of the heavens, the sweat of the sun, the tears of the moon. Despite what appears to be an endless struggle against obstacles of all kinds, no Hopi has ever thought, or been heard to say, "Stop the world, I want to get off." Just the opposite is true of these indomitable people. They have created an inspiring culture and have led and still lead a remarkably beautiful way of life. What have been problems and frustrations to most people have received a philosophical and creative response from the Hopi. Therefore, Hopi culture embodies a number of universal truths and inspiring factors, particularly when you measure them and their accomplishments in the light of other people of the world.

Man has always tried to find better worlds. From time immemorial on earth, he has endeavored to improve his condition. Today as never before people throughout the world are confronted with problems relating to their environment. In a desperate effort to improve living conditions and obtain a balance with nature, we have made the quality of the environment a major preoccupation of our time.

In the last half of the fast-moving record-breaking twentieth century, man has, finally, not only landed on the moon, but has made his presence felt on other planets as well. Despite the tremendous scientific progress we have made in this century, we are still earthbound creatures. Perhaps we are doomed to live on the planet Earth; we may not be able to escape to other parts of space and colonize. Twentieth-century space exploration may prove that life on Earth is the ultimate, and that man had better learn to live in harmony with nature and its terrestrial resources, and to live in peace and friendship with his fellow earthbound men. The last quarter of the twentieth century may bring this great awakening and realization to the people of the Earth.

Peace and friendship always appeared on the Indian peace medals, which were struck for the Presidents of the United States, with the head of the President on one side and

peace and friendship on the other. From the beginning of the United States until today, these symbols were designed to bring the white man and the red man together. The peace pipe was to take the place of the tomahawk. Peace and understanding were the ways to obliterate the warpath. The path to peace was to be the understanding and appreciation of different cultures and, ultimately, through mutual admiration, cultural concord would be achieved.

Unfortunately, despite the attempts of generations of well-meaning Americans, peace and friendship did not become one of the pillars of American society. Even today, after the bicentennial year of the United States of America, citizens are still struggling to create a better, more humane society. Ethnic groups, black, brown, and yellow Americans have joined the red man and the white man in their struggle for mutual appreciation. Officially the United States has proclaimed liberty, equality, and freedom for its citizens, but even after two hundred years of practical progress in relation to the development of the United States and its people, our society has a long way to go before the brotherhood of man can be realized in the manner envisioned by the Founding Fathers or by others responsible for the idealism and humanity associated with the United States as a great free nation in the world.

At least today there is a national awareness of many of the problems relating to the American land—its many kinds of people and their diverse cultures. This is the great richness of the United States, and it has enabled this country, though still imperfect, in a little over two hundred years to become one of the world's leaders and to offer to all people everywhere a stimulating example of what free men can achieve.

American culture, history, and progress are very real forces in the world today. Often they are recognized and appreciated more by foreigners than by Americans. All too frequently, American lore of all kinds is better understood by people from other countries than by our own citizens. Conversely, many of us are more familiar with the ways of nations across the sea than we are with our American traditions.

Distance lends enchantment, and, travel being what it is today, the culture of faraway places often seems more attractive than our own. Our metropolitan urban culture provides us with constant exposure to imports from around the world. We often allow ourselves little opportunity to discover the richness of our own heritage. The cultural resources of the American people are deep and broad throughout the land. Our heritage is an inspiring one, accessible to the interested, with precious little work or travel involved. The rediscovery of America is a challenge to all Americans as the United States enters its third century as a republic.

Not taken for granted but largely overlooked is an inspiring group of indigenous Indian people whose life represents one of the oldest continuities of culture known to man. These are the admirable and honorable Hopi people, who still live in a world of their own on the high mesas of northern Arizona. In this ever-demanding, earth-shrinking, mundane day-to-day existence, where anything can happen and often does, the ideal, the noble, and the inspiring are often lost to the ever-increasing lack of cultural checks and balances.

Man is called the cultural animal. He has developed society, politics, the arts, and the sciences to serve him; yet he is frustrated at the results. In his big world he often takes refuge in one of many little worlds of his own making—refuge from a reality he is no longer able to understand, appreciate, or afford. Modern man could learn much from the Hopis and their way of life.

It is almost unbelievable that the Hopis can live as they do in their mesa island world, surrounded by the conflicting cultures of their fellow citizens. The Hopi life style is a rewarding one for them, however strange it may seem to the outsider. It has all the elements of the good life, not only for the Hopis, but for all who can understand and appreciate it.

It is not by accident that from a Hopi village one views the world as though he were at its center. North, east, south, and west, the view is unobstructed through to the horizon. Morning, noon, or star-drenched night, Hopi eyes, for hundreds of years, have peered off into the distance from the center of their world. Few societies of people have been in such an enviable geographic position. The Hopis have made the most of it.

Hopis see the Painted Desert, the Petrified Forest, the San Francisco Peaks, the Grand Canyon, the Sunset Crater, the Wupatki Ruins among the other meaningful places and things in their neighboring world. All the universe around them helps them lead a better, richer life. As a social condition of man they have been called primitive, but are they? In what sense? They have purpose, they have beauty, they have philosophy, they have respect, they have self-reliance, and above all they have love for life, for one another, and for their fellow man. What a contrast to our civilized man, particularly in the big cities today, which are filled with hate, lust, fear, brutality, greed, and lack of appreciation and love of mankind.

In the long saga of their being, Hopi history tells of the Indian marauders who came to upset their way of life and destroy their culture. But from those distant days until the coming of the Spanish, in the sixteenth century, and the Mexicans and hordes of Anglo-Saxons, in the nineteenth century, and despite the progress of the twentieth century, the Hopi have remained secure, their culture intact. The view from the center of their world is still un-dimmed and unchanged, free from what has bothered so many millions of the world's less fortunate people.

The Hopis resistance to explorers, missionaries, soldiers, settlers, clergymen, an-thropologists, scientists, cameramen, and tourists is nothing short of remarkable. Despite the constant onslaught from people who threaten their life style, the Hopis remain serene. When people occupy as beautiful, as interesting, and as significant an area as do the Hopis, it is remarkable that they have been able to maintain themselves, their culture, and their sanity in so inspiring and admirable a fashion.

Few American Indian tribes in the United States have been written about or photo-graphed as much as the Hopis. They deserve all the interest they have created. To those interested in Hopi history, the Hopi way of life and Hopi culture will merit and repay all the studies they have inspired. Despite this great body of work, we are only now beginning to truly appreciate them as fellow citizens and their impact on our society. There is much to learn and much to exchange when one considers the wealth of material represented in Hopi society and accomplishments. Only now are we Americans beginning to realize the richness and the inspiring quality of life, art, philosophy, and religion which we have had available from our fellow citizens of American-Indian background.

It is not too late to understand the culture of the red man and his America. Much of what has been lost can still be refound. The majority in America must change their attitudes in order to appreciate the great contributions of the minorities that make up this great nation. When one learns this, he sees that the Hopis represent a cultural milestone achieved by their beautiful but diverse life style.

Patricia Janis Broder has found her place in the sun. She is well on her way in that famous Hopi journey to the Sun. An aware, patient, sensitive, understanding humane human being, Patricia Broder has endeared herself to the Hopi people. She has won their admira-tion, respect, and friendship—not an easy thing to do, especially in these times when so many would-be friends have taken advantage of Indians and their folkways.

In her inspired work *Hopi Painting—The World of the Hopis,* Patricia Broder has brought together a body of knowledge that has heretofore only appeared in scattered, minute, and unrelated publications. In a masterful manner, she has shown the world of the

Hopis through their art. Hopi art is the great common denominator in revealing the remarkable depth and breadth of Hopi life and culture.

For years too many to mention, the Hopis have been besieged by well-wishers, do-gooders, glad-handers, and others who actually preyed on Hopi good nature and hospitality. No wonder that they have questioned so much of the white man's (bahana) intent. Unfortunately, anthropologists have been among the greatest transgressors.

Patricia Janis Broder has been successful in completing this significant project because her work has received the fullest cooperation of the Hopis. As a wise people, they are quick to spot an enlightened soul, a kindred spirit, and one with humane perception.

Patricia Broder did not, as do many others, try to "venture in where angels fear to tread" but was invited and warmly accepted by Hopi clans and tribal leaders. Because of her remarkable rapport with Hopi people and her respect for their customs, she was able to gather significant material to build a bridge of understanding between the Hopis and their arts and those sensitive appreciative people on the outside world who appreciate the Hopis as an amazing, virile, inspiring, and unique cultural force.

In an age of electronic, photographic, and recording gadgetry, Patricia Broder's research represents something refreshing for our time. She has utilized her own human skills over extended periods of investigation. She has recorded and understood this remarkably diverse culture with devotion and appreciation. The continuity of the Hopi way of life is its ultimate triumph, and this fact alone is worth the attention of intelligent people throughout the world.

The Hopis created and have maintained one of the earliest of urban societies. They still dwell in some of the oldest apartment houses in America. They have always tried to make life itself an art. They are today an inspiration and pattern for many groups of people caught in economic, cultural, social, and political problems in many parts of the world. Patricia Broder's view on Hopi art becomes a catalyst for action in producing an example of a continuity of life based on a rich continuity of culture.

Anthropologists, architects, city planners, demographers, and economists have been fascinated by Hopi history. They have concluded that such a village system should not work—but it does! Hopi life style has been a strong influence in the American Southwest for hundreds of years, for thousands of people. Patricia Broder's engaging book focuses attention on this important aspect of Hopi life. Her work deserves to take its rightful place among the outstanding, artistic, photographic, and literary works that dramatize most effectively the rich contributions of the American Indian.

Hopi Painting—The World of the Hopis provides the reader with words and pictures that truthfully, skillfully, and intelligently convey this significant phase of Hopi life and culture.

After becoming a part of Patricia Janis Broder's work the reader will "want to stop the world and get on." The Hopi way of life will not only interest you, it will involve you in its charm and capture you with its enchantment.

The Southwest Museum is privileged and proud to have had a small part in assisting Patricia Janis Broder in her creative, beautiful, and enlightening work, that is dedicated to the inspiring genius of the Hopis.

Carl Schaefer Dentzel
Director of the
Southwest Museum
Los Angeles, California

Publisher's Note

Because the Hopis do not have a written language, the spelling of Hopi words has never been standardized. Thus, the reader will notice that within the text some words will differ in spelling and capitalization.

CHAPTER 1

Hopi Painting—Past and Present

Modern Hopi painting has a unique importance in twentieth-century American art. Today, throughout the art world, people are involved not only in a search for new forms of expression but have developed a great appreciation of America's heritage of Indian art. At a time when Americans are rediscovering their ethnological past and are developing a new respect for and understanding of their indigenous art history, the paintings of the most innovative contemporary Hopi artists stand as a cultural milestone.

The forerunners in modern Hopi painting are the members of the Artist Hopid, a group of artists who utilize many of the techniques and artistic innovations of the twentieth century as well as the traditional symbols and stylistic conventions of ancient Hopi art to express the aesthetic and cultural values of their people. They experiment and test new ideas and techniques but retain traditional Hopi design and concepts. Their goal is to achieve a synthesis of the past and the present, of tradition and innovation. The work of the Artist Hopid has special value today, for it is the goal of these artists to create a meaningful art out of the best of two cultures. These Hopi artists recognize the problems of life in modern America and through their multidimensional art identify both with their traditional heritage and with the contemporary art world around them (Fig. 1–1 ,p. 17).

The work of the Artist Hopid reflects a continuity of past and present and mirrors the evolutionary changes in the attitudes and creative impulses of a new generation of Hopi artists. They find inspiration both in the designs used through the centuries in petroglyphs and in ceremonial murals and in the traditional motifs of pottery, baskets, and textiles, as well as in the stylistic innovations of outstanding twentieth-century artists. Contemporary Hopi art includes many symbolic representations, but these symbols are not archaic icons, remnants of the past; they are symbols of religious beliefs and rituals of daily life which are the foundation of the Hopi world today. Their art is at all times focused on subjects that are meaningful to their lives.

Hopi art is one of the oldest surviving artistic traditions in North America. The modern Hopi is the descendant of the prehistoric people who, almost two thousand years ago, lived on the mesas and deserts of the Southwest. Hopi designs of the past are etched and painted on caves and rocks, and ancient Hopi paintings are found on the walls of kivas, underground ceremonial chambers, which have been buried in the ruins of ancient Hopi villages. Primitive Kachina figures and specimens of Hopi pottery and baskets have been excavated from these ruins.

Since about A.D. 900, the Hopis have lived over six thousand feet above sea level in villages made of stone. These villages stand on the mesas and on the deserts surrounding the mesas of northern Arizona (Fig. 1–2) (Fig. 1–3). The land of the Hopis is about one hundred miles east of the Grand Canyon and about sixty miles north of Winslow, a town built on the route of the Santa Fe Railroad. The Hopis are the westernmost of the Pueblo Indians. Today there are twelve Hopi villages which stand on and at the base of three mesas, which are fingered extensions of Black Mesa.

On the top of First Mesa are Hano, Sichimovi, and Walpi, and at the foot of the mesa is Polacca. Hano was founded by Tewa Indians, refugees from the Rio Grande country. Following the Pueblo Revolt of 1680 and the subsequent Spanish reconquest of Mexico, the ancestors of the inhabitants of Hano were invited to live on the mesa in return for helping to protect the Walpi from Ute invaders. Second Mesa splits into two fingers. On one finger are the villages of Shipolovi and Mishongnovi and on the other is Shungopovi. Old Oraibi stands on Third Mesa. To the north are Hotevilla and Bacabi which were settled in the first decade of the twentieth century, following a deep ideological division between Bear and Spider Clan leaders in Oraibi. The immediate reason for the split was the refusal of Youkeoma, the leader of the conservative Hopis, to agree to the demands of the Bureau of Indian Affairs in 1906. He and his followers were forced to leave Oraibi. They established Hotevilla, which is still the most conservative Hopi village. New Oraibi, which stands at the foot of Third Mesa, is the home of the Hopi Tribal Council and several missions. Moencopi, which historically was an agricultural colony of Oraibi, is built on the site of ancient ruins, forty miles to the west of the three mesas.

Throughout the centuries, the Hopis were forced to abandon their homes and to build new villages, each in the image of its predecessor. Old Oraibi dates back to about A.D. 1150 and is the oldest, continuously inhabited village in North America. Although in the 1880s Oraibi was the home of over half of the Hopi population, in 1968 its population was about 167.[1] The Hopis, in order to protect their villages from the attacks of Apache, Navajo, and Ute raiders as well as from the Spanish conquistadors, were forced to move to the mesa tops. High on the mesas, they found the best possible defense against each successive wave of invaders.

Throughout the years, all who came in contact with the Hopis noted the sophisticated level of development of their art and crafts. In the sixteenth century, the Spanish conquistadors became the first white men to visit the villages of the Hopis. The first contact of the Hopis with the Spanish was the arrival in 1540 of Pedro de Tovar. He was accompanied by the Franciscan priest Juan Padilla, his cavalry men, foot soldiers, and Zuni guides. Tovar had been sent by Francisco Vasquez de Coronado, the thirty-year-old leader of the Spanish expedition to North America, who was exploring the Southwest in hope of finding the riches of The Seven Cities of Cibola. Disappointed with the Pueblos of Zuni, Coronado still hoped to find the legendary cities in the north. Tovar looked upon the friendly Hopis (the name of the Hopis in their own language is *Hopi-Shinumu* meaning "peaceful people") as savages

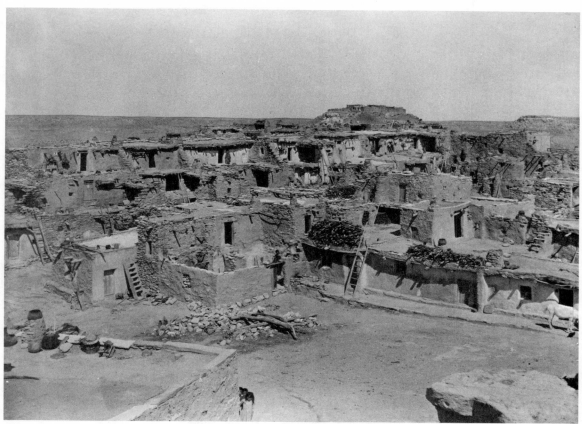

1-2. *A. C. Vroman. View Looking Over Mishongnovi, Shipolovi in the Distance. 1901. Photograph. Collection: Southwest Museum, Los Angles, Calif.*

and treated them with brutality. Finding no gold in the Hopi villages, Tovar declared his journey a failure and returned to Coronado. That same year the Hopis received a visit from Don Garcia Lopez de Cardenas, whom the Hopis furnished with guides to the "Great River." Thanks to the Hopis, Cardenas became the first white man to see the Grand Canyon.

For the next forty-three years, the Hopis were free from Spanish interference, but they had heard reports from neighboring Pueblo Indians of Coronado's brutal and inhuman treatment of the Indians in the villages near Zuni and of the horrors of the massacre at the Acoma Pueblo. In 1583, Antonio de Espejo, also seeking riches in the American Southwest, passed through the Hopi towns and arrived at the village of Awatovi. Terrified by tales of the Spaniards, and remembering the violence of Espejo's predecessors, the Hopis at once pacified him with gifts and speedily sent him westward with tales of wondrous gold and silver mines. Like those before him, however, Espejo failed to find an El Dorado of great riches in the Southwest. The Spanish Crown gave royal approval to Juan de Onate for the conquest in the name of Spain of all Indian settlements in the Spanish provinces. In 1598, Onate came to the Province of Moqui, the land of the Hopis, demanded and received from the Hopi leaders formal submission to the Spanish Crown. Today, the Hopis, like most tribes of the Southwest, claim title to land deeded to them by the Spanish Crown. Most tribes still hold only a fraction of their original portion.

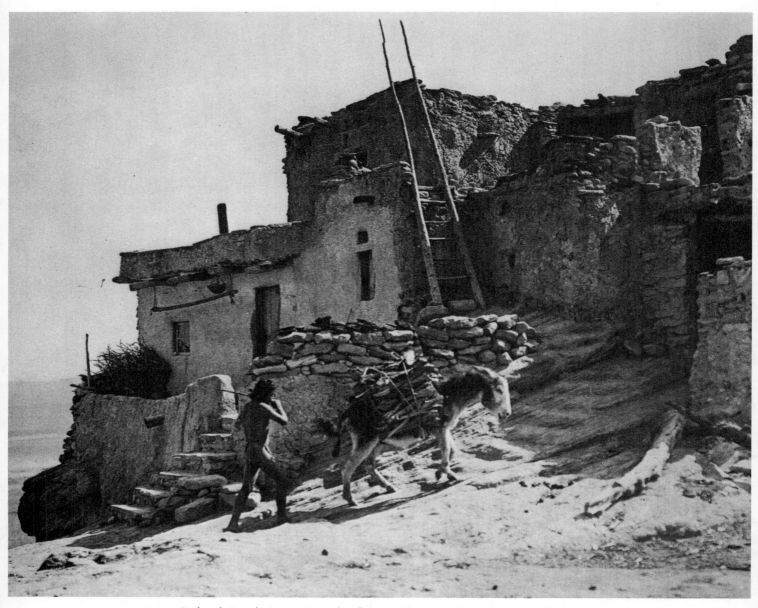

1-3. Roland Reed. Hopi Woodgatherer. *Photograph. c.1903. Collection: Southwest Museum, Los Angeles, Calif.*

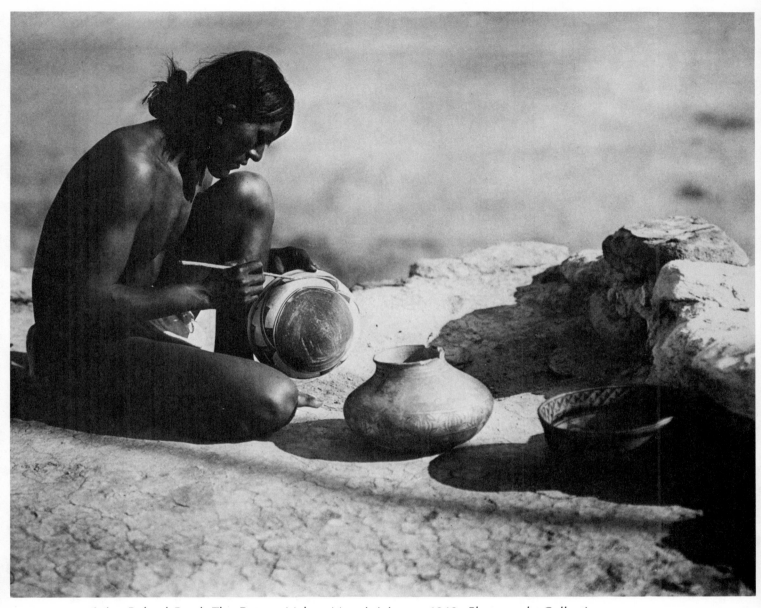

1-4. *Roland Reed.* The Pottery Maker, Moqui Arizona. *1913. Photograph. Collection: Southwest Museum, Los Angeles, Calif.*

1-5. *Honvantewa—Terrance Talaswaima. Awatovi. 1975. 24" x 36". Acrylic. Collection. Hopi Cooperative Arts and Crafts Guild.*

Although, in 1604, Onate returned on his way to search for the "South Sea" (the Gulf of California), for thirty years following their submission to the Spanish Crown, the Hopis were spared the colonizing and missionary zeal of the Spanish. In 1628, however, the first missionaries arrived, and the following year the mission-building program was started in earnest. The Hopis docilely cooperated and built three churches. They were forced to carry the giant timbers used as beams for the church on their shoulders. They carried these beams a distance of more than forty miles from the forests surrounding the San Francisco Peaks to the mesas. In later years, the Hopis used these same beams in the construction of kivas in Oraibi and Shungopovi. For twenty-five years they quietly endured the missionaries, but in 1680 the Hopis supported the Pueblo Revolt and killed the four Spanish missionaries living in their land. In 1700, the Hopis, primarily those from Walpi, prevented the return of the missionaries and the zealous imposition of the alien religion by destroying the Hopi village of Awatovi (Fig. 1–5). Awatovi was the only Hopi village to welcome the returning priests and to reestablish the Catholic church.[2]

During the next century only a few adventurers, traders, and trappers ventured into the land of the Hopis. During the early nineteenth century, however, several Anglo-American exploration parties reached the Hopis, and during the years of the Mexican War, the soldiers and government officials who traveled to the Southwest recorded visits to the mesas. By the end of the nineteenth century, the anthropologists and a new wave of Mormon and Protestant missionaries began their crusades to the world of the Hopis.

Despite the successive waves of Spanish, Mexican, and Anglos, the Hopis have been able to preserve their culture with a greater degree of success than any other Indian tribe. Thanks to the inaccessibility of their land, the severity of conditions of life on the mesas, and the great strength of their social structure, the world of the Hopis has been left relatively undisturbed by the expansion of white civilization and the growing industrialization of the American West.[3] Throughout the years, the Hopi people have possessed a sense of environmental and artistic conservation. The Hopis take a great pride in the past history of their people, place a high value on life today, and work to create a solid foundation for the future.

The Hopis believe there is a fixed order in both the natural and supernatural world. Men, animals, plants, even inanimate objects like rocks are a vital part of this order, and each possesses a spirit which must be in harmony with the order of the universe (see chapter 5). Only through recognition of this order and the maintenance and when necessary the restoration of universal harmony can man survive and prosper in the world of the living and contribute to universal progress. Each person has a special responsibility which increases with age and continues into the world beyond life.

All aspects of life, whether the rituals of daily existence or the sacred religious ceremonies, whether on a physical or a spiritual plane, have the same universal goals— harmony, fertility, and regeneration. Universal harmony, fertility, and regeneration have always been and still are the dominant themes of Hopi painting, for artistic expression is but one aspect of Hopi life and it must be an integral part of the Hopi world. In the Hopi world it is impossible to separate the activities of daily life, religious observance, and artistic creation.

Hopi paintings, like all Hopi culture, have retained a remarkable continuity of symbol, design, and subject, from the earliest petroglyphs etched on the cave walls by the Anasazi (a Navajo word meaning *ancient one*), who were ancestors of the modern Hopi, to the studio paintings and murals of the twentieth-century Hopi artists.

Until the end of the nineteenth century, all Hopi paintings were part of religious ceremonies. Indeed the paintings themselves were a form of visual prayer. Hopi ritual arts included dry pigment sand mosaics and mural paintings on the walls of the underground kivas. The Hopis painted prayer sticks, dance wands (Fig. 1–6), *tablitas* or ceremonial headdresses (Fig. 1–7) and dance masks (Fig. 1–8). Of particular importance were paintings on cotton cloth which hung as altar pieces (Fig. 1–9). Painting was always a communal occupation. The artist, as a contributor to the tribal welfare, was rewarded with inner peace and a sense of well-being, rather than with the pride of personal achievement or status as an artist. The paintings on the altar pieces and murals (Fig. 1–10) are two-dimensional linear representations of figures from religious ceremonies—stylized animals, birds, corn, and other plant forms. Symbols of the sun, rain, clouds, and lightning are all representative of the Hopis' prayers for rain and for crop germination. These paintings are primarily in earth tones, for today many Hopi artists use the symbols and colors of the ancient religious paintings.

The land of the Hopis is a windy, sandy world of desert and rocks. The annual rainfall in this arid land is a little more than ten inches. This rainfall comes optimally as the wind-driven snows of winter and inevitably as the torrential storms of mid-summer. These rain storms erode the soil, damage the crops, and leave little rainfall for the ground to absorb. For centuries the Hopis have fought against draught, famine, and disease, and until recent years they lived in physical isolation, aware that they alone with the help of their deities shouldered the responsibility of their own survival. Prayer and work were the only keys to their salvation. Without water there could be no crops and without crops there could be no survival. Water, crop germination and growth, and the perpetuation of the Hopi people have

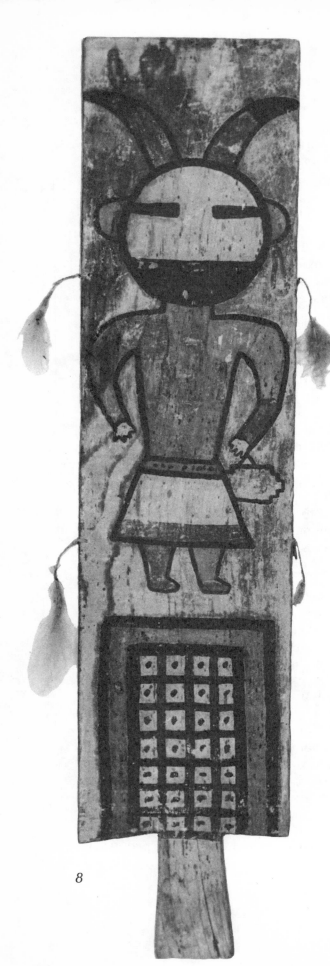

8

1-6. Dance Wand. *c. 1890. Oraibi. 21¹/₂" x 4³/₄".*
Wood painted with representation of Aloska
Kachina. Collection: The Museum of the Ameri-
can Indian, Heye Foundation, New York, N.Y.

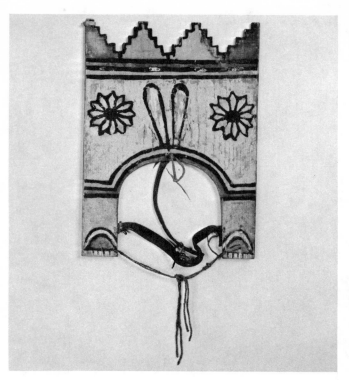

1-7. Tablita Headdress. *1910 to 1915.*
Moencopi. 13½" x 9½". Wood
with painted decoration. Collection:
The Museum of the American Indian,
Heye Foundation, New York, N.Y.

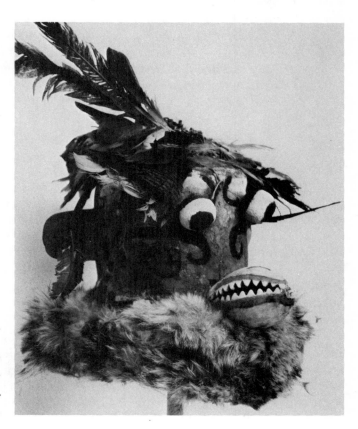

1-8. Mask. *Collected by H. R. Voth in*
1898. Oraibi. H. 11". Collection:
The Museum of the American Indian,
Heye Foundation, New York, N.Y.

9

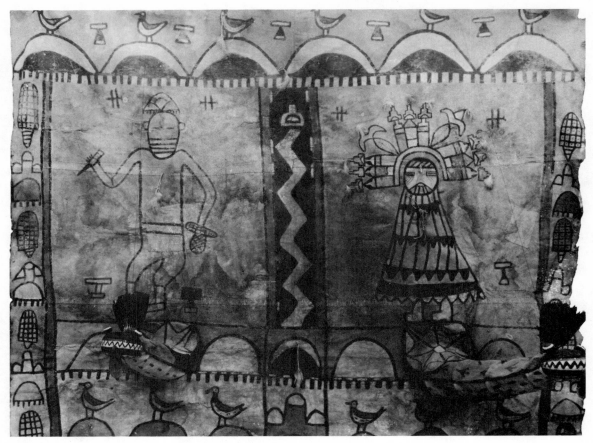

1-9. Altar Cloth. *1890 to 1895. Oraibi. 78¹/₂" x 89¹/₂". Feathered serpent screen—Palalükong of cloth. Used in kiva during night ceremonies in March. The feathered serpent effigies, constructed of cloth on a series of hoops, are thrust through the openings and operated by men who insert their arms in the effigies and make them writhe. Collection: The Museum of the American Indian, Heye Foundation, New York, N.Y.*

for centuries been the central focus of the Hopi world, and thus they are the principal subjects and primary symbols of Hopi art from ancient days to the present.

Today the work of the most innovative Hopi painters has the identical focus and utilize the same symbols and designs as the art created centuries ago. Hopi painters now as in the past work in a two-dimensional linear style as they celebrate the basic themes of Hopi life. Contemporary Hopi painters have returned to the stylized, decorative art of their ancestors, after an extensive detour into an anthropological and descriptive art which focused on authenticity of detail. For several decades many Hopi painters, with varying degrees of success, have followed the artistic traditions of European art by striving to achieve maximum realism and three-dimensional illusion.

The first major occurrence of Hopi nonceremonial paintings were the two hundred drawings of Kachinas, commissioned in 1900 by Dr. Jesse Walter Fewkes, the anthropologist who directed the excavation of the Sikyatki ruins and encouraged Nampeyo to revive the Sikyatki style of pottery painting. Fewkes hired four Hopi artists because he felt their drawings would be a valuable means of studying the symbolism of the tribe.

The drawings commissioned by Fewkes showed little evidence of the traditions of European art. They are similar in style to the figures in the Pueblo mural paintings (Fig. 1–10). Of the four artists, Kutcahonauu (White Bear) was the most sophisticated, for he had had some schooling at Keams Canyon. Fewkes preferred the paintings of Kutcahonauu's uncle, Homovi, whose work he felt was uncontaminated by the white man's influence. The third artist was Winuta, who was also a naïve painter. However, Fewkes completely rejected the work of the fourth artist, a boy who had been to school in Lawrence, Kansas, for he felt the boy's drawings clearly showed the influence of the white culture. Fewkes identified the artists in the text, but the individual drawings were unsigned. The drawings commissioned by Fewkes were published in 1903 as "Hopi Kachinas Drawn by Native Artists" by the United States Bureau of American Ethnology in Annual Report No. 21.

Although this was the first occasion of the Hopis accepting payment for paintings, they had a precedent, in that since the early 1850s several Hopis had been selling Kachina carvings to the white man. The major difference was the Kachinas had always been carved for educational rather than religious purposes, whereas painting had been considered a religious ceremonial art. The elders of the Hopi villages reacted with suspicion and hostility to the painting of religious images for secular purposes and condemned the nonritual paintings. Upon completing the Fewkes project, all four Hopi painters ended their careers as commercial artists.

During the period that he worked on the Fewkes commission, however, Homovi also created a hide painting utilizing Kachina figures, an eagle, a rainbow, rain and cloud symbols (Fig. 1–12). The iconography and composition of the hide painting is similar to that in traditional altar hangings. The painting was bought by Thomas V. Keams, a trader at the canyon which today bears his name. The hide painting was probably sold to Keams by the artist. The creation of an independent work of art was truly an exception at this time. The idea of a hide painting may have been inspired by the creations of the Plains Indians.

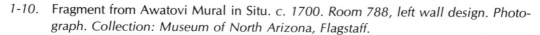

1-10. Fragment from Awatovi Mural in Situ. *c. 1700. Room 788, left wall design. Photograph. Collection: Museum of North Arizona, Flagstaff.*

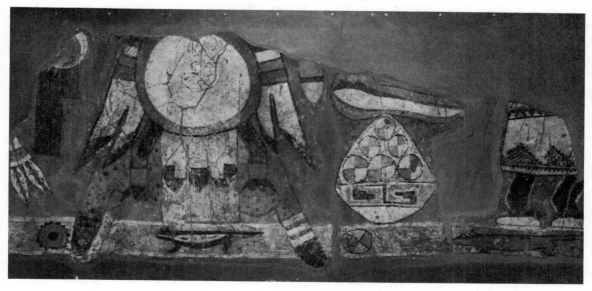

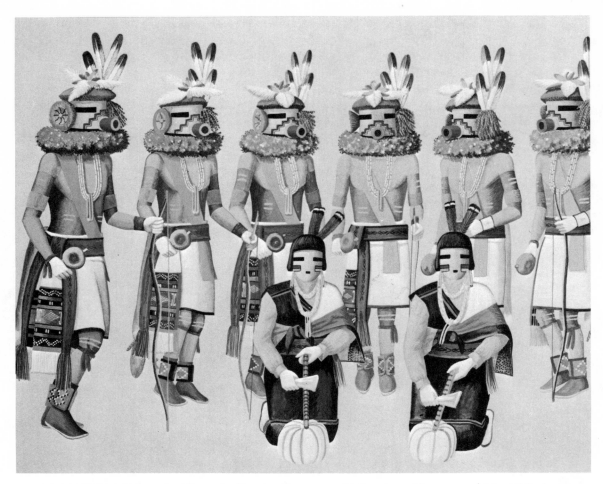

1-11. *Waldo Mootzka. Squash Dance. Tempera. Collection: Museum of New Mexico,*
Santa Fe.

 With the exception of occasional efforts by school children, it was almost two de-
cades after the Fewkes drawings were completed before the next major wave of nonceremo-
nial Hopi painting. These were the paintings of Fred Kabotie and Otis Polelonema, created at
the Santa Fe Indian School between 1918 and 1925. Kabotie and Polelonema were two of
seven Indians encouraged to become artists by school superintendent John D. Dehuff and
his wife, Elizabeth. Both Kabotie and Polelonema were from tradition-oriented Hopi fam-
ilies. Kabotie had been forced by the United States Government to attend school in Santa
Fe. It is probable that neither artist would have received the sanction of the conservative
Hopis to paint the ceremonies or the rituals of the Hopi people. Both Kabotie and
Polelonema learned to paint utilizing the techniques of traditionally European representa-
tional art. Their work is primarily descriptive. Their paintings are anatomically correct and
give the illusion of dimension (Fig. 1–13) p. 19, (Fig. 1–14). The artists achieve a sense of
texture and atmosphere in their work and in their most sophisticated paintings; their em-
phasis is on color rather than on line. In 1929, Kabotie was commissioned by the Heye
Foundation of the Museum of the American Indian to paint a series of representations of the

12

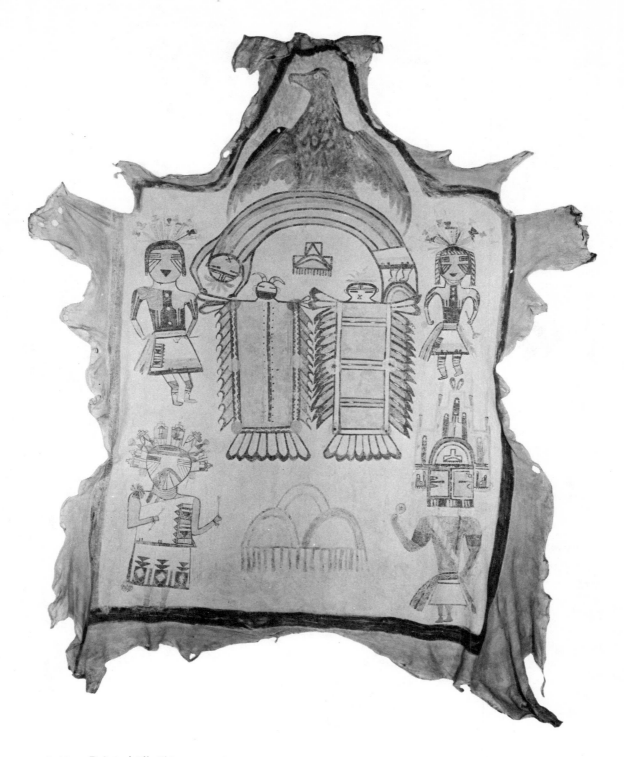

1-12. Painted Elk Skin. c. 1900. Homovi. L. 75". Watercolor on animal hide. Collection: The Museum of the American Indian, Heye Foundation, New York, N.Y.

1-14. Fred Kabotie. Social Dance. *late 1940's. 18³/₄" x 24³/₄". Watercolor. Collection: The Gilcrease Institute of American Art and History, Tulsa, Okla.*

tribal dances of the Hopis. Fred Kabotie was truly the first Hopi to receive individual recognition as an artist.

The traditions of descriptive painting established by Kabotie and Polelonema were carried forth by the majority of Hopi artists from that time on. During the 1920s and 1930s most Hopi paintings were done by artists who were living away from the mesas. In 1937, Kabotie returned home to teach at the Oraibi High School. He helped to train a succession of Hopi painters who illustrated the rituals and ceremonial figures of the Hopi people. Two of the most successful Hopi artists to study with Fred Kabotie were Raymond Naha , p. 184 and Peter Shelton , p. 160.

Even those artists who adopted European techniques of naturalism occasionally created paintings in which they returned to the traditions of ceremonial art. Fred Kabotie in *The Legend of the Snake Clan* (Fig. 1–15) worked in a two-dimensional style, utilizing the symbols of his ancestors. Using an animal hide as his canvas, as Homovi did many years before him, he included primitive, stylized figures and symbolic representations of the sun, clouds, and rain. Kabotie's painting *Germination*, p. 215 shows the strong influence of the Awatovi murals (see chapter 9), which today are among the strongest influences on the work of the Artist Hopid.

Waldo Mootzka is a transitional figure in the history of Hopi painting. Although he painted dozens of Kachina figures , he was magnetically drawn to the Hopi fertility

14

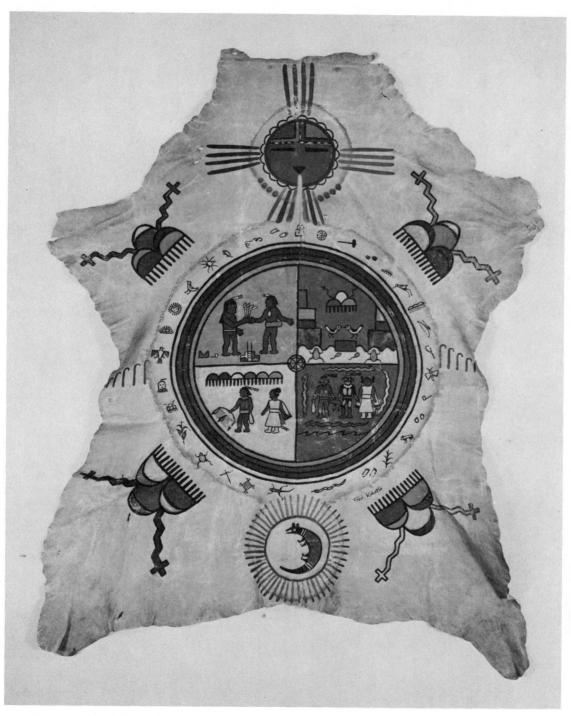

1-15. *Fred Kabotie. The Legend of the Snake Clan. 61" x 47". Casein on animal hide. Collection: The Museum of the American Indian, Heye Foundation, New York, N.Y.*

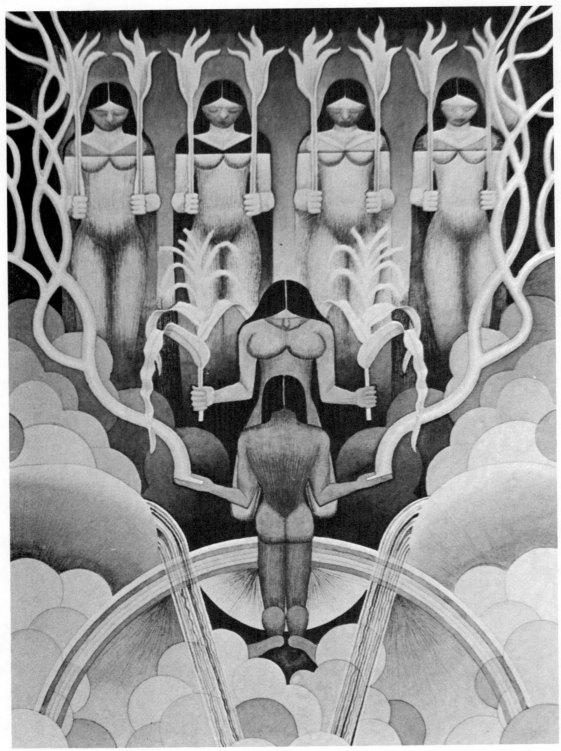

1-16. *Waldo Mootzka. Fertilization. 1948. 16" x 11". Tempera. Collection: Nettie Wheeler, Muskogee, Okla.*

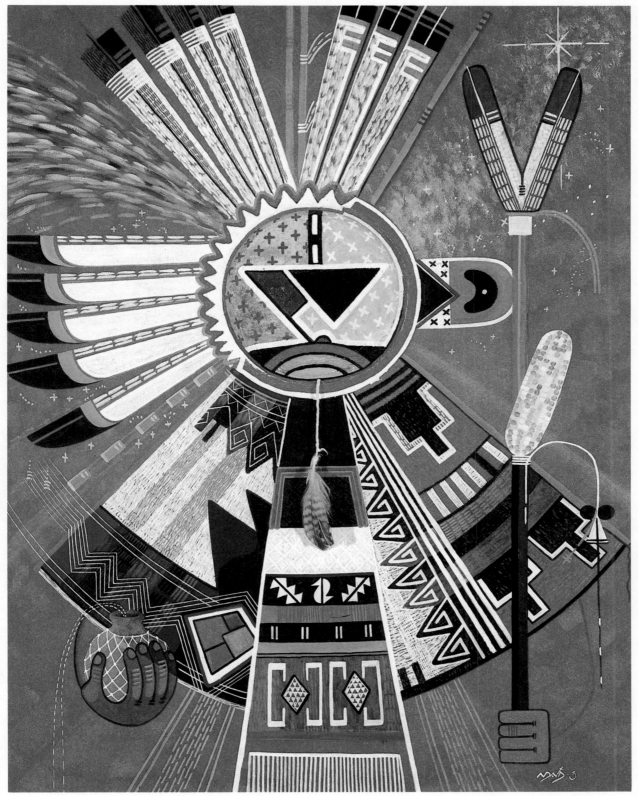

1-1. *Neil David, Sr. Ahula, the Germinator. 1974. 40" x 30". Mixed media. Collection: Hopi Cooperative Arts and Crafts Guild.*

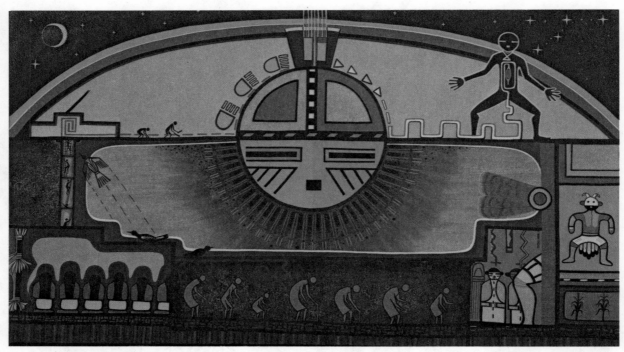

2-5. *Dawakema–Milland Lomakema. Emergence. 1974. 48″ x 84″. Acrylic. Collection: Hopi Cooperative Arts and Crafts Guild.*

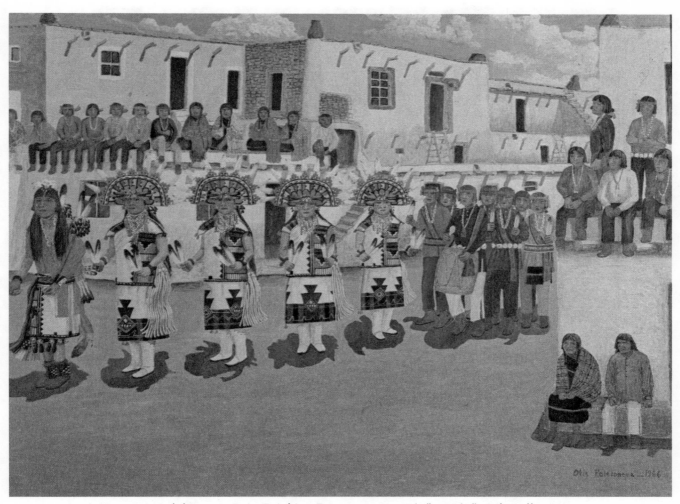

1-13. *Otis Polelonema. Rain Drinking Dance. 1966. 17¹/₂" x 23¹/₂". Oil. Collection: James
T. Bialac, Scottsdale, Ariz.*

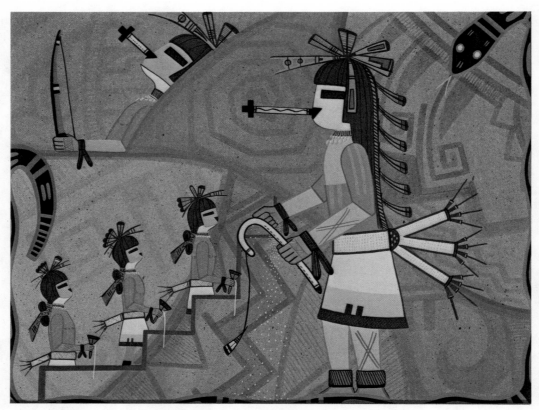

Coochsiwukioma–Delbridge Honanie. Hopi Ceremony. 1975. 31" x 39". Acrylic. Collection: Hopi Cooperative Arts and Crafts Guild.

rites (Fig. 1–16) and approached this theme time and again. Through his powerful sense of composition and use of traditional symbols, he simultaneously portrayed the fertility rites for the corn crop and the fertility rites for the propagation of the Hopi people. Mootzka's paintings have a ceremonial quality and radiate a sense of the power of the eternal cycle of life. The stylized figures, muted colors, and overall design of the painting are reminiscent of the sacred altar paintings of the past and look forward to the symbolic compositions and abstractions of the mid-twentieth-century Hopi artists.

From the 1930s until the 1960s, one of the strongest influences on Hopi painters as on Indian painters throughout the Southwest was the artistic style developed by Dorothy Dunn at the Santa Fe Indian School. From 1932 to 1939, Miss Dunn taught her pupils to paint stylized, two-dimensional forms which were both decorative and symbolic. Her technique emphasized the use of firm and even contours and the flat application of opaque watercolor

Palahiko Mana Kachinas. Bureau of American Ethnology Annual Report 21, *Plate LVI. Photograph. Smithsonian Institution, National Anthropological Archives, Bureau of American Ethnology Collection, Washington, D.C.*

or casein. She believed that certain forms, particularly animal, plant, and weather abstractions, were authentic Indian prototypes and, thus, should be the basic components of Indian art. Although all of the students were taught a basic vocabulary of Indian symbols, most of which were derived from early Pueblo and Kiowa art and from the murals of ruins excavated during the 1930s, the individuals were encouraged to turn to the ancient symbols of their own tribes for inspiration.

Two Men Praying for Rain (Fig. 1–17) by Lorenzo H. Quannie, shows the strong influence of the techniques of the studio style on painters during the 1930s. Riley Sunrise

(Quoyauema), a Hopi adopted by a Kiowa family, joined Fred Kabotie and Waldo Mootzka to illustrate *Rhythm for Rain,* which was published in 1937. His work shows the influence of both Kiowa painting and studio techniques.

Miss Dunn's techniques of teaching and her aesthetic principles were followed by instructors at Indian schools throughout the West. Many of her pupils became teachers and many of her traditions and techniques are still taught and flourish today. The work of Gibson Talahytewa, who studied in Santa Fe in the early 1950s, shows the strong influence of the Dunn theory of Indian art (Fig. 1–18). Other well-known Hopi painters who studied in Santa Fe were Lewis Numkena, Eric Humetewa, and Lawrence Outah.

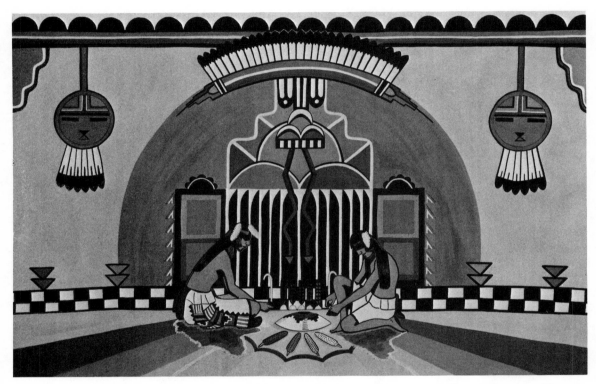

1-17. *Lorenzo H. Quannie. Two Men Praying for Rain. 1934. Watercolor. Collection: The Museum of New Mexico, Santa Fe.*

Artists learned that adherence to Miss Dunn's formula for Indian painting produced an aesthetically pleasing and commercially marketable work. It must be remembered that the United States had sent the Indians to government schools to be taught a trade so that they could learn to make a living in the white community. All of the studio paintings were completed by artists living in a foreign environment, separated from their people, their homes, and the rituals of traditional Hopi life. Their work is ethnological rather than spiritual, and their emphasis is visual rather than conceptual. The colorful Kachina became the favorite subject of Hopi artists, and for decades they have continued to paint individual

22

Kachina figures and lines of dancers. Among the best-known painters of Kachinas are Louis Lomayesva p. 121 , Bruce Timeche, and Leroy Kewanyouma.[4]

The painters of the Artist Hopid are no exceptions, for all began their careers by painting representational Kachina figures. Little by little they abandoned the restrictions of European realism and turned toward abstraction, stylization, and symbolic design. *Coming of the Salako* (Fig.1–19) by Mike Kabotie is a highly competent, descriptive Kachina painting which is typical of his early work. *Kachinas and Mudhead* (Fig.1–20) by Delbridge Honanie illustrates some innovation in design but is still dependent on traditional Kachina figures.

Today these modern Hopi artists continue to use the Kachina or groups of Kachinas as the subjects of their paintings, but their goal is an aesthetic creation rather than an anthropological document or a recognizable example of an authentic Kachina. In his painting, *Long Haired Kachina* (Fig. 1–21) Milland Lomakema, has created a design based on two Bearded Kachinas, one male and one female. The turkey feathers of their costume, the cloud, the rain, and the lightning symbols, as well as the triangle, which traditionally decorate Hopi textiles, all serve as stylized design elements and are subordinate to the overall composition of the painting. In *Ahula, the Germinator* (Fig.1–1), Neil David, Sr., employs the techniques of collage to achieve a two-dimensional hard-edge representation of the Sun Chief. The radiant brightness of his costume, decorated with rain and sun symbols, proclaims the brilliance and germinative powers of the Ahula.

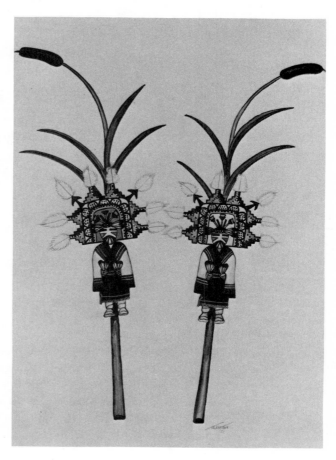

1-18. Gibson Talahytewa. Dance Wands.
1951. Watercolor. *Collection:*
The Museum of New Mexico, Santa Fe.

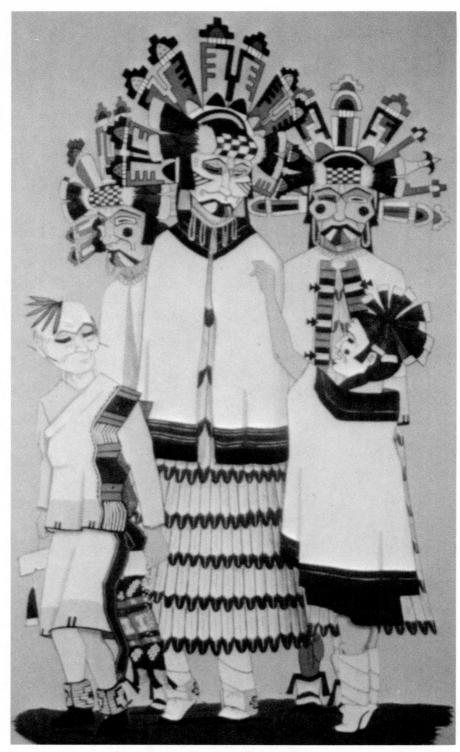

1-19. *Lomawywesa–Mike Kabotie. Coming of the Salako. c. 1966. 29" x 17". Casein.
Collection: James T. Bialac, Scottsdale, Ariz.*

1-20. Coochsiwukioma–Delbridge Honanie. Kachinas and Mudhead. *14" x 19". Acrylic. Collection: The Museum of the American Indian, Heye Foundation, New York, N.Y.*

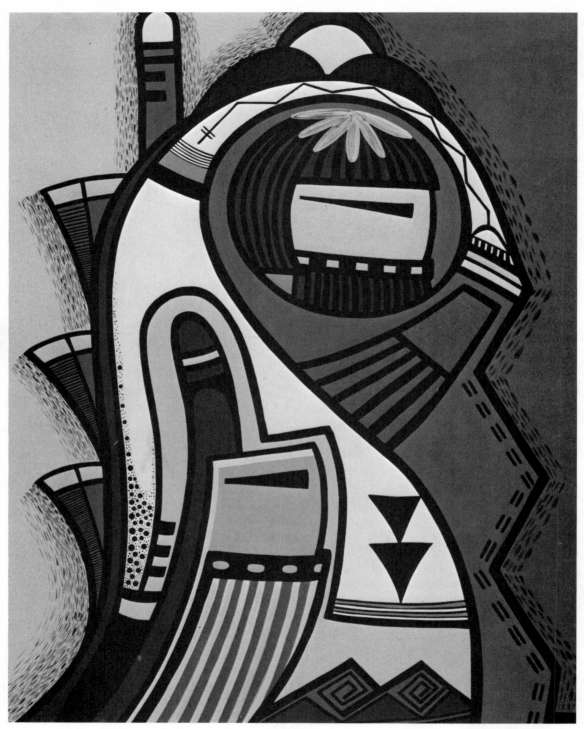

1–21. Dawakema–Milland Lomakema. Long Hair Kachina. 1974. 29" x 22". Acrylic. Collection: Hopi Cultural Center, Second Mesa, Ariz.

26

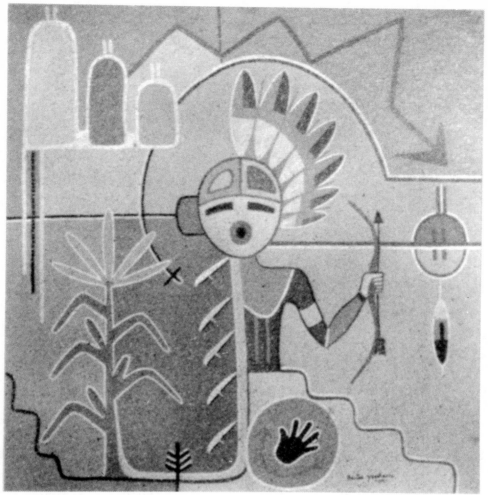

Lomaquaftewa–Bevins Yuyahoeva. The Fertile Corn. 1969. 18" x 17". Casein. James T. Bialac, Scottsdale, Ariz.

The painters of the Artist Hopid have chosen to live and to work on the mesas in the land of their ancestors. They participate in the ceremonies, rituals, and daily activities of Hopi life and are constantly a part of all that is meaningful to the Hopi people. Their paintings express the heart of Hopi life rather than the surface design. The members of the Artist Hopid address themselves to those both in the Hopi and in the white man's world. The world of the Hopis, the stone villages on Arizona's Black Mesa, stand virtually unchanged by passing centuries. It is hard to believe that today they are only a few hours drive from the jetport of modern Phoenix. The modern Hopi artists have learned to live in both worlds. Mike Kabotie, the spokesman of the group, expresses the ideal of the Artist Hopid: "We, the Hopis, have a lot to offer from a spiritual standpoint and as a living force. We are hoping that from the presentation of our traditions and from the interpretations of the Hopi way in our art and paintings a new direction can come for American spirituality."[5]

There are many differences and inconsistencies in the stories and legends of the Hopis. Today there are twelve villages and within each village there are many clans, societies, and families. Each has a heritage to preserve and to pass on to future generations. The Hopi language has never been written down and from generation to generation the his-

27

tory and beliefs of the Hopis have been passed solely by word of mouth.[6] With the passing of time, different conditions of living and individual personalities have caused the stories to vary so that each might best serve a particular village, clan, generation, or individual. Every legend is for the benefit of the person using it and every legend must change with time. Myth and history are both usable tools and, therefore, variations in the expression of myth and history in painting must be accepted as a valid expression of the beliefs and vision of the individual artist.[7]

NOTES

1. Harry C. James, *Pages from Hopi History* (Tucson: The University of Arizona Press,1974), p. 15.

2. *Ibid.*, pp. 33–70.

3. Edward H. Spicer, *Cycles of Conquest* (Tucson: The University of Arizona Press, 1962), pp. 189–209 and pp. 567–580.

4. Dorothy Dunn, *American Painting of the Southwest and Plains Areas* (Albuquerque: The University of New Mexico Press, 1968); Clara Lee Tanner, *Southwest Indian Painting: A Changing Art* (Tucson: The University of Arizona Press, 1957); and J. J. Brody *(Indian Painters and White Patrons* (Albuquerque: University of New Mexico Press, 1971) are three independent comprehensive histories of the first sixty years of twentieth-century Indian painting.

5. Michael Kabotie, "Artist Hopid," *Many Fires,* Vol. II, No. 1 (Gallup, New Mexico: Inter-Tribal Indian Ceremonial Association, March 1975) p. 1.

6. The Hopis speak a dialect of the Shoshonenan branch of the Uto-Atzetam linguistic family. There is no written language, and so uniformity of spelling has never been achieved. The people of village of Hano, which was settled by the Tewa Indians from the Rio Grande, speak their own language as well as that of the Hopis. The people of the other villages, however, have never learned the language of Hano.

7. My role in writing this book is as art historian, analyzing the style and the iconography and reporting the history and legends depicted in the paintings of a group of seven modern Hopi artists. These paintings depict Hopi life and legend; the present, past, and future. Each artist has interpreted his own work with the exception of Tyler Polelonema, who has left the mesas, and Bevins Yuyahoeva, who was killed in 1971. Mike Kabotie has helped to interpret Polelonema's and Yuyahoeva's paintings and has also provided most of the background information on the work of the group. In addition to the members of the Artist Hopid, Fred Kabotie has dated and interpreted his paintings. When necessary for the continuity of the text, I have also drawn from several books of Hopi history and legend which are listed in the bibliography. My job is to analyze the paintings and to report and synthesize the explanations of the paintings of these artists; it is not to interpret or evaluate the religious beliefs of the Hopis. Above all I have no intention of interpreting the role of the Kachina or any other aspect of Hopi religious life, for only the Hopis can do this.

CHAPTER 2

The Land of the Hopis—
A World of Stone and Sunshine

The land of the Hopis is the central focus of Hopi life and a theme of primary importance in modern Hopi art (Fig. 2–1). For centuries, the life of the Hopi people was dictated by the land they lived on, by the necessities of survival in a windy, dry, desert far from outside influence or help. For the Hopis living on the mesa tops or on the desert surrounding the mesas, their very survival depended upon their ability to plant suitable crops and successfully nurture and harvest these crops. Crop failure meant famine, and famine threatened the end of Hopi civilization. The success of the Hopi people in achieving the optimal cultivation of their land was demonstrated during the course of a project conducted during the 1920s by the University of Arizona's College of Agriculture in Tucson. The agricultural specialists concluded, after exploring the possibilities of new crops for the Hopis and studying the most effective methods of desert planting and cultivation, that they were unable to broaden the range of successful desert crops or to improve the Hopi methods of deep planting, cultivation, and harvest without bringing in new sources of water.[1]

For the Hopis there were two keys to survival in the desert. One was hard physical work: devotion to the most efficient methods of planting, cultivation, and harvest. The other was spiritual dedication: prayer and the observance of those rituals which would propitiate the deities, maintain harmony in the natural world, and thus ensure the well-being of the Hopis. In Hopi art, the germination and survival of the crops and the germination of life and the survival of the Hopi people are always inseparable. In a desert land, the germination and survival of the crops are dependent upon an adequate supply of water. Until just a few decades ago, the snows of winter and the rains of spring and summer were the primary sources of life to the Hopis, thus the most sacred Hopi prayers were their prayers for water. Without water there could be neither life nor growth. For the Hopis, all symbols of water—

29

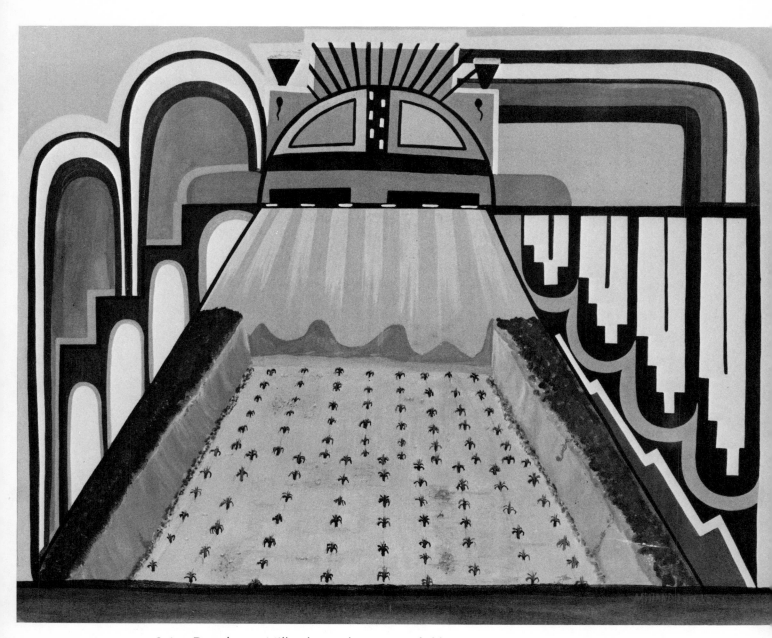

2-1. Dawakema–Milland Lomakema. Cornfield. 1968. 16 5e x 20 5e. Casein. Gift of Byron Harvey to The Heard Museum of Anthropology and Primitive Art (Indian Collection), Phoenix, Ariz.

rain, clouds, snow, lightning, and water animals, such as lizards, tadpoles, and frogs—are fertility symbols. Almost all Hopi art—petroglyphs, altar hangings, mural paintings, Kachina art, and modern painting—includes one or more symbols of water, the source of life.

The very remoteness of the land of the Hopis and the privations of life in the desert have not only been the sources of hardship for the Hopis, but have been the keys to the survival of their civilization and the preservation of their culture and religion. The stony heights of the mesas offered the Hopis excellent protection and fortification against those who threatened to invade or raid the Hopi villages. Few settlers were tempted to brave the hardships of life in the desert, for it was a life in which survival was the principal reward. Very few Spaniards, Mexicans, or Anglo farmers ever attempted pioneer life in the land of the Hopis. Miners and prospectors were frustrated in their search for the riches of the earth, because the land of the Hopis offered no rewards of gold, silver, turquoise, or other mineral wealth. (Ironically, today the land is highly valued for its rich coal deposits.) The religious zeal of the missionaries was thwarted by the unsuitability of their preaching to the realities of Hopi life and by the Hopi people's steadfast adherence to their own beliefs and rituals. In *Sun Chief,* an autobiography of Don Talayesva, an Oraibi man born in 1890, the author tells of the inability of the missionaries to comprehend a life in the desert, in which the spiritual and temporal necessities are dictated by the priorities of survival:

> One day I visited Kalnimptewa, my father's old blind brother, and said, "Father, as I stood in my door I saw a Hopi missionary preaching to you from a Bible." "Yes," the old man answered. "He talked a great deal, but his words failed to touch me. He warned me that it would not be long before Jesus Christ would come down from the sky, say a few sharp words, and destroy all disbelievers. He said that my only chance to escape destruction was to confess and pray to his holy God. He urged me to hurry before it was too late, for a great flood was coming to Oraibi. I told him that I had prayed for rain all my life and nobody expected a flood in Oraibi. . . . Now Talayesva, my son, you are a full-grown man, a herder, and a farmer who supports a family, and such work means a happy life. When our ceremonies come round, pray faithfully to our gods and increase the good life of your family, and in this way you will stay happy." I thanked him and went home feeling confident that I would never pay any serious attention to the Christians. Other gods may help some people, but my only chance for a good life is with the gods of my fathers.[2]

Although in the last two decades, modern highways and improved sources of water have become part of the Hopi world, in comparison with the greater part of the trans-Mississippi West, the effects of industrial civilization have been minimal in the land of the Hopis. Although today modern supermarkets exist in Hopi-land and the survival of the Hopi people is no longer directly tied to the land, the Hopis' identification with his land is as strong as in the past. To the Hopis, their land is sacred. Religious shrines of both the past and present stand on every part of their land, and the Hopis fervently believe that this land was willed to them by their Creator and must be theirs for eternity. Despite contemporary boundary disputes—and the boundary disputes between the Hopis and the Navajos present some of the most pressing and difficult problems of land distribution in the Southwest today—the Hopis' belief in the absolute divine right of ownership of their land is firm. Whatever the courts decree, the Hopis' concept of boundaries of their hereditary land remains constant.

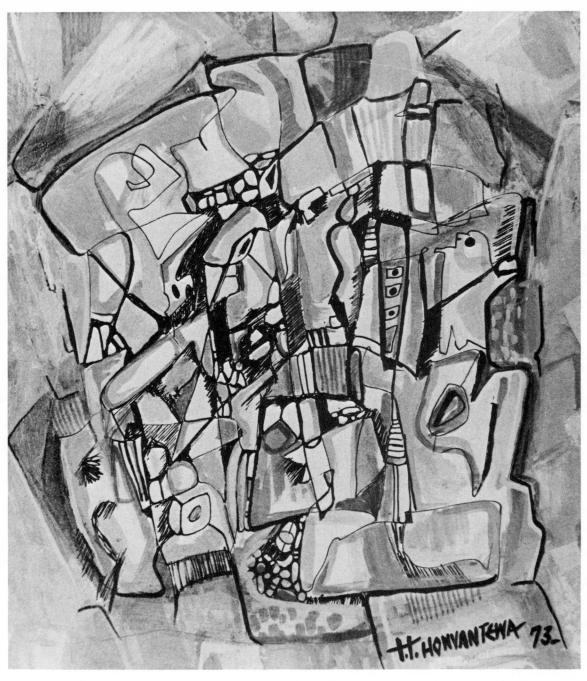

2-2. *Honvantewa–Terrance Talaswaima. Study of Rocks I. 1973. 10¹/₂″ x 9″. Acrylic. Private Collection.*

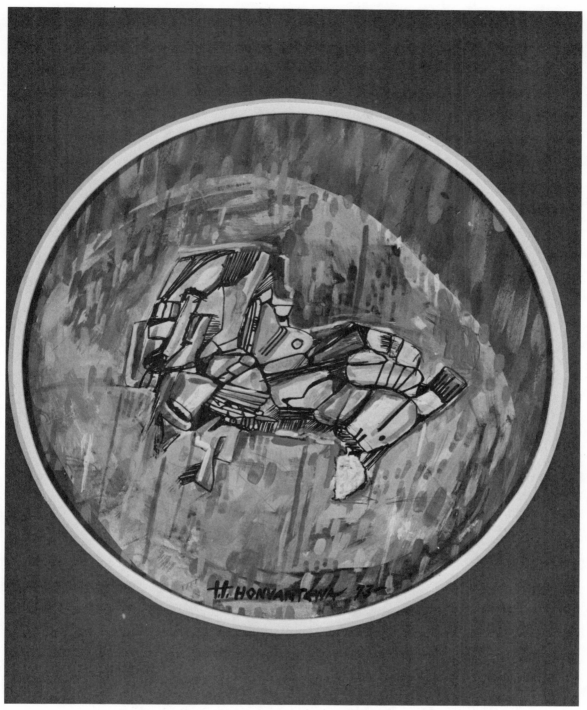

2-3. *Honvantewa–Terrance Talaswaima.* Study of Rocks II. *1973. D. 8". Acrylic. Private Collection.*

This belief in the sacred quality of their land and the total identification of the Hopi people with their land have helped the Hopis to remain culturally intact and avoid total assimilation into the mainstream of Western life. Although three waves of conquerors were the titular rulers of the land and each attempted to bring a new mode of civilization to the Hopis, the Hopis retained their cultural identity and remained on their ancestral land. From 1891 to 1934, the years during which the allotment system flourished, most Hopis rejected the temptation of land allotment. Allotment, which was designed to erode the social structure of Indian life and to facilitate the purchase of Indian land, would have forced the Hopis to abandon their villages and pursue agricultural life as independent individuals in the surrounding area. Once removed from their community life, they easily would have been absorbed into the mainstream of American culture. For almost one thousand years, the Hopis have remained on the mesas, and their sense of identification with their land remains complete.

The composition, textures, and silhouettes of the land of the Hopis play an important role in modern Hopi painting. The Hopi world is a world of stone. The stone mesas loom above the desert floor and are topped by the stone buildings of the Hopi villages. The Hopi houses are made from the stones of the mesas, and from the distance it is almost impossible to determine where the rocks of the mesas end and the stone buildings begin. The structures which have been formed by the Creator of the Earth are almost indistinguishable from those built by the hand of man. The rocks of the mesas and the Hopis' ancestral homes on the mesas are one in the minds of the Hopi people. The mesas and the rocks of the mesas have inspired many paintings and are major iconographical elements in Hopi art. Terrance Talaswaima often has chosen the rocks as the subject of his abstract paintings. *Study of Rocks I* (Fig. 2–2) and *Study of Rocks II* (Fig. 2–3) explore the variation of color, outline, texture, and mass of the mesa rocks. For Talaswaima, rocks have a character of their own. He recalls that in every area that the Hopis brought their culture and religion, they built shrines of rocks outside their villages where they dedicated their prayers to all of the spirits of the Hopi world. He believes that rocks have an independent spirit and exist as separate entities in space. In both of these paintings, Talaswaima tries to express the spiritual essence of the rocks and to explore the artistic possibilities of their relation to each other and to the space around them. In *Study of Rocks II,* a composition of orange, green, and turquoise, the colors symbolize the change in color wrought both by the time of day and by the seasons of dryness and rain.

The silhouette of the mesas is another important iconographical feature of Hopi painting. Mike Kabotie uses the mesa form as part of his background in both *Homage to Hopi Creativity* p. 264 and *Coming of the Water Serpent* p. 103.

A unique geological phenomenon which is found on the surface of the mesa tops are cuplike sandstone formations, each with a hole in the center. This formation is caused by the impacts of violent rainstorms on the parched desert land. In *Corn and Rain Clan Symbols* (Fig. 2–4), Delbridge Honanie has created a heavily textured, abstract representation of this geological rarity. He surrounds the central earth-form with ears of corn and rain, cloud, and lightning symbols.

The story of how the Hopis came to their sacred land, a world of stone and sunshine, is one of the important Hopi legends and is an ever-present part of the Hopi consciousness. The Hopis believe that the earth, as we know it today, is the Fourth World to be created. The three earlier worlds were all lands beneath the present world. The story of the Emergence into the Fourth World has many variations. In different versions of the legend, there are differences in the degree of evolution attained by plant and animal life in these early worlds,

34

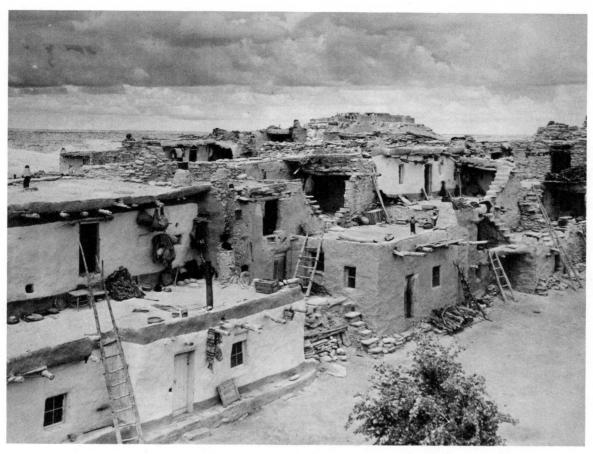

Frederick Monsen. Hopi Second Mesa. Photograph. c. 1903. Collection: Southwest Museum, Los Angeles, Calif.

differences in the method used to reach the entrance to the Fourth World, and differences in the location of the entrance.

Milland Lomakema in *Emergence* (Fig. 2–5) p. 18 depicts his personal understanding of this all-important legend. Milland writes:

> Emergence from the first world to the third world life was so corrupt the chiefs wanted to move people far away from the last three worlds. The chiefs [facing backward in the lower left corner] began searching for another world by chanting and sending birds one at a time. Three birds were sent, and finally a fourth bird went high up through untrespassed skies and found the exit out to the open, which was to be the fourth world. The chiefs again tried three ways to reach the opening and once again the fourth one was a success, a giant reed plant which had a hollow inside through which the people began their journey to another world and by chanting of the old chiefs.
>
> In the lower right-hand corner are two doll figures, legs and Kachina-like figures representing the women's ceremony (performed in October) which was the time of their departure, also indicated by the moon and stars which tell

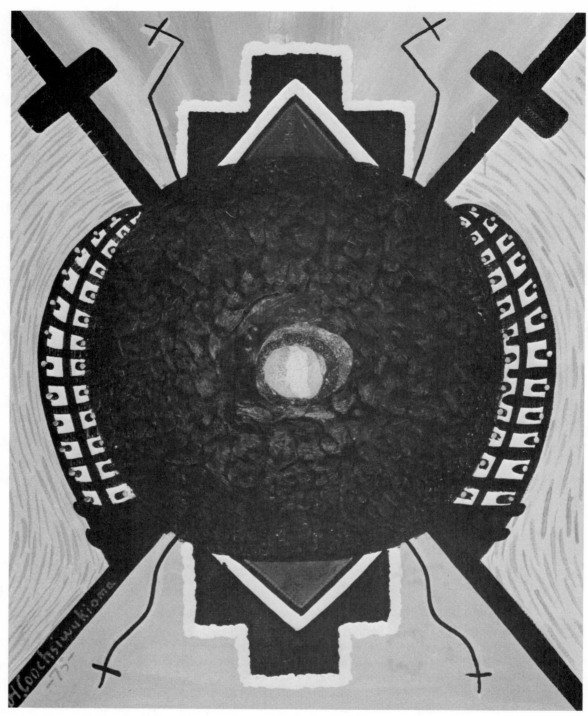

2-4. Coochsiwukioma–Delbridge Honanie. *Corn and Rain Clan Symbols. 1975. 10" x 8".*
Mixed media. Collection: Hopi Cooperative Arts and Crafts Guild.

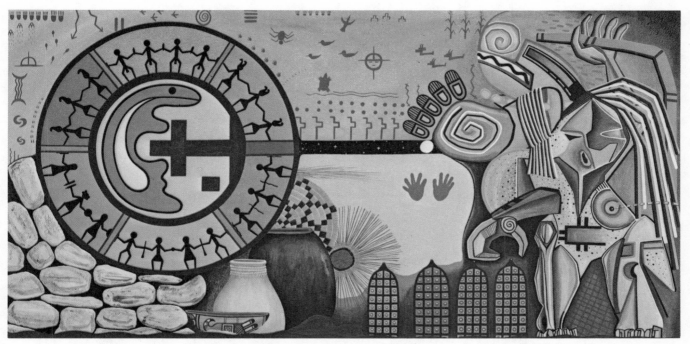

3-1. Coochsiwukioma–Delbridge Honanie. Hopi Life. 1974. 52" x 98". Acrylic. Collec-
tion: Hopi Cooperative Arts and Crafts Guild.

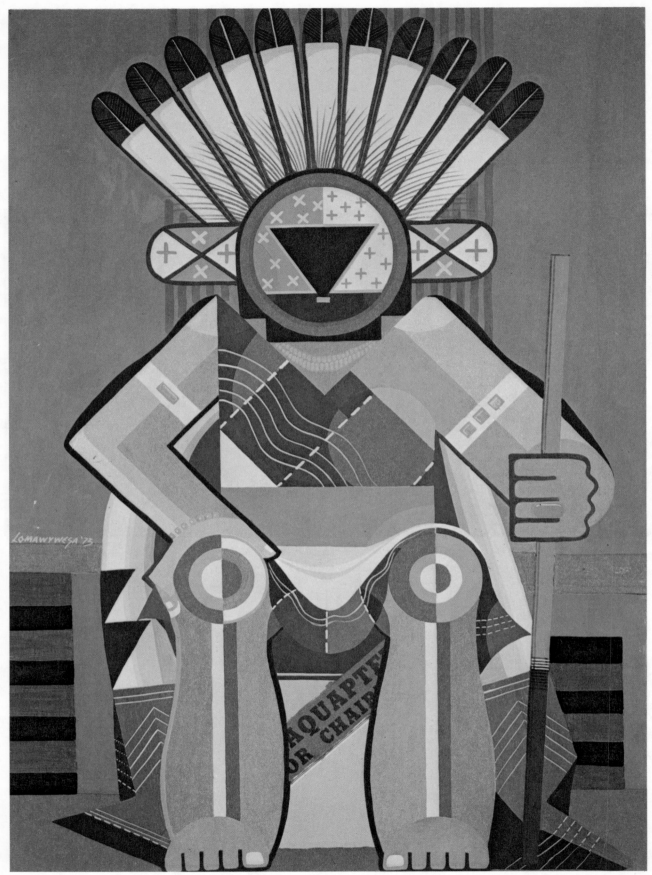

4-4. *Lomawywesa–Mike Kabotie. The Candidate. 1973. 40" x 20". Mixed media. Collection: Hopi Cooperative Arts and Crafts Guild.*

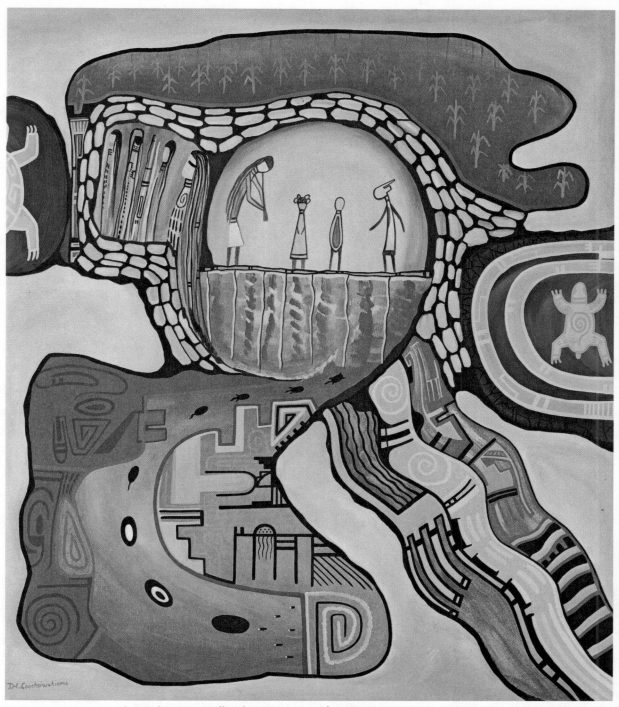

4-9. *Coochsiwukioma–Delbridge Honanie. Flute Society. 1973. 42″ x 36″. Acrylic. Collection: Hopi Cooperative Arts and Crafts Guild.*

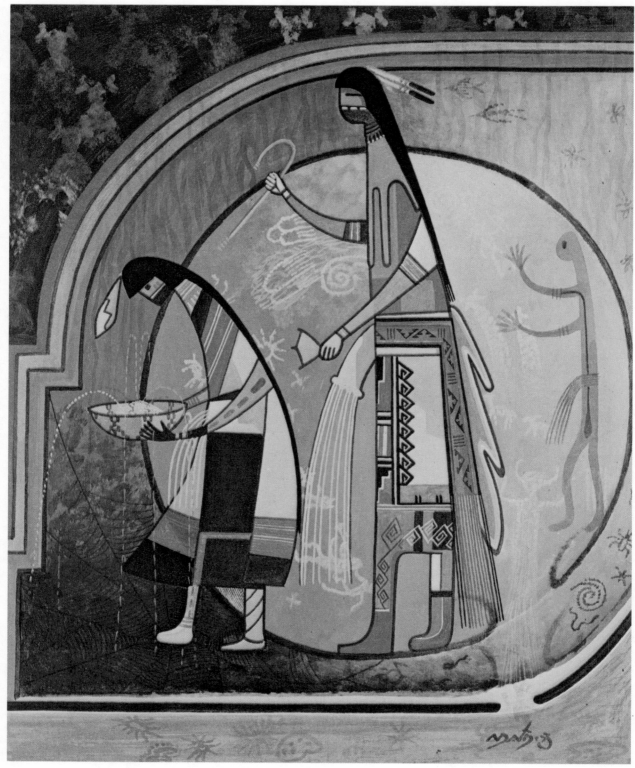

5-2. *Neil David, Sr.* Spider Woman and Muingwa. *1973. 19$\frac{1}{2}$" x 13$\frac{1}{2}$". Acrylic. Private Collection.*

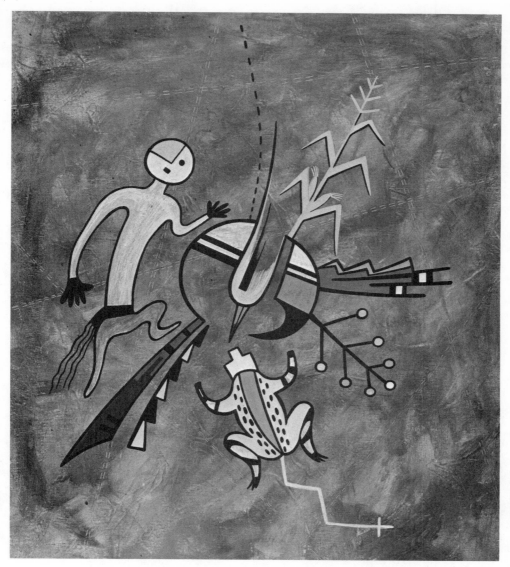

2-6. *Coochsiwukioma–Delbridge Honanie. Petroglyph—Water Clan. 1975. 24" x 20"*
Acrylic. Collection: Hopi Cooperative Arts and Crafts Guild.

the time—late fall and after midnight. Emerging through the kiva, the figure in black [Massau] was the creator, a supreme being who lived alone on the fourth world, who welcomed our people to live with him. With his help, the people lived and multiplied. This is the reason mother corn is symbolized in his body. The reason he is in black is because I, personally, do not know what he looks like. The center circular design symbolizes the bear clan who has become the leader of his people from the Emergence.[3]

Lomakema uses the face of a Bear Clan Kachina as a Bear Clan symbol. Over the face are bear tracks which are also symbolic of the Bear Clan. On the right of the painting is a

prayer feather or *paho,* which is one of the most important Hopi ceremonial artifacts. There are many different kinds of pahoes, single and double, small and large, but all are made with string, pieces of wood, and bird feathers. They are used in almost all ceremonies to carry aloft the fervent prayers of the Hopis. The Hopis use the feathers of different types of birds as well as feathers from different parts of the body of a single species of bird because they believe that different feathers have different meanings. For example, the large feathers from the wings of the eagle signify power, and the eagle's soft fluffy breast feathers are symbolic of the breath of life.

Honanie uses both the paho and the bird who sought the opening to the Fourth World as design elements of his painting, *Petroglyph—Water Clan* (Fig. 2–6). Using the decorative motifs of ancient pottery, he includes in his composition a stylized plant form, which represents the plants used by the Hopi to obtain different colors of dye, and a stalk of corn.

Corn is one of the most important iconographical features of Hopi art. The Hopis believe corn is the principal source of life. It is the most important of the basic staples of life and today, as in the past, the Hopis depend upon corn to sustain them. Cotton, beans, squash, and melons are the other staples. The Hopis believe that corn was of major importance for both food and ceremonial use in each of the three earlier worlds as well as in this, the Fourth World. Talaswaima gives visual expression to this concept in *Four Hopi Worlds with Corn* (Fig. 2–7).

2-7. *Honvantewa–Terrance Talaswaima.* Four Hopi Worlds with Corn. *Watercolor. Museum of North Arizona, Flagstaff.*

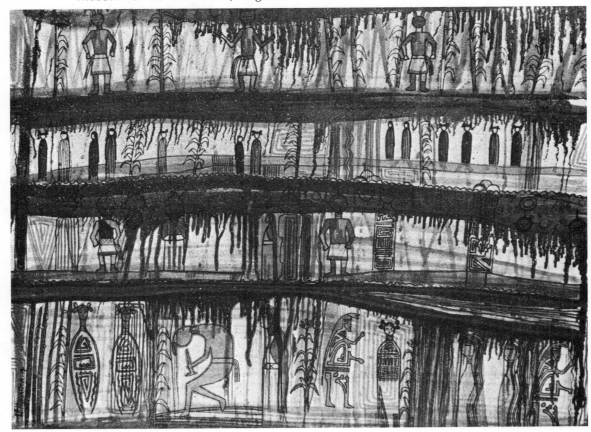

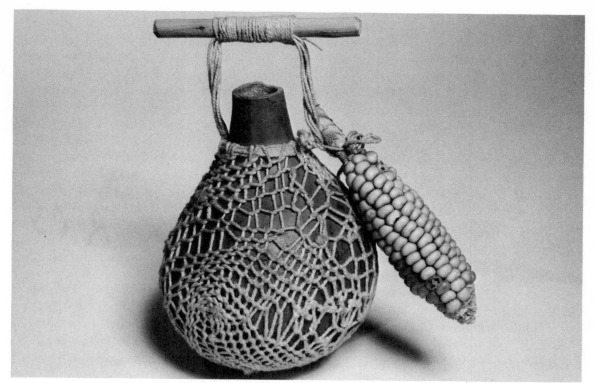

2-9.	Gourd Water Container in Net—Carried by Chief in Kiva Ceremonies. *Walpi. Collected by H. R. Voth in 1895. Gourd is 5¹/₂" x 4¹/₂". Collection: Museum of the American Indian, Heye Foundation, New York, N.Y.*

The Hopis believe that all races of man and all tribes of Indians were participants in the Emergence to the Fourth World: Upon arrival, their leader offered each race and tribe a choice from all varieties of corn—yellow, red, gray, blue, speckled, and white—and varieties of grains, fruits, and melons. The Navajos selected the largest ear of yellow corn which was hard to grow and would not last long. This corn signified a short life of enjoyment. The Hopis, who were the last to make their selection, selected an ear of short blue corn, which symbolized a life of hardship, but one of endurance and survival.

The Hopis think of corn as the Corn Mother, for corn was given to them as the principal source of food for mankind. The Hopis draw life from the corn as the child draws life from its mother. When a healthy child is born, an ear of perfect white corn whose tip ends in four perfect kernels, is placed beside him as his Corn Mother. The Corn Mother is to be the spiritual mother of the child. It is used in the naming ceremony and is a prize possession of the household.

The perfect ear of corn is at the heart of one of the most important ritualistic symbols of the Hopis: the *Tiponi,* the Corn Mother fetish, which is used in nearly all ceremonies. The perfect ear of corn is dressed with feathers and wrapped in layers of homespun cotton string, which keeps the feathers in place. The wrapped corn stands on a wooden base, but the ear of corn is not visible, only the bound feathers. The Tiponi is the valued possession of the chiefs or high priest of the societies, because it was carried by the Chiefs in the Underworld and upon Emergence. The Tiponi represents the Corn Mother, the mother of the Hopi people, and thus becomes a symbol of life.

The Hopis see the sun as the Father of Life and the combination of sun and corn is a familiar iconographical pattern. *The Cornfield* p. 30 , by Milland Lomakema, is an innovative composition which focuses on the parental role of the sun and corn in Hopi life. As the sun forehead appears at the top of the painting, the rays of the sun pour down on the corn and on the mesas and mountains which rise in the distance. Stylized rain, terraced clouds, and a rainbow frame the composition. Tadpoles, which represent fertility, have both a symbolic and a decorative value. In *The Fertile Corn* p. 27 , Bevins Yuyahoeva has painted a stylized representation of the sun and corn. Yuyahoeva includes in his composition several varieties of corn, a Sun Kachina, a prayer feather, and a handprint, which is a symbol of the Bear Clan.

There are several deities who play an important role in the evolution of the Hopis through the three preliminary worlds and in the Emergence into the Fourth World. The Hopi deity, Massau, who is the God of life and death, is the principal figure in the Emergence legend. God of the upper world, Massau gave the Hopis permission to live on the Earth. Although Lomakema portrays him as a black figure (Fig. 2–5), he is often thought of as wearing a bloody mask. Massau also gave the Hopis a sacred water jar which they were to plant in the earth wherever the Hopis decided to settle. If they were in a state of purity at the time of the planting and followed certain specific rituals, water would then flow from the ground. For centuries the sacred water jar (Fig. 2–9) has been an important Hopi design element. In modern paintings as in early murals, the sacred water jar is represented by a netted gourd. Neil David, Sr., frequently uses the sacred water gourd as a symbol of creativity and fertility. In both *Ahula, the Germinator* p. 17 and *The Giver of Life* (Fig. 2–10), David includes the netted gourd as a symbol of the life-giving powers of both the Sun Kachina and the sacred water.

Other principal figures in the Emergence legend are the Hurung Whuti, deities who during the creation of the Third World parted the water so the dry land should appear in the Underworld. They lived under the waters on the East and West coasts, and are responsible the creation of hard substances such as coral, shells, and turquoise. Many Hopis believe that that the Hurung Whuti created the animals, birds, men, and women of the Earth. Terrance Talaswaima has chosen the Hurung Whuti as the subject of a painting, *Deities of Hard Substance* (Fig. 2–13). Although in the popular legend there were two deities, he has added a third deity for the sake of composition. In Talaswaima's painting, the deities' bodies are composed of their precious stone creations. As the Hurung Whuti participated in the early stages of creation, the artist shows them still in the world of darkness with only an aura of light around them.

One of the most important concepts of the Emergence legend, is the specific site of the Emergence or the *Sepapu*. The Sepapu is a physical reality, a yellow pool located at the confluence of the Colorado and Little Colorado rivers (Fig. 2–11). For the Hopis, this opening deep in the Grand Canyon is the precise site of the entrance into the Fourth World.[4] In *Sun Chief,* Don Talayesva tells of his visit to the Sepapu and part of the ritual of a salt-gathering mission.

> We followed down the stream and reached the place of blue salt. There
> we deposited prayer feathers and climbed onto a little hillock surrounded with
> bushes. This was the original kiva and the hole through which all mankind
> emerged. We stepped over the soft, damp earth and worked our way through
> the bushes of hard wood, such as is used in making drills to kindle new fires in
> the kiva for the Wowochim ceremony. Beyond the ring of bushes we came to a

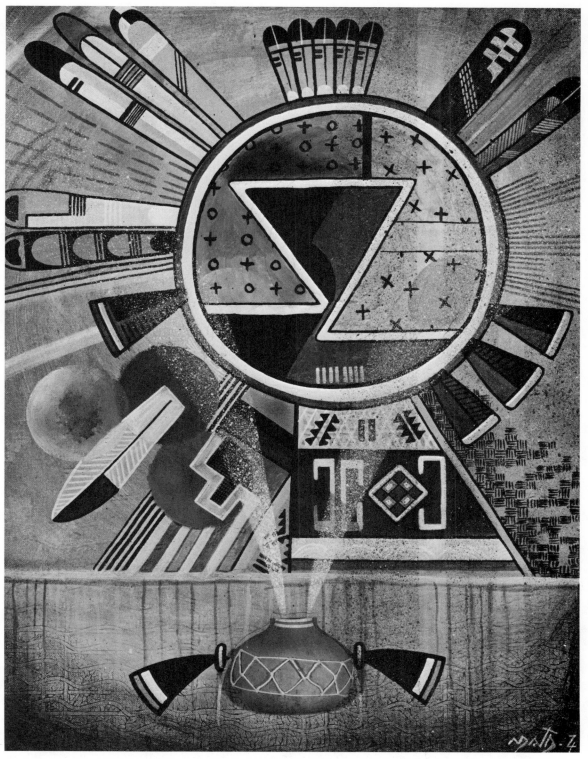

2-10. Neil David, Sr. Giver of Life. 1974. 24" x 18". Mixed media. Collection: Hopi
 Cooperative Arts and Crafts Guild.

central mound of yellowish earth and stepped to the north side to remove our moccasins before entering the sacred place. The War Chief took four prayer sticks and four feathers, one with a breath line on it, and stepped with us upon the hillock to a flat area about ten feet in diameter. At the very center was the original sepapu, the opening leading to the underworld. There was some yellowish water about two feet down which served as a lid for the sepapu so no ordinary human could see the marvels of the underworld.[5]

Milland Lomakema has painted *Se Pa Po Nah* (Fig. 2–12), an abstract representation of the Sepapu in which the four rings represent the four worlds. The figures are High Priests and the interlocking crescents in the center represent friendship or the brotherhood of man at the time of the Emergence. The ladders coming out in four directions and the inclusion of the four prayer feathers are Milland's original concepts. This painting illustrates the interrelation between the place of Emergence and the kiva, the central underground meeting place of the Hopis. Lomakema emphasizes that his painting simultaneously represents the Sepapu and the kiva. The friendship symbol also represents the spirit of brotherhood in the kiva. The kiva, like the Sepapu, is a womblike form p. 228 . Emergence is a symbolic birth from one world

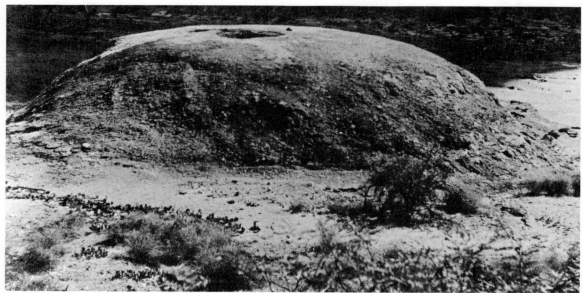

2-11. Sepapu. *Entrance to Hopi Underworld. Bottom of Canyon at confluence of Colorado and Little Colorado Rivers. Photograph. Collection:Center of Astrogeology, U.S. Geological Survey.*

to another, in which man the child is symbolically reborn from the Earth Mother. In the kivas, each generation of priests teaches the young and performs the sacred rites in order to assure the spiritual rebirth of the Hopi people. The kiva symbolizes the Earth Mother, and within each kiva is a symbolic representation of the Sepapu. In Wuwuchim (see chapter 6) the Hopis reenact the Emergence, the rebirth of man. In *Bear and Kachina Migration Patterns* p. 60, Milland Lomakema again includes a stylized representation of the Sepapu.

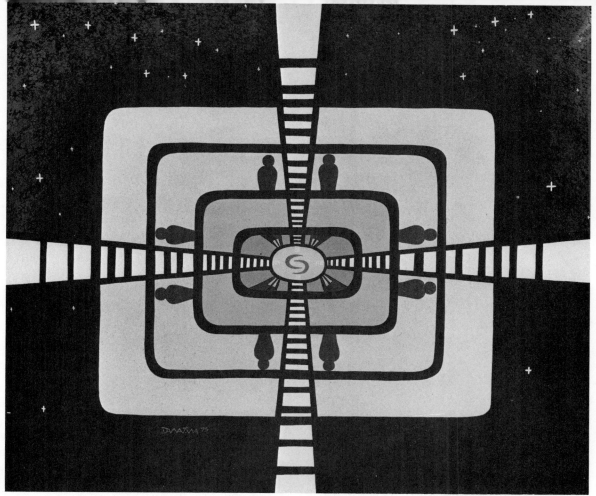

2-12. Dawakema–Milland Lomakema. *Se Pa Po Nah.* 1975. 30" x 32". *Acrylic. Collection: Hopi Cooperative Arts and Crafts Guild.*

A sacred opening for spiritual regeneration—which is the basic concept of the Emergence, the Sepapu, and the kiva—is also present in the body and mind of the individual Hopi. The Hopis believed that within each man is an open door, called the *Kopavi,* which enables him to communicate with his Creator. This open door is at the top of a person's head and is the soft spot of the human head at birth. Many years ago man was able to communicate freely with his Creator through this opening, but today the door is almost always closed during a man's lifetime. In this world, life still enters the body through the Kopavi, but it opens again only at death in order for life to depart. However, when a man wishes fervently to communicate with his Creator, he must try to open the door in his head. In *Hopi Warrior Spirit* p. 289, Mike Kabotie depicts the Kopavi, the door to the Creator and the opening to the next world.

The concepts of Emergence and rebirth pervade every level of Hopi life and thought. For the Hopi, all of life is a progressive cycle. In the Fourth World, man has emerged to a new level of existence. Within the kiva, the chiefs seek tribal regeneration through their ceremonies and laws, and the creative spirit of the individual is reborn as the individual Hopi strives to open his mind and communicate with his Creator.

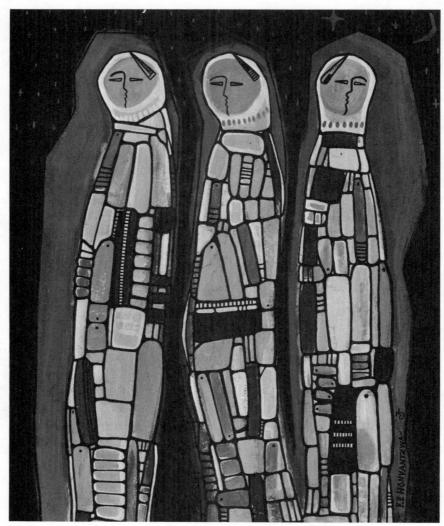

2-13. *Honvantewa–Terrance Talaswaima. Dieties of Hard Substance. 1975. 20" x 16". Acrylic. Collection: Hopi Cooperative Arts and Crafts Guild.*

NOTES

1. Harry C. James, *Pages from Hopi History* (Tucson: The University of Arizona Press, 1974), p. 178.

2. Don C. Talayesva, *Sun Chief: The Autobiography of a Hopi Indian,* Leo W. Simmons, ed. (New Haven: Yale University Press, 1963), pp. 376–377.

3. Milland Lomakema, description written for author, December 1975.

4. In another version of the Emergence legend, it is told that the people first appeared on Earth in the middle of the Great Ocean. In order to reach their mountain and desert destination, it was necessary to cross many islands using them as stepping stones.

5. Talayesva, pp. 240–241.

CHAPTER 3

The Migrations—Messages from the Past

The Hopis believe that from the time they entered the Fourth World through the sacred Sepapu, until the time that they reached their chosen destination, the sacred rocks of the mesas, there was a period of wandering and searching that lasted for centuries. These were the years of the Migrations. The concept of Migration, like that of Emergence, is an ever-present part of Hopi life, thought, and art. Today as in the past, the concept of Migration pervades the individual as well as the tribal consciousness of the Hopis (Fig. 3–1).

Once in the new world, the elders prayed for guidance, because those who had reached the new world were destined to carry out the universal plan of the Creator. If they failed in this Fourth World, as they had in the previous three worlds, the Fourth World would also be destroyed, but following the destruction of this world, there would be no rebirth. Four is the sacred number of the Hopis; for example, four different birds tried to find the opening for Emergence and four types of trees or reeds were planted before the bamboo grew high enough to reach the opening. Since there is never a fifth chance, the destruction of the Fourth World would be the end of mankind.

After the Chief and those Hopis who had been chosen to reach the Fourth World had ascended the reed, the One Horn Chief who had remained below cut down the bamboo reed so that those who were destined to remain below might be prevented from climbing to the Fourth World. Those who were still climbing in the reed were trapped in place and as the reed dried, the outline of their bodies protruded in the bamboo, creating the jointed shape which is still the form of the bamboo. Finally, the opening in the Sepapu was slowly covered with water so that the people would not be tempted either to look back or to return to their old homes and the evil life of the past.

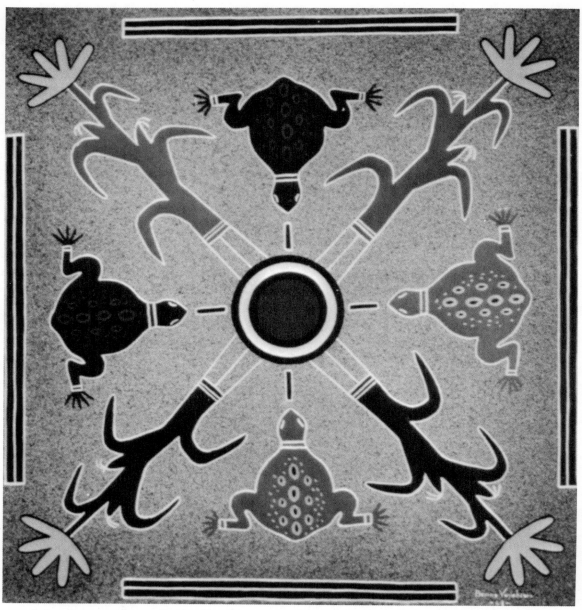

3-2. *Lomaquaftewa—Bevins Yuyahoeva. Sand Painting. 1969. 18¹/₂" x 17¹/₂". Collection: James T. Bialac, Scottsdale, Ariz.*

50

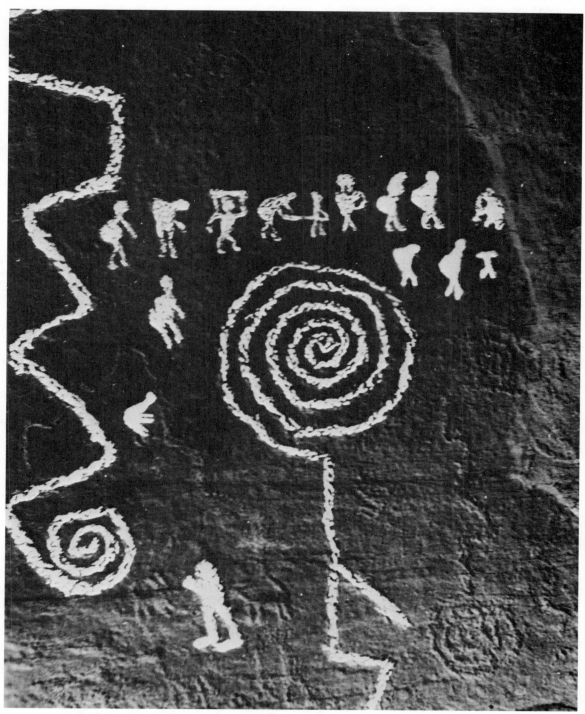

3-3. Migrations. *Crack in the Rock. Petroglyph. Photograph. Collection: Museum of Northern Arizona, Flagstaff.*

Massau told the newly emerged people to separate and follow the paths of life determined by their Creator. Each group would follow a predestined route to the land that the Creator had chosen for them. They were urged to try to keep the doors in their heads open so that they might best succeed in hearing and obeying the will of their Creator.

The Migration plan for the Hopis was for them to follow their stars and to travel in each of four directions to where the land meets the sea. Having made these pilgrimages to claim the land for their Creator, they would then settle in the sacred land which was to be their permanent home. Once on their sacred land, they were to dedicate their land and their lives to their Creator. Although they would stop many times along their route and build many villages, in time they would abandon these villages and proceed on their course to the mesas. The Hopis believe that many Indian tribes today are descendants of those Hopis who decided to settle permanently before completing their Migrations. Mike Kabotie feels a deep tie with the Mayan people and sees his aquiline profile p. 254, p. 285, as evidence of their common ancestry.

Each of the four directions is associated with a color. Blue is the color of the West, yellow the North, red the South, and white the East. The four directions are important symbolic and decorative motifs in Hopi painting. As in most Pueblo religions, however, six directions rather than four have ideological importance to the Hopis. These are the four cardinal points plus the zenith and nadir. The four directions are the daily route of the sun from east to west and the yearly route of the sun from south to north. To be precise, the four directions are the places of sunrise and sunset in winter and summer, which are not north, east, south, and west but northwest, southwest, southeast, and northeast. This image of a flat earth with directions stemming from the corners is seen in traditional sand paintings and in Bevins Yuyahoeva's tempera painting entitled *Sand Painting* (Fig. 3–2), in which corn and frogs are symbolic representations of fertility and germination. In most Hopi paintings, however, the four directions are north, east, south, and west. In the composition of *Hopi Elements* p. 253, Mike Kabotie includes four paths which symbolize the Hopi receiving blessings and inspiration from four directions.

The universal plan of creation and the laws for leading a life of harmony in this final world of creation were inscribed on stone tablets, which Massau gave to the newly ascended people. These tablets also indicated the prescribed routes of Migrations to the lands that were to be their permanent homes on Earth. One tablet indicated the boundaries of the land that the Creator indicated for the Hopis. Massau told them that someday they might fall into difficult times, but that they would eventually be delivered by the *Bahana*, their white brother who had emerged into the Fourth World along with the other tribes of man. Massau then broke a corner from one of the tablets and gave it to the leader of the white race as they were about to start on their Migration east to the Great Ocean. There they might touch the forehead of the sun. The Hopis began their long and patient wait for the arrival of the Bahana.

This concept of the Bahana, the white brother as a Messiah, is a common belief of many Indian religions. It was with joy that the Hopis welcomed the first Spanish visitors to the mesas, but they were disappointed to learn that the Spaniards did not carry the missing piece of their sacred tablet. The Hopis learned quickly, from bitter experience, of the cruelty and avarice of the Spaniards. With great sadness, the Hopis concluded that the arrival of the conquistadors did not signify the arrival of the promised white Messiah.

When the Hopis began their Migrations, they separated into many groups. Each group was to follow one of four basic routes and would enter the promised land from four different

52

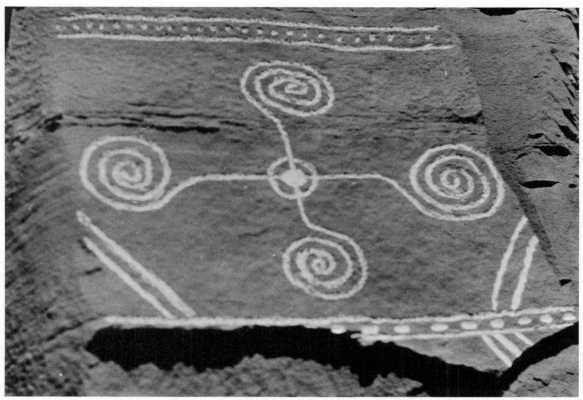

3-4. Cross with Spiral Ends. *Two Miles North of Hubbell's Store Near Site 1712. Petro-glyph. Photograph. Collection: Museum of Northern Arizona, Flagstaff.*

directions. The Bear Clan came to the mesas from the West, the Kachina Clan from the red cliffs of the North. The Water Clan came to the mesas from the South and the Hopis still await the arrival of the Bahana from the East.

These groups are the roots of the Hopi clans, and each clan has special stories of its years of Migrations and symbols that are related to events of the journey. Most clans take their names from experiences of the journey. A popular legend tells that as one group traveled near the Little Colorado River, they came upon the body of a dead bear. They took the name of the Bear Clan and cut off the paws of the bear as their symbol. The next group came upon the body and cut straps from the bear's hide to help carry their burden. These became the members of the Bear Strap Clan. Another clan, which saw a bluebird perched on top of the decaying bear, became the Bluebird Clan and another in the same manner became the Spider Clan. The last group to arrive found the bones and skull of the bear with the eye sockets covered with a greasy solution. This group took the name of Greasy Eye Socket Clan. All of the different groups that took their names from the bear are considered a phratry, a group of related clans. The Hopis take their clan identification from their mother and are not permitted to marry within their clan or within the phratry.

The Migrations is one of the important ideological concepts of Hopi art. From the earliest petroglyphs to the most abstract modern Hopi paintings, the round or square spirals, which are the symbols of the Migrations, appear as major iconographical elements in Hopi

painting and pottery design. The Hopis interpret the Migrations spirals that are etched into rocks throughout the Southwest as the permanent record made by their ancestors as they followed their sacred missions (Fig. 3–3). A single spiral generally winds four times, but occasionally there are groups of four spirals in the early petroglyphs (Fig. 3–4). The ancient travelers also incised on the rock walls the symbols of their clans and representations of ceremonies and daily life. Throughout the Southwest, there are found representations of corn, different species of wild life, and snakes, which are symbols of water, clouds, and lightning (Fig. 3–5) (Fig. 3–6).

The Hopis believe that many villages, which today stand in ruins, were built by their ancestors during the years of the Migrations. The apartment complexes built against the walls of the Canyon de Chelly and Chaco Canyon, the ruins on the mesa tops of Puye, and Betatakin and Keet Seel, which are sheltered by protruding rock walls—these ruins of prehistoric civilizations which include ceremonial kivas—all bear a great resemblance to the villages inhabited by the modern Hopis.

3-5. Detail on Glyph on Road from Hotevilla to Oraibi. *Petroglyph. Photograph. Collection: Museum of Northern Arizona, Flagstaff.*

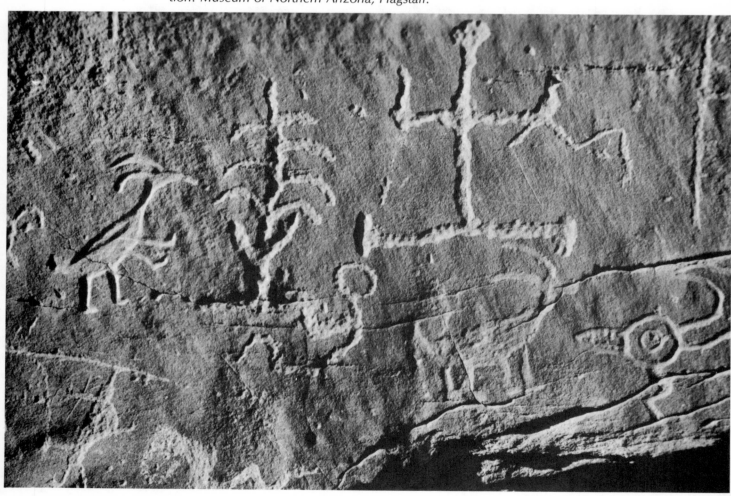

3-6. Snakes. *First Mesa. Petroglyph. Photograph. Collection: Museum of Northern Arizona, Flagstaff.*

The travels and early settlements of their ancestors are ever-present in the thoughts and artistic creations of contemporary Hopi artists. Again and again they use the stylized petroglyph of figures as symbols in order to reaffirm their identity with the past. In the painting *Hopi Pottery Design* (Fig. 3–7), Delbridge Honanie uses the motif of ancient pottery to show the importance of the past for contemporary Hopis. In the center of the pottery specimens are figures of a boy, a girl, and a Warrior. The rain-washed earth forms the background, and the pottery stands partially buried in the dark earth. The heavy-textured lower part of the painting represents the underground. The hole in the pottery in which the figures stand are similar to the holes that were made in ancient pottery to assure that the ceremonial pieces would never be used again. The importance of the years of the Migrations to the Hopis is emphasized by the placement of the Migration spiral within the body of the boy and girl and by the tracks of the wanderers across the background.

In *Petroglyph Turtle* (Fig. 3–8), Terrance Talaswaima has chosen the Migration symbol as the central design on the back of the turtle. The four lines streaming from the spiral represent the Paths of Life. To the right of these sacred paths is a figure which represents the spirit of man. The turtle is a traditional symbol of water and moisture and, thus, of fertility. For this painting, Talaswaima has chosen a desert turtle, which symbolizes the strength of the Earth. The turtle, like the Hopi, has endured through the ages, and because he carries his shell on his back, his history is an ever-present part of him. Because water is necessary for the survival of crops, the artist has edged the turtle's shell with water symbols, and tadpoles

55

3-7. *Coochsiwukioma–Delbridge Honanie. Hopi Pottery Design. 1975. 10" x 34". Acrylic. Collection: Hopi Cooperative Arts and Crafts Guild.*

(fertility symbols) float in the background. Talaswaima evokes the memory of the ancient Hopis by including: petroglyph-style mountain sheep, Kokopelli, the humpback flute player who carries seeds in his hump and is a fertility symbol, and bear tracks, which are symbols of the Bear Clan. In *Message from Yesteryear* (Fig. 3–9), Terrance Talaswaima again uses petroglyph figures to recall the Migrations of the Hopis. He includes the Migration spiral and symbols of the Bear and the Kachina Clans, as well as many water symbols (frogs, turtles, and tadpoles) which represent the Water Clan. The background of the painting is the rocks on which the petroglyphs were etched. The washes of paint represent the wash of the rains on the rocks through the centuries.

In *Signatures of the Past* (Fig. 3–10), Mike Kabotie, through the use of petroglyph figures and symbols, evokes the spirit of the years of the Migrations. Mike's petroglyphs are abstracted and stylized, which give the painting a Miró-like quality. Mike includes the footprints left by the travelers centuries ago, for the marks of their journey have endured through the ages. In a central figure, Mike illustrates the Hopi concept of "the breath of life," a line which comes from the heart. At death, the breath of life departs from the body through the mouth and joins the Spirit of the Dead. A meandering line which crosses the body silhouetted in the center of the painting also represents the breath of life. The headless priest on the right is dead, for his breath of life has departed from his body. Mike, a member of the Snow Clan, which is part of the water phratry, usually uses many water symbols in his work and here includes a reverse cloud form which is a Water Clan symbol. Mike uses color washes for his background on which the crosses and dots represent the stars and the snow.

One of the most complex of modern Hopi paintings to celebrate the Hopi Migrations is *Hopi Life* (Fig. 3–1), p. 37 by Delbridge Honanie. Here the artist portrays the people of all tribes just after they have emerged into the Fourth World. They are still fighting and have not yet developed a concept of tribal identity. They do not yet know who of them are Hopis. They fight with sticks as they prepare to begin their Migrations. The large circle represents the circle of the Earth. Each section represents one of five sacred societies: Two Horn, One Horn, Wuwuchim, Snake, and Flute. In the center of the Earth is a stylized bear—a Bear Clan symbol—for the Bear Clan was the first to reach the sacred mesas and has led the Hopis through the centuries. Delbridge Honanie is a member of the Bear Clan and symbols of his clan play an important role in his work. The hand print and the bear track are familiar elements of his paintings. For Honanie, the Bear Clan is the father of all people and his paintings extol the role of the Bear Clan in Hopi life.

56

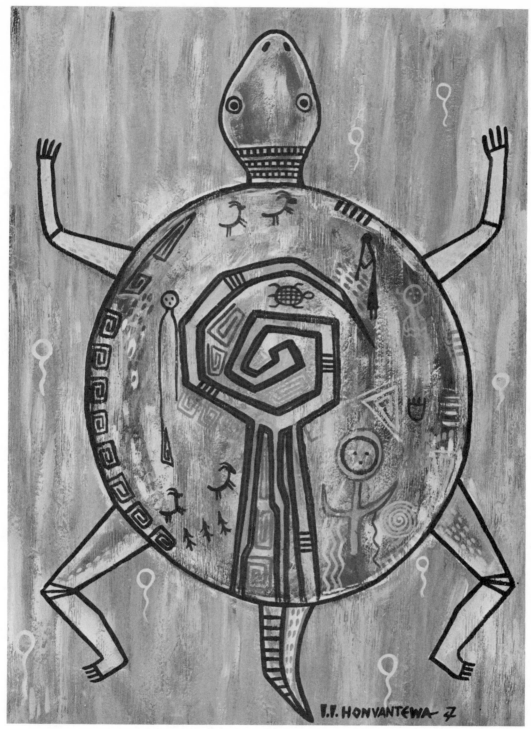

3-8. *Honvantewa—Terrance Talaswaima. Petroglyph Turtle. 1974. 19" x 14". Acrylic.
Collection: Hopi Cooperative Arts and Crafts Guild.*

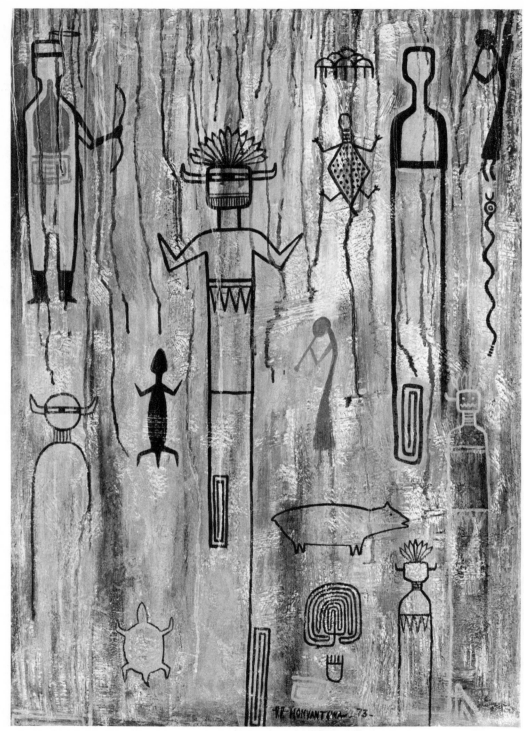

3-9. *Honvantewa–Terrance Talaswaima. Message from Yesteryear. 1973. 36" x 24". Acrylic. Collection: Hopi Cooperative Arts and Crafts Guild.*

3-10. Lomawywesa–Mike Kabotie. Signatures of the Past. 1975. 51¹/₂" x 95". Acrylic.
Collection: Dr. Maria Louise Koch, Cedar Grove, N.J.

In *Hopi Life,* the Hopis are planting four types of corn and making both coil and wicker baskets. The rocks in the lower left corner represent the homes of the Hopis, which have the strength of rocks and have stood through the ages. The rows of dots symbolize those wounded in the fighting and the bracket forms in the lower right corner symbolize the dead. Honanie also includes symbols of animal and plant life as well as sun, rain, and snow symbols, and symbols of the different clans including the divided half circle which is the Sun Forehead symbol. In the far right there are interlocking crescents, the symbol of friendship and the goal toward which mankind struggles.

The Migrations and the symbols of the Migrations are frequently used as purely aesthetic rather than as narrative elements in paintings, important components of composition and design, rather than as a means to express the tenets of Hopi life. In *Bear and Kachina Migrations Patterns* (Fig. 3–11), Milland Lomakema includes two Migration spirals and a representation of the Sepapu, from which is suspended a turkey feather, which represents the warmth of the womb. Eagle and parrot feathers from Kachina costumes are used to create an original design. Every element of this design, however, has an intense personal significance to Lomakema.

The concept of Migration goes deeper into the Hopi psyche than simply events of the past. The Hopis look upon the span of life from birth to death as a Migration through life, a Migration in which they seek the meaning of their existence and spiritual enlightenment. Mike Kabotie is especially intellectually and emotionally involved in the concept of Migration. He compares *Music for Fertility* (Fig. 3–12), an early undisciplined work, with *Spiritual Migration* p. 191 which was made just following his Initiation. *Music for Fertility* is a decorative composition utilizing the symbols of Hopi life. It was composed during the years when Mike lived away from the mesas. The flute player, through his music, encourages the

3-11. *Dawakema–Milland Lomakema. Bear and Kachina Migrations Patterns. 1975. 28" x 24". Acrylic. Collection: Hopi Cooperative Arts and Crafts Guild.*

60

3-12. *Lomawywesa–Mike Kabotie. Music for Fertility. 1963. 11½" x 17". Casein. Collection: Hopi Cooperative Arts and Crafts Guild.*

growth of the corn, and the woman represents human germination and the increase of mankind. All of the symbols, the Migration spiral, the hand print, snow, rain, and stars, have purely ornamental rather than a structural or conceptual value. In *Spiritual Migration*, the Hopi, a figure Kabotie readily identifies with, is surrounded by symbols of the Migrations. Kabotie says that the painting has a sense of mysteriousness that echoes the bewildered state in which he emerged from his Initiation. All of the symbols—the spiral, clouds, rain, and sun—are included, but Kabotie feels that at the time he did not yet have a true understanding. The sun is surrounded by a 360-degree rainbow. This rainbow, called *The House of the Sun,* signifies strength and speed because a runner, however hard he may try, can never catch the sun. At the end of the rainbow is cornmeal which, when rubbed on the runner's body, can give him speed like the rainbow. Kabotie explains that he has painted the Hopi in a priestly manner, for, someday in the future, when he has gained greater understanding, he might be able to become a Priest.

In the Hopi world, all of life is interrelated. Art can never be isolated from daily work or religious celebration and the past can never be isolated from the present or the future. On every level, psychological, historical, and aesthetic, the concept of Migration is a fundamental part of Hopi life and art.

CHAPTER 4

The Bonds of Hopi Life

The bonds of Hopi life are intricate and of great strength. Through the centuries, they have given to the Hopis a strong sense of identity and the power to follow the Hopi Way of Life. The complex ties of Hopi society date back to the years of the Migrations and the establishment of the first villages on the mesas.

Following many years of Migrations, the Hopis finally reached their promised land, the three mesas. Once there, they determined to dedicate their lives and their land to their Creator. Their first settlement was the village of Shungopovi, which soon was followed by the settlement of Oraibi. The settlement of Oraibi, the oldest permanently inhabited village of the mesas, was thought to have been the result of a family feud. The ancient village of Shungopovi was not at the site of the village which bears that name today, for many years ago the Hopis abandoned the lower village and moved to the mesa top in order to gain protection from invaders.

The Bear Clan was the first to complete its Migrations. As each subsequent clan reached the mesas, the clan leaders asked permission from the leader of the Bear Clan to settle there. The Bear Clan leader asked what would be their contribution to the settlement. If they brought new ceremonies or could fill a vital function in the Hopi community, they were invited to stay and were allotted a section of communal land. Each village included many clans, some of which are no longer in existence.

The symbolic decorative motifs of the different clans have inspired many contemporary paintings. In *Awatovi Motifs of the Kachina Clan* (Fig. 4–1), Milland Lomakema presents his own version of the designs of both the Parrot and Kachina Clans, two of the most important clans in the village of Awatovi, which was destroyed in 1700 (see chapter 8).

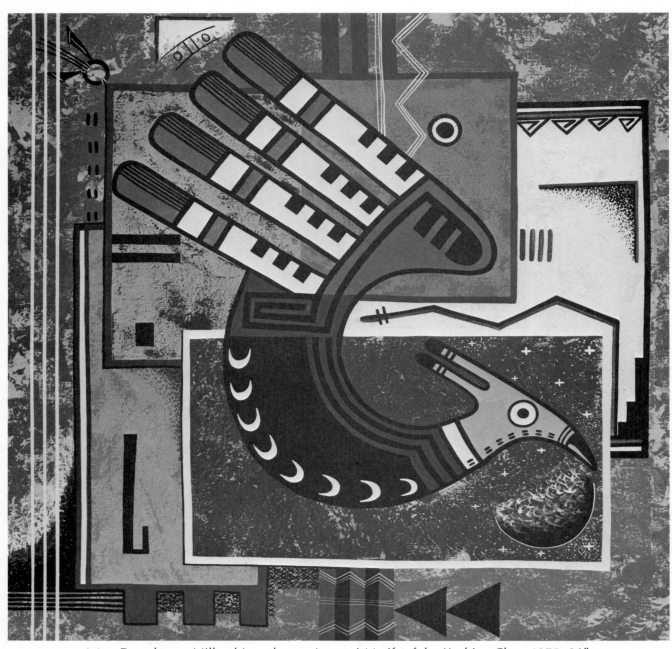

4-1. *Dawakema—Milland Lomakema. Awatovi Motifs of the Kachina Clan. 1975. 36" x 31". Acrylic. Collection: John Cartwright, Santa Fe, N.M.*

64

Lomakema has created an abstract composition based on stylized forms of Parrot and Kachina masks. He includes the stars and moon in order to evoke the image of night dancers and he utilizes decorative motifs of textiles and pottery which have remained unchanged from the time of Awatovi to the present. In *Symbols of the Bear Clan* (Fig. 4–2), Lomakema has stylized and abstracted elements of Bear and Kachina symbols with emphasis upon the decorative elements of the mask and costume of the Soyal Kachina. In *Snow Clan Kachina* (Fig. 4–3), Delbridge Honanie uses all the ceremonies in which the Snow Clan takes part as

4-2. Dawakema–Milland Lomakema. Symbols of the Bear Clan. *1974. 36" x 40". Acrylic. Collection: Hopi Cooperative Arts and Crafts Guild.*

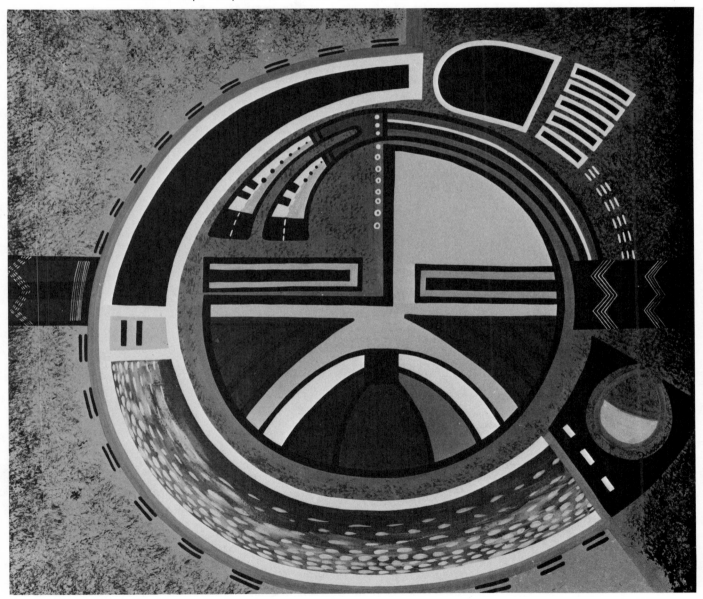

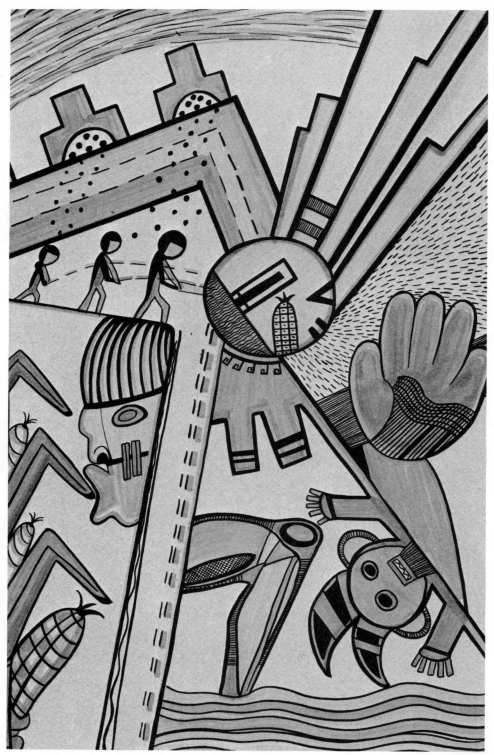

4-3. Coochsiwukioma–Delbridge Honanie. Snow Clan Kachina. 1974. 18¹/₂″ x 11¹/₂″.
Acrylic. Collection: Hopi Cooperative Arts and Crafts Guild.

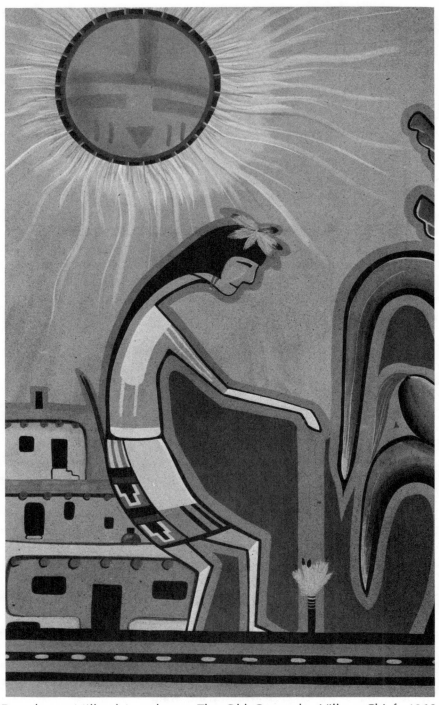

4-5. *Dawakema–Milland Lomakema. The Old One—the Village Chief, 1968. 30" x 18¹/₂". Casein. Collection: Byron Harvey, Phoenix, Ariz.*

the basic elements of his composition. He includes the masks of the Kachina warrior and the Two Horn Kachina which represents fertility, a woman's leg which represents the dances of the Women's Society at harvest time, as well as traditional symbols of corn, snow, clouds, rain, and water.

One of the strongest influences throughout life is the Hopi's sense of identity as a member of a specific clan. There are, however, many clans within a village, and until recently each village was an independent political entity.

Since the arrival of the Hopis at the mesas and the founding of Shungopovi, whenever possible, the Mongwi, who is the ruler of the village, has been a member of the Bear Clan. In 1936, a plan of a Hopi Tribal Council was imposed on the Hopis by the United States Government. The Council is still a topic of great controversy and is almost completely rejected by conservative elders. It is only in the last few years that the Tribal Council has had any acceptance, for it is the most effective means of dealing with United States Government agencies, industry, or any large organizational body. The leaders of the Council are elected to office, whereas the High Priests were chosen by their elders to fill a hereditary role.

Mike Kabotie explains that the Hopis are in the process of changing from a theocracy to an experiment in democracy. In *The Candidate* p. 38, which is a Pop Art painting that has the appearance of a political poster, Kabotie shows Ahula, the right-hand man of the Sun and one of the most important Hopi deities, campaigning for public office. Although Ahula holds the staff of authority and wears the ceremonial robes of the High Priests, a campaign band is across his chest. Mike explains that today even the deities must turn to the people for confirmation and election.

Milland Lomakema frequently paints the Mongwi, the traditional leader who was responsible for the well-being of his people. In *The Old One—the Village Chief* (Fig. 4–5), Lomakema depicts the leader planting a prayer stick in the corn field. In *Kikimongwi* (Fig. 4–6), the leader holds a basket and a prayer feather, which is decorated with many fertility symbols, as he prays for rain. In *Hopi Chief in His Field* (Fig. 4–7), a more recent painting, the Chief carries the sacred water in a netted gourd and ceremoniously sprinkles sacred cornmeal on the ground. He is surrounded by the most important elements of Hopi life— corn and water.

Every Hopi is a member of a clan, and in those communities which retain their traditional ceremonies, men and women upon reaching spiritual maturity are initiated into a ceremonial society. In recent years, the time when a man is considered mature may be delayed until after he has married and started his own family. There are several men's societies—One Horn, Two Horn, Wuwuchim, Singers, Snake, Antelope, and Flute. These societies have tremendous importance in Hopi life. All women have the opportunity to become members of the Women's Society.

All members of the Artist Hopid find a rich source of artistic inspiration in the Hopi ceremonial societies. Of the members of the Artist Hopid only Neil David, Sr., does not belong to a society, for he is a Tewa from Hano and they have their own ceremonial traditions. Milland Lomakema and Delbridge Honanie are members of the One Horn Society and Mike Kabotie and Terrance Talaswaima are members of the Wuwuchim Society. Lomakema tries to reduce the complex costumes of the ceremonial figures to simple geometric designs in his paintings. He writes of his composition *Antelope Priest* (Fig. 4–8): "*Antelope Priest* is in the petroglyph style. This particular figure symbolizes the Rain Clan Priest in the Antelope Society in its ceremonies, indicated by a lightning design from the head and at the end of the cloud design."[1]

4-6. *Dawakema–Milland Lomakema. Kikimongwi. 1970. 16³/₄″ x 11³/₄″. Casein. Private Collection.*

4-7. *Dawakema—Milland Lomakema. Hopi Chief in His Field. 1975. 28" x 28". Acrylic. Collection: Hopi Cooperative Arts and Crafts Guild.*

70

4-8. *Dawakema–Milland Lomakema.* Antelope Priest. *1975. 13¹/₄" x 10¹/₄". Acrylic. Collection: John Cartwright, Santa Fe, N.M.*

Delbridge Honanie frequently turns to the Flute Society for inspiration. In *Flute Player* p. 228, he portrays the kiva of the Flute Society. Within the kiva can be seen part of a mural which is an exact replica of a mural fragment excavated from an Awatovi kiva. Each year the kiva murals are covered with whitewash and new murals painted. Honanie explains that the two young people in the mural are in the four-year period of learning. On top of the kiva is Kokopelli, the humpback flute player, painted in the style of the petroglyphs. Kokopelli, a fertility symbol, plays for rain.

Flute Society (Fig. 4–9) p. 39, is a complex composition in which Delbridge Honanie celebrates the rituals of the Flute Society. The primary responsibility of the Flute Society is to pray for the last rains of summer, which will assure the maturity of the crops. Their song should also warm the earth. The Flute Dance is held every other year, alternating with the Snake Dance, at the time of the summer solstice, the time of year when the sun has reached its northernmost point. During this ceremony, the Hopis enact the Emergence into the Fourth World. In this painting, Honanie has placed all the activities and symbols beneath the surface of the ground. The central form is that of an underground water spring, surrounded by rocks. Water and fertility symbols—clouds, rain, water, tadpoles, and frogs—are ever-present. Development of the tadpole into the frog is symbolic of the migration through life. In

71

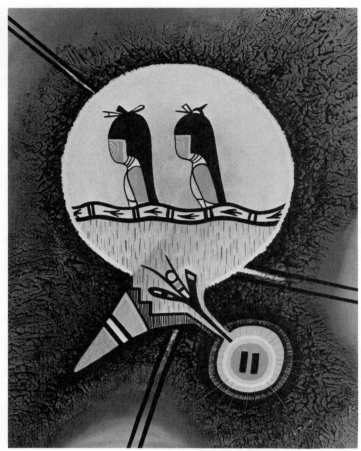

4-10.　*Coochsiwukioma–Delbridge Honanie. Warriors. 1975. 20" x 16". Acrylic. Collection: Hopi Cooperative Arts and Crafts Guild.*

the lower left of the painting are abstract forms of the Dead, who are included in the composition because another of the primary responsibilities of the Flute Society is to pray for the Dead. Beneath the Dead are Migration spirals which have the double connotation of the Migrations of the Dead to the Spirit World and the Migrations of the Hopis to the Fourth World. Within the spring, the Flute Player prays for the corn. In the center are children in the process of being initiated, and on the right, a Warrior protects the sacred ceremonies. Delbridge Honanie includes the figures of Warriors in many of his paintings. In *Warriors* (Fig. 4–10), he has created a stylized composition of the Warriors who protect the Snake Society. On their shield are parallel marks which are symbols of the Warrior. The use of orange in the composition represents the blood of the snake because the Warriors use snake poison. Other elements of this painting are a war shield and a prayer feather.

　　The One Horn Society is the most powerful Hopi society. It is the duty of the One Horn Priests to look after the Dead. After death the spirit of those in the One Horn Society remain in the Underworld to carry out their responsibilities among the Dead as they have among the living. These Priests serve Muingwa, the God of Germination and owner of the Underworld, and Massau, the God of Earth and Death. The One Horn Priests are responsible

72

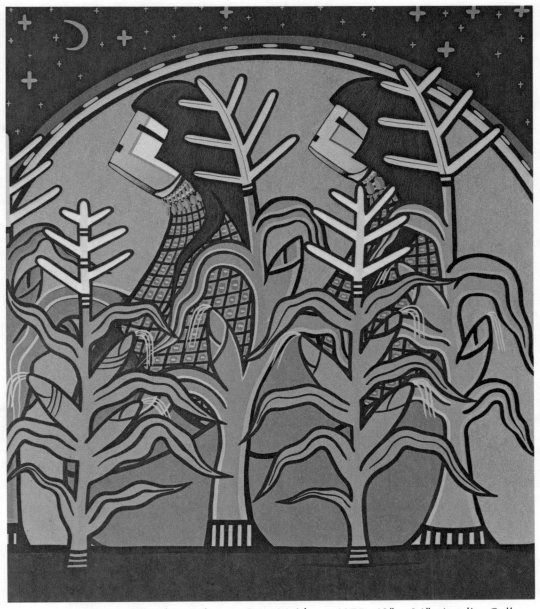

5-6. *Dawakema–Milland Lomakema. Corn Maidens. 1975. 40" x 34". Acrylic. Collection: Hopi Cooperative Arts and Crafts Guild.*

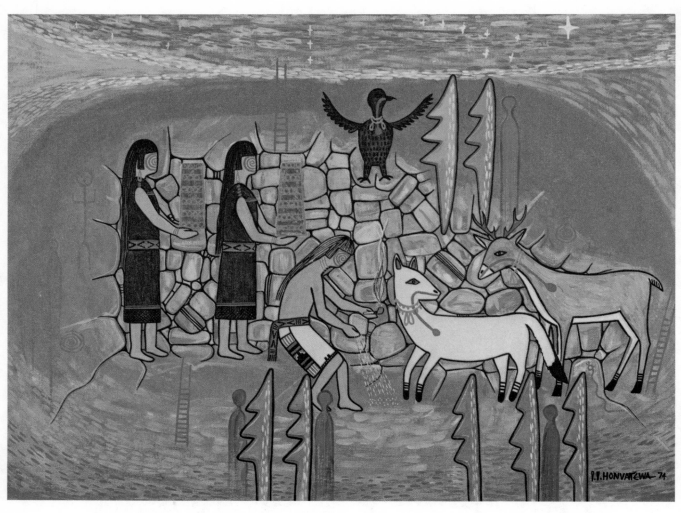

5-12. *Honvantewa—Terrance Talaswaima. Two Hearts II. 1974. 18" x 24". Acrylic. Collection:John Cartwright, Santa Fe, N.M.*

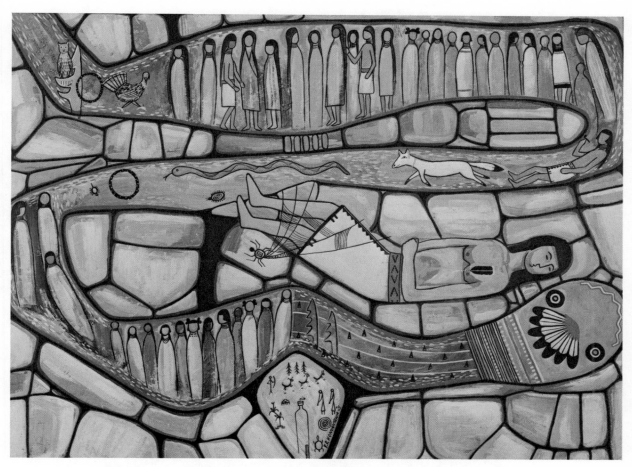

5-13. *Honvantewa–Terrance Talaswaima. Two Hearts III. 1975. 29¹/₂" x 39¹/₂". Acrylic.*
Collection: Mr. and Mrs. Gerald Peters, Santa Fe, N.M.

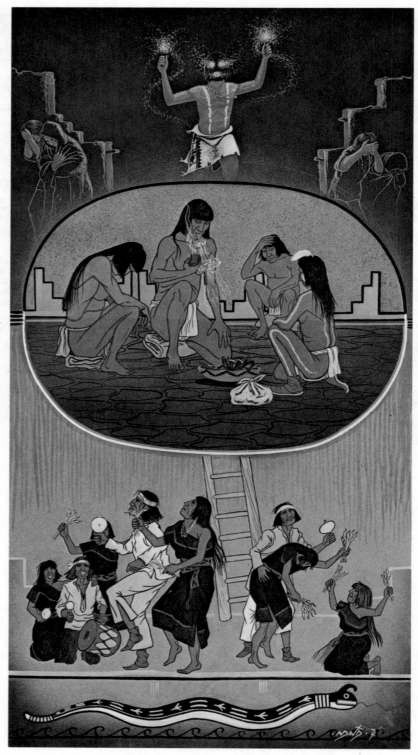

5-14. *Neil David, Sr.* The Destruction of Palotquopi. *1974. 27" x 14¹/₂".*
Acrylic. Collection: Ed Comins, Phoenix, Ariz.

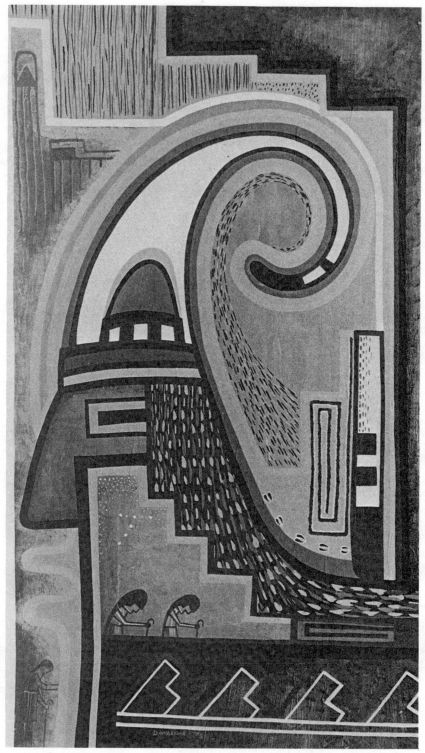

4-11. *Dawakema–Milland Lomakema. One Horn Priest. 1973. 30" x 17". Acrylic. Collection: Hopi Cooperative Arts and Crafts Guild.*

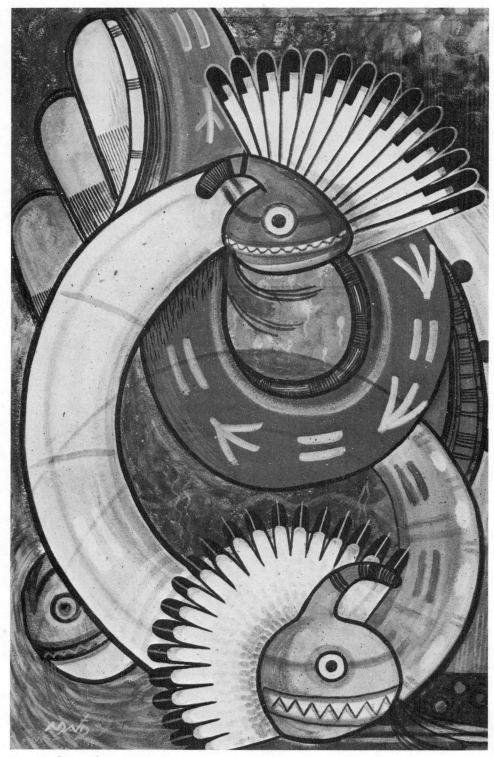

4-12. *Neil David, Sr. Water Serpents. 1973. 31" x 19". Acrylic. Collection: Hopi Coopera-*
tive Arts and Crafts Guild.

for the spirits on their journeys to the Underworld. Milland Lomakema, a member of the One Horn Society, frequently includes One Horns in his paintings. *One Horn Priest* (Fig. 4–11) is his stylized representation of the Chief of the One Horn Society. Milland includes two members of the One Horn Society and deer tracks, because deer are used in the One Horn ceremonies as well as cloud, rain, and Migration symbols.

Neil David, Sr., chooses the Hopi societies as artistic subjects primarily for their design value, but, unlike Lomakema's simple geometric abstraction, David's designs are extremely complex. He frequently paints the One Horn Priests, but his focus is upon their aesthetic qualities rather than upon their ceremonial functions. In his paintings, Neil explores variations of geometric form and uses both traditional symbols and ancient and modern design elements. (His work is occasionally influenced by painters from other Pueblos. Several of his works show the influence of the Santa Domingo artist, Julian Lovato.) In David's painting *One Horn Priest and Warrior Priest* p. 281 , his interest is primarily in the elements of composition. He employs the techniques of Cubism to combine the figures of the One Horn Priest and the Warrior Priest. In *Warrior Priest* p. 273 , David paints a single figure within whose body is a complex juxtaposition of shapes and colors, symbols and design elements. He includes traditional water symbols and kilt designs.

In *Awatovi Snake Society* p. 147, David paints stylized Snake and Antelope Priests in a style similar to that of the figures in the Awatovi murals. His goals in portraying figures of the Snake Ceremony are neither to instruct nor to interpret but to achieve a valid artistic creation. The Priests and the vessels of sacred water circle the altar within which are the snakes and prayer feathers. The snakes are decorated with designs from the kilts of the Snake Dancers. David has inverted the bottom half of the composition so that the two Snake Dancers appear as two mirrored images. The Hopis believe that snakes are messengers who carry their prayers to the Underworld. In the Underworld everything is in the opposite order from that in the world above the ground. If it is light on the Earth, it is dark in the Underworld, and when it is dark on Earth, it is light in the Underworld. Left and right are reversed, as are up and down. In *Water Serpents* (Fig. 4–12), Neil has created a painting which is composed of a variety of water symbols, including water serpent symbols, designs from the costumes of Snake Dancers (the parallel marks are similar to those in the kilts of the dancers) and the sacred water jar.

In *Snake Society and Prayers with Warrior Maidens* (Fig. 4–13), Neil David achieves a unified composition by using intercepting circles within which stylized figures and symbols are juxtaposed. In the uppermost circle, Antelope and Snake Society Priests are joint participants in the Snake Dance. For David, the Two Horn Priest placed above the two horns represents germination. In the center circle is Hehe, the Warrior Maiden (see chapter 6). She is the Joan of Arc of Hopi history. Below her is a parrot and in the bottom circle is a roadrunner. All of the figures are in the style of the Awatovi murals (see chapter 9), except the roadrunner in the bottom circle. The roadrunner is the most abstract figure in the composition; his head and bill stand in sharp contrast to his geometric wing and tail designs. In David's work, the design rather than any complex ideology ties these figures and symbols together.

Hopi Ceremony p. 17 by Delbridge Honanie is an iconographically complex interpretation of the Snake Dance. Like Neil David, Honanie frequently paints in the style of the Awatovi murals. Honanie is at all times conscious of the role of his clan, the ruling Bear Clan, in Hopi ceremonies. In this painting, the Bear Clan Priests pray that the snakes carry the prayers of the Hopis to the Underworld. The snake in the upper right-hand corner of the

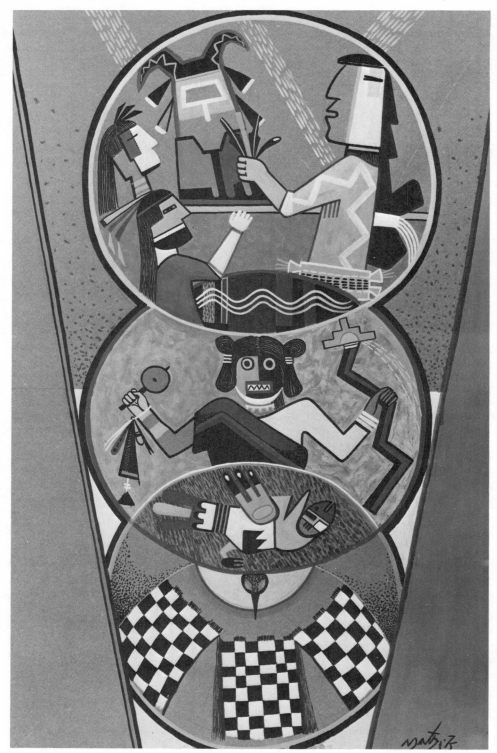

4-13. Neil David, Sr. Snake Society and Prayers with Warrior Maidens. 1975. 21$\frac{1}{2}$" x 19$\frac{1}{2}$". Acrylic. Collection: Mr. and Mrs. Gerald Peters, Santa Fe, N.M.

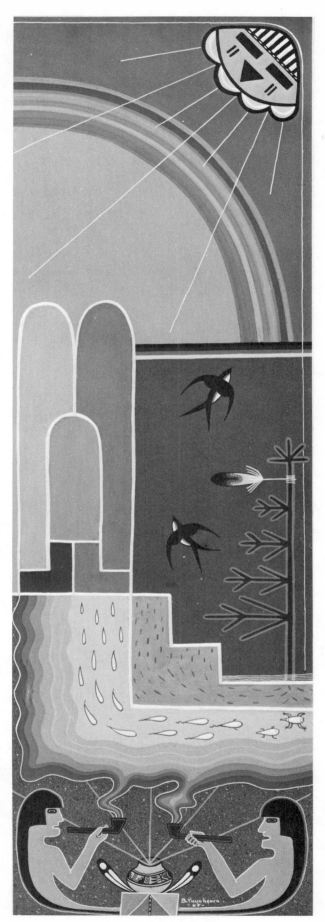

4-14.
Lomaquaftewa–Bevins Yuyahoeva.
Smoking for Rain. 1968. 32" x 10¹/₂".
Casein. Gift of Byron Harvey to the
Hopi Cultural Center Museum.

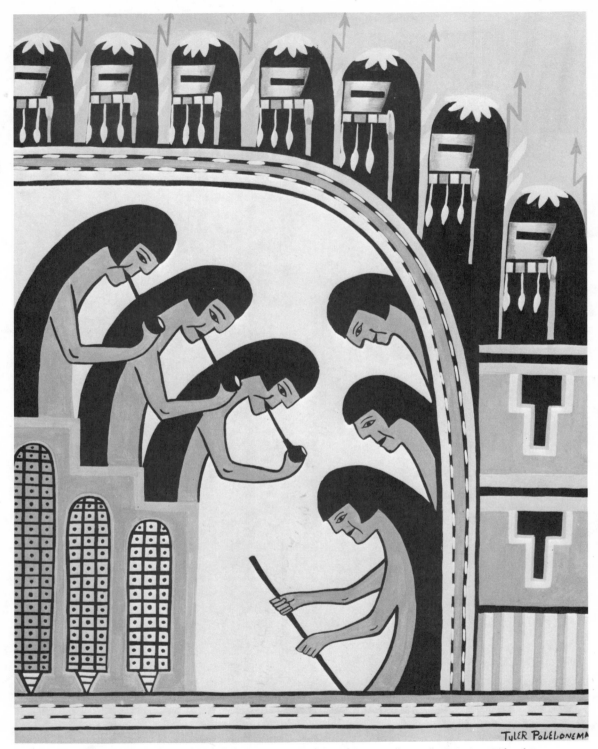

4-15. *Duvehyestewa–Tyler Polelonema. Ritual Smoking. 23" x 19". Casein. Gift of Byron Harvey to the Hopi Cultural Center Museum.*

composition appears as a plumed serpent. The Priest feeds cornmeal to the snake and the snake in turn looks after the well-being of the Hopi people. The snake receives the prayer stick from the Priest. In the lower left-hand corner, three men carry prayer feathers for the snakes, and in the upper left corner is a Warrior who carries a bow and arrow to protect the Snake Ceremony. The overall background design is taken from ancient pottery motifs of fertility and Migration symbols. The Priests have pipes in forms of cloud and lightning symbols. The Hopis often refer to a pipe as a "cloud blower."

The ritual of smoking is one of the most important forms of Hopi prayer. The Hopis believe that their prayers are carried to their destination by the smoke as it rises in the air. It is only in very recent years that the concept of recreational or nonceremonial smoking is acceptable to any of the Hopis. The smoking of tobacco in the kiva also symbolizes harmony between men. Edmund Nequatewa in *Truth of a Hopi* describes the smoking ceremony: "When they had finished their paho-making, every man with his tray or plaque full of prayer sticks held in front of him, again circled the fire and filled his pipe with tobacco to smoke. With a Hopi, smoking a pipe is the most true and earnest way of showing himself in prayer. Here they let the smoke pass from their mouths onto the trays of their prayer offerings and let the gods know they were earnest. With the Hopi, the smell of smoke is the most sincere message to the gods, and for this reason much smoking is done at the times of all cere-monies."[2]

Tyler Polelonema, the son of Otis Polelonema, many times chose ceremonial smok-ing as the subject of his paintings. In *Smoking for Rain* (Fig. 4–14), two figures, whose forms rise from the Earth like coils of smoke, offer their prayers for the nourishment of their crops. On the Earth stands the sacred water vessel. After a Hopi has been initiated, ritual smoking for the well-being of the tribe becomes one of his principal responsibilities. In this painting, the prayer comes in the form of smoke from his pipe. The raindrops evolve into tadpoles which in turn become frogs, a process symbolic of germination. The rainbow represents "life in bloom." The sun and the cornstalk, to which a prayer feather is tied, represent fertility. The bird represents the airborne quality of the smoke as it carries forth the prayers of the Hopi.

In *Ritual Smoking* (Fig. 4–15), Tyler Polelonema places a row of Rain Kachinas above the rainbow. Beneath the rainbow, three Hopis smoke in prayer and three plant corn. In *Smoking for Sunshine, Rain, Cattle, and Corn* (Fig. 4–16), Tyler places the ritual smoker in the center of the 360-degree rainbow, the "House of the Sun." Sunshine, rain, cattle, and corn are placed in each of the four corners of the painting, and into each of the four parts of half of the central circle. On the other half of the circle, the Hopi smokes, praying for the basic ingredients of survival in the Hopi world.

As a mature member of society, each Hopi has a complex web of affiliation and responsibilities. He is a member of an individual family, a village, a clan, and a ceremonial society. He is governed by his uncles, the village Chief, the clan Chief, and the society Chief. He has obligations of learning and of teaching. As he follows his duties in seasonal rituals, he progresses in the cycle of human life, the yearly cycle of tribal ceremonial life, and the cycle of universal progress.

Hopi men and women are tied to the mainstream of Hopi history, life, and thought by an intricate web of ties that have withstood centuries of cultural and religious crusaders. Despite many surface changes, their family, clan, and tribal beliefs and their affiliations remain constant. In their paintings, contemporary Hopi artists express this sense of identity and satisfaction with the Hopi Way of Life, and Hopi history, life, and thought remain the focus of their work.

In his poem, *Hopid,* Mike Kabotie expresses the dedication and cultural integrity necessary for the survival of the Hopi artist and of Hopi art:

Hopid

Among rocky plateaus
shifting sands, whirlwinds
junipers and sagebrushes
their afterbirths dry.
Born, baptized by a rich life
during violent world chaos
but sweet was theirs;
nourished to adolescence,
maise their mother.
Children of Bear, Kachina
and Hopi clans
 Then
into the cold
grey concrete, asphalt
confusions they were cast;
BIA books, crosses, time-punches
 unrelated
refined by blinding lights,
slick wheels;
bourbon, wine an escape
 their addiction.

But young, proud and reckless
they return back to
their womb kiva,
 sandstone dwellings
now antennaes, 'lectricwebs
but sewerless barren rocks
their security.
Among their people,
tapping infinite creativity
power unknown, they travel
 among priestly clouds
 mysterious stars
coordinating abstract thoughts
with skilled hands,
 Artist hopid their identity.

NOTES

1. Milland Lomakema. Description written for the author, December 1975.
2. Edmund Nequatewa, *Truth of a Hopi* (Flagstaff: Northland Press, 1967), p. 10.

84

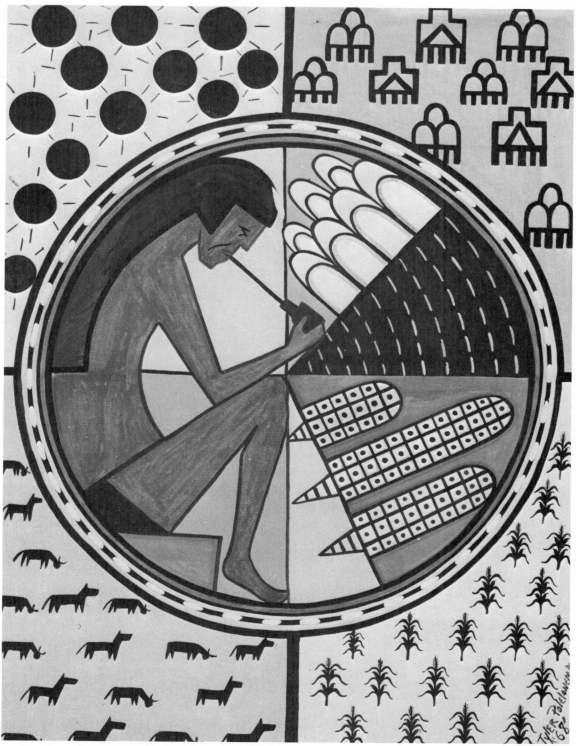

4-16. *Duvehyestewa–Tyler Polelonema. Smoking for Sunshine, Rain, Cattle, and Corn. 1968. Casein. Gift of Byron Harvey to the Hopi Cultural Center Museum.*

CHAPTER 5

The Spirit World

The Spirit World is a dominant force in Hopi life. The universe was created and is sustained by supernatural deities and spirits. In the heavens, the sun, moon, stars, lightning, clouds, and even the rainbow, are important universal spirits which help determine the course of life on Earth. All things in the natural world—animals, plants, trees, and inanimate objects such as stones and pottery jars—possess a spirit and life of their own. Spirits of the past as well as of the future help determine present-day life on Earth. The spirits of the Dead have a vital impact on the world of the Hopis, and, in some instances, even the spirits of those still unborn are present in the world of the living (see chapter 8).

The focus of the Spirit World is the land of the Hopis. In both the natural world and in the supernatural world there is a fixed order. All spirits must be in harmony with this order before life can progress smoothly, crops flourish, and the Hopis can achieve their universal goals. It is necessary that the Hopis recognize order, and through appropriate rites and ceremonies maintain this order. Whenever it becomes necessary, they must recognize their errors and restore order as quickly as possible. For the Hopis, prosperity and universal progress depend upon propitiating the deities and spirits of the natural and supernatural worlds.

The pantheon of Hopi deities and spirits varies in different villages and among different clans. The relative importance of those in the Spirit World may also differ in the beliefs of individual Hopis or change with the passage of time. The hierarchy given by Don Talayesva of Oraibi illustrates the complexity of the Hopi Spirit World:

The Sun is the highest god. He ("Our Father") is believed to be a strong, middle-aged "man," who makes daily journeys across the sky, lights and heats the world, and sustains all life. In the far-distant oceans to the east and west live

two aged goddesses of hard substance (Hurung Whutis), who still answer Hopi prayers. Associated with the Sun are the Moon and Star gods (both male and female) who assist him in his important work. Eagle and Hawk deities also live in the sky and look after the interests of the people. Lesser sky gods are the wind, lightning, thunder, rain, and rainbow deities. Serpent deities live in the springs and control the water supply. Below these gods in rank are the Six-Point-Cloud-People, departed ancestors who visit Oraibi in billowy clouds and drop a little rain on the parched lands. Massau, the god of fire and death, is master of the underworld of spirits but resides also in shrines near the Hopi villages. He is a restless nightwalker who carries a firebrand and guards the people while they sleep. Muingwa lives below the earth with his wife and looks after the germination of all seeds and the growth of plants. The old Spider Woman (who is also the Salt Woman) lives with her grandsons, the Twin War gods, in a shrine near each village, but resides also at many other distant places. She, with the War gods, protects the interests of all good and faithful Hopi. There is a Corn Mother and her Corn Maidens who watch over the maize plants, and the Mother-of-Wild-Animals who rewards the hunters with game.

The Kachinas, ancestral spirits, are in contact with the Oraibians six months of every year and promote the prosperity of the village with their masked dancing and by conveying the prayers of the people to the more important gods. Every person also has a Spirit Guide who may protect him from danger and direct his course throughout life. In addition to these and other well-known supernatural agents, there are many unidentified spirits—both benign and malignant—who frequent Oraibi and must be avoided, coerced, or propitiated.[1]

Several pantheons of deities include a supreme being, Sotukeu-nangwi, who is a Heavenly God served by all other gods.[2]

Today, as in the past, Hopi art is an inseparable part of the mainstream of Hopi life, and the deities and spirits are a vital part of Hopi painting. In Hopi art as in Hopi life, all deities and spirits are not of equal importance. In modern painting, as in ancient Hopi art, those most frequently represented are those spirits who protect the Hopi people and assure their survival and prosperity. The spirits of germination and protection are of primary importance in Hopi art. The germination spirits are responsible for the fertilization, nourishment, and harvest of the crops which sustain Hopi life and assure the procreation of the Hopi people. Many protective spirits safeguard the Hopis from their enemies and from the malevolent forces of external nature, as well as from evil within the tribe and within specific individuals.

There are very few paintings of the deities of creation. There are no representations of Sotukeu-nangwi, the Supreme Being, and Terrance Talaswaima's painting *Deities of Hard Substance* p. 46, is a rare and highly individualized interpretation of the Hurung Whuti. There are also few representations of Tewa, the Sun. The Sun Spirit is thought of as a male force that impregnates Mother Earth, who gives birth to all living things. Tewa, the Sun Spirit, must not be confused with the sun, which was placed in the sky in order to give light to the Fourth World.[3]

Of all the Hopi deities, it is Muingwa, the Germinator, God of the Underworld and Creator and Guardian of Life, who appears most frequently in Hopi paintings. In *Giver of Life #2* p. 144 , Neil David, Sr., has painted two inverted images of Muingwa. This inversion suggests the turning of the Earth and illustrates the concept of the negative image of the Underworld. The left half of the painting is in the sunlight of daytime. It is summer, and crops

and flowers flourish in the sunshine. The parrot evokes the distant past. It is known that parrots and macaws, which were probably brought from Mexico, were owned by the Pueblo Indians in pre-Spanish times, and parrot burial sites have been excavated in northern Arizona. In the past, parrot feathers were used ceremonially to carry the prayers of the Hopis to the Spirit World. Because its feathers have the power to bring rain clouds, and, ultimately, life-giving rain, the parrot is a germination symbol. In the right half of David's painting, it is winter and the dark of night. During periods of cold and darkness, when there is no sign of plant life on Earth, Muingwa keeps the plants alive beneath the ground. In *Hehe* (Fig. FTK), Mike Kabotie includes the figure of Muingwa. This powerful deity wears a cloud-and-rain headdress and carries the symbol of universal friendship. Muingwa blesses the seeds of the earth, for he has great importance as the Germination God of vegetation and seed.

There is another fertility god or Germinator whose identity is frequently fused with that of Muingwa. Aloska, a two-horned germination deity, is often but not always interchangeable with Muingwa. Fred Kabotie has chosen this Germinator as the central figure of his composition *Germination* p. 215 . The Germinator, surrounded by rain, cloud, and lightning symbols, holds a prayer stick which includes the feathers of the bluebird, small blackbird, roadrunner, turkey, and finch. Above him looms a Rain Priest, while below both figures is a rainbow from which arises a representation of the moon and its rays. Within the moon is a stylized figure symbolic of animal life on Earth.

Neil David, Sr., portrays the spirit of germination in *Prayers for the Lives of All* (Fig. 5–1). In David's composition, the Germinator is represented by a giant hand.[5] The Germinator blesses all of the Hopis' planted crops, which are symbolized by corn in an earthen pottery jar. Coming from the jar are tracks of all creatures who walk on the Earth. The Hopi holds a prayer feather as he prays to the Great Spirit. The Great Spirit has given all species of birds to the Earth, and in David's composition the birds fly earthward from a giant outstretched hand. On the far left of the painting are cloud and rain forms and a rainbow.

In *Prayers for the Lives of All,* the hand of the Great Spirit is the hand of the deity Massau. Massau is owner of the Underworld and guardian and protector of the Upperworld. It was Massau who gave permission to the Hopis to inhabit the Earth. The face and figure of the deity appear very infrequently in Hopi painting, for Massau is greatly feared by the Hopis. Massau is the God of Fire and the God of Death, and it is thought that to meet him face to face is a sign of death. To touch Massau would mean impending death. The only ones who need not fear Massau are members of the One Horn Society. The imaginative representation of Massau in *Emergence* p. 18 by Milland Lomakema is indeed rare.

Massau is both revered and feared by the Hopis. He is portrayed in legend as wearing a rabbit-skin cape. There is blood on his head; it is thought to be animal blood, since he is the God of Game. Massau has great importance as a fertility spirit. He played an important role in the days following the Emergence, for he gave fire to the Hopis for the warming of the Earth. Massau's fire is thought to cause the crops to grow with magic speed, and he has the power to provide rain for the Hopi people. He guards the villages at night and sometimes carries a torch.

A favorite deity of the Hopis is Spider Grandmother (Kokingwuti). In many legends describing the creation of the Fourth World, she is said to have molded the first human beings, birds, and animals from the earth. She is wise and always ready to help the Hopis. She appears among the people just in time to offer protection or salvation to villages, clans, or individuals. She is a woman of great cunning and she is on hand to help the Hopis make all important decisions. She can make herself small enough to fit into the human ear.

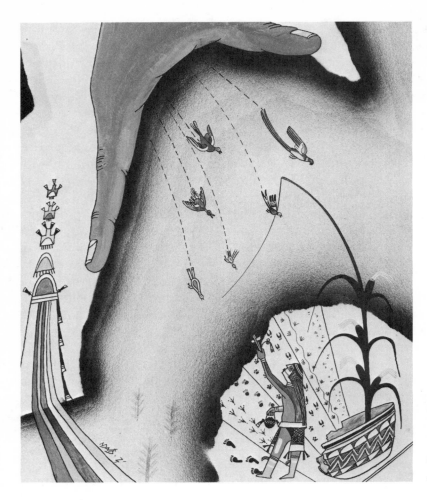

5-1. Neil David, Sr.
Prayers for the Lives of All.
1974. 20″ x 16¹/₄″. Mixed
Media. Collection: Hopi
Cooperative Arts and Crafts
Guild.

Many Hopis think of the Spider Woman as an Earth Mother figure, a germination deity. Neil David, Sr., in *Spider Woman and Muingwa* (Fig. 5–2 , p. 40) portrays two male and female germination spirits. Both stand under a rainbow and within a circle. There is the break in the circle, symbolic of the place of Emergence. Spider Grandmother walks on her web and sprinkles cornmeal. Hopi maidens with their hair dressed in whorls appear in the air above the deities. Petroglyph etchings, an echo of the days of the Migrations, surround the principal figures. Muingwa wears a sacred rain sash which symbolizes fertility.

Spider Woman has five grandsons. The Twin War Gods (Polongahoya and Pokanghoya), Poker Boy (Kochoilaftiyo), the Cotton-Seed Boy (Pe-chinsi-vastio), and Patches (Pivitomni). She is wise and tolerant and has many of the qualities of a human grandmother. She is there to help and advise but on occasion errs and must correct her mistakes. She is frequently teased by her twin grandsons, but constantly saves them from trouble. Mike Kabotie's painting *Warrior and Water Serpent* (Fig. 5–3), is a scene from a children's story of Spider Woman and her grandson. Pokanghoya, her most mischievous grandson, has defied his grandmother's control and has played with a Water Serpent. The Serpent has coiled himself around the Twin so that the boy is now in serious trouble. Spider Grandmother looks

90

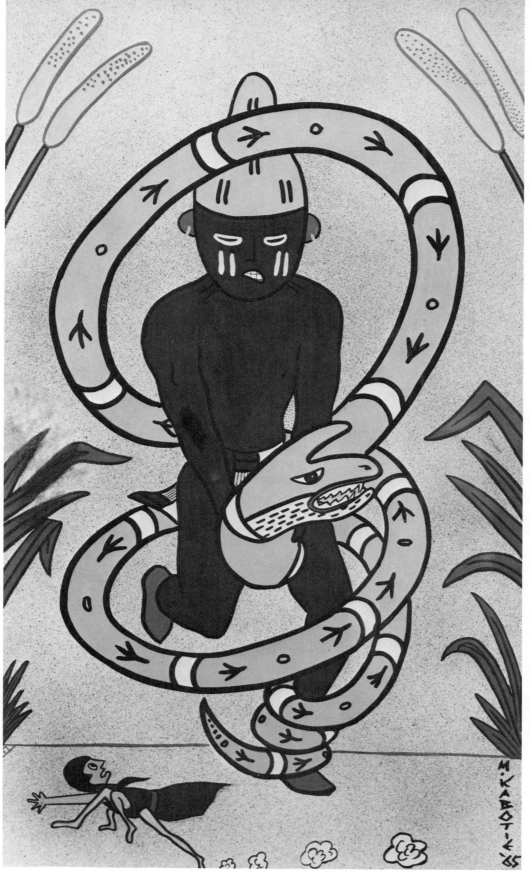

5-3. *Lomawywesa–Mike Kabotie. Warrior and Water Serpent. 1965. 28" x 15¹/₂". Casein. Gift of Byron Harvey to The Heard Museum of Anthropology and Primitive Art (Indian Collection), Phoenix, Ariz.*

at him in horror. The Twins are the wards of Spider Grandmother and they live with her in a kiva near the mesa villages. Terrance Talaswaima, in *Spider Woman and Warrior Gods* (Fig. 5–4), portrays this deity with her grandsons in the chambers of their underground kiva.

The Twins represent the polarization of the Earth. They are stationed at the north and south axes of the world in order to stabilize the rotation of the Earth and keep the world in proper motion. The young Twins are Warrior Gods, protectors of the Hopi people. Like their grandmother they have many human qualities and are favorites of the Hopis. They enjoy games, races, and tricks and love beautiful Hopi maidens. They carry lightning arrows to destroy the enemies of the Hopis and frequently battle against giants and other evil spirits. Long ago, during the creation of the Earth, the twins used their arrows to create canyons and valleys in the mountainous land. Pokanghoya appears in *Hehe* p. 140 by Mike Kabotie, as a warrior protecting a Water Serpent which represents the mystery of the powers of nature. Here, as in many contemporary paintings, the Twins are depicted as stylized small black children. In both *Awatovi Woman's Ceremony* p. 226 , and *Symbols of War God* (Fig. 5–5), Delbridge Honanie portrays Pokanghoya, the eldest, as a small black figure, identical to those in the fragments of the Awatovi murals.

In addition to the deities, the spirits of the plants and animals of the Hopi world have great iconographical importance in modern Hopi painting. Everything in the Hopi world is considered to be living and to have positive power. There is a spiritual essence in all matter. Many Hopis believe that in the supernatural world the ultimate form of life is the human form. In *Truth of a Hopi,* Edmund Nequatewa explains: ''To the Hopi all life is one—it is the same. This world where he lives is the human world and in it all the animals, birds, insects, and every living creature, as well as the trees and plants which also have life, appear only in masquerade, or in the forms in which we ordinarily see them. But it is said that all these creatures and these living things that share the spark of life with us humans, surely have other homes where they can live in human forms like ourselves. Therefore, all these living things are thought of as human, and they may sometimes be seen in their own forms even on earth. If they are killed, then the soul of this creature may return to its own world which it may never leave again, but the descendants of this creature will take its place in the human world, generation after generation.''[6]

The Hopis believe that all plants have a life that is dormant during the winter and which flourishes during the seasons of germination, growth, and harvest. The Underworld is the storehouse of the dormant crops. The most popular of the Hopi plant spirits are the spirits of the Hopi corn. In *Corn Maidens* p. 73 , Milland Lomakema portrays two spirits which he describes as ''corn plants with two ears of corn with heads on them. Their spirits meet at night and help the corn grow into healthy big corn, as corn is our principal food.''[7] These Corn Maidens are the spirits of the multicolored kernels of corn.

In *Spotted Corn Germination* (Fig. 5–7), Terrance Talaswaima portrays the Corn Spirits beneath the ground ready to rise and grow. Terrance explains that after the corn is planted, the spirits take care of the plants and prepare them to grow. The figure on the far left represents blue corn and the adjacent figure represents spotted corn, the corn of many colors. Talaswaima frequently conceives of the Corn Spirits as pregnant, for they are spirits of fertility and germination. Each of the Corn Spirits is different, because each has its own character and therefore is a distinct individual. On the right of the painting are male and female Corn Spirits. Talaswaima has integrated the Migration symbol into the bodies of the spirits to show that corn has sustained the Hopis since the days of the Migrations. The steps represent stages of growth, and beneath the steps are personifications of rain.

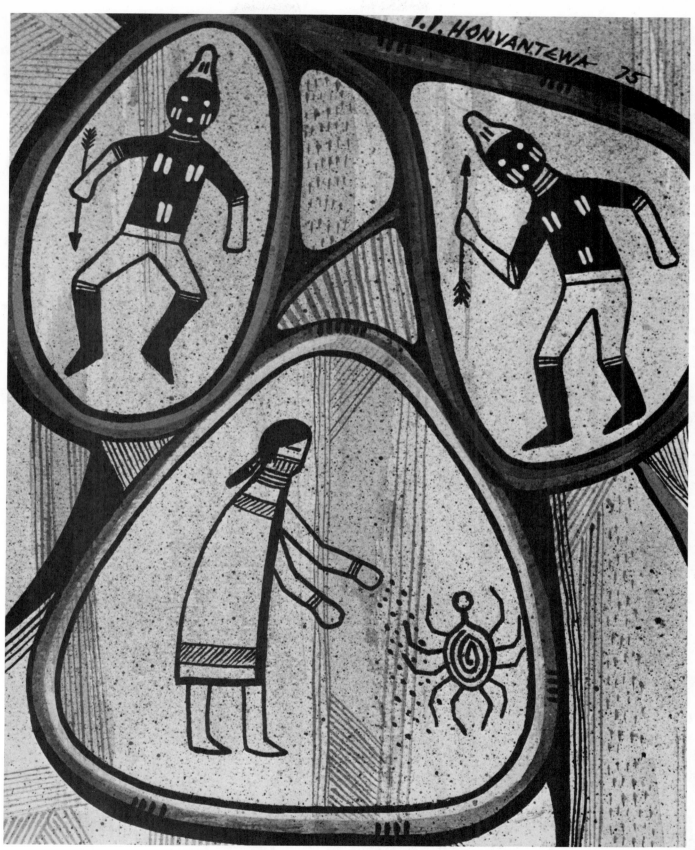

5-4. *Honvantewa–Terrance Talaswaima. Spider Woman and Warrior Gods. 1975. 11¹/₄″*
x 8¹/₂″. Acrylic. Collection: Rene Jacobs, West Orange, N.J.

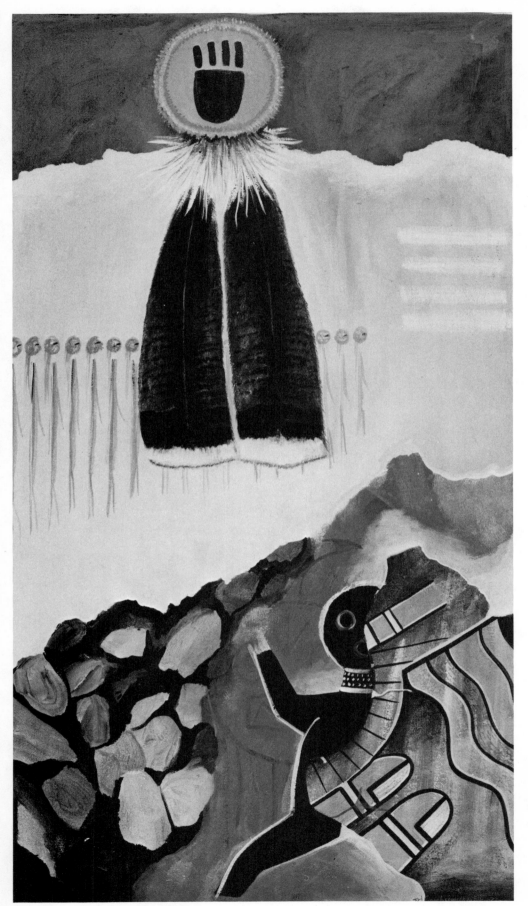

5-5. Coochsiwukioma–
Delbridge Honanie.
Symbols of War God.
1973. 36" x 18". Acrylic.
Collection: John Cartwright,
Santa Fe, N.M.

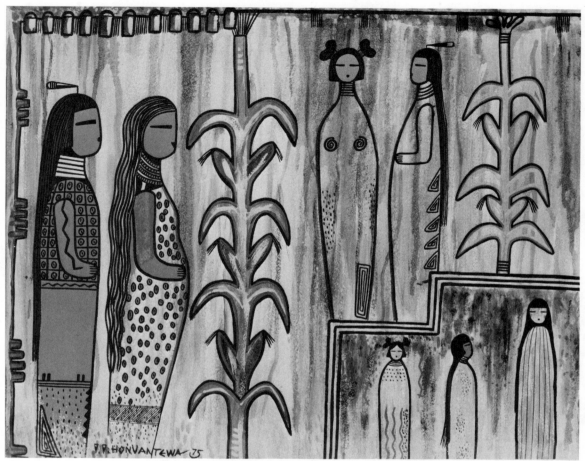

5-7. Honvantewa–Terrance Talaswaima. Spotted Corn Germination. 1975. 19" x 23". Acrylic. Collection:Hopi Cooperative Arts and Crafts Guild.

In *Prayer to Corn People* (Fig. 5–8), Talaswaima portrays male and female Corn Spirits. As prayer sticks have a spiritual essence of their own, the artist depicts them with animated features and with each possessing the breath of life. Talaswaima integrates the Migration symbols into the bodies of the Corn Spirits. In both *Prayer to the Corn People* and *Spotted Corn Germination,* he places the Corn Spirits beneath the ground within a womblike form.

The figure of the Squash Maiden is another familiar element in modern Hopi painting. In *Awatovi* p. 6 , Talaswaima includes a stylized representation of the Squash Maiden painted in a style similar to that of the Awatovi murals (see chapter 9).

In *Sun and Rain Spirits Over Corn Plants* (Fig. 5–9), Milland Lomakema has created a stylized design in which he portrays the sun and rain as living entities. The frog, a water symbol, sits beneath the growing corn. The Sun Spirit wears a headdress of clouds from which rain, snow, and lightning radiate. Lightning, a symbol of rain and fertility, is fused to the body of the corn. The Rain Spirit is connected to the Sun Spirit, for all spirits of nature are part of a single universal plan. The faces of the Sun and Rain Spirits strongly resemble the masks of the Sun and Rain Kachinas.

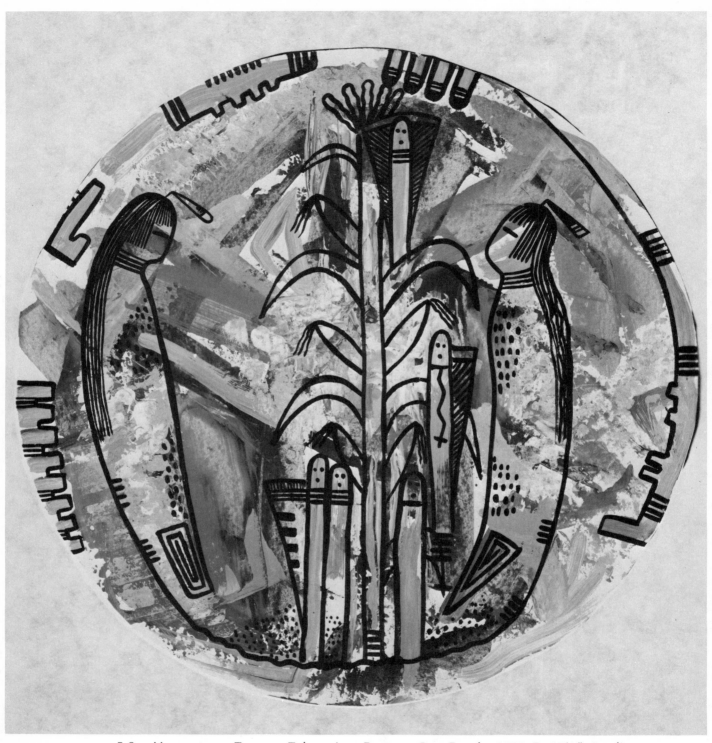

5-8. *Honvantewa–Terrance Talaswaima. Prayer to Corn People. 1975. D. 12¹/₂″. Acrylic. Private Collection.*

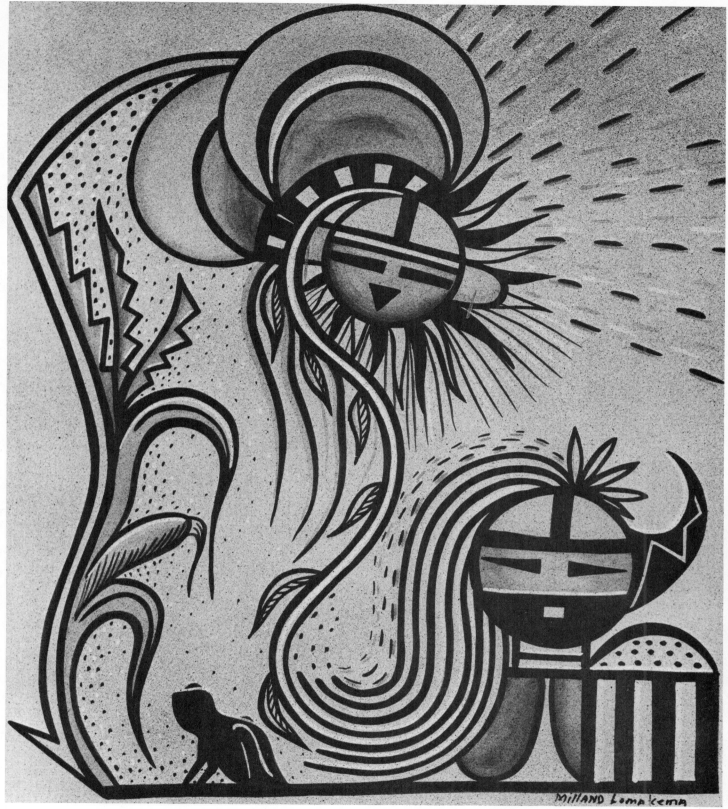

5-9. *Dawakema–Milland Lomakema. Sun and Rain Spirits Over Corn Plants. 1967. 14¹/₂"*
x 12". Casein. Collection: Brian Hunter, Phoenix, Ariz.

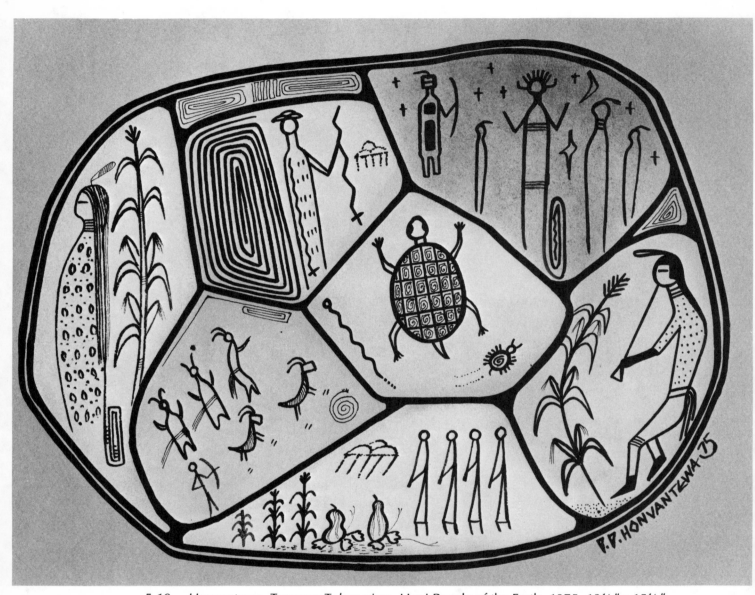

5-10. *Honvantewa–Terrance Talaswaima. Hopi People of the Earth. 1975. 12$^1/_2$" x 15$^1/_4$". Acrylic. Collection: John Cartwright, Santa Fe. N.M.*

In *Hopi People of the Earth* (Fig. 5–10), Terrance Talaswaima uses a combination of his personalized corn symbol and the stylized forms of the petroglyphs to depict the center of the Hopi world, which is populated by ancestral spirits. The pregnant Corn Spirit emphasizes the importance of corn in assuring the survival of the Hopi people. A Rain Spirit, which includes in its body lightning and rain symbols and wears a cloud headdress, stands next to a Migration symbol. The turtle, snake, and insect are Earth Spirits and represent all creatures that crawl on the Earth. At the bottom of the painting are corn and squash plants, which are nourished by the rain and clouds and encouraged in growth by the four flute players, who

5-11. *Honvantewa–Terrance Talaswaima.* Two Hearts Going to Feast. *1973. 19" x 31". Acrylic. Private Collection.*

are symbols of fertility. Another flute player also encourages the growth of the sacred corn. On the top right of the painting are the Kachina Spirits who Talaswaima explains are intermediaries who carry the prayers of the Hopis to the Spirit World. The Migration symbol, which represents the past history of the Hopis, appears in all sectors of the paintings. Once again the composition is contained within a womblike or kiva form. This form emphasizes the theme of regeneration, the power of the Hopi culture to survive and retain its vitality through the ages.

Although animal spirits are not as frequently included in paintings as plant spirits, they are an ever-present part of Hopi life. A Hopi always prepares prayer feathers before he

99

begins to hunt. He prays that the spirit of the animal will forgive him, and explains to the spirit that he is asking the animal to sacrifice its life because it is necessary for the survival of the Hopi people. In *Hopi Warrior Spirit* p. 296 , Mike Kabotie, using the iconography of the Awatovi murals, depicts the spirits of the puma and the eagle as symbols of the Earth and the sky. The puma represents the strength of the physical world and the eagle the power of the heavens. The frog is a water or fertility spirit.

Among the most important Hopi spirits are the Cloud Spirits. The Cloud Spirits or the Cloud People are responsible for sending life-giving rain to the thirsty crops of the desert. Don Talayesva recollects the advice of his uncles and father, which emphasizes the critical role of the Cloud People: "Corn is our mother—the main support of our lives—and only the Cloud People can send rain to make it grow. Put your trust in them. They come from the six directions to examine our hearts. If we are good, they gather above us in cotton masks and white robes and drop rain to quench our thirst and nourish our plants. Rain is what we need most, and when the gods see fit, they can pour it on us. Keep bad thoughts behind you and face the rising sun with a cheerful spirit, as did our ancestors in the days of plenty. Then rain fell on all the land; but in these evil days it falls only on the fields of the faithful. Work hard, keep the ceremonies, live peaceably, and unite your heart with ours so that our messages will reach the Cloud People. Then maybe they will pity us and drop the rains on our own fields."[8]

The Six-Point-Cloud-People are believed to be the Spirits of the Dead which return to the villages with rain. It is their responsibility to bring rain to nourish the crops which will sustain the living. When a Hopi dies, his face is covered with a white-cotton mask with holes for his eyes and mouth. This mask represents the clouds, the form in which the spirit will bring rain upon its return to Earth. Neil David, Sr., includes a Cloud Maiden as the central figure in both *Awatovi Ceremonials* p. 219 , and *Murals of the Kachina Society* p. 218 . In *Spirits of Dead Lifted by Clouds* p. 194 , Delbridge Honanie portrays the Cloud Spirits as they bring rain to the Hopi people. He explains that he sees faces when he looks at the clouds. He sees the faces of the Dead for a second and then they disappear.

In the world of the Hopis, there are evil as well as benevolent spirits. The Two Hearts possess a supernatural power which is a negative power and which may be exercised for malevolent purposes; for example, a Two Heart may delay the time of his or her own death by causing the death of another. A Hopi who is pure in thought and deed and is dedicated to a good life is said to have one heart. The Hopi who has permitted evil to enter his being is said to be of "two hearts." The Hopis are constantly frightened by the existence of Two Hearts in their community and by the possibility that, if evil befalls those around them, they themselves may be possessed by a Two Heart and unknowingly be a malevolent spirit.

In the Fourth World, the first contact of the Hopis with a Two Heart or *Pawaca* was shortly after the Emergence. When the people first emerged, there was neither sickness nor death, for they believed they had left the Two Hearts behind, sealed off in the Underworld. Soon after they emerged, a child of the Chief took sick and died. The Chief in order to identify the Two Heart made a ball of cornmeal and threw it into the air so it might fall on the head of the one with the evil heart. It fell on the head of a young woman who had been one of the last to climb through the Sepapu. The Chief wished to throw her back, but she begged to remain in the Fourth World and told him that his son still lived in the Underworld. The Chief was told to look down in the Underworld and there saw his child playing. The Chief then permitted the Two Heart to remain in the new world, but forbade her to join them on their Migrations. Since this time, the Hopis have had to accept as part of life on Earth the forces of both good and evil.

100

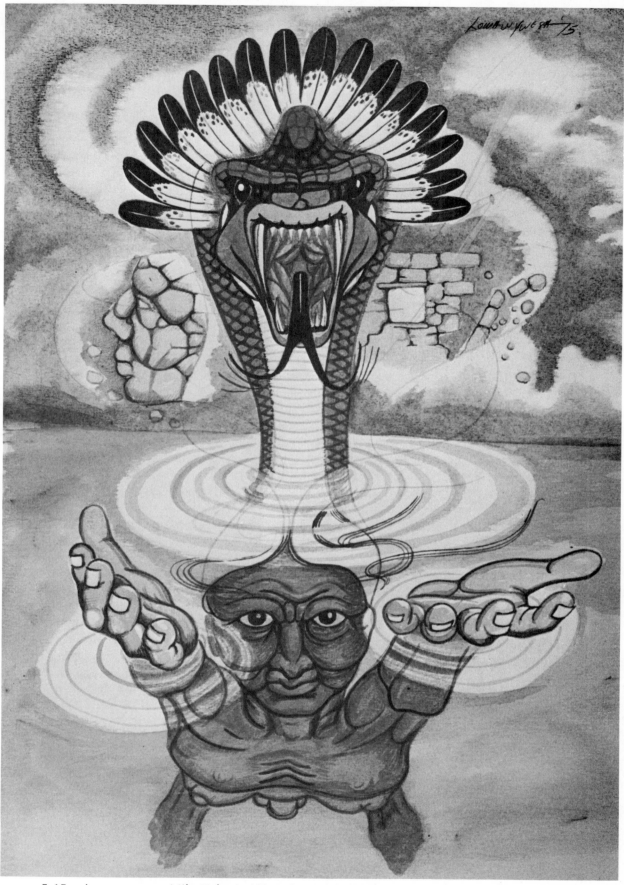

5-15. *Lomawywesa–Mike Kabotie. Water Serpent My Father. 1975. 21¹/₂″ x 14¹/₂″. Acrylic.*
Collection: Hopi Cooperative Arts and Crafts Guild.

There are many Hopi legends of the Two Hearts. Terrance Talaswaima retells a legend of the Two Hearts in a series of three paintings, *Two Hearts Going to a Feast, Two Hearts #2* and *Two Hearts #3* (Fig. 5–11 and 5–12 p. 74, 5–13 p. 75). Many years ago a man in Mishongnovi noticed that his wife was cooking every day but that she never served what she cooked. Several times he awoke at midnight and discovered his wife was gone. One night he decided to follow her, for he suspected that she was a Two Heart. He followed her to a kiva and inside of the kiva all of the people were at a feast. Everyone at the feast was a Two Heart.

The Two Hearts soon traveled from their kiva to a rendezvous point in the North where the witches of all tribes joined together for a great feast. Two Hearts have supernatural powers to change into any kind of animal, and customarily they travel in animal form from their villages to the forest or to their kivas. In the top left section of the first painting, *Two Hearts Going to Feast* (Fig. 5–11), the Two Hearts are starting off from the village. In the next section, a Two Heart meets with an owl, the guardian of witches and a symbol of the Two Hearts. In the upper right section the Two Hearts, transformed into a red-tailed hawk, a swallow, and a fox, are en route to their meeting place in the North. In the bottom left is a Two Heart maiden who offers *piki,* a thin wafer of corn bread, to a Two Heart man who is sprinkling cornmeal. In the center, the male Two Heart smokes over a bowl of cornmeal.

Before they depart for the North, the Two Hearts detect the husband outside the kiva and invite him to join them. They ask him to choose an animal form, and he chooses to travel as a turkey, one of the slowest creatures. In the lower right corner, the husband, transformed into a turkey, stands with the evil spirits before their departure to the North. At the very bottom are representations of food—corn, squash, melon, and beans—that the witches grow in the North. Under the power of the Two Hearts a plant takes only a few hours to grow to maturity. Two Hearts do not have faces; therefore, Talaswaima has covered many of their faces with a spiral, which symbolizes inner turmoil.

In the second painting of the series (Fig. 5–12), the Two Hearts are arriving at the kiva in the North. Some have already returned to human form. A Two Heart maiden serves piki and a Two Heart male smokes and sprinkles cornmeal in a witches' ceremony. All of the background designs are symbols of witchcraft. On the bottom are spirit figures traveling through the forest on their way to the feast.

The husband, in turkey form, arrives late and is very tired. He soon falls asleep, and when he awakes he finds that the Two Hearts have placed him in a crevice at the edge of a cliff. In the third painting (Fig. 5–13), Talaswaima depicts the husband's escape from the crevice. Spider Grandmother knows that the witches are coming to kill the husband; therefore, she makes a prayer feather and places it on his breast. She also gives him a medicine root and tells him to chew it. The witches build a Water Serpent sack and they climb into it. Talaswaima includes in the sack the magic hoops of the witches, which enable them to transform themselves into animals and to return to human form. In this serpent form they intend to crawl into the crevice and push the husband off the cliff.

Spider Grandmother then weaves a web to prevent the husband from falling. He chews the root and blows medicine at the witches; this forces the serpent sack to fall and the Two Hearts to perish. Spider Grandmother then tells a chipmunk to plant a spruce-tree seed, which, with supernatural speed, grows tall enough for the husband to climb down and return to his village.

Talaswaima includes a central section of petroglyph symbols in the lower part of his painting as a biography of the pure Hopi man. He explains that while tied in the crevice, the Hopi thought about his life as a mortal—the planting of his corn, the need for rain, and the

hunting of game during the winter. The husband also thought about the Flute and Kachina ceremonies and the Migrations of the past. The turtle represents the Earth and all of the things that move on the face of the Earth. A good Hopi is content with life as nature has dealt it to him and completely rejects the supernatural powers and temptations of the Two Hearts.

The Snake and Water Serpent deities play a very important role in the religion as well as in the art of the Hopis. The snake is an agent of fertility and, when the snakes are released at the end of the Snake Dance, it is believed that they act as messengers who carry the powers of the Hopis to the Spirit World, so that the spirits might send clouds and rain for the crops. The snake is a Hopi symbol of lightning, because the rapid movement of the snake through the water or across the earth is similar to the movement of lightning across the sky. Lightning signifies the coming of rain, and a field struck by lightning is supposed to be especially fertile.

The Horned Water Serpent is particularly important in Hopi legend. This gigantic serpent presides over all the waters of the Earth. It is believed that under the Earth there is a

5-16. *Lomawywesa–Mike Kabotie. Coming of the Water Serpent. 1974. 31" x 30". Acrylic. Collection: John Cartwright, Santa Fe, N.M.*

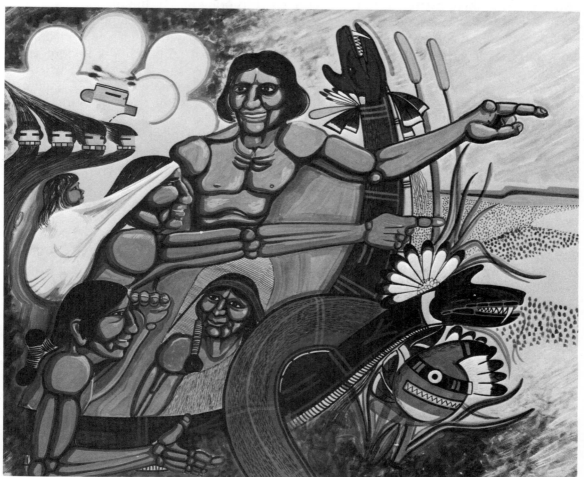

large reservoir of water, and the Horned Serpent is God of these waters and God of floods over the Earth.

One of the most important stories of the Migrations is the account of the destruction of Palotquopi by flood. It is a part of Water Clan history, a story of their migration and arrival at the mesas from the South. The people of Palotquopi had fallen into evil ways and forgotten to resume their migratory paths to the mesas. The Chief, determined to destroy the village, enlisted the help of his nephew (his sister's son, for it is the uncle–nephew relationship, not the father–son relationship, that is of primary importance to the Hopis). On four consecutive nights, the nephew ran around the village with a series of masks within which were coals that glowed with a supernatural brightness and terrified the people. On the fourth night, the nephew was captured by Kochoilaftiyo (the Poker Boy), who is a grandson of the Spider Woman. When the masks were stripped away, the nephew was discovered and he was buried alive with his arm raised, so that his fist with four fingers extended appeared above the ground. Each day another finger disappeared, and on the fourth day the nephew was transformed into a Water Serpent which rose and swayed to and fro in the plaza. The village began to shake as from an earthquake until water poured forth in great floods.[9] The people were forced to leave Palotquopi and resume their journey toward the mesas. When the Water Clan arrived at the mesas, they offered as their contribution to the village of Walpi the power given to them by the Horned Water Serpent to bring rain to the mesas.

Neil David, Sr., uses the Palotquopi legend as inspiration for a painting entitled *The Destruction of Palotquopi* p. 76 . On the top of the painting, the chief's nephew appears with coal fires in his eyes frightening the people around him. On the very bottom of the painting is the Horned Serpent. Above the Serpent, people are dancing, for they have abandoned the religious ceremonies of the kiva. Above the people, the Chiefs gather in prayer. They prepare prayer feathers and smoke as they pray for the deliverance of the people from their evil ways.

Mike Kabotie, a member of the Snow Clan, which is part of the Water Clan, has a strong sense of identity with the Water Clan. Two of his paintings, *Water Serpent My Father* (Fig. 5–15) and *Coming of the Water Serpent* (Fig. 5–16), tell the story of the Palotquopi legend and demonstrate Kabotie's strong identity with the past history of his people. In *Water Serpent My Father,* Kabotie paints the nephew as he is transformed into the Serpent. With the arrival of the Serpent, thunder and lightning shook the earth, causing the houses to fall. Mike explains that the older people who remained behind became part of the rock formation; therefore, he has created a rock profile of a Hopi man.

In *Coming of the Water Serpent,* Kabotie illustrates the arrival of the Hopis at the mesas following the long years of Migration. The cattail, which grows only where water exists, is a symbol of the Water Clan. Mike portrays the Hopis as arriving with three Water Serpents who wear prayer feathers. Three Bearded Kachinas, whose flowing hair and beard represent rain, and a Cloud Spirit who wears a *tablita* (headdress) of East, West, and North clouds, appear above the heads of the Hopis as they reach their destination. The leader of the Water Clan points to their new homeland, the center of the Hopi universe—the flower-covered cliffs. Junipers grow below the mesas. These "cloud-blessed children" bring the serpent cult with them.

Both of Mike Kabotie's paintings of the Water Serpent were inspired by a traditional Hopi poem which tells the story of Palotquopi and expresses the total identification of the cloud-blessed children of the mesas with their migratory ancestors.

"I have come"
The Water Serpent
My father will say,
Rocking Bean Blossom
 Maidens

As storytellers
renew legends
 there.

There below
At legendary southern city of Palotquopi,
standing among Red Cliffs
and swaying and in
the center of the plaza
The Water Serpent
 My father.

To here
He wants
his people
 To emerge

So with beautiful clouds
he blessed them
As Soyal Kachina
Priest of Winter Solstice
stands in front to lead
 cloud-blessed children

Then to here
east to Tokonakai
He leads to plant
 cloud-blessed children

listening below
to Holy Spring of
Muingwa,
 Brother and sister
and blessers of fertility,
blessing their rain
 seasons
Thundering throughout
 the night

Here at Tokonakai
cloud children grow
atop land altars of
 Muingwa
increasing,
 growing and blossoming

among Flower-covered cliffs
As terraced villages.

So like this it is unto here
Blue clouds
Settled as rain

Unto here
White Clouds
settled, as rains
over the land

As frogs
croak their songs
among ponds of
 cloud-blessed children.

For modern Hopi artists and for the majority of Hopis living in the mesa village, the Spirit World has as great an influence on their lives and their art as it had for their ancestors in ancient days.

NOTES

1. Don C. Talayesva, *Sun Chief: The Autobiography of a Hopi Indian,* Leo W. Simmons, ed. (New Haven: Yale University Press, 1963), pp. 17–18.

2. Edmund Nequatewa, *Truth of a Hopi* (Flagstaff, No. 12., Northland Press, 1967), p. 125. This book was originally published in 1936 by the Museum of Northern Arizona as Museum of Northern Arizona Bulletin No. 8.

3. In different legends, the Sun was placed in the sky by Spider Grandmother or the Hurung Whuti.

4. Watson Smith, *Kiva Mural Decorations at Awatovi and Kawaika-a with a Survey of Other Wall Paintings in the Pueblo Southwest* (Cambridge, Mass.: Peabody Museum of American Archeology and Ethnology, Harvard University), p. 180.

5. The representation of the Great Spirit by a giant hand is a familiar element in the painting of Julian Lovato of the Santa Domingo Pueblo.

6. Nequatewa, pp. 133–134.

7. Milland Lomakema. Description written for author, December 1975.

8. Talayesva, p. 224.

9. There are many variations of this legend. In several versions a boy and a girl are sacrificed to the Water Serpent.

CHAPTER 6

The Importance of the Kachinas

Throughout the centuries, the Kachina has been the most important iconographical element of Hopi painting. Many people identify Hopi painting as Kachina painting because until recently most Hopi artists devoted their energies to representations of these masked figures.

The concept of the Kachina is highly complex, for Kachinas exist on at least three levels. On the highest level, Kachinas are important members of the Spirit World, who have a special place in the order of the universe and play a major role in the universal plan of creation. The Kachinas are often thought of as spiritual guardians of the Hopi people, intermediaries who carry the prayers of the Hopis to the Spirit World. The Kachinas are ancestral spirits whose beneficence is necessary for the prosperity of the Hopi people and for the maintenance of order in the Hopi world.

There are hundreds of Kachinas in the Hopi pantheon, and within this pantheon there are great differences in function and in importance. Mike Kabotie occasionally compares the Kachinas with Christian saints. Some Kachinas have been part of the Hopi religion for centuries, while others have appeared with the passing of time. Many Hopis believe that the Kachinas are supernaturals who embody the spirit of living things. For these Hopis, the Kachinas represent the spirits of their ancestors, spirits of rain and clouds, spirits of animals and plants, and of all forms of life in the Hopi world. The word "Kachina" is thought to come from the Hopi word "kachi" which means "life" or "spirit" and "na" which means "father."[1]

The Hopis believe that the home of the Kachinas is the San Francisco Mountains. Many years ago, when the Hopis first came to the mesas, the Kachinas lived within or near the Hopi villages. Whenever they danced, the Hopis enjoyed abundant rain for their crops. In the course of time, the Kachinas moved from the villages to the San Francisco Peaks. There are many legends explaining why the Kachinas left the villages; however, for six months of every year they return to the mesas to dance while the Hopis pray. Milland Lomakema in his painting *Kachina Kivas on San Francisco Peaks* (Fig. 6–1) depicts the life of the Kachinas during the period in which they live away from the mesas. Milland writes: "This one is my

6-1. *Dawakema–Milland Lomakema. Kachina Kivas on San Francisco Peaks. 1973. 36" x 36". Acrylic. Collection: Hopi Cooperative Arts and Crafts Guild.*

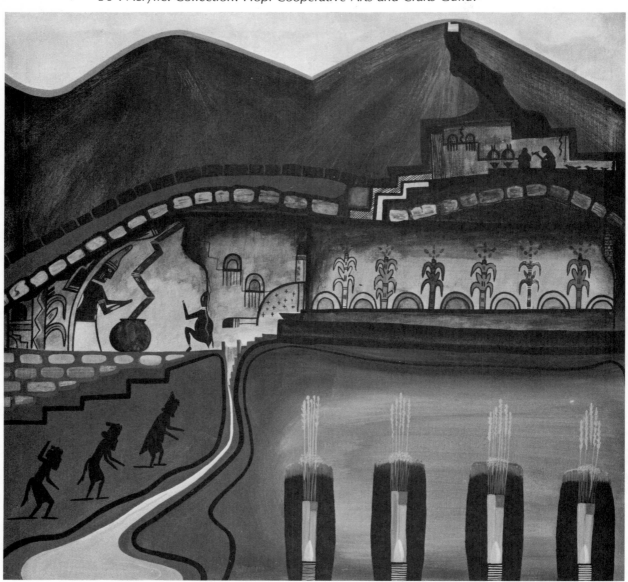

6-15. Dawakema–Milland Lomakema. Symbols of Home Dance. 1974. 24″ x 30″. Acrylic.
Collection: Hopi Cooperative Arts and Crafts Guild.

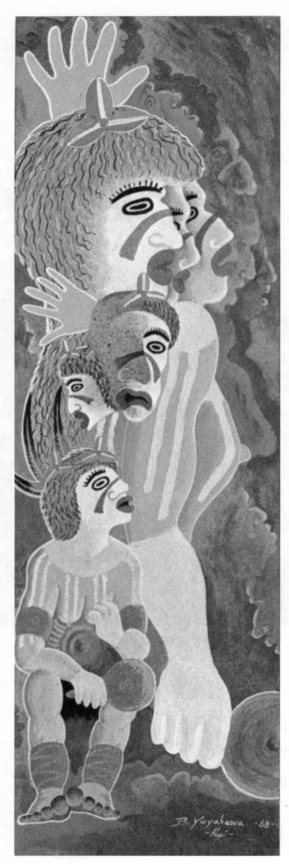

6-9. *Lomaquaftewa–Bevins Yuyahoeva.*
Dreams of Hopi. 1968. 20" x 6". Casein.
Collection: James T. Bialac, Scottsdale, Ariz.

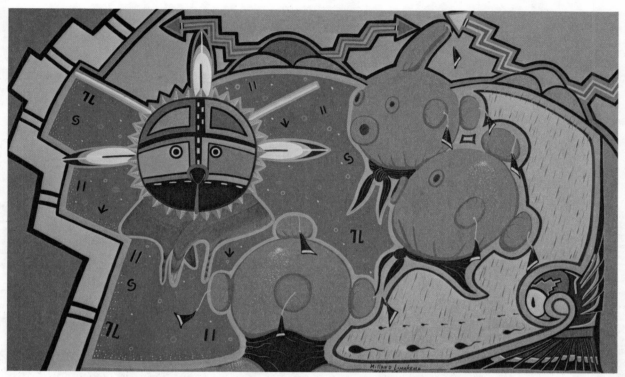

6-28.　*Dawakema–Milland Lomakema. Mudheads. 1968. 20" x 32". Casein. Collection: Byron Harvey, Phoenix, Ariz.*

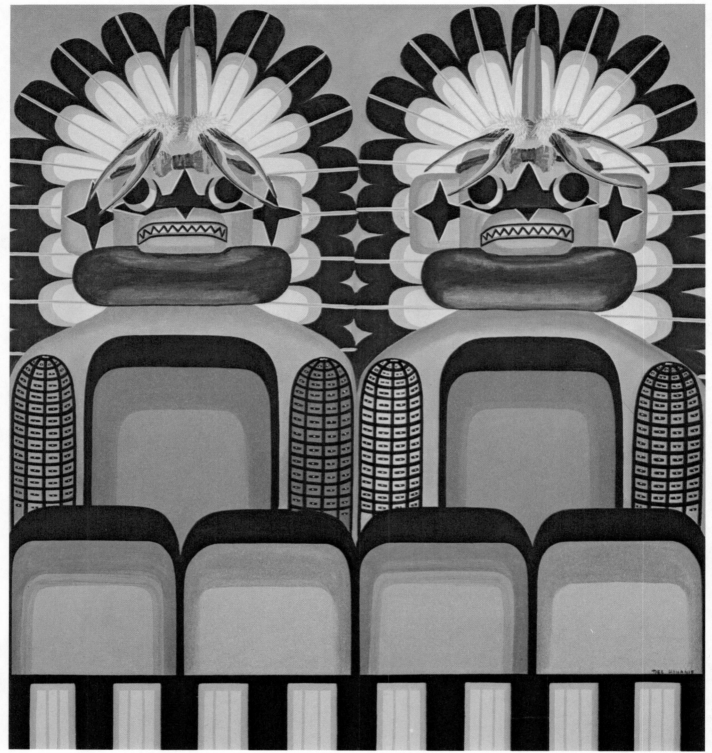

6-23. *Coochsiwukioma–Delbridge Honanie.* Two Uncle Star Kachinas. *1969. 40¹/₂" x 36¹/₄". Casein. Collection: The Heard Museum of Anthropology and Primitive Art (Indian Collection), Phoenix, Ariz.*

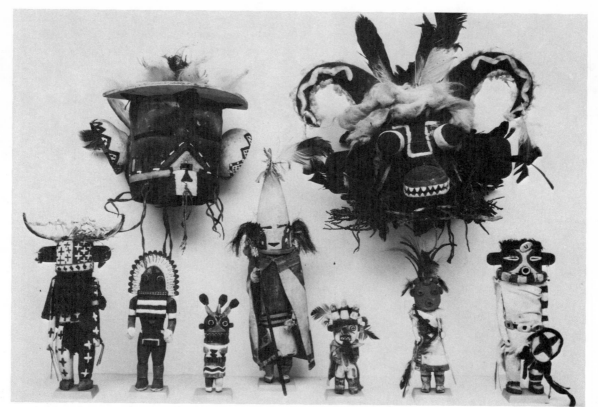

6-2. Two Masks and Kachina Dolls. *1900 to 1920. Tallest 17¹/₂". Collection: Museum of the American Indian, Heye Foundation, New York, N.Y.*

version of the belief that Kachinas live in the San Francisco Peaks in their kivas, and this is the way I thought they might live in these peaks. On their kiva walls are, possibly, mural paintings of certain symbols. In the lower foreground are springs and the prayer feathers which our chiefs have been sending to these peaks."[2] On the walls of the kivas, Milland has painted representations of corn, frogs (fertility symbols), and the War Gods.

On the second level, the Kachinas are masked dancers who participate in rituals during six months of the calendar year. These dancers are priests who, during the time they wear the sacred masks, embody the spirits of the supernatural Kachinas. These dancers have been the principal artistic subject of Hopi artists since early in the twentieth century. On the third level, the term "Kachina" refers to dolls (Fig. 6–2) (Fig. 6–3) ceremonially presented to the children by the Kachina Dancers. As the Hopi children live with the dolls, they learn to recognize the different Kachinas and to differentiate between their costumes. The Kachina dolls are never idols or icons but are educational tools that help the children to understand the ceremonial and ideological functions of the different Kachinas. Kachina dolls have never been considered sacred but are important aids in teaching the young. For centuries the Hopis have carved and painted the Kachina dolls, and today the antique dolls are treasured collectors' items. In the mid-twentieth century, the Hopis continue to carve Kachina dolls (Fig. 6–4). Many have ceremonial and educational value, whereas others are carved specifically for a secular market. These dolls vary in quality from the highest craftsmanship to please discriminating collectors to simple tourist souvenirs. Through the years, very few paintings have been inspired by the Kachina dolls, but Fred Kabotie's painting *Kachina Dolls* (Fig. 6–5) is a rare exception.

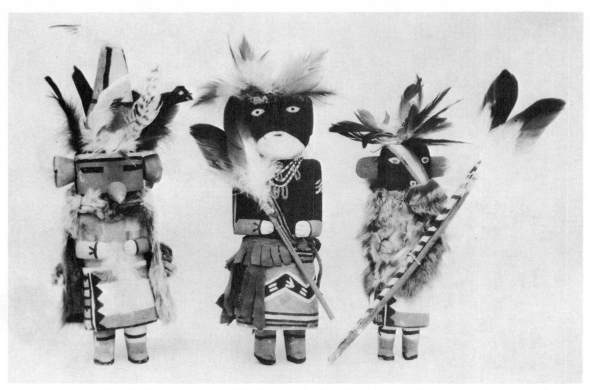

6-3. Kachina Dolls. *1900 to 1920. Center doll 12¹/₄" high. Collection: Museum of the American Indian, Heye Foundation, New York, N.Y.*

The Kachinas have always been a popular subject for Hopi painters. Before the twentieth century, during the time when all art was an integral part of the religious life of the people, the Hopis focused much of their creative energy on the painting of Kachina images. They made the Kachina masks worn in religious ceremonies p. 9 and painted representations of Kachinas on altar cloths and on dance wands p. 10. Kachinas frequently were the central figure of the murals painted on the walls of the kivas.

Kachinas were the subject of the first nonritual paintings, the documentary likenesses commissioned by Jesse Walter Fewkes in 1895 and subsequently published in the U.S. Bureau of Ethnology *Annual Report* 21 as "Hopi Kachinas Drawn by Native Artists." During the early years of the twentieth century, those painters who were sent to the Indian boarding schools and particularly those who were educated at the Santa Fe Indian School by John and Elizabeth DeHuff devoted their full energy to representations of Kachinas and Kachina ceremonies p. 203 . Those Hopi artists who studied with Dorothy Dunn during the 1930s and the generation of Hopi artists who followed in the footsteps of the Dunn studio painters almost exclusively painted Kachina figures and ceremonies (see chapter 1). Both generations of artists painted individual Kachinas in correct costume (Fig. 6–6) (Fig. 6–7) so the Kachina would be readily identifiable. The artists painted lines of Kachina Dancers p. 19 and p. 187 in order to depict different rituals. Many artists painted narratives of Kachina ceremonies including the activities of the clowns. Some artists were so zealous in their desire to illustrate every aspect of the Hopi dances that they even painted scenes that depicted the preparations of the dancers in the kivas. These paintings violated Hopi religious tenets, but the temptation to illustrate every aspect of the Kachina cult was irresistible.

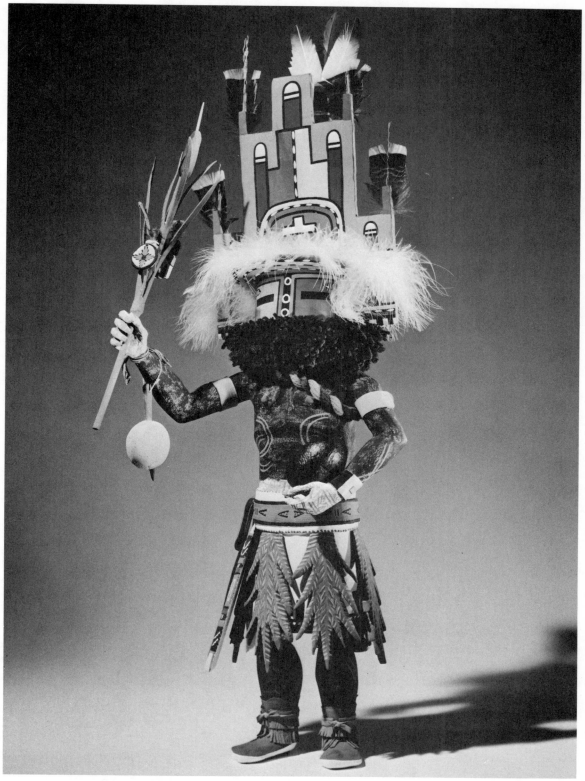

6-4. Hemis Kachina Doll. *1972. H. 34". Photograph. Collection: Museum of the American Indian, Heye Foundation, New York, N.Y.*

FIGURINES OF CORN MAIDENS

TACAB AÑA AND MANA

Tacab Anya and Mana Katchinas. *Bureau of American Ethnology* Annual Report 21, *plate XXVII. Photograph. Collection: Smithsonian Institution, National Anthropological Archives, Bureau of American Ethnology Collection, Washington, D.C.*

Owanozruzro Katchinas. *Bureau of American Ethnology* Annual Report 21, *plate XXXVIII. Photograph. Collection: Smithsonian Institution, National Anthropological Archives, Bureau of American Ethnology Collection, Washington, D.C.*

AÑYA KATCINA MANAS GRINDING CORN

Anya Katchina Manas Grinding Corn. *Bureau of American Ethnology* Annual Report 21, *plate XXXII. Photograph. Collection: Smithsonian Institution, National Anthropological Archives, Bureau of American Ethnology Collection, Washington, D.C.*

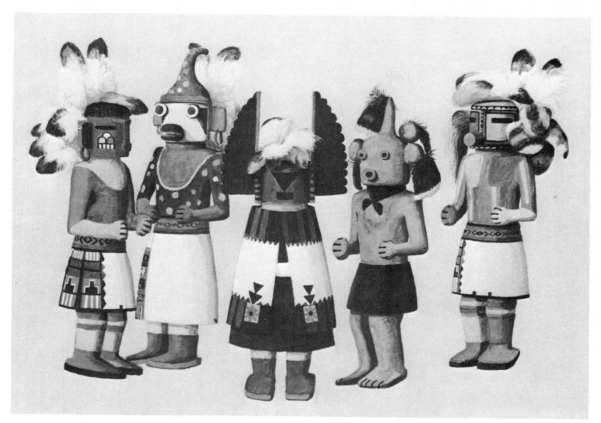

6-5. *Fred Kabotie. Kachina Dolls. c. 1925. 9" x 12". Watercolor. Collection: The Heard Museum of Anthropology and Primitive Art (Indian Collection) Phoenix, Ariz.*

The studio painters were the first Hopis to seek independent recognition and an identity as artists, rather than be content with the sense of well-being earned as members of the community who were participants in tribal rituals. Most of the early documentary artists completed their Kachina paintings while living away from the mesas. The focus of these artists was anthropological and educational. It was these artists who brought the Kachina and Kachina ceremonies to the attention of the white man's world. People soon learned to associate Hopi painting with representations of one or more masked figures. The paintings of these early artists are now in private collections and museums throughout the country. Today a younger generation of artists follows in their footsteps creating an endless succession of paintings of single and multiple Kachinas for the eager public. Many of these paintings of standing Kachina figures and lines of dancers are created for tourists or collectors interested in authentic representations of Hopi life.

The members of the Artist Hopid, in contrast to those who echo the works of the past, see the Kachina as one of the mainstays of Hopi spiritual life and a subject of inexhaustible aesthetic potential. For these contemporary artists, the Kachinas have great importance, because the focus of their art is ideological, spiritual, and aesthetic rather than anthropological and documentary. By painting Kachina figures and masks, they can evoke the spirit of the past, the essence of present-day Hopi life, and the hopes of the Hopis for the future.

119

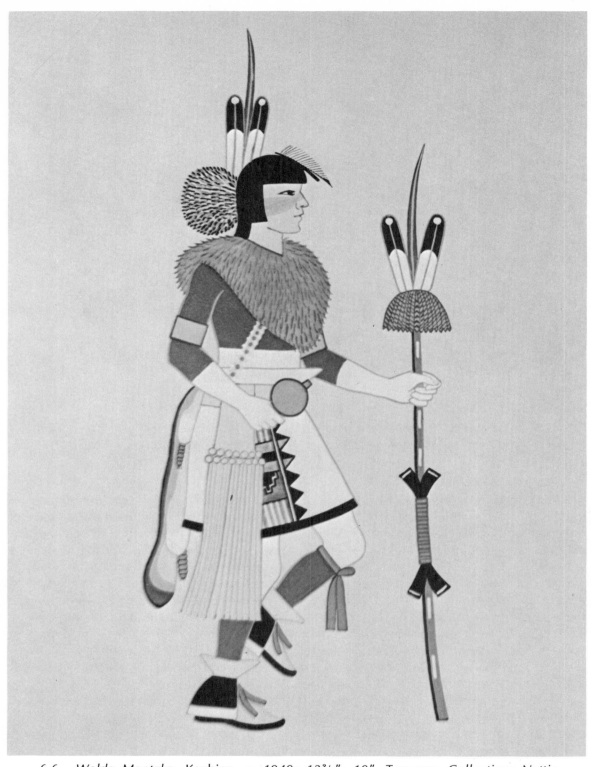

6-6. *Waldo Mootzka. Kachina. c. 1940s 12³/₄"x 10". Tempera. Collection: Nettie Wheeler, Muskogee, Okla.*

Modern Hopi artists utilize several styles in portraying the Kachina figures and masks. The petroglyph style evokes the history of their people and the years of the Migrations. The style of the Awatovi murals emphasizes that the Hopi religious rituals have been able to survive through the centuries. These artists portray particular masked dancers or combinations of dancers in order to suggest the specific powers or duties of the Kachinas. The modern Hopi artists frequently use Kachina figures to represent fertility and germination. One of the

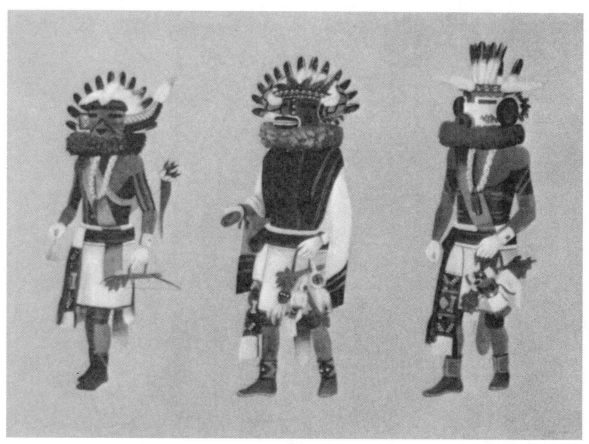

6-7. *Louis Lomayeusa. Kachina. 14" x 20". Collection: James T. Bialac, Scottsdale, Ariz.*

principal functions of the Kachinas is as fertility spirits, for they have powers that influence human and crop reproduction. Kachinas are often thought of as rain spirits, and most of the dances are ceremonies that focus on prayers for rain. The members of the Artist Hopid never violate the sanctity of the Kachinas by illustrating dance preparations or other aspects of the Kachina cult that are taboo to the uninitiated. Their paintings are not intended as educational, anthropological documents, but as expressions of the spirit of the Hopi world.

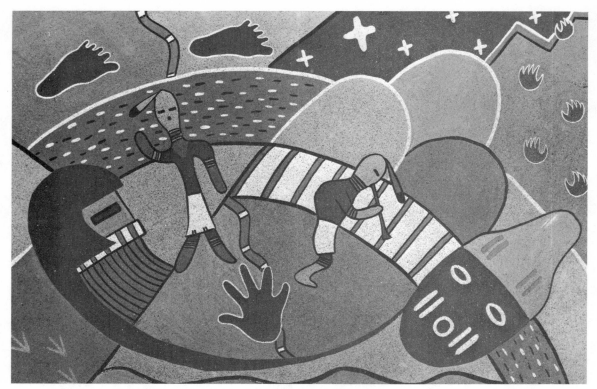

6-8. *Lomawywesa–Mike Kabotie.* Kachina World. *c. 1960. 18¹/₂" x 28". Casein. Collection: Museum of North Arizona, Flagstaff.*

 The members of the Artist Hopid paint all aspects of the Hopi world in which the Kachinas are an integral part. In painting Kachinas, groups of Kachinas, or Kachina masks, they combine and abstract forms and isolate elements of design in order to explore the potential aesthetic value of the Kachina. In one of his earliest paintings, *Kachina World* (Fig. 6–8), Mike Kabotie depicts the whirl of chaos in the minds of the young that is produced by the complex Spirit World of the Hopis. He paints a Bearded Kachina and a Warrior surrounded by clan symbols and symbols of the Migrations in order to create a visible echo of the thoughts of the immature and uninitiated. As in most of Mike's paintings, the symbols of the Water Clan—rain, snow, clouds, and snakes—are an important part of the design structure. He is always conscious of his clan identification and his responsibilities in the Hopi world. The handprint and footprint which symbolize the Bear Clan are central to the composition, for the Bear Clan plays an important role in the lives of all of the Hopi people. The Flute Player, a figure of the Anasazi past and a stylized Hopi, the man of the present, stand in contrast in the center of the painting. These figures represent the continuity of the past and present in the beliefs of the Hopis.

 In *Dreams of Hopi* (Fig. 6–9), p.110, Bevins Yuyahoeva has a compositon in which a Kachina dreams of Kachinas of past centuries. Kachina faces similar to his own loom above his head. Behind the uppermost mask echo countless identical images, as if viewed through a series of infinite mirror reflections. In *Kachina World* (Fig. 6–10), Yuyahoeva has chosen

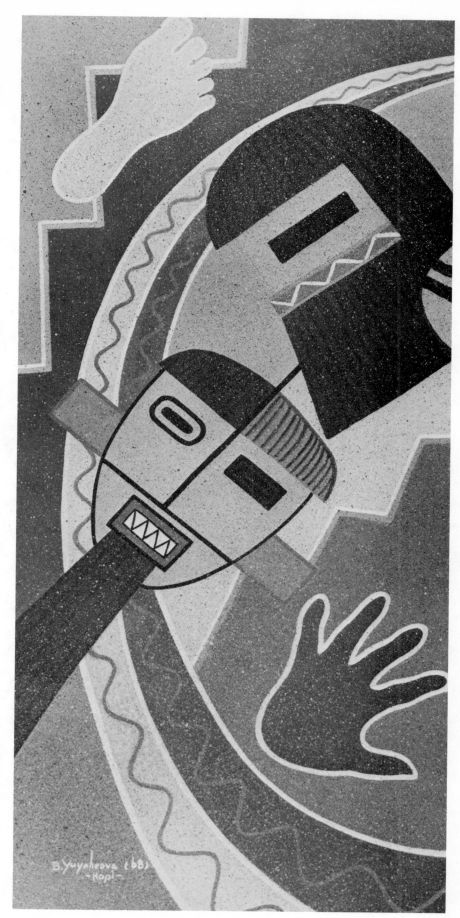

6-10. *Lomaquaftewa–*
Bevins Yuyahoeva.
Kachina World. *1968.*
20" x 9¹/₂". Casein. Gift of Byron
Harvey to The Heard Museum of
Anthropology and Primitive Art
(Indian Collection), Phoenix, Ariz.

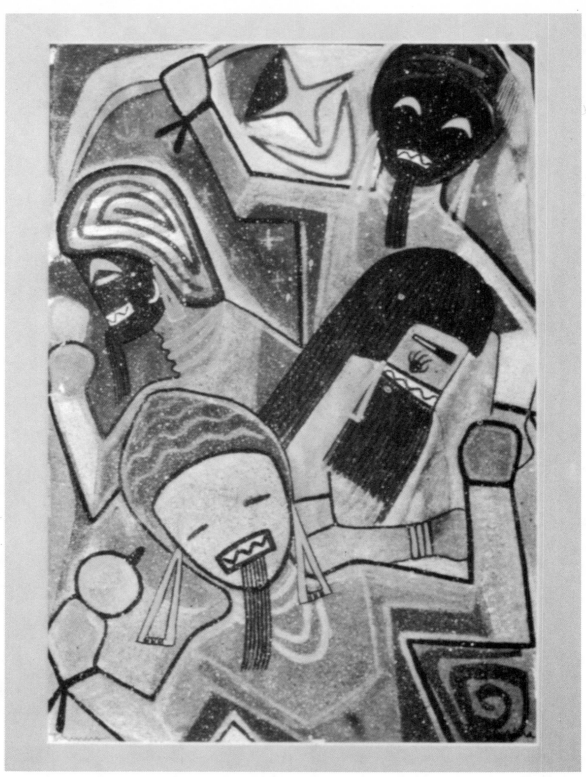

6-11. *Honvantewa–Terrance Talaswaima. Kachinas. 1969. 21¹/₂" x 15". Collection: James T. Bialac, Scottsdale, Ariz.*

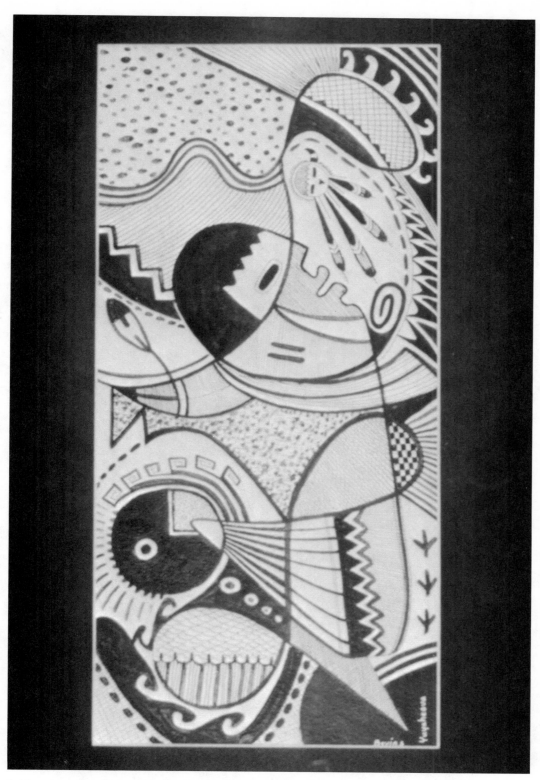

6-12. *Lomaquaftewa–Bevins Yuyahoeva. Hopi Study. 9" x 19". Ink. Collection: James T. Bialac, Scottsdale, Ariz.*

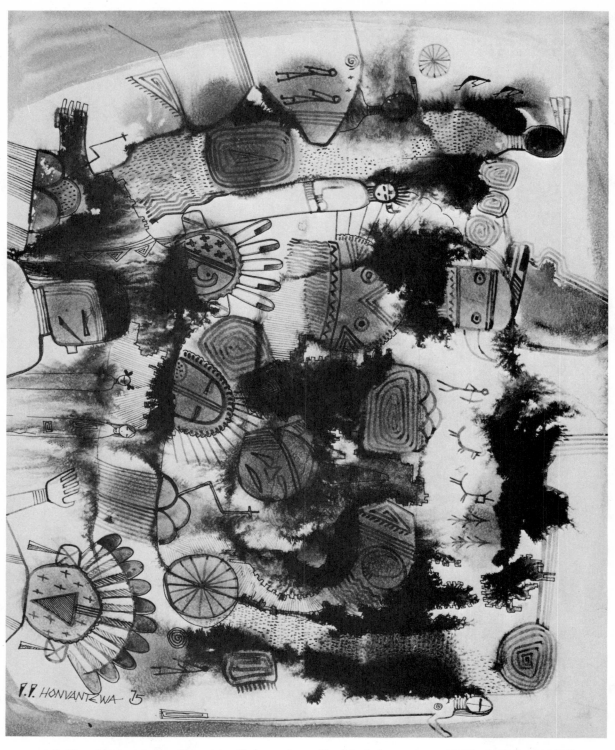

6-13. Honvantewa–Terrance Talaswaima. Kachina Ancestors. 1975. 15¹/₂" x 19¹/₂".
Acrylic. Collection: Hopi Cooperative Arts and Crafts Guild.

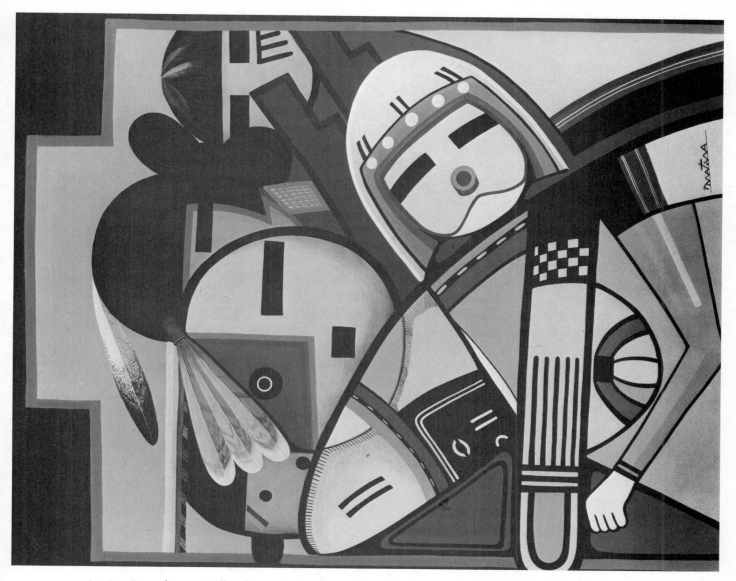

6-14. *Dawakema–Milland Lomakema. Faces of Kachinas. 1974. 30" x 24". Acrylic. Collection: Hopi Cooperative Arts and Crafts Guild.*

two Bearded Kachinas surrounded by symbols of the Bear Clan to represent the rich spiritual heritage of the Hopis.

Many modern compositions have an aesthetic rather than an ideological focus. The masks of the Kachinas are important iconographical elements of modern Hopi art, because the masks not only represent specific Kachinas but have independent aesthetic value. The Kachina masks offer an endless variety of design and form, and the modern Hopi artists utilize a great variety of techniques in painting them. *Kachinas* (Fig. 6–11) by Terrance Talaswaima and *Hopi Study* (Fig. 6–12) by Bevins Yuyahoeva explore the design possibilities of the elaborate Kachina forms. Both artists are at all times aware of their cultural

127

6-16. *Neil David, Sr.* Chief Kachina of Walpi Village. *1973. 20″ x 16″. Acrylic. Private Collection.*

128

heritage, for the Kachinas are surrounded by symbols of the past—clan symbols, footprints, and Migration spirals. In *Kachina Ancestors* (Fig. 6–13), Talaswaima has created a composition of Kachina masks set against a background of petroglyph figures and symbols in order to emphasize the importance of history to the modern Hopis. The artist paints simplified, stylized images reminiscent of the petroglyphs rather than detailed, realistic Kachina masks.

In *Faces of Kachinas* (Fig. 6–14), Milland Lomakema has painted highly complex designs based on Kachina masks which include several Zuni Kachinas and Pokanghoya, the mischievous grandson of Spider Woman.

Lomakema painted *Symbols of the Home Dance* (Fig. 6–15), p.109 after seeing a photograph of industrial plants and highways in a newspaper. The Hemis Kachinas and the Hemis Manas (Maidens) are the principal dancers in the Home Dance, the final Kachina Dance of the ceremonial year (see chapter 8). Corn plants and terraced clouds appear behind the heads of the dancers, like chimneys rising from an industrial complex. On the left of the painting is a Kachina Maiden and on the right side is a profile of a Hemis Kachina.

Chief Kachina of Walpi Village (Fig. 6–16) by Neil David, Sr., is an abstract painting that explores the design potential of two Kachina masks. Neil frequently uses designs from Hopi textiles to enrich his composition. Delbridge Honanie in *Navajo Kachina Faces* (Fig. 6–17) simplifies and abstracts several basic elements of Hopi ceremonial life. The One Horn

6-17. *Coochsiwukioma–Delbridge Honanie. Navajo Kachina Faces. 1975. 15¹/₂" x12". Acrylic. Collection: Hopi Cooperative Arts and Crafts Guild.*

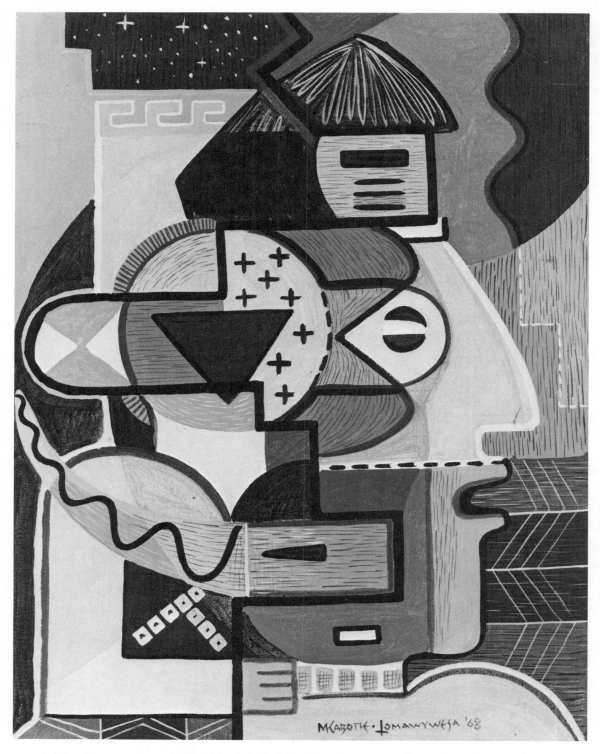

6-18. *Lomawywesa–Mike Kabotie. Kachina Faces. 1968. 24" x 18". Casein. Collection: The Heard Museum of Anthropology and Primitive Art (Indian Collection), Phoenix, Ariz.*

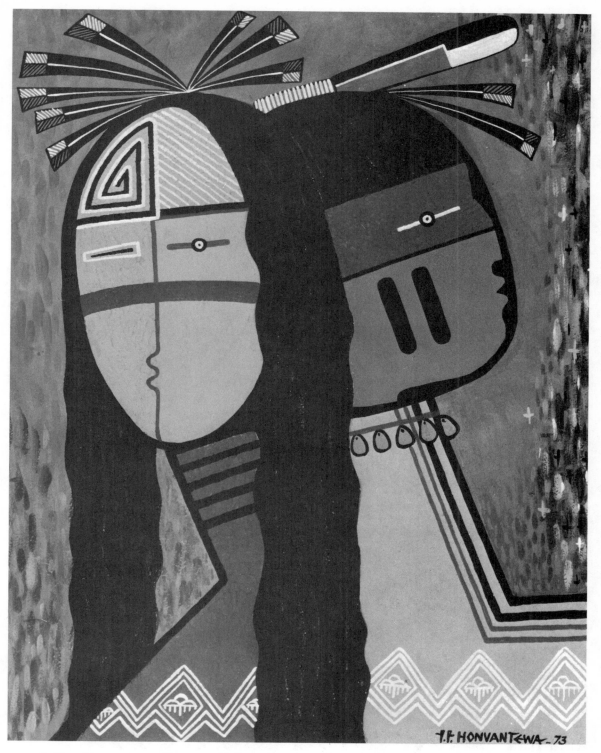

6-19. Honvantewa–Terrance Talaswaima. Impersonation. 1973. 19" x 15". Acrylic. Col-
lection: John Cartwright, Santa Fe, N.M.

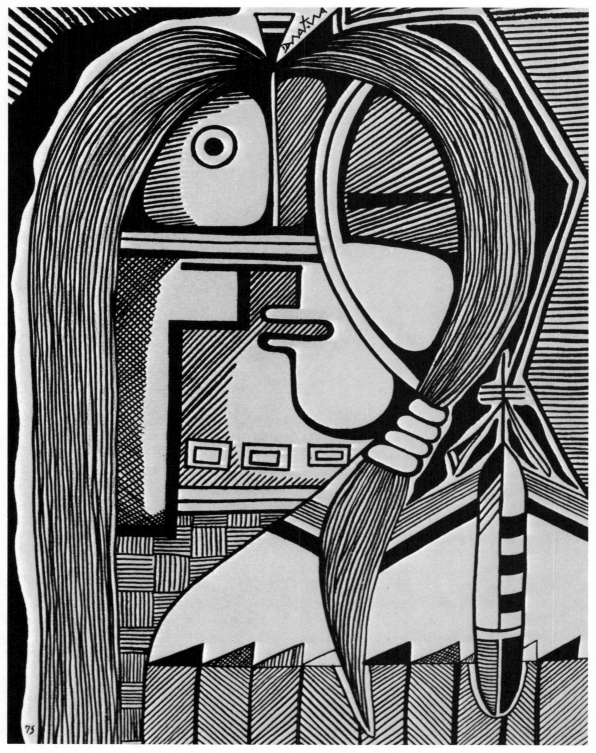

6-20. Dawakema–Milland Lomakema. Dance Maiden and Mask. 1975. 12″ x 19″. Ink.
Collection: Hopi Cooperative Arts and Crafts Guild.

Kachina faces the viewer and the Bearded Kachina appears in profile on the right of the corn stalk. Both masks are Hopi representations of Navajo spirits. As these Kachinas appear in corn dances, Honanie feels that the cornstalk is central to their identity. Cattails, which are rain symbols, surround the masks. They are used as pouches during the ceremonies and given to the children as gifts. The rocks of the mesas serve as a border to the composition.

Kachina Faces (Fig. 6–18) by Mike Kabotie is a Cubist composition of Kachina masks. Mike portrays the Long-Haired Kachina who represents rain, the One Horn Kachina, Ahula the Germinator, and a Mayan profile against the background of water symbols. Mike includes design elements from Kachina costumes. The Mayan profile of the Hopi has several levels of significance in this work. Kabotie identifies with the Mayans as ancestors who failed to complete their Migrations. Mike is conscious of the dual identity of the Kachinas, for they represent spirits of the supernatural world yet are personified by men from the world of the living. This duality of man and mask, the contrast and fusion of the living Hopi Priests with the Kachina Spirits, is a central theme of many modern Hopi paintings.

In *Impersonation* (Fig. 6–19), Terrance Talaswaima has painted two contingent portraits of a Hopi man and a Warrior Kachina. The Hopi wears a prayer feather and a Migration symbol is on his forehead. The Kachina Spirit is a part of the Hopi psyche as the Migrations are an important part of the history of the Hopis. Rain and cloud symbols and textile designs decorate the costumes of both man and Priest, for both are integral parts of the same ideological and cultural heritage.

Milland Lomakema uses the theme of man and mask in his painting *Dance Maiden and Mask* (Fig. 6–20). He is clearly influenced by the work of Picasso. In this composition the Maiden and the Kachina appear as a single frontal form, yet each figure when viewed in profile retains a separate identity. Within the composition are prayer feathers and design elements of basket weaving and textiles.

In *Chaquina II* (Fig. 6–21), Lomakema portrays back-to-back the mask of the Kachina and the profile of the man who wears the mask. The eagle feather represents the power of this Kachina and the star signifies that the dance is often held at night. A basket-weave pattern forms the background. *Kachina Lovers* (Fig. 6–22) by Mike Kabotie is another variation on the theme of the dual identity of the Kachina. Mike emphasizes that although the Kachina is revered by all of the Hopis, the Kachina also has a human side. In this painting Kabotie portrays a Kachina who has fallen in love with a Hopi woman, a theme often found in Hopi legends.

Modern Hopi artists frequently select a specific Kachina or two Kachinas as the subject of their painting. These paintings, however, stand in sharp contrast to the work of the past, in which the artists' objective was a documentary painting which identified the Kachina and facilitated the recognition of that Kachina. Modern Hopi artists seek to express through symbols the role and spirit of the Kachina, and to explore the aesthetic potential of the design elements of the individual Kachina. In *Two Uncle Star Kachinas* (Fig. 6–23), p. 112 Delbridge Honanie depicts the Star Priests who appear in the Mixed Kachina Dance. During the ceremonies, these Kachinas dance in the center while the other Kachinas dance around them. Geometric stylized cloud forms and small rectangles of rain decorate the lower portion of the painting. Honanie emphasizes the role of these Kachinas by painting cloud forms and corn as part of their bodies.

Milland Lomakema frequently paints specific Kachinas and the symbols of these Kachinas purely for their decorative or compositional value. *Female Warrior* (Fig. 6–24) depicts the Kachina who dances in the front in the Chaquina Dance. *Chaquina I* (Fig. 6–25),

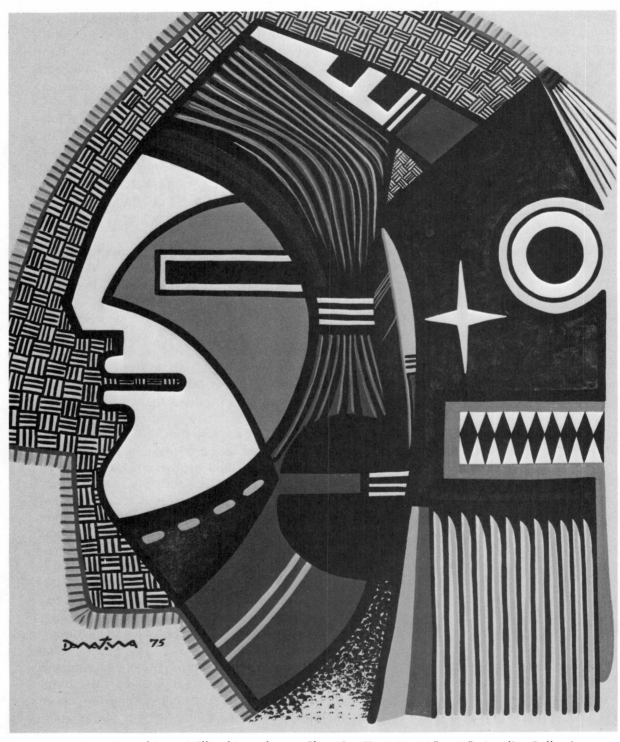

6-21. *Dawakema–Milland Lomakema. Chaquina II. 1975. 20" x 16". Acrylic. Collection:*
Hopi Cooperative Arts and Crafts Guild.

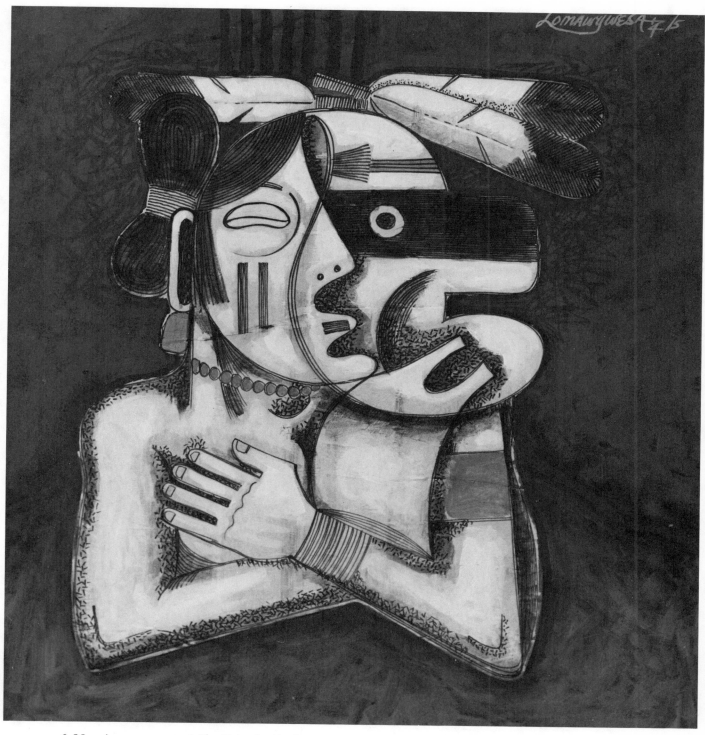

6-22. *Lomawywesa–Mike Kabotie. Kachina Lovers. 1974. 27" x 26". Mixed media. Collection: Hopi Arts and Crafts Guild.*

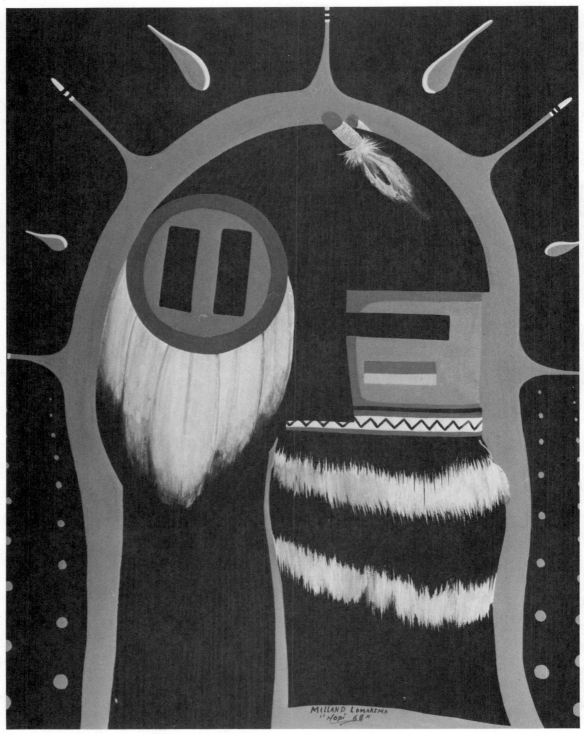

6-24. *Dawakema–Milland Lomakema. Female Warrior. 1968. 20" x 16". Casein. Collection: The Heard Museum of Anthropology and Primitive Art (Indian Collection), Phoenix, Ariz.*

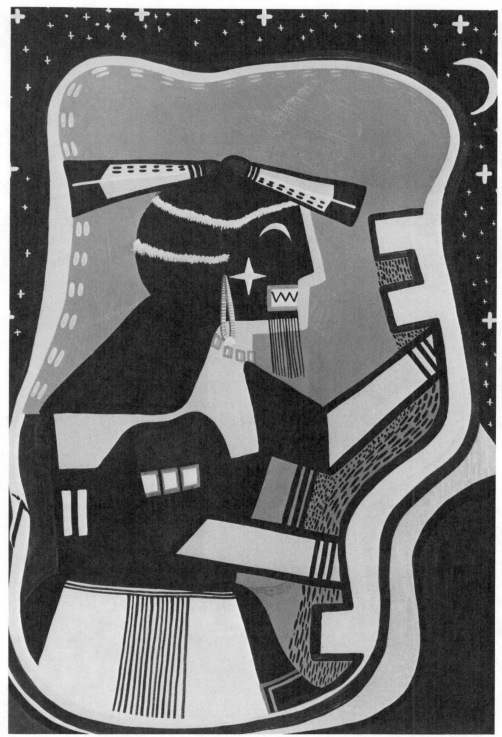

6-25. *Dawakema–Milland Lomakema. Chaquina I. 1974. 23" x 15". Acrylic. Collection:
Mr. and Mrs. Stanley Jacobs, West Orange, N.J.*

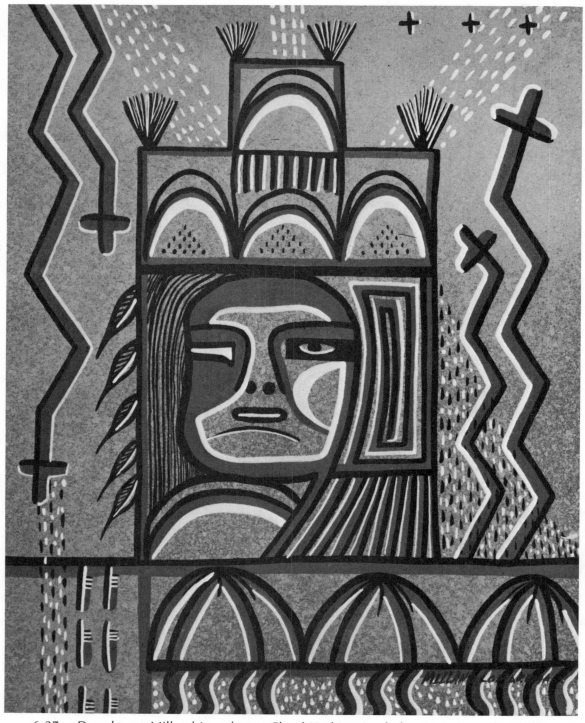

6-27. *Dawakema–Milland Lomakema. Cloud Kachina Symbol. c. 1970. Acrylic. Collection: Museum of Northern Arizona, Flagstaff*

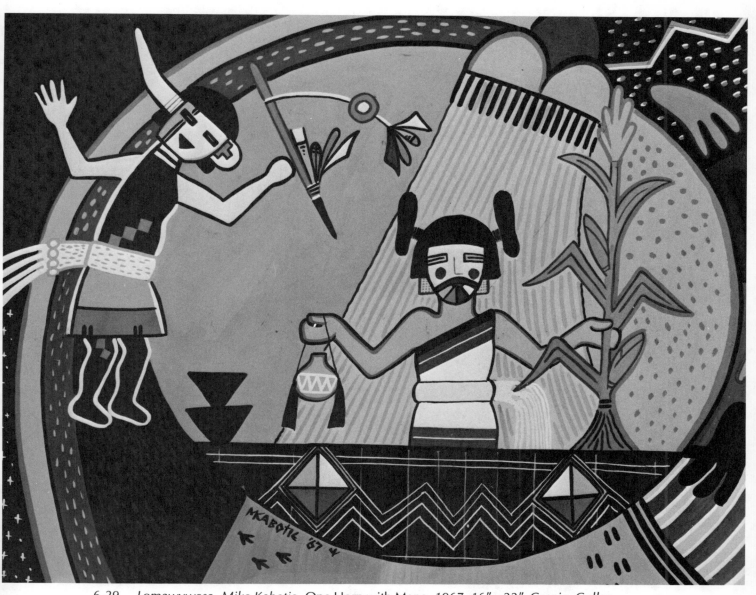

6-29. Lomawywesa—Mike Kabotie. One Horn with Mana. 1967. 16″ x 22″. Casein. Collection: Hopi Cooperative Arts and Crafts Guild.

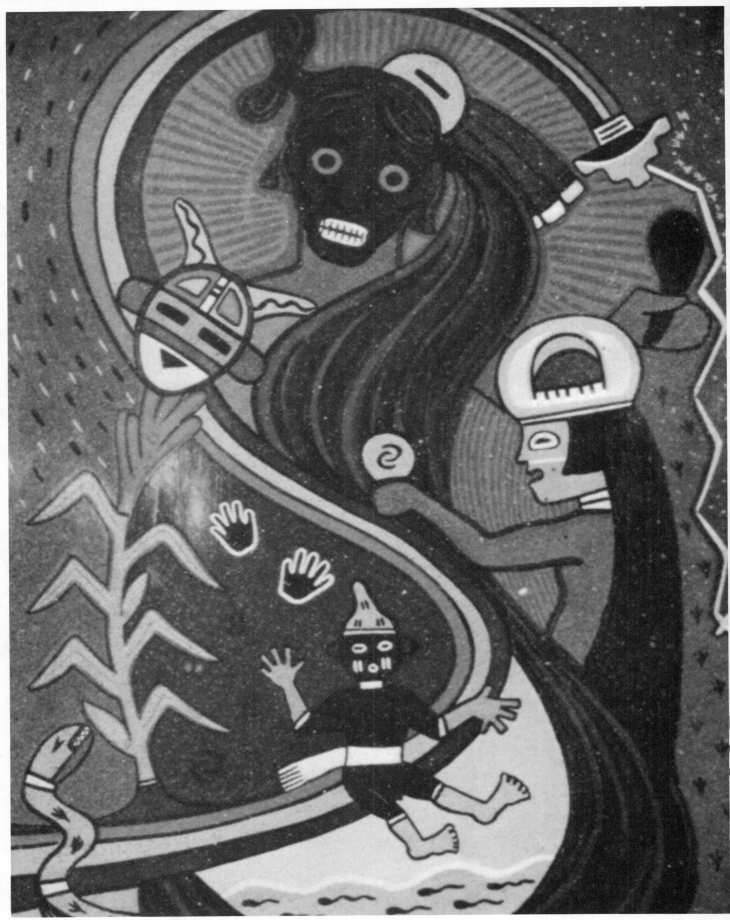

6-30. *Lomawywesa–Mike Kabotie. Hehe. 1967. 22" x 16". Casein. Collection: James T. Bialac, Scottsdale, Ariz.*

a First Mesa Kachina who is a participant in Night Dances, is also a warrior and a symbol of the Chaquina Clan. Parallel lines, which symbolize the Warrior, decorate the headdress. In *Long-Hair Kachina and Rainbow,* (Fig. 6–26), p. 145, which is one of his earliest paintings, the figure of the Rain Kachina fuses with the rainbow and the cornstalk in a decorative expression of the germination theme. The prayer feather and lightning emphasize the spiritual powers of this Kachina. In another early painting, *Cloud Kachina Symbol* (Fig. 6–27), the artist explores the design potential of the Cloud Kachina. Lomakema decorates the costumes of this Kachina with all of the symbols of rain and germination. *Mud Heads* (Fig. 6–28), p. 111, is a successful composition of Hopi Kachina figures. In this painting Lomakema portrays the Mud Heads teasing the Wopumuk Kachina. The Mud Heads act as guards at the Bean Ceremony. They represent fertility and are surrounded by fertility symbols—tadpoles, clouds, and lightning—and markings from Kachina costumes.

Mike Kabotie's paintings are frequently ideologically complex. In *One Horn with Mana* (Fig. 6–29), Mike paints a Kachina that was originally part of the Zuni spirit world but was adopted by the Hopis and today is an important Hopi Kachina. In the center of the composition is the Mana, the Kachina Maiden, wearing a squash blossom or whorl hairdo. In her right hand is a quart of sacred water which is bordered by prayer feathers. In her left hand, she holds a stalk of corn. Mike explains that as she meditates she is blessed by rain. She stands in the center of the land within a circle which represents "the Circle of Life." The corn germinates life and the rainbow surrounds the Circle of Life. The One Horn Priest wearing a sacred rain sash prays for light. He is painted in the sacred colors worn by the priests. Mike includes deer, rabbit, and bird tracks, symbols of all forms of life in the Hopi world, and a variety of water symbols. In *Hehe* (Fig. 6–30), Mike portrays the all-powerful Kachina Warrior Maiden, Hehe, who was the savior of the Hopis. Hehe was having her hair arranged in whorls when the enemy attacked. Immediately she went out to fight and single-handed turned the enemies back. She is always shown with a single whorl and the other half of her hair flowing. She is important as a rain and fertility Kachina; therefore, Mike has included a rainbow, a Water Serpent, and other water symbols in his composition. He also includes Pokanghoya, a Rain Priest, and Muingwa, the Germinator, blessing the seeds.

The Kachinas are essential to Hopi paintings as they are to Hopi life, because the Kachina world is in many ways a microcosm of the Hopi world. The Kachinas work grinding corn, engage in athletic competition, participate in the rites of procreation, and dance for rain, fertility, and germination. They act as disciplinary figures and are disciplined in turn. The Kachinas are uppermost in the minds of the Hopis for they are ever-present on many levels of existence. Of all of the spirits in the universe, the Kachinas have an immediacy which pervades every area of Hopi life. The Kachina Dancers remain with the Hopis six months of every year, and every Hopi living on the mesas attends many dances, for the Kachina Dances are among the principal rituals of the ceremonial year (see chapter 7). Kachina dolls are given to the children and are a cherished possession of every household. The modern Hopi artists paint the Kachinas in order to visually express the essence of the Hopi world.

NOTES

1. Frederick J. Dockstader, *The Kachina and the White Man* (Bloomfield Hills, Mich.: Cranbrook Institute of Science, 1954), p. 9.

2. Milland Lomakema, description written for the author, December 1975.

CHAPTER 7

The Hopi Ceremonial Year

The Hopi ceremonial year determines the course of life in the Hopi world. The rituals of the ceremonial year follow a continuous rhythmic cycle and are the focus of all religious and secular life. In the Hopi world, religious and secular life are inextricably fused in order to follow the Path of Life determined by the Creator. It is only by following this divinely ordered Path of Life that the Hopis may aspire to universal progress. The sequence of rituals in the ceremonial year is part of the fixed order of the universe and to disturb this sequence, to advance or postpone a ceremony, would disrupt universal harmony.

Every ritualistic detail must be observed at a precise time, which is determined by solar or lunar observance, and all rituals must be enacted with absolute perfection of every detail. It is a necessity that all Hopis be pure of heart and body during the time when they participate in the sacred rituals. They are expected to observe sexual continence and abstain from salt for at least four days before the beginning of each ceremony and for at least four days following the conclusion of the ceremony. The Hopis believe that it is only through understanding and following the sacred order of the universe that it is possible to survive and prosper on Earth.

The sequence of rituals in the cycle and the laws for observing these rituals have followed the same basic pattern for centuries. During the years following the Migrations, when the clans first arrived at the mesa villages, many of the clans offered new ceremonies as their contribution to the tribal welfare. The Bear Clan leader determined whether to accept the newcomers and whether it would benefit the Hopis to incorporate the new clan's

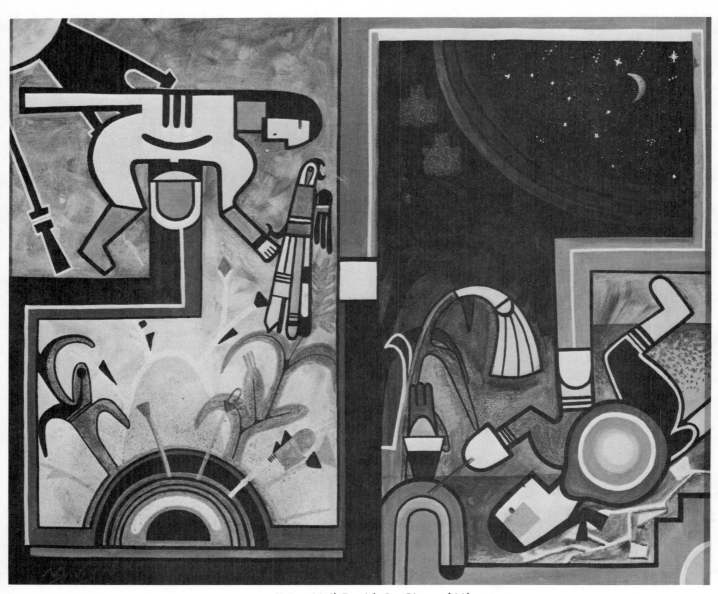

7-1. *Neil David,* Sr. Giver of Life.

144

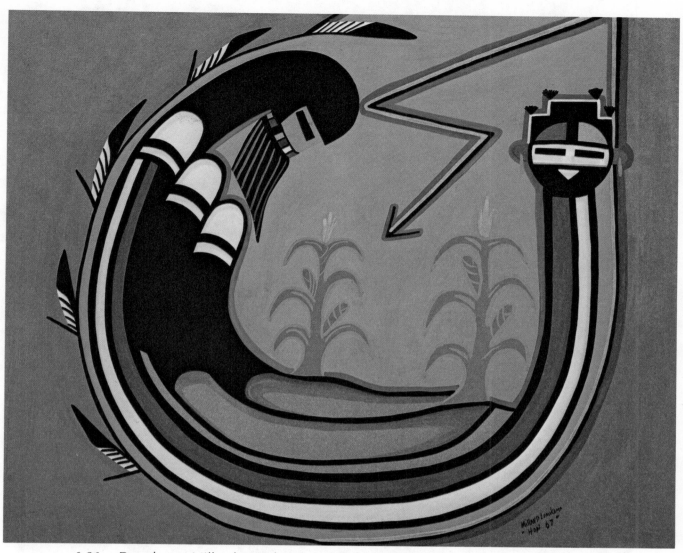

6-26. *Dawakema–Milland Lomakema. Long-Hair Kachina and Rainbow. 1967. Gift of Byron Harvey to The Heard Museum of Anthropology and Primitive Art (Indian Collection), Phoenix, Ariz.*

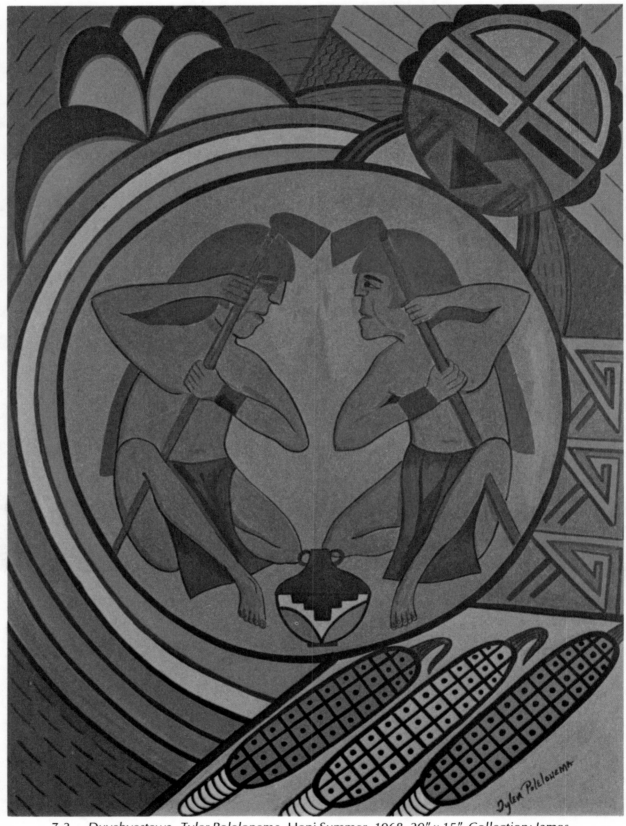

7-2. *Duvehyestewa–Tyler Polelonema. Hopi Summer. 1968. 20" x 15". Collection: James T. Bialac, Scottsdale, Ariz.*

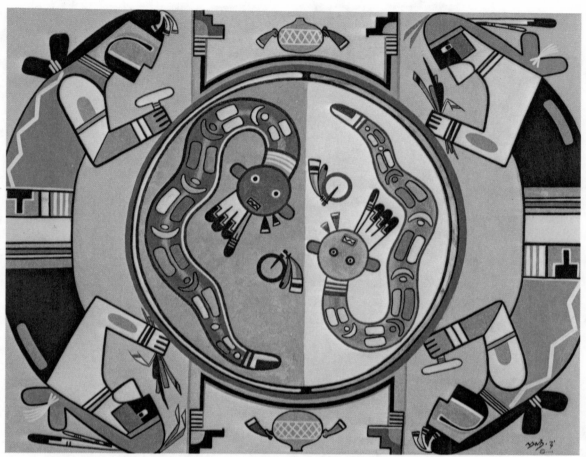

7-7. *Neil David, Sr. Awatovi Snake Society. 1974. 24" x 30". Acrylic. Collection: Hopi Cooperative Arts and Crafts Guild.*

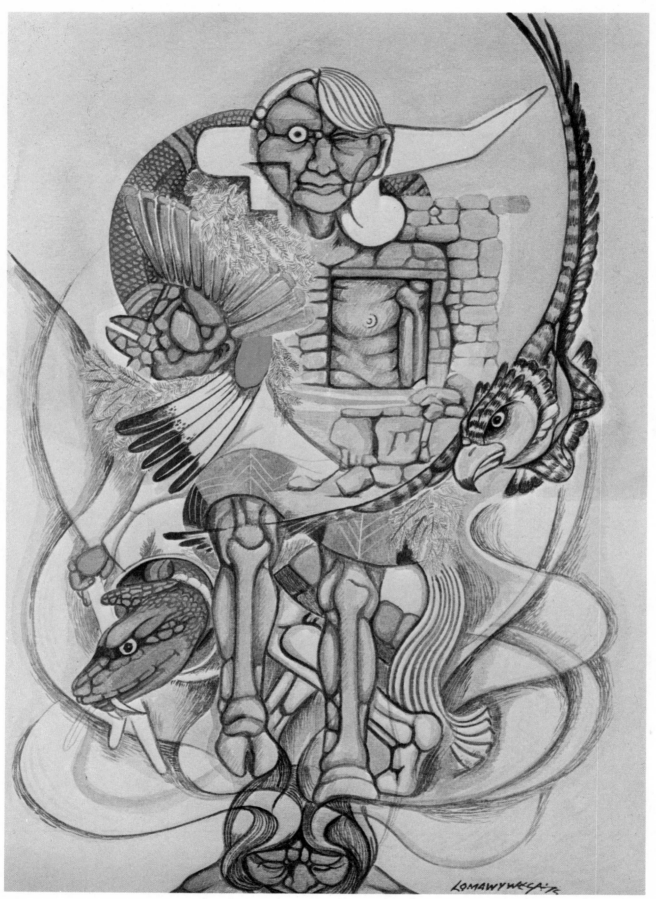

12-5. *Lomawywesa–Mike Kabotie. A Hopi Dream. 1975. 21" x 15". Acrylic. Collection: Hopi Cooperative Arts and Crafts Guild.*

rituals into the ceremonial year. With the passing of time, great differences evolved in the forms of observance, for different clans settled in different villages and each clan brought unique ritualistic contributions. Today each village does not observe every event of the ceremonial year and there are great variations in those ceremonies that are observed.

All of Hopi life is part of a rhythmic cycle of generation, growth, and regeneration. The Hopis believe that within the seed is stored the generative power and strength for renewed life. Each harvest provides the seed for the next cycle of germination. During winter, a time when there is little work in the fields, there are many sacred ceremonies which are necessary for the procreation of life on Earth. This period of dormancy is of particular importance for religious rituals, because prayers and the preparation of prayer feathers and dances during this period have a great influence on the potential strength of the new crops.

The Hopis believe that the Underworld is a negative image of the Earth. During the period after the summer solstice, when the sun moves away from the Earth and it is winter in the land of the Hopis, in the Underworld it is summer and there the plants are alive. Similarly, during the nights when the sun has set, having completed its journey from east to west over the land of the Hopis, the sun travels its course from west to east over the Underworld. *Giver of Life* (Fig. 7–1) by Neil David, Sr., illustrates this belief in the continuous germination of crops during winter and night. Neil divides his painting into light and dark halves in order to illustrate the concepts of the rotation of the world, winter and summer, day and night. Muingwa, the Germination God, keeps the plants alive in the Underworld as he sustains them and causes them to grow on Earth.

The ceremonial cycle of the year is determined by the rhythm of the seasons. The basis of the ceremonial cycle is the sustenance of life on Earth; therefore, ceremonies follow the pattern of fertilization–germination–growth–harvest–regeneration. Many of the most sacred prayers are prayers for water, for in the harsh desert land of northern Arizona, snow during the winter and rainfall during the spring and summer are primary necessities for the germination of seed, which begins the cycle of life on Earth each spring. Until the mid-twentieth century, the corn harvest was the principal support of all life in the Hopi world. Summer rains were of critical importance, for if the rains did not come, the Hopis were forced to wait another year to grow food.

For the Hopis, summer is the period during which the sun journeys toward the Earth. This time of germination and the growth of all life on Earth has become a favorite subject of modern Hopi painters. In *Hopi Summer* (Fig. 7–2), Tyler Polelonema places two Hopis within the circle of the Earth, which is surrounded by symbolic representations of the rainbow, clouds, the sun, water, and corn. Men carry the planting sticks that the Hopis have used through the ages in their method of deep planting which is necessary for the germination of seeds in the arid world of the mesas. Between the Hopis is the sacred water jar, the symbol of continued life on Earth.

Bevins Yuyahoeva's painting *Hopi Summer* (Fig. 7–3), like Polelonema's is composed of symbols of water and the germination of life. Abstract images of the Sun Kachina, the Bearded Kachina, the One Horn Kachina, Migration spirals, prayer sticks, and water symbols represent the rituals of summer which have survived through the centuries and are fused into this intricate celebration of summer. In *Frog, Sun, Flute Player, and Bird* (Fig. 7–4), Milland Lomakema utilizes ancient fertility symbols to express his vision of the germination of life during the summer months. The sweep of curvilinear forms unify his design and give this work tremendous vitality and a sense of the creative forces of life.

149

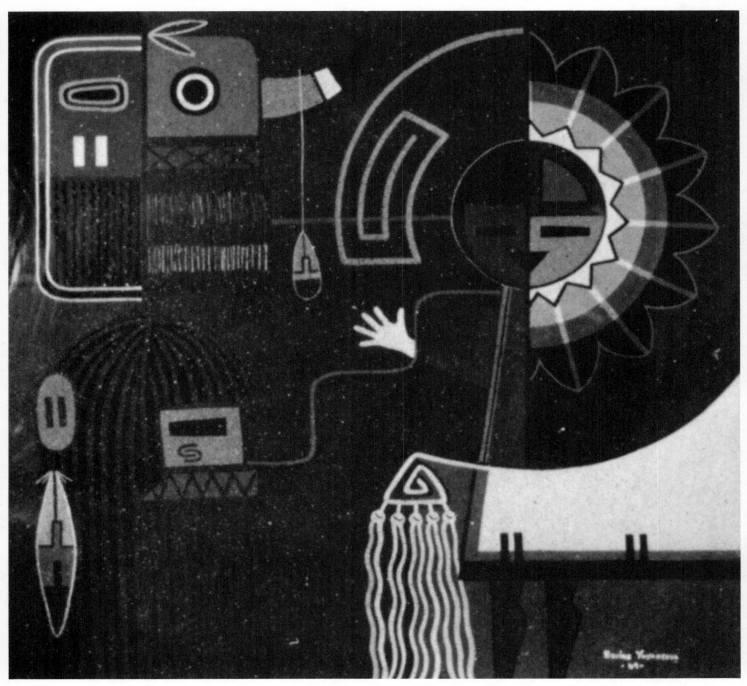

7-3. *Lomaquaftewa—Bevins Yuyahoeva. Hopi Summer. 1969. 18" x 18¹/₂". Collection: James T. Bialac, Scottsdale, Ariz.*

White civilization and industry have changed the Hopi world in countless ways, and the survival of the people is no longer dependent upon rain and the success of the crops. The reaction to these changes is reflected in the changes in the ceremonial cycle on all three mesas. Some villages have remained close to tradition and have retained most of their sacred rituals while others have abandoned many of the ancient ceremonies. In modern Hopi art, however, the Hopi ceremonial cycle is an all-powerful force. The basic beliefs of the Hopis in the continuity of life and in the power of the spiritual forces of the universe have remained unchanged through the centuries. Today Hopi artists utilize the traditional ceremonies in order to declare their faith in the Hopi Way and to celebrate the powers of endurance and the vitality and the spiritual and physical regeneration of life in the Hopi world.

The most comprehensive artistic statement of the cycle of Hopi religious life is *The Hopi Ceremonial Calendar* (Fig. 7–5), a 274-square-foot mural, which is in the Hopi Cultural Center on Second Mesa. The mural was painted by Mike Kabotie, Milland Lomakema, Delbridge Honanie, and Neil David, Sr. The dedication of the mural proclaims the strength of the Hopi faith in the Hopi Way of Life:

> This mural was painted in reverence and in homage to HOPI:
> A life force and philosophy that nurtured and gave strength to countless generations of HOPI PEOPLE.
> A way of life, time tested by the forces of Mother Nature for eons; survived and matured.
> A concept so deep that deliberate attempts by gold and soul hungry ideologies to unroot it have failed.
> A spiritual outlook so strong, that despite the hardships, it prays for all living beings to have fulfilling lives,
> And those beautiful souls that live its teachings, and guide it,
> The HOPI PEOPLE
> So with the greatest honor and respect, members of ARTIST HOPID dedicate the HOPI CEREMONIAL CALENDAR to the HOPI PEOPLE and all living beings.
> ARTIST HOPID[1]

Mike Kabotie, spokesman for the Artist Hopid, outlines the basic structure of the mural:

> *The Hopi Ceremonial Calendar* depicts the Hopi ceremonial cycle based on the moon cycle. The mural is painted in the traditional (ca. A.D. 900 to 1400) Hopi mural style, flat, two-dimensional, and using earth colors. This style was used in painting kiva frescos long before the coming of Columbus and the Bahana.
> The background colors of the mural represent the colors of the four directions; yellow for the north, green or blue for the west, red for the south, and white for the east. Surrounding the mural is a rainbow rising from the oceans, which cover much of the earth. Against this background are painted the moons, represented by six smaller circles each standing for two moons. Looking at the mural, the circle farthest to the left, outlined with a thin white crescent, represents the coming of a new moon; the center large circle, the full moon; and the moon to the farthest right finishes the cycle of one lunar month.
> In the center large circle or the full moon, stand two Kachinas representing the two leading clans of the Hopi. The Soyal Kachina (left), representative of

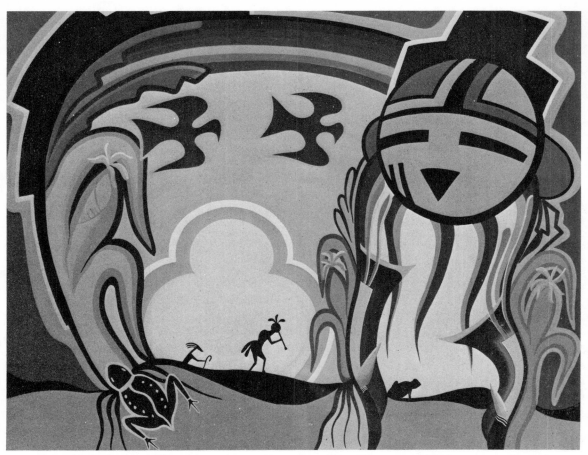

7-4. *Dawakema–Milland Lomakema. Frog, Sun, Flute Player, and Bird. 1968. 32" x 13".
Casein. Collection: Byron Harvey, Phoenix, Ariz.*

the Bear Clan, and the Ahula (right) representing the Kachina Clan. Both stand
atop the Sun, giver of warmth and beauty, and all are connected to the earth by
a Bahu or prayer stick that is dipping into the medicine bowl, containing seeds
of plants useful to mankind. The medicine bowl sits atop the land altar covering
plants and seeds that will bloom and cover the land in the spring and summer.

From two ends of the mural, two corn-meal (white) lines representing
the roads of life run toward the Sun, being blessed by two Hopi priests; the
priest to the right smokes sacred tobacco and the other sprinkles corn meal; the
crooked canes represent the steps to old age. Beneath the canes the Bear paws
represent the migration of the Bear Clan, and the other clans, the blue pyramid
clouds bringing moisture to the corn.[2]

Mike Kabotie further explains the sequence of events in the ceremonial cycle and the
iconography used to celebrate the sacred path of Hopi life:

Looking at the mural, all those ceremonies that are conducted under the
guidance of the Bear Clan are to the left. The circle to the farthest left, with the
crescent moon, represents the Christian month of August. During this month,
most mesas perform the Snake-Antelope and Flute ceremonies. Both cere-

152

monies are for rain, and for an abundant harvest. The Snake Ceremony is represented by both members, the Snake and Antelope Society, blessing the snake. The Flute Society members are blessing the corn crops and flowers with sweet sounding flute.

The second circle represents the months of September and October. It is during the latter part of September that the Mumzoid (Women's Society) perform their Knee High Dances, signifying the maturity of a woman to be able to make proper prayers by painting her flesh in the sacred symbols of the prayer stick. This ceremony is represented by a female with her thighs painted in the symbols of prayer.

In October, the Lakon or the Basket Dance is performed with the women again doing the prayers—as preparation for the coming winter; for an abundance of wild game for the men in the tribe to hunt. Usually within the dance there is a long-distance race. Another dimension of the ceremony is the confirmation of the young women as weavers of a craft, representing a cycle of life from birth to death—the basket. In the mural, two women are singing and dancing with baskets as the third member shares with the audience the crops that the women helped to grow through their prayers.

The left smaller circle, nearest the large circle, represents the moons of November and December. In the last part of November, the Wuwchim, or Men's Societies of the Sacred Song Society, One Horn, Two Horn and the Wuwchim are in the kiva praying for the rebirth of life. The Wuwchim is represented by the One Horned Priest.

Then in December, all members of the societies are in the Kiva, meditating in homage to the Sun; seeking in prayer for the Sun as Father to lead us back to warmer seasons. Here Ahlusaka, the fertility priest, stands as a symbol of Soyalung, the winter solstice. It is during the conclusion of the winter solstice that the leadership passes from the Bear Clan to the Kachina Clan. Ahula, the old Kachina Priest, is the first to make his appearance at the end of December.

The first small circle to the right of the large full moon is the month of January. During this month, the Hopis always participate in the Social Dances represented here by the Buffalo Dancers. January represents the barbaric past of the Hopis, thus singers and dancers can give loud whoops and war cries. The other side of the Melting of the Moon month is to prepare for the long journey toward summer.

Powamuya, or February, is the moon of Purification. During this month is portrayed the coming of the Kachina to the Hopi to purify them, during the Bean Ceremony and a prayer for a fertile summer. The Kachinas represented in the mural are the Crow Kachina Mother and the High Priest Eototo and the Quoklo, the story-telling friend of the children.

The center small circle to the right represents April through June when the Kachina comes with clouds to bless and entertain the people. They come with gifts and songs of goodwill. This portion is represented by the Kachinas arriving with the rainbow to dance in the kiva and plazas of the Hopi villages.

Then in June again the priests meditate in the middle of summer for a fruitful summer. This is represented by a priest sitting in meditation preparing prayer feathers.

In July, which is the last circle farthest to the right, the last of the Kachina ceremonies takes place, the Niman Dance or the Home Dance. This Kachina Dance, in conjunction with the Purifying Society, again purifies the people before the Kachina Spirits depart for their cloud homes to the mountains, west and east.

153

7-5. *Artist Hopid. Seven intercepting circles (right to left).* Hopi Ceremonial Calendar. *1975.*

This ceremony is depicted in the mural by the Purifying Society sitting in a smoke circle and the corn stalks, because corn is the first crop to be harvested. The Kachina Priest, Eototo, holds the sagebrush with which he purifies the people. The other Kachinas in the pictures are the Niman Kachina, crowned with cloud symbols, and the Kachina Maiden with the butterfly whorl hairdo.

With the conclusion of the Niman ceremony, the leadership is again passed to the Bear Clan to lead until the winter solstice.[3]

Members of the Artist Hopid, in addition to their cooperative work on *The Hopi Ceremonial Calendar,* have created many independent paintings which celebrate specific rituals of the ceremonial year. These paintings differ greatly from traditional Hopi ceremonial paintings—for example *Big Horn Ceremony* by Otis Polelonema (Fig. 7–6), which follows the tenets of the Indian schools and the Santa Fe Studio painters. Until recently, Hopi artists inevitably painted lines of costumed dancers. Today, in contrast to this tradition, the members of the Artist Hopid focus on symbols of the ceremony or on abstract patterns inspired by design elements from the costumes of the dancers. The modern artists utilize the style of the petroglyphs and murals, as well as the techniques of twentieth-century abstract painting. These artists do not record these events as memories of their tribal past or as academic illustrations of Hopi life; as initiated participants in Hopi ritual life, these painters proclaim their total involvement with their heritage and their pride in the Hopi Way of Life.

In the Hopi world, each season has special rites and ceremonies. Until recent years the Hopis did not use an annual calendar with specific months and days but relied upon the

154

L. 35'. Gift of Tiffany Foundation. Collection: Hopi Cultural Center Museum, Second Mesa, Ariz.

cycles of the moon and the progress of the sun across the horizon. The beginning of a ceremony was not announced until the conclusion of the previous ceremony, a tradition which continues today.

In August the Snake-Antelope Ceremonies and the Flute Ceremonies are held on alternate years. These are the first rituals in the cycle following the return of the Kachinas to their homes in the Santa Fe Mountains. At this time the Hopis pray for rain for the crops planted after the summer solstice and for a plentiful harvest of the first crops. The Snake-Antelope Ceremonies include complex rituals of gathering, washing, and blessing the snakes. The Hopis dance with snakes in their mouths and then release them as sacred messengers who will carry their prayers to the Underworld. Neil David, Sr., in *Awatovi Snake Society* p. 147, uses images and colors inspired by the Awatovi murals to represent the Snake and Antelope Priests who are joint participants in these ceremonies. In the center of the painting is the ceremonial altar surrounded by a rainbow and stylized cloud forms. Netted gourds of sacred water stand between the cloud forms. A design of parallel lines, symbols of the Warrior, decorates both the snakes and the kilt of the Snake Dancers. Snakes represent lightning, and both snakes and lightning are traditional water symbols. The jagged lightning symbols decorate the bodies of the Snake Dancers. Mirror images of the Antelope Priests are in the upper left and lower right corners, and mirror images of the Snake Priests are in the lower right and upper left corners. This inversion and repetition of all images in the painting symbolize the rotation of the Earth.

In *Snake Society and Prayers with Warrior Maidens* p. 80 , Neil David, Sr., again uses the iconography of the Awatovi murals to represent the Snake and Antelope Priests.

155

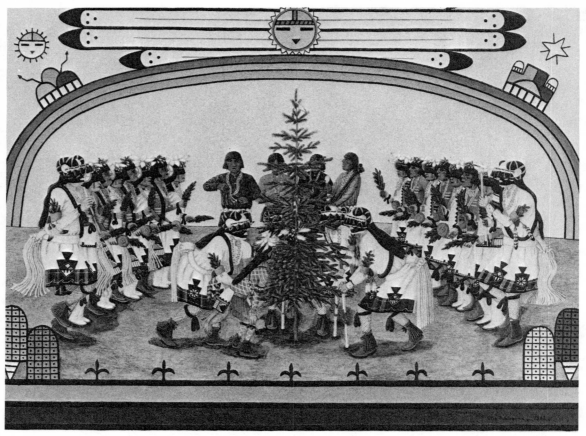

7-6. *Otis Polelonema.* **Big Horn Ceremony.** *1966. 25¹/₂" x 19¹/₄". Casein. Hopi Cooperative Arts and Crafts Guild.*

On the Second Mesa, the appearance of the Soyal Kachina announces the onset of the winter solstice. Milland Lomakema in *Emergence* p. 18 and in *Sun and Rain Spirits Over Corn Plants* p. 97, utilizes stylized representations of the mask of the Soyal Kachina. In *Symbols of Bear Clan* p. 65, the central image of the composition is an abstraction of the Soyal Kachina mask. The Soyal Kachina Ceremonies include prayers for the propagation and welfare of all life on Earth. These are ceremonies in which the Kachinas enact the symbolic fertilization of the women, the consecration of the corn and the sanctification of the Hopis' dwelling place on Earth. On each mesa different ceremonies celebrate the opening of the kivas.

During winter months the Hopis enjoy many social dances. Milland Lomakema's *Social Dance Maiden* (Fig. 7–11) is an abstract design based on the maiden in her costume. During this ceremony, the Antelope Priests sing and the Snake Priests dance with the snakes suspended from their mouths, while the Hopis pray for rain and for the well-being of their people. The Two Horn Priests represent germination. A comparison of these paintings with the traditional representation *Snake Dance* by Fred Kabotie (Fig. 7–8) illustrates the evolution of Hopi painting during the past decade. Two innovative paintings inspired by the Snake Ceremony are *Water Serpent* p. 78 by Neil David, Sr., an abstract composition of plumed

serpents, and *Antelope Priest* p. 71 by Milland Lomakema, which is painted in the style of the ancient petroglyphs. In *Flute Society* p. 39, Delbridge Honanie portrays the initiation of the children into the Flute Society while the flute player performs the ancient musical rites of prayers for the corn.

Each autumn the Women's Dances take place. In *Awatovi Woman's Ceremony* (Fig. 7–9), Honanie uses Awatovi-style images to represent the role of women in Hopi society. In *Women's Society* (Fig. 7–10), he uses simplified stylized forms to represent the Women's Dances. Honanie explains that the Women's Society is led by members of the Bear Clan and that the Frog Clan often joins the Bear Clan in carrying out ceremonial duties. Lightning emanates from the body of the frog, for the frog, like the dragonfly, is a symbol of water and growth. The suspended triangular forms represent prayer feathers, an important part of all Hopi religious rituals. A prayer feather is also attached to a circular form which symbolizes the coils of the woven baskets. The linear design on the left of the painting represents the straw of the Hopi baskets. During the Basket Dance, which is a harvest celebration, women throw corn at a wheel; therefore, Honanie has included a stylized representation of the corn husk wheel and two ears of corn. The woman's leg symbolizes the Knee High Dance. Design elements of the Women's Ceremonies are occasionally used as symbols of autumn. In *Emergence* p. 18 , Milland Lomakema uses a woman's leg to indicate the season in which the Hopis emerged into the Fourth World.

Wuwuchim celebrates the rebirth of life in the Hopi world. During the Wuwuchim Ceremony, members of the Wuwuchim Society reenact the beginning of life on Earth, the Emergence of the Hopi people from the Underworld. During Wuwuchim, the Hopis pray for the successful germination of all forms of life on Earth—human, animal, and plant. One of the most important rituals of Wuwuchim is the ceremony of new fire, the symbolic distribution of the new fire to each Hopi home. Every four years during Wuwuchim, the members of the Wuwuchim Society conduct the first stages of the initiation rites which mark the transition from youth to adulthood.

Most of the rites of the Wuwuchim ceremony are closed to all but the initiated. During one sacred ceremony the road to Shungopovi is closed and access to the village is reserved for members of the Spirit World. Mike Kabotie and Terrance Talaswaima are initiated members of the Wuwuchim Society; however, all members of the Artist Hopid, in respect for the sanctity and secret nature of Wuwuchim rites, have abstained from painting descriptive narratives of these ceremonies. In *The Hopi Ceremonial Calendar* p. 154, the artists have painted a One Horn Priest praying for the rebirth of life in order to suggest the spiritual focus of the Wuwuchim Ceremony.

The Soyal Ceremonies, which are performed at the time of the winter solstice, mark the beginning of germinated life in the cycle of the year. At this time the sun has reached its southernmost point and the course of the sun is redirected toward the Earth so that the light, warmth, and strength of the sun will germinate and nourish life. All human, animal, and plant life is determined by the powers of the sun.

At the time of the winter solstice, the first Kachina of the year appears on the mesas. The feathers of her headdress are symbolic of rain. The background of the painting is inspired by a woven-basket pattern. The maiden, wearing the traditional manta and a wedding sash, dances with a prayer stick.

The most popular of the social dances are the Buffalo Dance and the Butterfly Dance. Both Hopi maidens and young men participate in the Butterfly Dance, which celebrates the flowering and fruition of life on Earth. The dancers wear elaborate masks and costumes

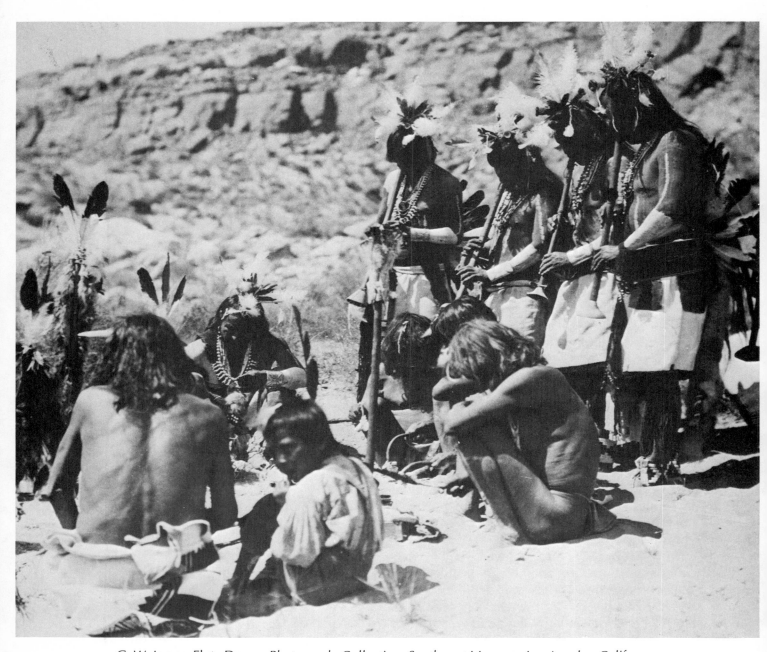

G. W. James. Flute Dance. *Photograph. Collection: Southwest Museum, Los Angeles, Calif.*

158

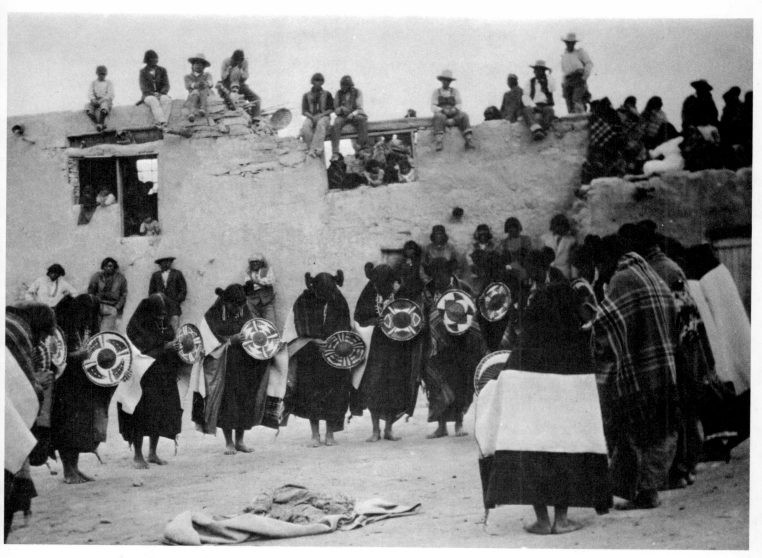

Emry Kopta. Lakon Ceremony: 1919. Basket Dance: women in circle holding baskets. Photograph. Collection: Museum of the American Indian, Heye Foundation, New York, N.Y.

which are decorated with symbolic representations of clouds, rain, and corn. Only unwed maidens may perform this dance. Often called cloud maidens, they wear headdresses with images of clouds and rain and an anklet decorated by cloud symbols. In *Cloud Maidens* (Fig. 7–12), Neil David, Sr., paints two dancers in the style of the Awatovi murals. Each dancer stands beneath a rainbow, and the rainbows meet in a terraced cloud which offers rain to the corn plants. These plants symbolize the germination and growth of the season's crops. Prayer sticks and clouds form the dominant symbolic designs in this painting, which celebrates the germination of life in the Hopi world.

Ahula, the old Kachina Priest, appears at the end of January and plays an important role in the Powamu Ceremony. The name, "Ahula" or "Ahulani," comes from the word "ahulti," "to return."[4] For modern Hopis, Ahula is one of the most popular Kachinas. In

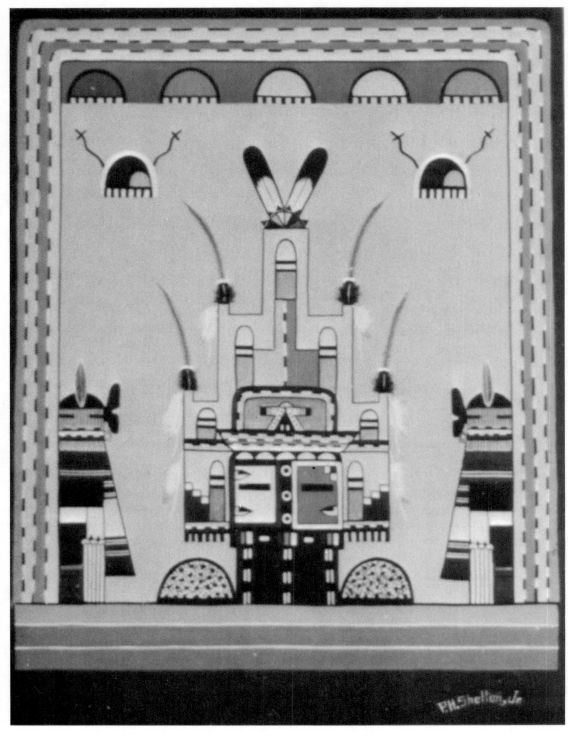

Peter H. Skelton, Jr. Hemis Figures. 16$^{1}/_{2}$" x 12$^{1}/_{2}$". Collection: James T. Bialac, Scottsdale, Ariz.

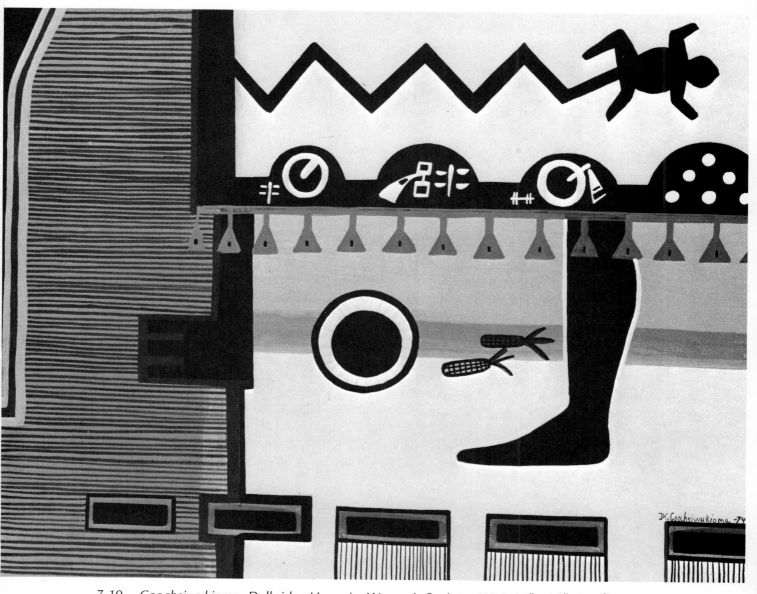

7-10. *Coochsiwukioma–Delbridge Honanie. Women's Society. 1974. 16" x 20". Acrylic. Collection: Hopi Cooperative Arts and Crafts Guild.*

161

most contemporary works he appears in his role of Ahula, the Germinator. Ahula, the Germinator, is the inspiration of many of the most powerful and innovative modern Hopi paintings. He has become the symbol of the life force in the Hopi world. Ahula is the Sun Kachina and thus represents the beauty and creative power of the sun. His radiant mask symbolizes the spirit of rebirth in the Hopi world. Not only has the world of the Hopis endured for centuries, but Hopi culture has a vitality and creative force which the artists identify with the germinative powers of the sun. In *Ahula, the Germinator* p. 17 , and in *Giver of Life* p. 45 , Neil David, Sr., has captured the brilliance and power of this Sun Kachina. In both paintings he combines the masks of the sun with the sacred gourd of water because sun and water are fundamental to the regeneration of all life on Earth. Milland Lomakema in *Rain and Corn Priest* p. 221 depicts Ahula with Eototo, the Chief of the Kachinas, surrounded by symbols of fertility (clouds, water, lightning, and frogs) and symbols of the germination of life on Earth (sacred water, rainbows, corn, and a bowl of fruit). Ahula and Eototo are joint participants in the final purification rites of the Bean Ceremony. In *Ahula, the Germinator* (Fig. 7–13), Lomakema utilizes geometric abstractions of Ahula's mask, corn and water symbols, and design elements from Hopi textiles to reaffirm the powers of regeneration in Hopi life. In the upper right corner a partial image of the sun echoes the theme of Ahula's life-giving powers as a Sun Kachina.

Powamu is a celebration of the return of the Kachinas. At this time the Crow Mother, the Corn Maidens, Eototo, and many of the Kachinas return to the Hopi people as they pray for a long and fruitful summer. There are many ceremonies interwoven into the rites of Powamu—the consecration and preparation of the fields, the Bean Ceremonies, the Initiation of the Children into the Kachina Society and into the Powamu Society (see chapter 8), the Soyoko Ceremony (see chapter 8), and the Bachavu Ceremony. All through Powamu the Hopis pray for the successful germination and growth of their crops during the coming seasons. The Powamu Chief personifies Muingwa, the God of Germination.

One of the highlights of Powamu is the Bean Ceremony. Beans are planted and grown in the kivas, then cut, tied, and distributed throughout the village for ceremonial feasts and dances. The success of the beans grown in the kivas is considered an omen of the crops of the coming harvest. The beans grow quickly in the warmth of the kivas and, thus, are chosen in preference to corn for this ceremony. A few corn plants, however, are also grown in the kivas. Eototo and Ahula are central figures in the Powamu Ceremonies, for they plant these sacred seeds of corn.

An important part of the Powamu Ceremonies is the initiation of the children into the Kachina Society, which includes whipping the children with yucca lashes to enlighten their hearts and to cleanse their spirits. The disciplinary Kachinas who take part in this ceremony are especially colorful and excite the imagination of contemporary artists. The Crow Mother, the leader of the Whippers, and two attendant Whippers are the focus of Neil David, Sr.,'s painting *The Coming of the Kachinas* p. 165 . A rainbow, a cloud design with prayer feathers, and a killdew bird surround the central figures. In *Bean Dance Kachina* (Fig. 7–14), Tyler Polelonema has painted Ogres, Mudheads and other Kachinas who are participants in these initiation rites.

In *Symbols of Powamu* (Fig. 7–15), Delbridge Honanie has created an iconographically and ideologically complex composition in which he combines elements of the Bean and Initiation ceremonies with symbols of the Bear Clan and the Migrations and with representations of Hopi arts and crafts. In the center of the painting are abstractions of the head, eyes, and mouth of the Whipper Kachina and the profile of the Crow Mother, a

162

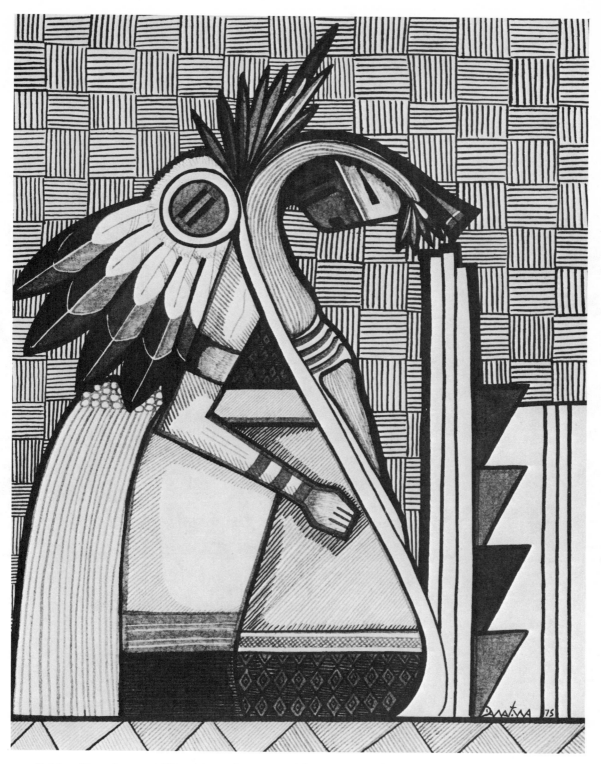

7-11. *Dawakema–Milland Lomakema. Social Dance Maiden. 1975. 12" x 9¼". Acrylic. Private Collection.*

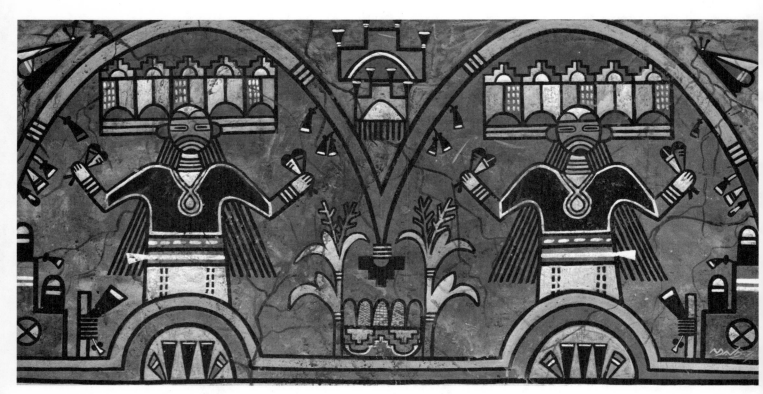

7-12. *Neil David, Sr. Cloud Maidens. 1974. 24" x 48". Acrylic. Collection: Hopi Cooperative Arts and Crafts Guild.*

164

Neil David, Sr. The Coming of the Kachinas. *1969. 20" x 16". Acrylic. Collection: Brian Hunter, Phoenix, Ariz.*

7-14. *Duvehyestewa–Tyler Polelonema. Bean Dance Kachina. 1967. 21½" x 15". Gift of Byron Harvey to Hopi Cultural Center Museum.*

protagonist in the Bean Dance. Honanie surrounds these forms with prayer sticks, hand prints, and bear tracks (symbols of the Bear Clan, which presides over the Powamu Ceremonies), Migration symbols, a pipe (smoking is an important part of the Powamu Ceremonies), rain symbols, and friendship symbols. In the upper right of the painting, a Hopi man, carrying pottery in a basket, looks at the corn and dreams of corn and rain.

In *Guardian of the Waters* (Fig. 7–16), Mike Kabotie portrays the disciplinary Kachina who is the guardian of the Plumed Serpent. Wearing a headdress of plumes, this Horned Kachina carries a yellow cloud which is symbolic of rain coming from the North. The snake is decorated with bird tracks and both the snake and the tracks are symbols of the Migrations of the Water Clan. The Migration symbols are ever-present reminders of the importance of past history in the lives of modern Hopis. Mike frequently uses bird tracks as iconographical elements, for Kabotie's childhood name was Walking Bird.

Every four years the Powamu Ceremonies include the Bachavu Ceremony, which is an important rite of the complex initiation which marks the completed transition of the young Hopi to full adulthood and the acknowledgment and acceptance of tribal responsibilities. Mike Kabotie has painted *Symbols of Bachavu* (Fig. 7–17), a Cubist abstraction which includes masks of a disciplinary Kachina, Ahula, and the Sun Forehead Kachina who represents dawn. Mike explains that in the upper right section of the painting is a Mayan profile which represents a Hopi Priest who has completed all stages of initiation and has a complete understanding of Hopi religious rituals. The faces are surrounded by a variety of symbols of Hopi life: the disciplinary hand of the Whippers, Warrior symbols, textile patterns, cloud, rain, snow, and star forms, and a waving line which symbolizes the breath of life.

Kabotie's use of Cubism in this painting of the final initiation rites is especially effective, for there is a parallel between the viewer's vision of a Cubist painting and the uninitiated's vision of a Hopi ceremony. In Cubism all design elements of a painting are fragmented into complex patterns of color, line, and form. The most sacred Hopi rituals take place in the kiva and are intended only for the initiated. All people, the initiated and uninitiated, Hopi and non-Hopi, are invited to witness public ceremonies such as the dances that take place in the plazas. Here the uninitiated may view the dances and acquire a fragmentary knowledge of Hopi religious rituals. Only through initiation and many years of learning is it possible to have a full understanding of Hopi beliefs and religious rituals.

During initiation years, the culmination of the Initiation Ceremonies is the Salako Dance which is different in both meaning and execution from the Zuni Salako Dance. In *Ceremonial* (Fig. 7–18), Mike Kabotie has painted the Salako with male and female profiles imposed on a single form. Mike describes his use of color as *celestial*. The hair of the male Salako represents rain, and the female Salako is dressed in feathers which represent showers and her ability to fly. The headdress includes symbols of clouds and squash blossoms. Surrounding the Salako figure are water symbols, hand prints, Migration spirals, and many other representations of Hopi ceremonial life.

Between Powamu and the departure of the Kachinas, there are many Kachina Dances during which the Hopi pray for rain and for the growth of their crops. Some dances are mixed Kachina Dances which include a great variety of colorful Kachinas while other dances are limited to specific Kachinas. *Squash Dance* (Fig. 1–11) by Waldo Mootzka and *Corn Dancers* (Fig. 7–19) by Otis Polelonema are traditional Hopi paintings of summer dances. A comparison of these detailed descriptive paintings with the poetic stylized painting *Corn Maidens* p. 73 by Milland Lomakema reveals the tremendous difference be-

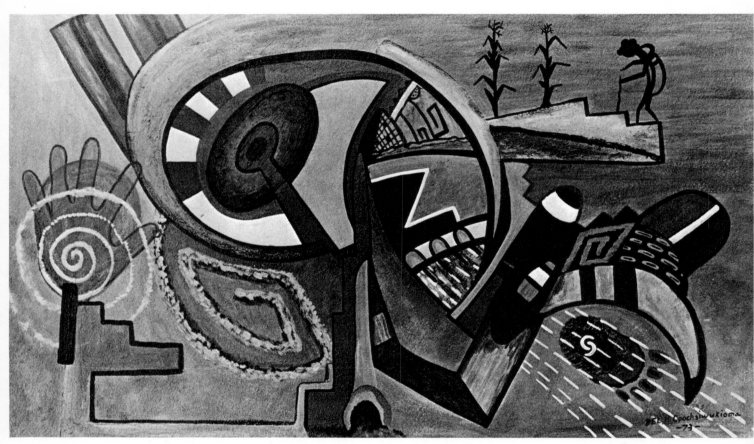

7-15. Coochsiwukioma–Delbridge Honanie. Symbols of Powamu. 1973. 19$\frac{1}{4}$" x 31$\frac{1}{2}$".
Acrylic. Private Collection.

168

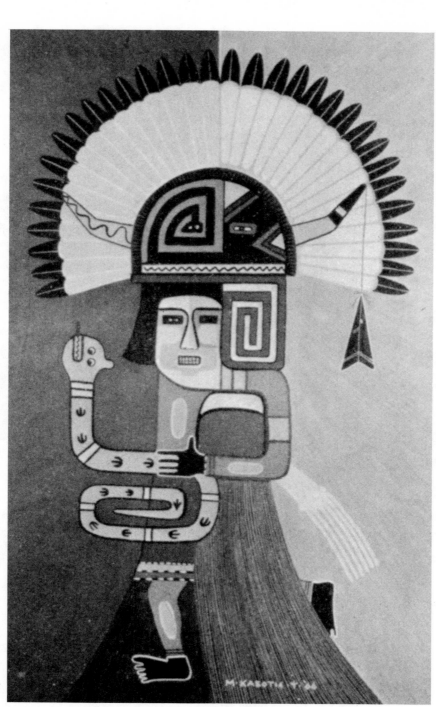

7-16. *Lomawywesa–Mike Kabotie. Guardian of the Waters. c. 1967. 25" x 15¹/₂". Casein.
Collection: James T. Bialac, Scottsdale, Ariz.*

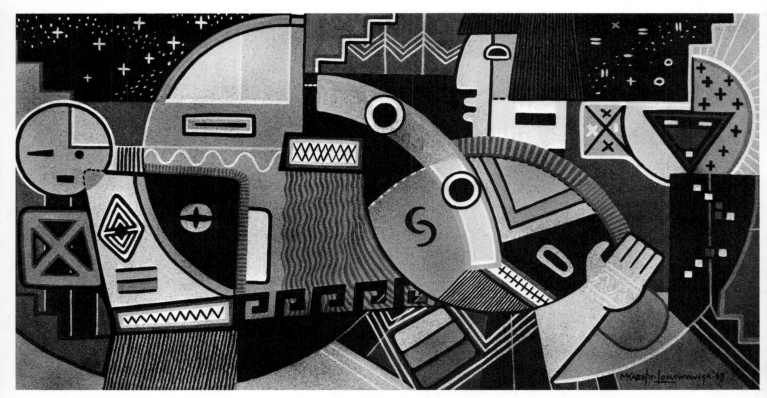

7-17. *Lomawywesa–Mike Kabotie. Symbols of Bachavu. 1968. 22" x 24". Casein. Gift of Byron Harvey to The Heard Museum of Anthropology and Primitive Art (Indian Collection), Phoenix, Ariz.*

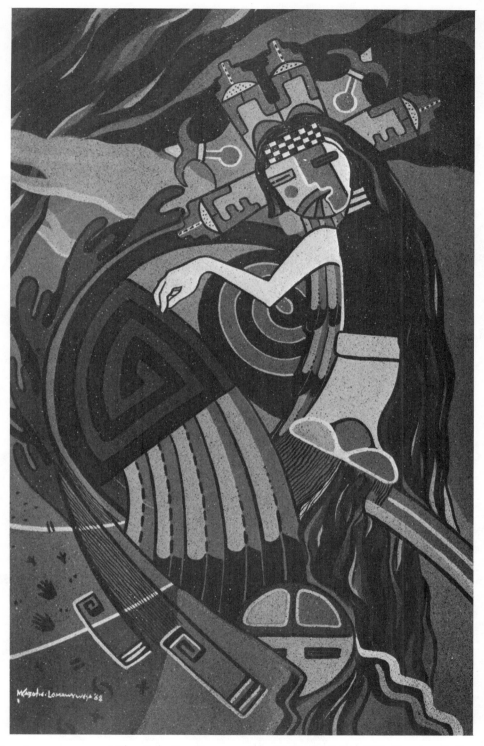

7-18. *Lomawywesa—Mike Kabotie. Ceremonial. 1968. 29¹/₂″ x 18″. Casein. Collection: The Heard Museum of Anthropology and Primitive Art (Indian Collection), Phoenix, Ariz.*

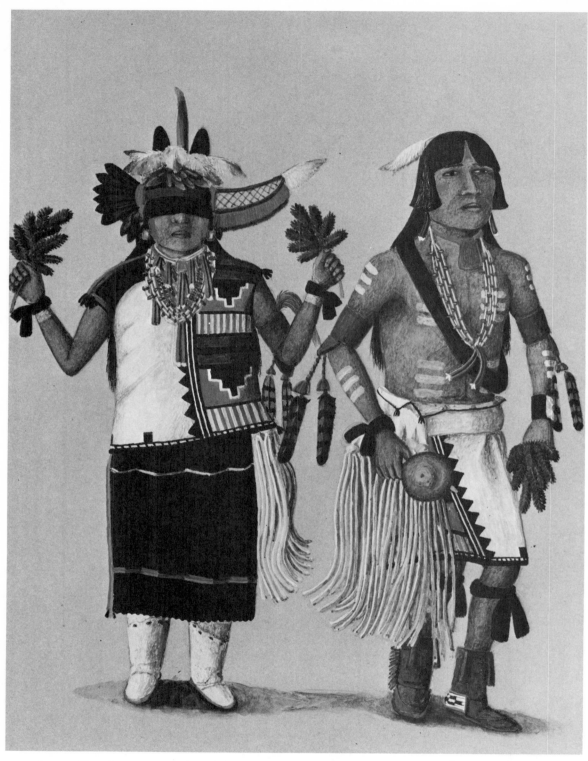

7-19. *Duvehyestewa–Otis Polelonema. Corn Dancers. 13¹/₂″ x 11″. Collection: The Heard Museum of Anthropology and Primitive Art (Indian Collection), Phoenix, Ariz.*

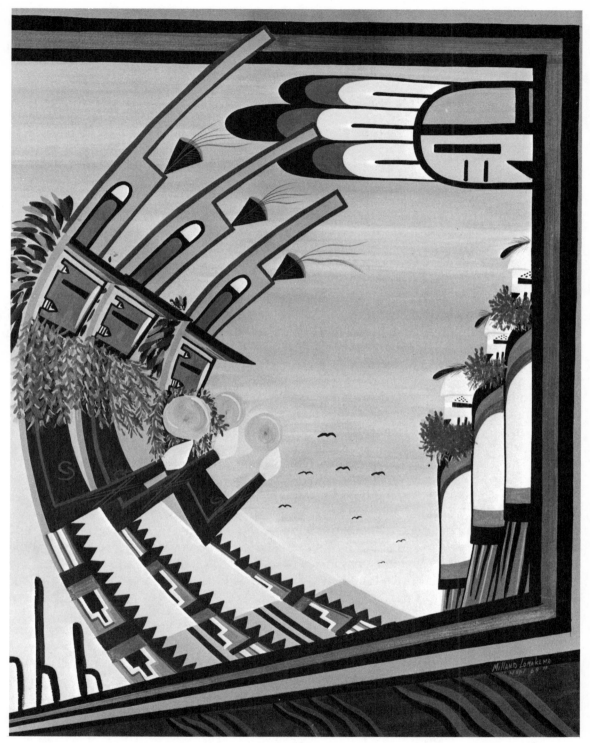

7-20. Dawakema–Milland Lomakema. The Home Dance. 1969. 19" x 15". Acrylic. Collection: Brian Hunter, Phoenix, Ariz.

173

tween modern and traditional Hopi painting. Milland's artistic goals are to create an innovative and powerful design and to express the spiritual qualities of the Corn Ceremonies.

The final Kachina Dance of the ceremonial year is the Home or Niman Dance. At this time the Kachinas distribute corn from the first harvest of the year and bring gifts of dolls and food for the children. This is the first time that the new brides of the year are permitted to attend a dance. This dance is performed at the time of the summer solstice. When it is the time of harvest in the land of the Hopis, it is the winter solstice and the beginning of the growing season in the Underworld; therefore, at this time the Kachinas must leave the world of the living. The Hemis Dance is performed by the Hemis Kachinas and the Hemis Kachina Manas. The Hopis bid these Kachinas accept their prayers and take their prayers for moisture and the renewal of life with them to their homes in the Santa Fe Peaks. Rain in the late summer is of critical importance because the Hopis need a long growing season for a successful second planting.

The costumes and particularly the masks of the Hemis Kachinas are the most elaborate and beautiful of those worn by any Hopi ceremonial dancers. The headdress of the Hemis Kachinas takes the form of terraced clouds on which symbols of rain and corn are painted. Prayer feathers adorn each level of the terraced clouds. These towering headdresses have inspired many generations of Hopi paintings. In *Hemis Figures* p. 160, Peter Shelton, a traditional Hopi Kachina painter, transcends the limits of representational art by exaggerating the size of the headdress so that it dominates the entire painting. Shelton includes in his composition stylized cloud forms and lightning forms which emphasize the meaning of the Home Dance. In *Symbols of the Home Dance* p. 109 , Milland Lomakema utilizes the forms of the Hemis Kachinas to contrast the ancient rituals with modern industrial life. By transforming the Kachinas into an industrial complex, he emphasizes the ability of Hopi culture to survive and flourish in the modern world. In *The Home Dance* (Fig. 7–20), Lomakema has abstracted the form of the Hemis Dancers and the sun and cloud symbols into curvilinear forms which suggest the movement, vitality, and magnetic powers of the Niman Ceremony. The perpendicular forms of the houses, in contrast to the rhythm of the dancers, stand motionless as Hopi homes have stood through the centuries.

In the mid-twentieth century an industrialized world of highways, food processing, supermarkets, and countless other innovations which are accepted parts of modern life have changed the Hopi world and negated the critical nature of the growth of crops. The survival of the Hopi is no longer dependent upon their growing their own food; however, the Hopis' belief in the continuity of life and the role of the Hopis in achieving universal progress has remained unchanged through the centuries. For many Hopis the observance of the rituals of the traditional ceremonial cycle reinforces a sense of well-being and reaffirms their belief in universal order and purpose.

NOTES

1. Mike Kabotie, *Dedication* written for the Exhibition of the *Hopi Ceremonial Calendar* mural at the Hopi Cultural Center (Second Mesa, Arizona; unpublished), July, 1975.

2. Mike Kabotie, description written for the Exhibition of the *Hopi Ceremonial Calendar* mural at the Hopi Cultural Center (Second Mesa, Arizona; unpublished), July, 1975.

3. *Ibid.*

4. Hamilton A. Tyler, *Pueblo Gods and Myths* (Norman: University of Oklahoma Press, 1964), p. 150.

CHAPTER 8

The Hopi Path of Life

In the Hopi world all life is cyclical. The ceremonial year follows a ritualistic pattern of fertilization, germination, growth, fruition, and regeneration which mirrors the life cycle of the crops and particularly the life cycle of corn. The Hopis believe that, although man is the focus of both the Spirit World and the natural world, he cannot prosper on Earth unless his life is in harmony with the fixed order of the universe. Hopi life must follow a path which coincides with the cycle of the natural world, a cycle of fertilization, birth, youth, maturity, death, and rebirth. On Earth the Hopis must follow a divinely ordered Path of Life and at death they must follow the sacred path to the Spirit World where the protection and sustenance of the Hopi people on Earth is their principal responsibility.

In *Pathway of Spirits* (Fig. 8–1), Terrance Talaswaima has chosen a circular form to portray the cyclical nature of life in the Hopi world. Terrance uses variations of brown and green tones, which are the colors of the earth and of growing plants. Two Spirit Trails project into the circle of the Hopi world. One is the path of spirits who are about to be born, spirits who will soon enter the earthly world of the Hopis. The other path belongs to spirits who, having completed life on Earth, are returning to the supernatural world. The spirits of the Hopis still unborn are partially defined figures on the left of the painting and the spirits, who have completed their life cycle appear on the right of the painting. They return as spiritual guardians of those on Earth. The spirals in the center of both Spirit Trails symbolize the Emergence and Migrations, the ancient journeys of the Hopis to the spiritual center of the Earth.

A. C. Vroman. Hopi Mother and Nursing Baby, Silas' Wife and Child *(note coil plaques), Second Mesa. Hopi. Taken during Gates Expedition, 1901. Photograph. Collection: Southwest Museum, Los Angeles, Calif.*

176

Frederick Monsen. Hopi Woman of Oraibi with Baby on Cradleboard *(note wicker plaques). c. 1903. Photograph. Collection: Southwest Museum, Los Angeles, Calif.*

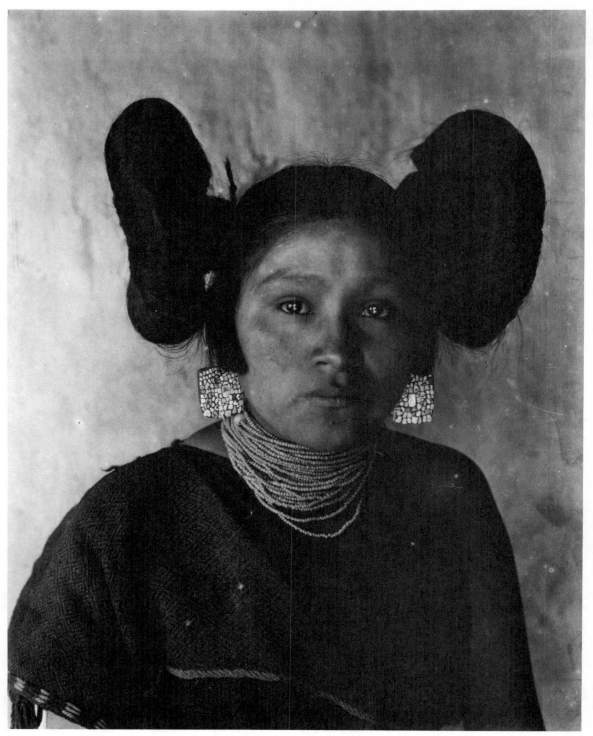

A. C. Vroman. Whorl Hair Dressing—Hopi Maiden 1901. *Turquoise Inlay Earrings, Necklace. Photograph taken during the 1901 Gates Expedition. Collection: Southwest Museum, Los Angeles, Calif.*

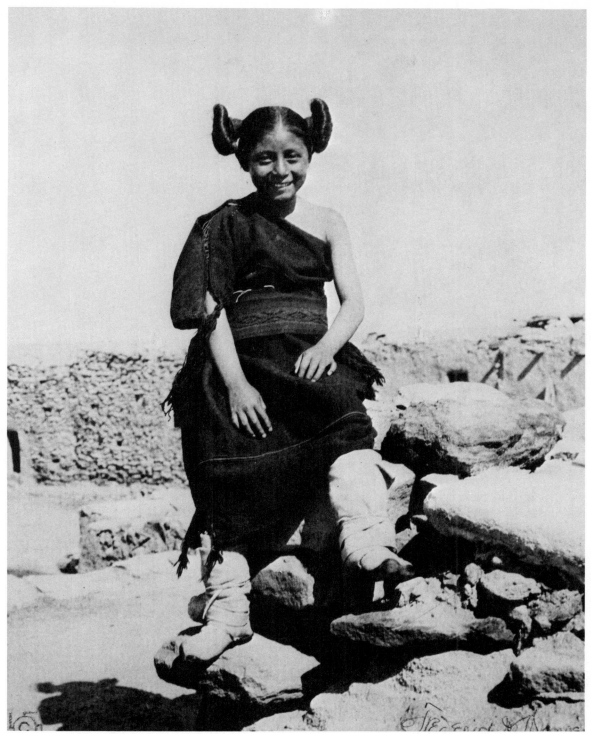

Frederick Monsen. Hopi Maiden (wearing manta and sash). c. 1903. Photograph.
Collection: Southwest Museum, Los Angeles, Calif.

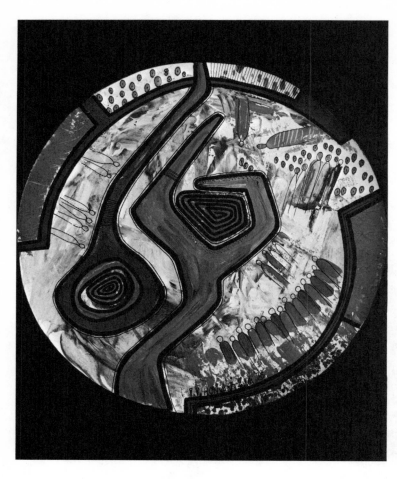

8-1. *Honvantewa*
Terrance Talaswaima.
Pathway of Spirits.
1975. D. 12⅝". Acrylic.
Collection: Hopi Cooperative
Arts and Crafts Guild.

The cycle of Hopi life on Earth and the transformation of the Hopis at the end of the life cycle into Spiritual Beings have inspired many of the most vital contemporary Hopi paintings. The members of the Artist Hopid frequently choose as subjects landmarks on the path of Hopi life and the path to the Spirit World. For these artists, however, each stage of development is looked upon as an integral part of a larger pattern, the never-ending cycle of Hopi life.

For twenty days after a Hopi child is born, the mother and child remain in a room protected from the sun's rays. At the end of this time the child is presented to the sun, the giver of life, and is blessed and given many names. One of these names will "take" and will be used throughout childhood. The Hopi child, however, acquires an additional name at the time of the initiation into the Kachina Society. Young Hopi men are given their adult names at the time of the final initiation.

The godmother cares for both mother and child during the time of birth and during the critical twenty days immediately following. The Hopis believe that if a child dies during this period, a mother may bear the same child again. The spirit of the baby climbs from the grave, enters the parents' house and waits in the ceiling for a chance to be born again. The child is expected to return in the form of the opposite sex.[1]

Hopi babies are an ever-present part of family life. During childhood the children are taught to live as good Hopis and follow the Hopi Way. The children play together in the

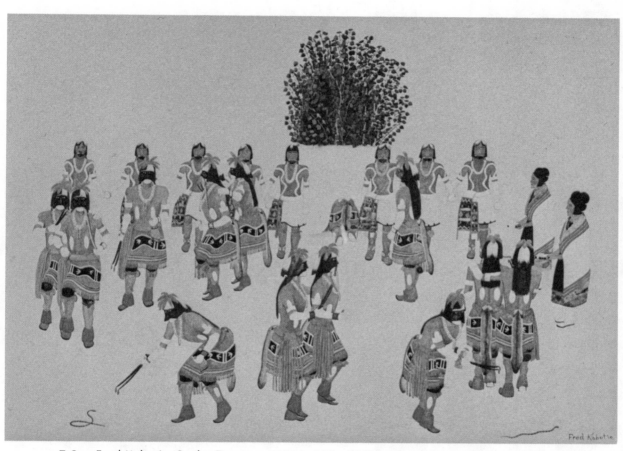

7-8. *Fred Kabotie. Snake Dance. c. 1918. 15" x 20¹/₂". Watercolor. Collection: James T. Bialac, Scottsdale, Ariz.*

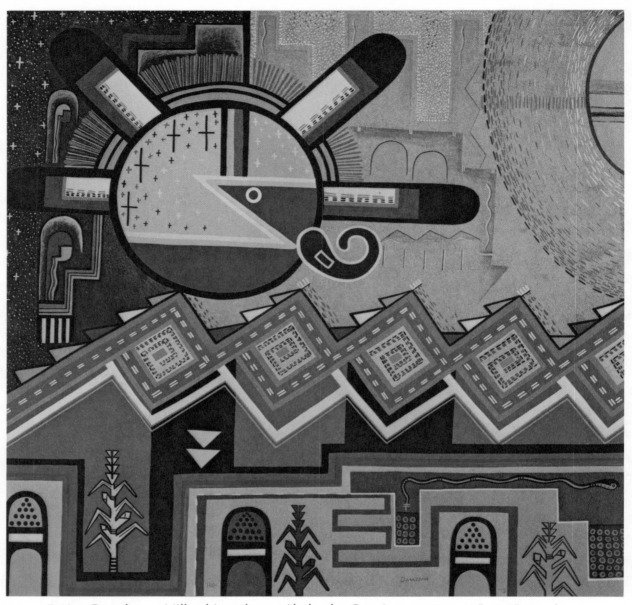

7-13. *Dawakema—Milland Lomakema. Ahula, the Germinator. 1973. 29″ x 30″. Acrylic. Collection: Hopi Cooperative Arts and Crafts Guild.*

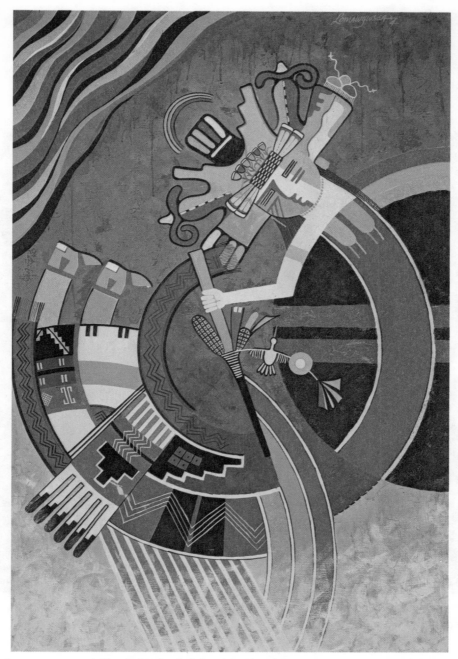

8-7. *Lomawywesa–Mike Kabotie. Salako the Cloud Priest. 1974. 72" x 118¹/₂". Acrylic. Collection: Hopi Cooperative Arts and Crafts Guild.*

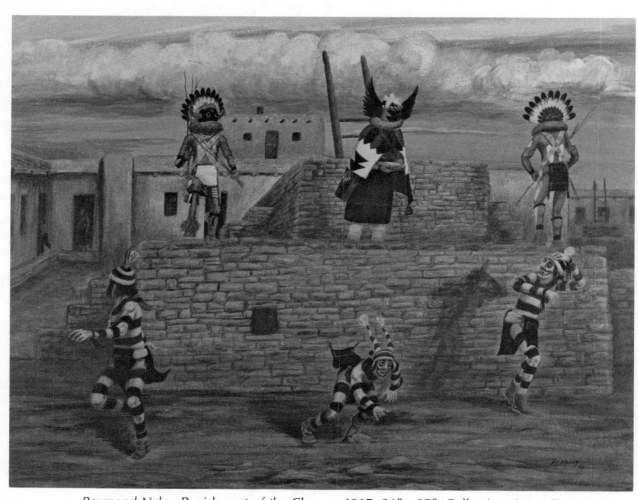

Raymond Naha. Punishment of the Clowns. 1967. 21" x 27". Collection: James T. Bialac, Scottsdale, Ariz.

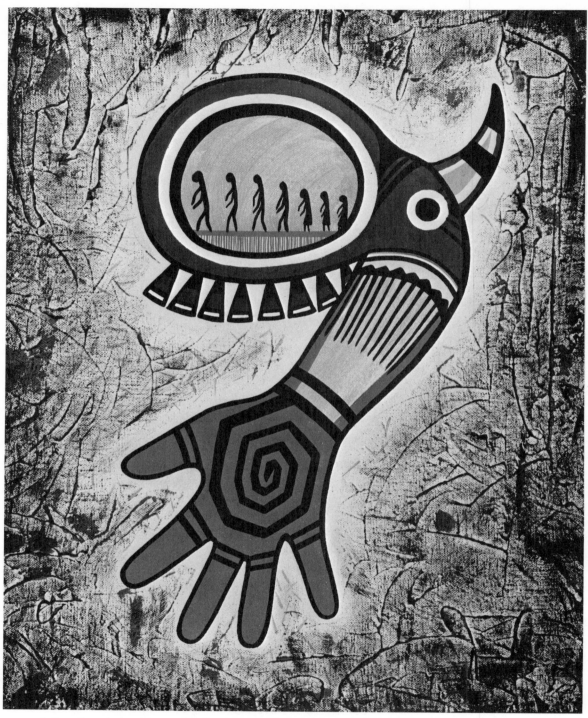

8-2. *Coochsiwukioma—Delbridge Honanie. Initiation of the Children. 1975. 28" x 24". Acrylic. Collection: Hopi Cooperative Arts and Crafts Guild.*

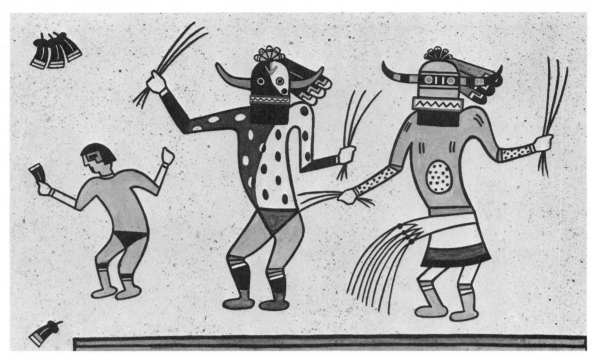

8-3. *Neil David, Sr.* Kachina Initiation. *1965. 9^1/$_2$" x 13^1/$_4$". Casein. Collection: Brian Hunter, Phoenix, Ariz.*

villages and learn to run, race, and develop their physical powers, because a strong healthy body is an important key to survival in the Hopi world. Children are expected to be productive members of the Hopi household and participate in all household tasks. Older children care for the younger children; the boys hunt, race, and learn to herd sheep and work in the fields, while the girls learn to grind corn, prepare food, and make pottery. The children are constantly taught the symbolism and spiritual meaning of each detail in the routine of traditional daily life. In *No Turning Back,* Polingaysi Qoyawayma (Elizabeth White) recalls a lesson in cooking: "A small portion of food is being prepared for many hungry people. To it we add sand for a prayer for abundance. Sand, whose grains are without number, have in it this essence. What is more plentiful than the sand of Mother Earth in its endlessness? We remember that as we mix our food in its lack of muchness. Now, as you knead this dough in your warm hands, there are good thoughts in your heart, that there be no stain of evil in the food. Ask that it may have in it the greatness and power of Mother Earth; then those who eat it may be nourished in spirit as well as in body."[2]

Each Hopi boy has a Spiritual Father or godfather and each Hopi girl has a godmother who advises and educates and sponsors them when the time comes for initiation into the sacred ceremonial societies. When the Hopi children reach ten years of age, they are initiated into the Kachina or Powamu Society (see chapter 7). The time of this first initiation is indeed a critical point in the life cycle of the Hopi. The time of this initiation is partially determined by the child's ability to keep a secret for, at the conclusion of the Powamu Ceremony, the children for the first time see the Kachinas dance without their masks. This unmasked dance marks the end of one of the most cherished illusions of childhood and is remembered as an important rite of passage.

186

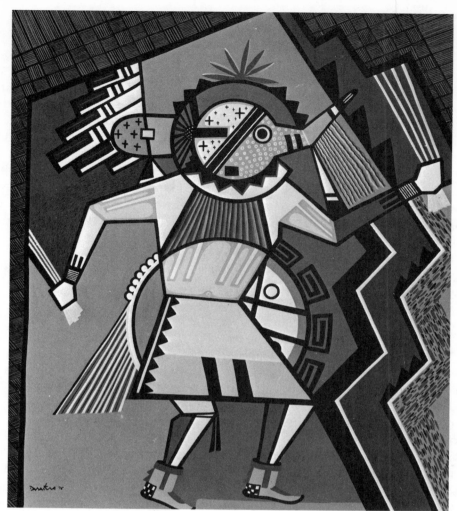

8-4. *Dawakema–Milland Lomakema. Abstract of Whipper. 1975. 30" x 25". Acrylic. Collection: Hopi Cooperative Arts and Crafts Guild.*

The children initiated into the Kachina Society are whipped during the Powamu Ceremony; however, the ceremonial father may receive several of the lashes in place of the child. It is believed that the ceremonial flogging with yucca whips enlightens the hearts of the children and the washing of their hair with yucca suds cleanses their spirits. Those initiated into the Powamu Society are not whipped as are those initiated into the Kachina Society. The latter will ultimately have great importance at ceremonial functions for they will be considered "Fathers of Kachinas."

The ceremonial whipping of the children is a Hopi ritual which has inspired many innovative contemporary Hopi paintings. *Coming of the Kachinas* p. 165, *Bean Dance Kachina* p. 166 , *Symbols of Powamu* p. 168, *Hopi Kachina Face Design* (Fig. 8–5), and *Guardian of the Waters* p. 169 are all highly individual modern representations of the whipping ceremony (see chapter 7). In *Initiation of the Children* (Fig. 8–2), Delbridge Honanie portrays children coming to be initiated into the Kachina Clan. The children are inside of an oval which is part of a stylized form composed of the eye and the horn of the Whipper Kachina and of an outstretched hand, which symbolizes the physical punishment dealt to the initiates. A Migration spiral is painted on the hand. Triangular forms below the children represent prayer feathers which symbolize the prayers of the elders for the children.

In *Kachina Initiation* (Fig. 8–3), Neil David, Sr., paints the Whippers and initiates in the style of the Awatovi murals. In *Abstract of Whipper* (Fig. 8–4), Milland Lomakema combines the basic forms, symbols, and design elements of the costume and mask of this Kachina with traditional water symbols, Migration spirals, and basket-weave patterns to create an intricate and vital two-dimensional design.

For centuries, Hopi children have also been disciplined by the threat of child-eating ogres. The giants, Soyoko and his mate, Soyoko Whuti, travel from house to house and are placated with gifts of food by the parents of the frightened children. In *Hopi Kachina Face Design* (Fig. 8–5), Delbridge Honanie has painted an abstraction of the mask of the ogre who threatens the children (see chapter 8). The Migration spiral, cloud, rain, and snow symbols, and bird tracks are integrated into this frightful figure of the Powamu Ceremonies. In *The Whippers of Old Shungopovi* (Fig. 8–6), Honanie paints the forms and masks of the ogres above geometric pottery designs resembling mural remnants found in kivas to illustrate the power of Hopi disciplinary rituals to endure through the ages.

The Bachavu Ceremony, which is held every four years as part of the Wuwuchim Celebration, has great importance in the initiation rites of the Hopis which celebrate the transition from youth to manhood. Initiation is a prerequisite for performing a man's ceremonial duties on Earth and assures him that after death his spirit will be ennobled by higher responsibilities. Today, initiation affirms the importance of tradition and traditional values in modern Hopi life. As the Hopis follow the spiritual path of initiation, they develop a deeper understanding of the meaning of their past history, of their role in contemporary life and of their responsibilities for the future. It is only through completion of all rites of initiation that it is possible to have a full understanding of the Hopi spiritual world. Mike Kabotie's *Symbols of the Bachavu* p. 170 is a Cubist abstraction of these initiation rites (see chapter 7).

The culmination of the Bachavu initiation rites is the Salako Ceremony. In *Salako, the Cloud Priest* (Fig.8–7), Mike Kabotie expresses the enlightenment experienced during the Salako Ceremony. He explains that the Salako represents life in full bloom; the rainbow over the Salako represents fertility and the flowers on the costume of the Salako represent the germination of life on Earth. The Salako wears a headdress with stylized representations of clouds, rain, and lightning which are symbolic of the rain-making and life-giving powers of this Cloud Kachina. On the headdress are feathers which represent the powers of flight, for the powers of flight enable the prayers of the Hopis to reach their intended destination. The Salako holds a prayer stick, representing the authority of the Priest. On the prayer stick is a bird who has delivered the prayers of the Hopis to the Salako. Corn, the principal staple of the Hopis, symbolizes germination and the kilt worn by the Salako represents cotton, a staple which has been domesticated and grown by the Hopis for many centuries.

The hair of the Salako represents rain. Mist has formed below the Cloud Priest and a rainbow appears at the upper lefthand corner of the painting. The body of the Salako takes the form of the rainbow. The colors of the painting represent the power of the Salako over all directions. They are the primary colors of the rainbow: blue (west), yellow (north), red (south), and white (east). *Salako, the Cloud Priest* was completed in 1974, and it is more unified and ideologically clearer than *Ceremonial* p. 171, a similar composition painted in 1968, the year of Mike Kabotie's initiation. The impact of initiation on the psyche of the artist is tremendous. Although the initiation rites offer explanations of many of the mysteries and complexities of Hopi thought and belief, it takes years for an individual to mature and to develop a full understanding of the many levels of the Hopis' spiritual legacy. In *Spiritual Migration* (Fig. 8–8), Mike Kabotie dramatically expresses the trauma induced by his initia-

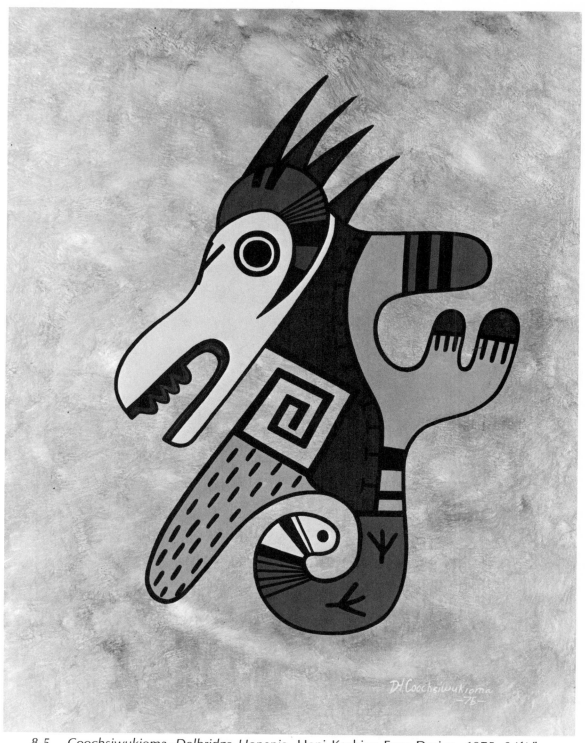

8-5. Coochsiwukioma–Delbridge Honanie. Hopi Kachina Face Design. 1975. 24$^{1}/_{2}$" x 18$^{1}/_{2}$". Acrylic. Collection: Hopi Cooperative Arts and Crafts Guild.

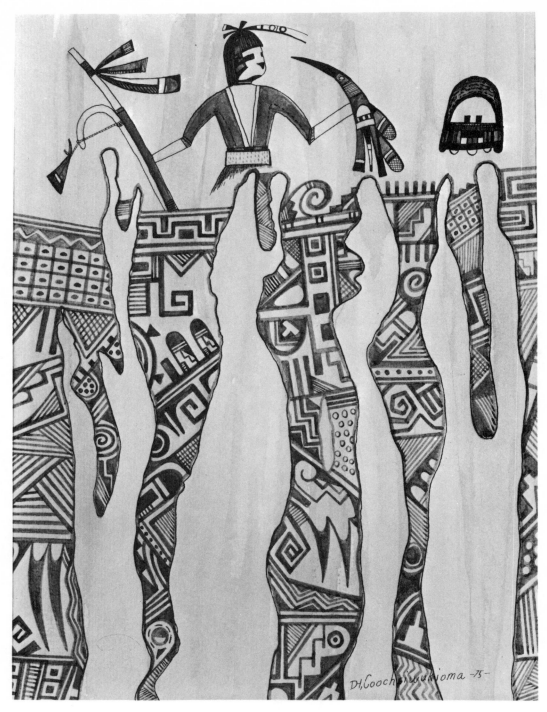

8-6. *Coochsiwukioma–Delbridge Honanie.* The Whippers of Old Shungopovi. *1975.*
 14¹/₂" x 10¹/₂". Acrylic. Private Collection.

8-8. *Lomawywesa–Mike Kabotie. Spiritual Migration. 1968. 18" x 13¹/₂". Casein. Collection: The Heard Museum of Anthropology and Primitive Art (Indian Collection), Phoenix, Ariz.*

tion. All of the symbols of Hopi life and thought are present, but the young man does not yet have a true understanding.

Marriage is a critical turning point in the lives of Hopi men and women. *Hopi Lovers* p. 282 is a Cubist representation of a lover's embrace. Mike Kabotie is influenced by the work of Picasso in this celebration of Hopi love. The wedding preparations and ceremony are complex and last several weeks and include extensive participation of friends and relatives of both the bride and the groom. The women grind corn and prepare food for the wedding feast while the father of the groom furnishes the wedding robes. He provides the cotton and feeds the weavers during the time they are working. The men clean, card, and spin the cotton and weave the wedding robes, a procedure which takes over two weeks. The bridal wardrobe includes two white blankets, a wedding sash or belt, and white buckskin moccasins. Prayer feathers are attached to the corner of the wedding garment, a symbolic prayer for the birth of a child. These feathers are the fluffy breast feathers of the eagle which are symbols of the breath of life. Each bride wears a large white blanket and carries a small one which will be draped around her at the time of her death as symbolic wings to bear her to the house of the Dead. The wedding belt has been compared to the tail of a bird guiding the bride on a spiritual flight.[3]

During the course of the wedding ceremonies, the hair of the bride and of the groom are washed separately in yucca suds and then strands of their hair are twisted together as a symbol of their union. Before their wedding, women traditionally wear their hair in whorls, but after the wedding ceremony they are expected to wear their hair in the style of the matrons. Each year, the new brides appear in public for the first time at the Home Dance. At first the newly married couple usually live with the parents of the bride. In time the young couple generally build their own home, but if the bride and groom are from different villages they traditionally live in the village of the bride.

The bearing of children is a sacred duty of a Hopi couple, for it is only through reproduction that the Hopis can survive on Earth. In past centuries drought and famine periodically reduced the meager population of the mesa villages to the point that the very survival of the Hopis was threatened. Even today, when the threat of annihilation and famine no longer exist, the Hopis desire to maintain or increase their population. *Mother and Child* (Fig. 8–9) is a Cubist representation of the role of motherhood in the Hopi world. Mike Kabotie completed this work at the time that his wife was pregnant. He explains that for the Hopis the child is thought of as a religious figure because only through regeneration, creation of a new life, can the Hopi people survive on Earth. Kabotie paints the mother and child in a pose similar to traditional religious representations of the Madonna and the Christ Child. At this time, Kabotie, strongly influenced by the Cubist work of Picasso, used the complex geometrical relationships of forms to explore the complexity of the mother-child relationship. Kabotie utilizes the techniques of abstraction to emphasize the strength of the woman's arm and the life-giving powers of her breast. He superimposes multiple profiles on the woman; however, the uppermost image portrays the human quality of the Hopi mother. The child, in contrast to the mother, is completely dehumanized, for he is a stylized icon, the symbol of renewed Hopi life.

In the Hopi world, the mother is the head of the house and the children take their clan identity from her; therefore, a girl-child is especially desirable for she will perpetuate her clan. Both husband and wife have mutual obligations; however, each retains personal independence. Divorce is possible in the Hopi world and the Hopi woman may end her marriage at will.

8-9.　*Lomawywesa—Mike Kabotie.* Mother and Child. *1970. 19¹/₂" x 15¹/₂". Casein. Collection: Ed Comins, Phoenix, Ariz.*

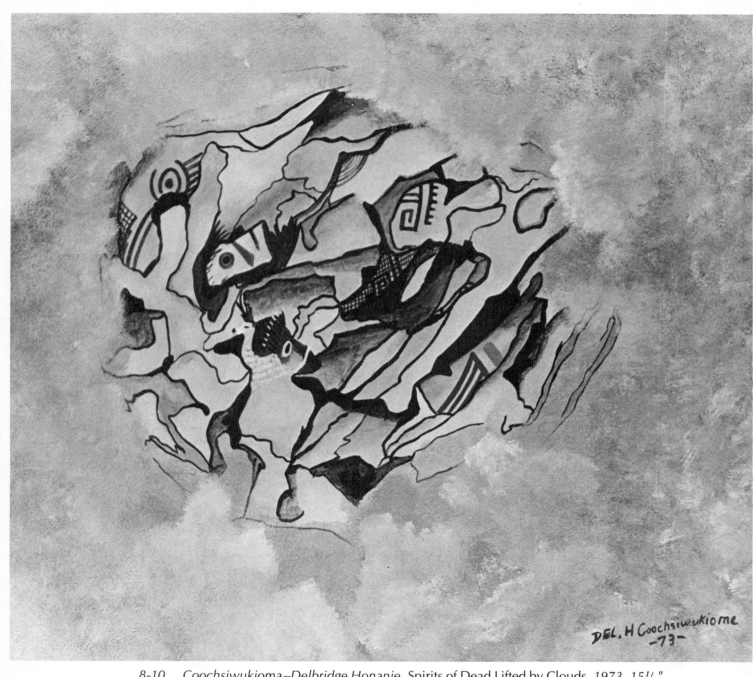

8-10. *Coochsiwukioma–Delbridge Honanie. Spirits of Dead Lifted by Clouds. 1973. 15¹/₂″ x 19¹/₂″. Acrylic. Private Collection.*

194

8-11. *Lomawywesa–Mike Kabotie. Becoming a Spirit. 1975. 19" x 30¹/₂". Acrylic. Collection: Hopi Cooperative Arts and Crafts Guild.*

After marriage, all duties in the Hopi household are divided and defined by tradition. The woman maintains the home, prepares meals, carries water, grinds corn. She devotes her spare time to pottery or basketry. The father plants, cultivates, and harvests the crops or herds sheep. The mother educates the daughters and the father trains the sons to follow their roles in the Hopi world and he teaches them their many ceremonial obligations. The men introduce their sons to the rituals of the kiva, where the boys also learn to card, spin, and weave.

Hopi men and women continue to lead useful lives until the time of their death. The aged are respected and cared for and remain a vital part of both the household and community, for they participate in the routines of everyday life and the rituals of ceremonial celebrations. The aged continue to do physical work and to excel in arts and crafts of every description.

When a Hopi dies, a member of the family washes the body and hair in yucca suds, combs the hair, and attaches prayer feathers to the head, hands, feet, and breast. He then dresses the deceased in ceremonial robes and places over the face a cotton mask with holes for eyes and mouth. This mask represents a cloud which will conceal the dead Hopi's face when he returns to bring rain to the land of the Hopi. Cornmeal is rubbed on the face and placed in the fist. The Hopis bury the dead in a sitting position facing east so that the Spirit may easily rise and begin its journey to the Spirit World. A grave ladder is set in the earth and food and water are placed near the body as food and drink for the journey. The ladder is a basic Hopi Emergence symbol, for the Hopis traditionally use a ladder to exit from the kiva and used a reed as a ladder to emerge into the Fourth World through the Sepapu.

195

The Dead and the world of the Dead have long been subjects of fear rather than artistic inspiration. Today, however, the Dead and their journey to the Spirit World are the subjects of several powerful Hopi paintings. In *Spirits of Dead Lifted by Clouds* (Fig. 8–10), Delbridge Honanie portrays the face of the Dead that he sees momentarily when he looks at the clouds. In *Becoming a Spirit* (Fig. 8–11), Mike Kabotie depicts the Hopi Spirits carrying the newly dead to the Spirit World. At the top of the painting are pottery designs which represent the supernatural world of the Spirits. Mike explains that the Kachinas are waiting as a welcoming committee for the new Spirits.

Journey to the Underworld (Fig. 8–12) by Milland Lomakema is a complex painting which gives symbolic form to many of the beliefs and traditions surrounding death in the world of the Hopis. The many levels of the Hopi world are clearly defined. The Hopi believes that life is ordered by a prescribed set of rules, and it is only through cooperation and adherence to these rules that it is possible to achieve the best possible life on Earth and harmony in the universe. The religious duties and responsibilities of the individual not only increase with age and are the central focus of the Hopis' life on Earth, but continue beyond the grave. Milland Lomakema's painting is a symbolic representation of the Spirit World, which is just beyond the boundaries of earthly life, and of the journey of the Spirit of the Dead to the Underworld. The morning star shines because very early in the morning, four days after the burial, the Spirit of the Dead rises and begins its journey.

The eagle, who is the embodiment of the strength and power of prayer, awaits the Spirit of the dead Hopi. The prayers of the people on Earth are carried by their prayer sticks and a prayer feather. The prayer sticks burn brightly on the Hopi's grave, which is in the lower lefthand corner. This area, bathed in a faint light, represents the home of the Hopis on Earth. The prayer feather, always the feather of an eagle, is first given a special blessing by an initiated member of the tribe. Once it has been blessed, the mourners lay down the feather and pray on it with cornmeal, the major sustenance of their life on Earth. The mourners then throw the feather into the air and it falls to the ground as they pray for the spirit of the newly dead.

The Spirit of the Dead, lifted by the power of the prayer feather, follows the trail of light to the Spirit World. The Spirit follows the illuminated trail to the entrance of the Underworld, where the inhabitants of the World of the Dead await its arrival. Beyond the entrance, which is veiled in white fog, the Dead, still in the costumes they wore when they were living on Earth, work from day to day as they did in life, carrying out their responsibilities and duties to the Hopi people. Their chins are painted gray to identify them as belonging to the Dead.

It is the duty of those who belonged to the Rain Clan on Earth to produce rain for the living Hopis. Those who belonged to the Snow Clan must make snow and hail, while those of the Cloud Clan must make the clouds and the lightning bolts which come from the cloud. It is the responsibility of those of the Corn Clan to make the seeds for the new crop. Milland Lomakema expresses these duties in symbolic form. The jagged lines represent lightning, the crescent shapes represent clouds, and the lines flowing downward are rain. These same symbols of clouds, lightning, and rain are echoed in the giant wing span of the eagle.

Lomakema's use of the eagle as the focus of the composition is especially meaningful, for the brief life span of the eagle is a mirror image of the Path of Life of the Hopi. Tremendous ceremonial importance is attached to both the natural and supernatural life of the eagle, and the eagle and eagle feathers play essential roles in many Hopi rituals. One of the tests of manhood is the difficult feat of capturing the young eagles. The Hopis must climb to the

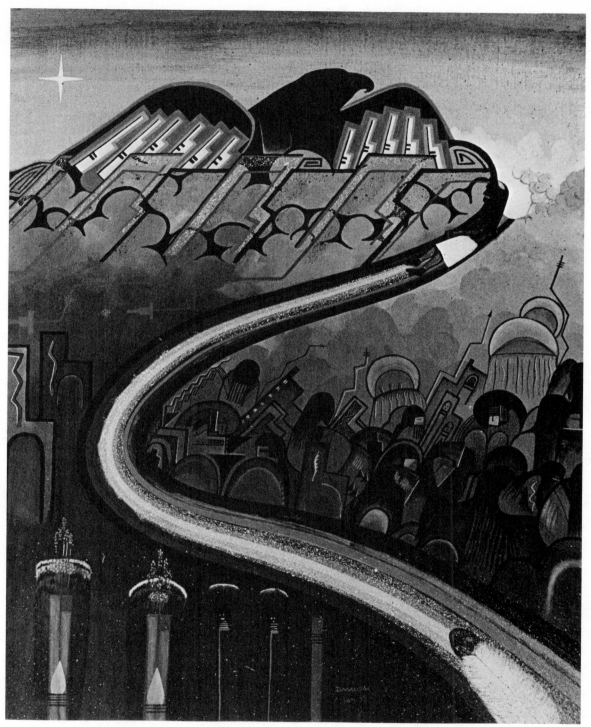

8-12. *Dawakema–Milland Lomakema. Journey to the Underworld. 1973. 28" x 22".
Acrylic. Private Collection.*

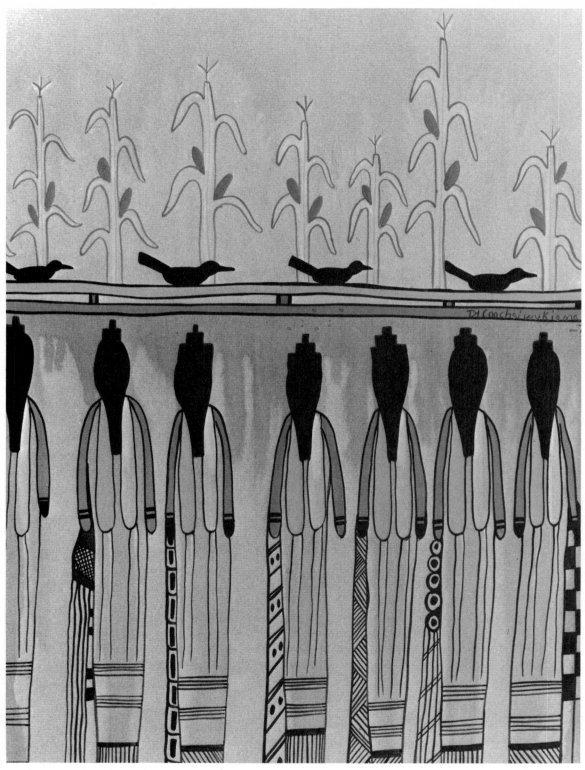

8-13. *Coochsiwukioma–Delbridge Honanie. Corn Spirits. 1976. 19" x 14". Acrylic. Collection: Hopi Cooperative Arts and Crafts Guild.*

birds' nests high in the rocky cliffs of northern Arizona and evade the protective zeal of the mother eagle. When the young eagles are captured, they are tied to cradle boards and carried like Hopi babies on the journey back to the mesas. Once in their new homes, their heads are washed in white suds and the eagles are named. The young birds are given Kachina dolls and plaques and are treated as children. The birds are tied to the house tops and fed and cared for until it is time to "send them home to the Spirit World." After the Hemis Ceremony, the Hopis bloodlessly kill the birds by pressing on their windpipes and thus return them to the Spirit World. They pray that the eagles' spirits will forgive them and will return the next year as young birds. The feathers are removed from the birds and sorted. The bodies of the eagles are buried with an elaborate ceremony in a special eagle cemetery. Their graves include Kachina dolls, woven plaques, a ladder, and food, because the spirits are expected to depart from the grave on the fourth day.

This yearly cycle of eagles who are sent home to the Spirit World has many similarities to the cycle of Hopi life, for when the Hopis have completed their journey on the Path of Life, they too must return to the supernatural world. The eagles are the most powerful of birds and the eagle and eagle feathers represent the power of Emergence and the regeneration of life. This magnetic life force, the power for the continuous renewal of life, is the essence of the Hopi cycle of life.

NOTES

1. Don C. Talayesva, *Sun Chief: The Autobiography of a Hopi Indian.* Leo W. Simmons, ed. (New Haven: Yale University Press, 1963), p. 261.

2. Polingaysi Qoyawayma (Elizabeth White), *No Turning Back* (Albuquerque: The University of New Mexico Press, 1964), p. 35.

3. Talayesva, p. 220.

CHAPTER 9

A Continuity of Culture—The Murals of Awatovi

Hopi painting in the mid-twentieth century is a clear reflection of life in the Hopi world. Today Hopi art and Hopi life are complex blends of an ancient world and modern society, of tradition and innovation. Tribal histories and current politics each have a vital impact on contemporary Hopi life and art. It is the strength of tradition in Hopi history, religion, and art that has enabled the Hopi culture to retain its validity and vitality. In the Hopi world, the belief and ceremonies of the past continue to pervade every aspect of modern life. Generation after generation continues to participate in the same religious rituals and ceremonial celebrations. As they follow the Hopi Way, the Hopi people continue to emphasize the same basic goals as necessities for achieving a fruitful and meaningful life.

The powerful impact of the past on present-day life is echoed in the influence of the artistic creations of the past on modern Hopi painting. Petroglyphs, ancient pottery, basketry and textile patterns, images and designs from ceremonial altars, masks, tablitas, dance wands, and prayer sticks, all are incorporated in the work of Hopi contemporary artists. It is the ancient kiva murals, however, particularly the murals discovered in the Awatovi ruins which were excavated in the 1930s, which have had the greatest influence on the work of modern Hopi painters.

The Awatovi murals are not simply decorative patterns and images from the past, for they served an important function in religious ceremonies which were the keystone of Hopi

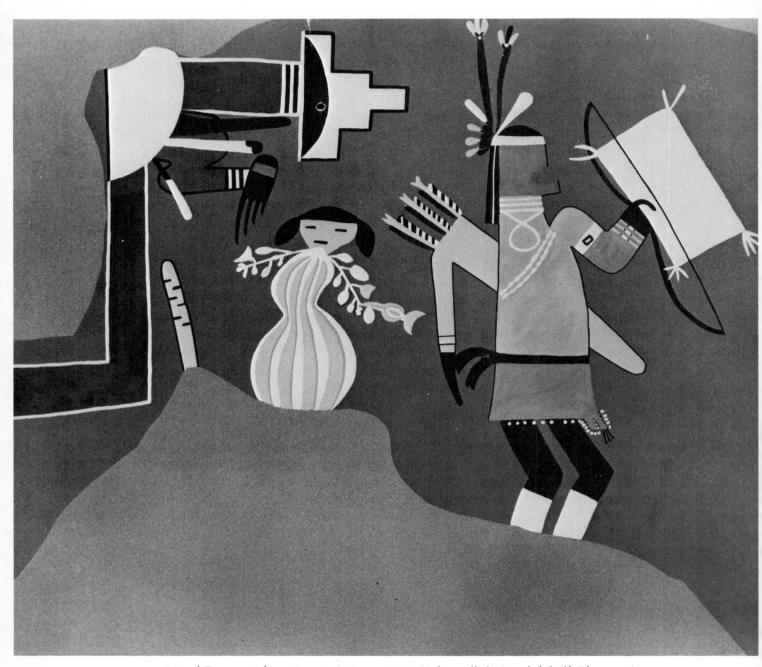

Mural Fragment from Awatovi. *Room 529. Right wall design, left half. The warrior figures and Squash Maiden appear to be unrelated to the baseband and are characteristic of Layout Group II. Peabody Museum Papers, vol. XXXVII, fig. 61b. Photograph. Collection: Peabody Museum, Harvard University, Cambridge, Mass.*

Fragment from Awatovi. *Test 14, Room 3. Right wall design 12. This design is characteristic of intricate Sikyatki style of Layout Group II. Note feathers, wings, clouds, and scrolls arranged radically around a central focus. Peabody Museum Papers, vol. XXXVII. fig. 48 a. Photograph. Collection: Peabody Museum, Harvard University, Cambridge, Mass.*

life. The murals were painted on a single wall of the kivas, the subterranean chambers in which the most sacred ceremonial rites were performed. It has been suggested that the earliest of the Awatovi kiva murals had the same function as upright altars and were used in place of painted screens and flat altars.[1] In the upper corners of the murals are open spaces on which pahoes, tiponis, and other ceremonial objects were placed. Several murals consist of horizontal and vertical bands which divide the wall space into rectangular patterns. It is conceivable that these rectangular murals served as borders for flat altars which were set up against the blank spaces, for these border murals contain images of corn, pahoes, prayer sticks, painted bowls, and many other ceremonial objects which traditionally surrounded kiva altars.

The same ancient ceremonies depicted on the walls of the Awatovi kivas are still observed in the Hopi villages today. The Soyal Ceremonies, the Powamu Ceremonies, the Wuwuchim Ceremonies, the Snake and Flute Dances continue to be an important part of the ceremonial year (see chapter 7). They are observed today as they have been through the centuries, for they have retained their meaning through the years. Deities represented in the murals, for example, Muingwa, the Germinator, and the Warrior Twins (see chapter 5) continue to live in the legends of the Hopis. Three of the most important Kachinas represented in the Awatovi murals, Ahula, Eototo, and Chaquina, continue to play a vital role in the spiritual life of the Hopis.

The iconography of the Awatovi murals continues to be the predominant iconography of contemporary Hopi painting. The traditional staples of the Hopis, multicolored corn, squash, and cotton (represented by kilt designs) and religious objects like tiponis, pahoes, prayer sticks, and netted gourds, which are recurrent images in the murals, are not thought of as archaeological specimens or museum relics, but retain their meaning as sacred religious objects which are still a vital part of Hopi homes, shrines, and kivas and continue to be used in almost all Hopi ceremonies. Water and fertility symbols, such as clouds, rain, snow, and lightning, and germination symbols, such as frogs, turtles, tadpoles, and dragonflies, continue to be major design elements of ceremonial art. Kachina masks, rain sashes, and tablitas are worn in the Hopi ceremonies today as they were in the past. Sacred birds (particularly parrots and eagles) and feathers retain their symbolic importance in Hopi ceremonial life. J. L. Brew in his foreword to the report of the Peabody Museum of American Archaeology and Ethnology, Harvard University, on *Kiva Mural Decorations at Awatovi and Kawaika-a* observes that "one of the most important aspects of the study is the fact that the history so preserved represents an unbroken current of cultural development which is still flowing in the modern Hopi towns and farms. Thus we have at hand one of the ideal situations in archaeology where the archaeologist can use effectively the researches of ethnologists, comparing the living culture of the present with that of the past, insofar as the latter may be deduced and reconstructed from the evidence in the ruins. The Expedition was particularly fortunate in that respect in the discovery of the wall paintings described in this report."[2]

It is to celebrate "this unbroken current of cultural development" and to emphasize the unifying bond of the past and the present that members of the Artist Hopid choose both the style and images of the Awatovi murals to express their vision of the Hopi world today.

The Peabody Museum Awatovi expeditions encompassed five years of field research. From 1925 to 1930, archaeologists excavated twenty-one sites which included the Jeddito Valley, Antelope Mesa, Roberts Mesa, Tallahogan Valley, and Bluebird Canyon. The drainage of the Jeddito River lies in northeast Arizona between 35 degrees and 36 degrees north

latitude. It is partly in the Navajo Reservations. The Awatovi ruins cover twenty-three acres and include an estimated five thousand rooms. The expedition excavated approximately thirteen hundred rooms which were used (not simultaneously) from the thirteenth to the eighteenth centuries and the ruins of a Spanish Franciscan mission, San Bernardo de Aguatubi, built during the seventeenth century. In addition to the Awatovi ruins, the Jeddito area also contains five other large pueblos and hundreds of small villages and houses built and occupied from about A.D. 500 to the present, a period lasting almost fourteen hundred years.[3]

The expedition grew out of the dedication and interest of William H. Claflin, Jr. In 1912, Claflin first became acquainted with the land of the Hopi and the ruins in the vicinity of the modern villages. Interested in exploring the archaeological possibilities of the Jeddito Valley, Claflin suggested the expedition and, with several private benefactors and the Exploration Fund of the Peabody Museum, subsidized the expedition. The murals were first discovered in 1936, the second season of the expedition. It is noted in the report that the murals "were found in sufficient profusion so that at least one kiva with painted walls was being worked at Awatovi or Kawaika-a at all times throughout the four main excavation seasons."[4]

The Awatovi murals were painted on a dry plaster base. Kiva murals were periodically replastered and new murals painted. In the excavation process, each layer was exposed, photographed, and a detailed drawing made to scale. Each layer was then preserved by an elaborate stripping and remounting procedure.[5] Detailed scale reproductions of the murals were made by painting on synthetic plaster and painting on illustration board.[6] In the kivas excavated, the number of plaster layers ranged from more than one hundred (Room 218 at Awatovi) to eight at Kawaika-a.[7]

Undoubtedly some of the murals were plastered in order to renew the surfaces, but more important was the need to obliterate sacred representations and change the murals with the progression of the ceremonial cycle. Delbridge Honanie, in *Symbols of the War God* p. 94 , a painting that represents two eras of Bear Clan Warriors, depicts the layering of the plaster and the murals. Honanie explains that each year the kivas are whitewashed and a new mural painted on the whitened surfaces. In Honanie's painting, which includes the ruins of two murals and the whitewashed surface of an ancient kiva, a new layer appears over the image of the Warrior Twins so there are three layers of paint beneath which are the rocks of the Hopi world. A line of Bear Clan Warriors is painted on the whitewashed surface and the four parallel lines represent four days. Pokanghoya is part of Bear Clan history, and Honanie paints his image in the style of the ancient murals.

All of the ancient murals have certain common characteristics: The paint is spread with uniform density and without shadow. The color areas are separated by definite, sharply marked lines and there is never shading or blending of color areas. The artists occasionally used a dry brush technique in which the color fades in relation to the pressure of the brush on the surface and a spatter technique which gives a spotted effect. The artists bordered or outlined each color area with a continuous line, which is predominantly black or white but is occasionally red. The members of the Artist Hopid follow the Awatovi style and paint broad areas of color, black and white outlines, and use both the dry brush and spatter techniques. The Awatovi murals were painted predominantly in earth tones, vermilion, brown, green, and maroon as well as blue, purple, black, gray, and white. With the exception of black, the pigments used for the kiva murals are entirely inorganic. They were ground from natural minerals and mineralized bits of sandstone and clay, for example, red and

Mural Fragment from Awatovi. Room 788. Right wall design 4. Note the migration spiral in the lower left figure. Collection: Peabody Museum, Harvard University, Cambridge, Mass.

206

Fragment from Awatovi. *Test 14, Room 2. Right wall design 6. Peabody Museum Papers, vol. XXXVII. Photograph. Collection: Peabody Museum, Harvard University, Cambridge, Mass.*

yellow ochres, malachite, and azurite. Black pigments were from various forms of carbon.

The most common method for binding the pigments to the plaster surface was to pulverize the pigments and then mix saliva into the resultant powder. Saliva was generated by chewing a variety of seeds which secrete a vegetable oil. Occasionally the artists used the white of eagles' eggs to obtain a glossy surface sheen. The ancient mural painters used strips of yucca leaves which were chewed at one end in order to form bristles as brushes. They also used strips of a green corn husk which they bent over their finger. Occasionally they used their fingers to spread the paint over the surface of the plaster and then used a brush for the outline.[8]

In their work, members of the Artist Hopid utilize the earth tones of the murals or the bright colors of Kachina masks in accordance with specific artistic goals. At first, members of the Artist Hopid worked in casein or watercolor. Today they use, primarily, acrylics to paint the traditional images and ancient rituals of the Hopi world. This use of plastic paint and commercial brushes is another example of the fusion of the past and the present in contemporary Hopi art.

Scientists used approximately two thousand tree-ring specimens, mostly fragments of timbers from the ancient buildings, to establish a chronology of the ruins.[9] The system of dating tree rings, established in 1929 by Dr. A. E. Douglass of the University of Arizona, has become an important tool for archaeologists. Ethnologists have established six general categories of cultural periods:

Basket Maker	prior to A.D. 700
Pueblo I	A.D. 700–900
Pueblo II	A.D. 900–1100
Pueblo III	A.D. 1100–1300
Pueblo IV	A.D. 1300–1550
Pueblo V	A.D. 1500– [10]

Archaeologists believe that wall painting is evident as early as Pueblo II and was at its height during Pueblo IV. The Harvard archaeologists believe that the latest of the Awatovi kiva murals, Room 788, was constructed no later than the mid-sixteenth century and was probably completed early in the sixteenth century. Other rooms contain murals that date from the fourteenth and fifteenth centuries.[11] The Awatovi murals, therefore, are the artistic expression of a period that is, basically, pre-contact, for they were completed before any significant Spanish or Anglo influence. Today these murals have become symbolic of Hopi cultural integrity—Hopi art uncontaminated by foreign influences.

The Spanish in the seventeenth century also recognized the symbolic role of the kiva and kiva murals and, therefore, chose to build their mission directly over Room 788, thus, physically and symbolically emphasizing the superiority of their culture and religion over that of the Hopis. Terrance Talaswaima in *Awatovi* p. 6 , has painted the detested San Bernardino Mission. Talaswaima explains that he surrounds the colorless, lifeless forms of the church with the colorful figures and symbols taken directly from Awatovi mural fragments in order to show that the ancient images and rituals have the greatest spiritual value for the Hopi people. Talaswaima image of the church is the only element of Anglo or Spanish culture found in any of the modern Hopi paintings. The only possible exception is the Cubistic study of a black Kachina, which Mike Kabotie has entitled *The Christian Kachina*

(Fig. 9–1). It is believed that this black Kachina evolved from Estevan, the black Moorish slave who in 1539 preceded Father Marios de Niza to Zuni on his expedition to find The Seven Cities of Cibola. Estevan, the first non-Indian to make direct contact with the Zunis, was killed in 1539 in Hawikuh. Estevan is the only non-Hopi to be transformed into a Hopi Kachina spirit or to become part of a Hopi ceremony.

Thanks to the dryness of the climate, the archaeologists also obtained examples of basketry, pottery, and fragments of cloth from the Awatovi site, and pieces of carved wood from the ecclesiastical buildings. The archaeologists used pottery sequences as well as tree rings to date the rooms. They divided their pottery findings into three distribution patterns and from these patterns determined the sequence of murals, ultimately dividing the murals into four chronological and stylistic groups, termed Layout Groups.[12]

They used as criteria: inclusion of figures (anthropomorphic, zoomorphic, biomorphic, and inanimate) and ceremonial objects, as opposed to the use of geometric and nonrepresentational designs, balance and symmetry of design, and the inclusion or exclusion of a baseband and the contact of the baseband with the figures and objects.

Layout Groups I and II include representations of anthropomorphic figures, animal and plant forms, ceremonial objects, water symbols such as clouds, rain, lightning, and rainbows. The anthropomorphic figures represent Deities, Kachinas, and Priests. These figures and symbols have deep roots in Hopi cultural history, for they are derived from petroglyph figures and designs and from images on ceremonial paraphernalia.

The major difference between Group I and Group II is that the forms in Group I are attached to a baseband. The grounding of these forms produces a sense of immobility. Group I murals evoke a sense of stability, for the images in these compositions are in a fixed relationship to each other and to the decorative surface as a whole. The overall composition of these murals is characterized by balance and symmetry. The murals of Group II have similar figures and symbols but do not have basebands to contain or restrict the figures. These murals give the impression of freedom and motion. These murals often include representations of Warrior figures. The Group II artists appear to have been less preoccupied with anatomical accuracy and costume detail and drew figures with greater freedom. In contrast to the murals of Group I, the compositions of the Group II murals are characterized by a lack of symmetry and balance.

Murals in Group III and IV consist of design patterns rather than of representational forms. Many of the designs in Group III resemble the designs of Sikyatki pottery (see chapter 10), for they include elaborate scrolls, stylized feathers, and tail and wing designs. Several designs utilize bold geometric patterns. The murals in this group include bold, highly stylized animal and bird forms. The paintings in Layout Group IV are simplified animal forms and designs that are similar to very early pottery designs. Thanks to the tree-band and pottery-dating techniques, anthropologists have determined that the Group IV murals were the earliest and the Group I murals were the latest to have been painted in Awatovi.[13]

The members of the Artist Hopid have chosen to work in a style and to utilize forms which are closest to the murals of Layout Group I and II, for these murals are the most comprehensive artistic statements of Hopi cultural history. Because of their balance and symmetry of design and their static, timeless quality, these murals emphasize the unity and stability of the Hopi culture.

It is the history of Awatovi, the existence of two conflicting cultures on a single site, which gives the village exceptional cultural significance in the minds of contemporary anthropologists and ethnologists and gives artistic inspiration to modern Hopi artists. The

Mural Fragment from Awatovi. *Room 788. Note Priest with cloud blower and parrot, and figure holding netted gourd. Kilts have scroll borders and rain sashes. The design of this mural fragment is characteristic of Layout Group I. Peabody Museum Papers, vol. XXXVII, fig. 816. Photograph. Collection: Peabody Museum, Harvard University, Cambridge, Mass.*

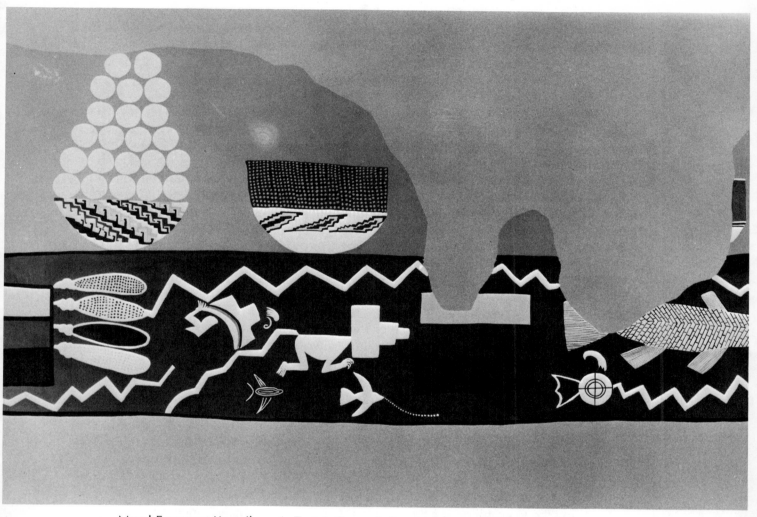

Mural Fragment Kawaika—A. Test 4, Room 4. Front, right, and back walls designs, left half. Note frog, lightning, terraced cloud fertility image, and ceremonial bowl with ears of corn. The design of this mural fragment is characteristic of Layout Group 1; however, the baseband is exceptionally wide and includes images. *Peabody Museum Papers,* vol. XXXVII, fig. 66a. Photograph. Collection: Peabody Museum, Harvard University, Cambridge, Mass.

two principal reasons for the selection of Awatovi as the site of a major excavation were the village's long record of occupation and the existence of the ruins of the late seventeenth-century Franciscan mission.

In 1583, Antonio de Espejo marched toward Awatovi (Aguato in the expedition chronicles). The Hopis, filled with suspicion and terrified by tales of Spanish brutality and greed, formally welcomed the explorers before sending them forward in their search for The Seven Cities of Cibola. The name Awatovi means "place of the bow," which is derived from the power of the Bow Clan in the village. The other powerful clans in Awatovi were the Tobacco, Sun, Rabbit, Badger, Eagle, and Parrot Clans. The principal rituals of the village were the Two Horn Ceremony and the Wuwuchim Ceremony.

In 1598, Juan de Onate visited the Hopi villages, including Awatovi, in order to receive the formal submission of the Hopi people to the King of Spain; however, the Spanish mission programs were not instituted until 1628 when a Franciscan visited the village. A year later three missionaries and some soldiers were assigned to the Hopis and began the construction of the San Bernardino Mission at Awatovi, San Bartoleme at Shungopovi, and San Francisco at Oraibi. The missionaries forced the Hopis to help build the churches by cutting and hauling tremendous pine and spruce trees from the distant San Francisco Peaks to the mesa tops. Spanish-Hopi relations worsened when, in 1633, the missionary at Awatovi, Father Francisco Porras suddenly died. For many years it was believed that he was poisoned; however, today scholars question the validity of this theory.[14]

At the time of Father Porras's death, the Franciscans changed their plans for the Awatovi Mission and built a smaller church at a different site, a site directly over an important kiva, thus superimposing Christianity over the Hopi religion. It is believed that the mission at Awatovi served as headquarters for the Franciscans in all of the Hopi villages. For the next twenty-five years, the missionaries tried to convert the Hopis by baptizing as many as possible and by teaching them to read and to write. The Spanish priests looked down upon the Hopi religion as primitive paganism and were horrified by the Hopi ceremonies. The Catholic Church forbade any Hopi converts to take part in any tribal ceremonies or traditional rituals which in the Hopi world encompassed every aspect of life.

In 1680, the Hopis joined in the Pueblo Revolt and killed the four missionaries, two of whom were at Oraibi, one at Shungopovi, and one at Awatovi. The Hopis tore down the churches, demolishing the altar that had been superimposed on the kiva, broke the mission bells, and converted the churchyards into sheep corrals. The hated carved beams or *vigas* of the churches, considered too valuable for firewood, were used as parts of Hopi buildings. Some *vigas* became roof beams of kivas in Shungopovi and Oraibi.[15]

During the years following the Pueblo Revolt, the Hopis gave sanctuary to the Tewa, Tano, and Keres fugitives who feared Spanish reprisals in the Rio Grande Valley. In return for sanctuary, the newcomers promised to help to defend the Hopis against Spanish attempts at reconquest. Two new villages, Hano on First Mesa and Payupki on Second Mesa, were established. Three Hopi villages were moved to more secure positions. Walpi was moved to the tip of First Mesa and Mishongnovi and Shungopovi were moved to the top of Second Mesa. A new village, Shipolovi, was established in the most inaccessible point of Second Mesa in order to protect sacred ceremonial paraphernalia. In 1692, General Don Diego de Vargas arrived at the mesas and found them ready to resist reconquest. Rather than pursue a military confrontation, de Vargas agreed not to fight if the villages would swear allegiance to the Catholic faith and to the King of Spain. The Hopis agreed to this token submission.

During the years following the Pueblo Revolt, almost all the Hopi villages returned to

their traditional way of life. The missionaries, nevertheless, had left their mark on the Hopi world. In several villages a schism developed between those devoted to Christianity and those true to the Hopi Way. This was especially true in Awatovi, where several Hopis remained steadfast in their conversion to Christianity. In 1699, a group of Christian converts sent a delegation to Santa Fe offering to rebuild the mission and requesting the return of the missionaries. The subsequent arrival of three missionaries in Awatovi caused great dissension in the village. The missionaries once again opposed all Hopi religious ceremonies, seized religious paraphernalia, destroyed shrines, and demanded that the people completely abandon the ways and beliefs of their ancestors. Tensions increased when a missionary arrived from Zuni and baptized seventy-three children. Francisco de Espeleta, the Village Chief of Oraibi, was the leader of those who wished to remain faithful to the Hopi Way. Espeleta sent a delegation to Santa Fe to ask for religious freedom and was denied his request. Open conflict became inevitable.

There are many stories which account for the destruction of Awatovi, but most versions follow the same general outline. Tapolo, Chief of Awatovi, was distressed over the religious conflict in the village and disturbed that many of his people had abandoned the Hopi religion and the Hopi way of life. He turned to the Chiefs of those villages that opposed the Spanish and asked their support in his plan for destruction of Awatovi. On a chosen night, when the Awatovi men were meeting in a kiva, the Warriors' Societies of Oraibi, Mishongnovi, and Shungopovi surrounded the kiva and pulled up the entrance ladders, trapping the men inside. Then they set fire to bundles of wood and strings of peppers and threw them through the collapsing roofs, killing the men inside. Most of the male population of Awatovi were killed and the remaining women and children were divided among the victors so that the clans and their rituals would be perpetuated in the Hopi villages. Awatovi was abandoned and fell to ruins, and it is believed that Massau, the God of Death, reigns as Village Chief. In 1892, a burial ground Skeleton Mound, was excavated by Jesse W. Fewkes. Fewkes published the details of this excavation in the *American Anthropologist* in 1893.

By destroying Awatovi, the Hopis ended the division among the people and the influence of the Spanish Crown and the Catholic Church upon the Hopis. In *Cycles of Conquest*, Edward Spicer concludes: "Spanish contact produced parties and issues with reference to the Spanish elements of culture, but as did not happen in the other cases, the Hopis for over a century were able to settle these issues among themselves without Spanish interference. The result was a clear choice of the Hopi way of life as against the Spanish."[16]

The first written observation describing Hopi mural paintings was that of Captain J. G. Bourke of the U.S. Army who in 1881 visited the Hopi villages, witnessed a Snake Dance, and subsequently described cloud, sun, moon, rain, star, snake, and antelope images as well as representations of Aloska, Star Kachinas, and Chaquina. Both Victor Mindendorf, who visited the mesas during the summers of 1882 and 1883, and Alexander M. Stephen, who also lived among the Hopis in the 1880s and made extensive anthropological studies, had the opportunity to see kiva mural paintings. These early Anglo visitors to the mesas saw only murals painted many years after the destruction of Awatovi, murals that show clear evidence of both Spanish and Anglo cultural influences. It is the Harvard excavations that made it possible to study kiva murals painted in the centuries prior to contact with explorers, missionaries, and anthropologists.

For members of the Artist Hopid, the Awatovi murals symbolize Hopi cultural integrity. These murals created before the intrusion of the Spanish and the Catholic Church, stand as eloquent expressions of the Hopis' artistic and religious heritage. The Awatovi murals,

painted years before the creation and destruction of the Mission of San Bernardino in Awatovi, include representations of religious ceremonies, Kachinas, Deities, animals, plants, pahoes, and all symbols of germination and regeneration that have been the basis of Hopi culture for centuries. Today the discovery and excavation of murals beneath the ruins of the mission are interpreted as a symbolic resurrection of Hopi art and Hopi culture. It is for this reason that the Artist Hopid painted *The Hopi Ceremonial Calendar* (Fig. 7–5) in the style of the Awatovi murals, a style which they remind us "was used in painting kiva frecoes long before the coming of Columbus and the Bahana."[17]

The Awatovi style of modern Hopi painting is characterized by flat areas of color bordered by black and white lines. The artists utilize stylized two-dimensional figures, many of which are identical to those in the Awatovi mural fragments, and traditional symbols of rain, clouds, snakes, rainbows, and netted gourds. In the *Hopi Ceremonial Calendar* mural, narratives in overlapping circles describe the ceremonial year. Across the circles are lines defining the surface of the earth and water. Each circle is vertically divided by a central form—pahoes, corn, lightning, rainbow. The surface lines, central forms, and interlocking borders of the circles which link the narratives have the same artistic function as the basebands of the Awatovi murals and thus add stability and balance to the mural.

The members of the Artist Hopid are not the first Hopi painters to be inspired by the Awatovi murals. In the mid-1940s, before the Harvard Papers on the Awatovi excavation were published, Fred Kabotie painted *Germination* (Fig. 9–2). Kabotie explains that he was inspired by the ancient paintings. Most of the images are based on the excavated fragments. The Rain Priest is almost identical to the mural representation, whereas Kabotie has improvised in creating the figure of Muingwa. The rainbow serves as the baseband.

Today each of the members of the Artist Hopid uses the images, the symbols, and the style of the Awatovi murals in order to achieve individual artistic goals. Neil David, Sr., has facility both in combining many representational elements in a united, highly complex composition and in creating a simple composition focused on one or two stylized figures. He includes in his work images which are identical to those in the murals and invents forms which are true to the Awatovi style. Neil uses these forms as elements of compositional design in order to create a work of art that is simultaneously innovative, yet part of Hopi tradition.

Awatovi Ceremonials (Fig. 9–3) is David's comprehensive statement on the importance of germination and regeneration in the Hopi world. Many of the figures, symbolic forms, and design elements are quoted directly from the Awatovi murals; however, each form is an integral part of the whole and has importance as a symbolic recreation of the past and as a creative expression of the focus and meaning of contemporary Hopi life. All of the figures are painted against a panorama of earth and sky. Earth and sky are divided by a line which represents the surface of the earth and by a rainbow which not only serves the function of the baseband but unites all the elements of the painting into a microcosm of the Hopi world. David explains that the central figure of the composition is Ahula, the Germination God, and Sun King. Ahula symbolizes the creative force central to the Hopi world. Above the rainbow are images of Hehe, three Cloud Maidens, and Muingwa. Below Ahula is a Rain Priest standing over a bowl of flowers which represents crop fertility. Opposite the priest is Kokopelli, the humpbacked flute player, who represents human fertility. Below these figures are water symbols—the turtle, the waterlily, and the dragonfly—and symbols of the evolution of life—the tadpole and the frog. In this painting, David uses primarily earth tones in order to emphasize the regeneration of life on Earth. Surrounding these figures are corn

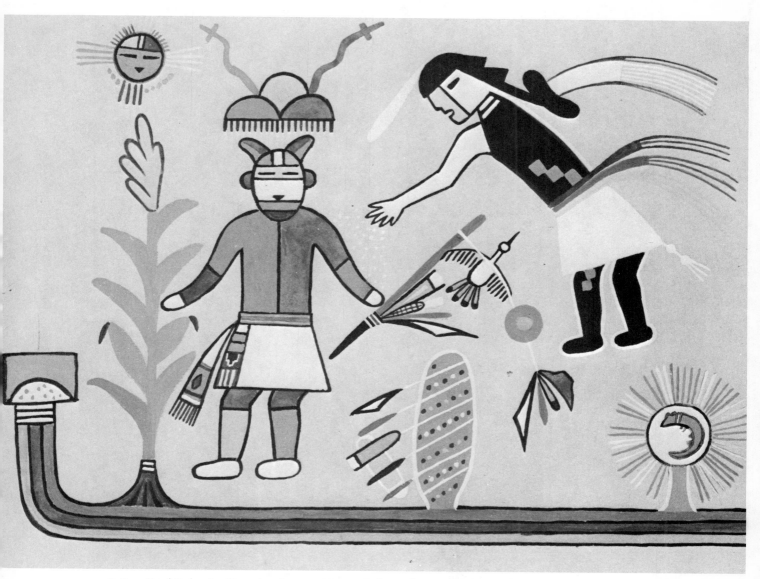

9-2. *Fred Kabotie. Germination. c. 1945. 9¹/₂″ x 12″. Watercolor. Gift of Byron Harvey to Hopi Cultural Center Museum.*

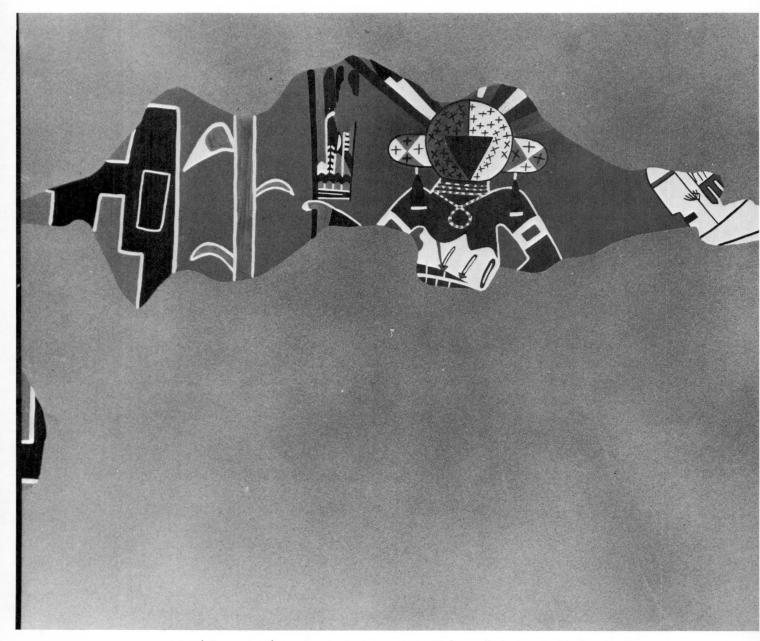

Mural Fragment from Awatovi. *Room 788. Right wall design 4. Ahula, the Germinator, holds a prayer stick. Peabody Museum Papers, vol XXXVII, fig. 79a. Photograph. Collection: Peabody Museum, Harvard University, Cambridge, Mass.*

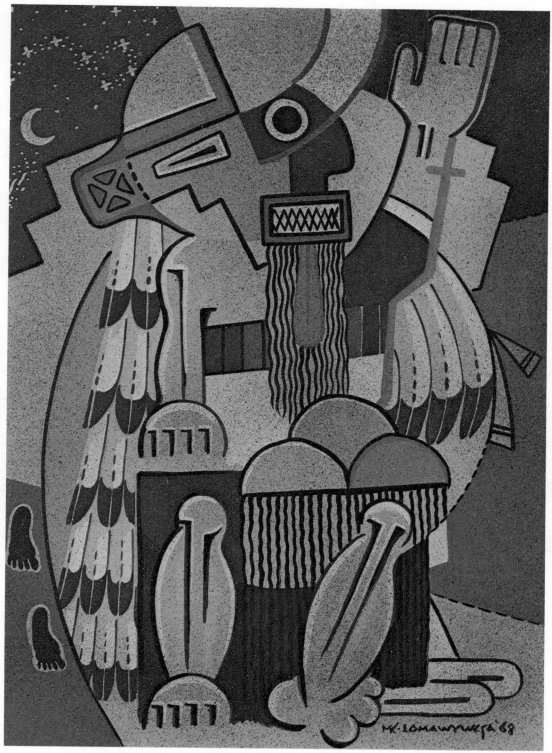

9-1. *Lomawywesa–Mike Kabotie*. The Christian Kachina. *1968. 20" x 14¹/₂". Mixed media. Gift of Byron Harvey to the Heard Museum of Anthropology and Primitive Art (Indian Collection), Phoenix, Ariz.*

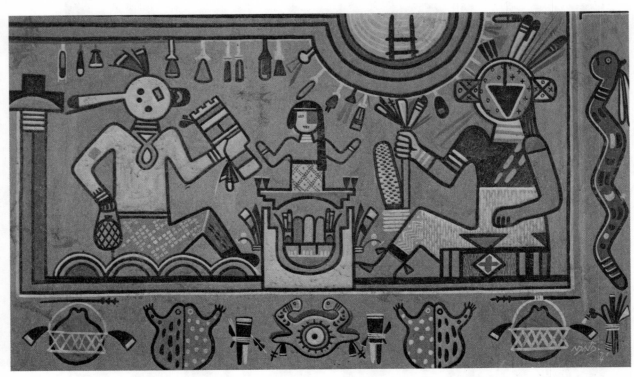

9-5. *Neil David, Sr.* Murals of the Kachina Society. *1974. 36″ x 60″. Acrylic. Collection: Hopi Cooperative Arts and Crafts Guild.*

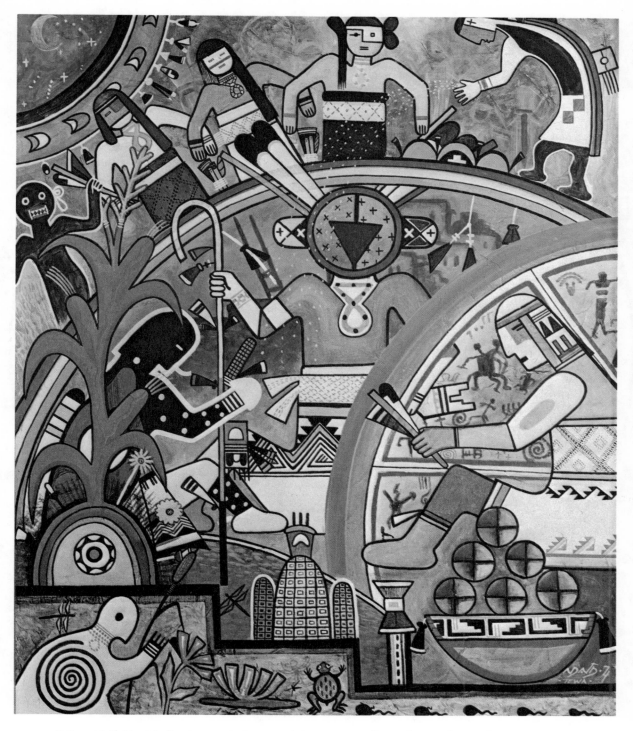

9-3. *Neil David, Sr. Awatovi Ceremonials. 1974. 49" x 40". Acrylic. Collection: Hopi Cooperative Arts and Crafts Guild.*

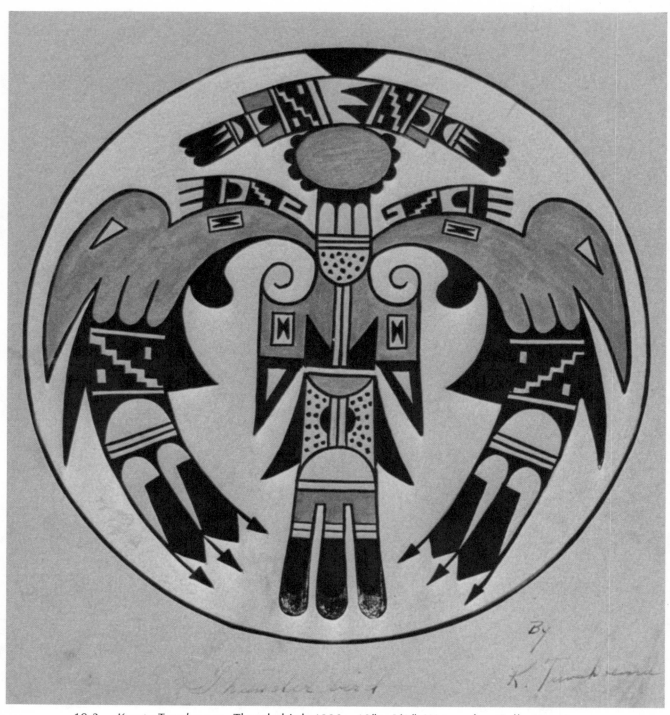

10-3. *Kyrate Tuvahoema. Thunderbird. 1930s. 10" x 8¹/₂". Watercolor. Collection: James T. Bialac, Scottsdale, Ariz.*

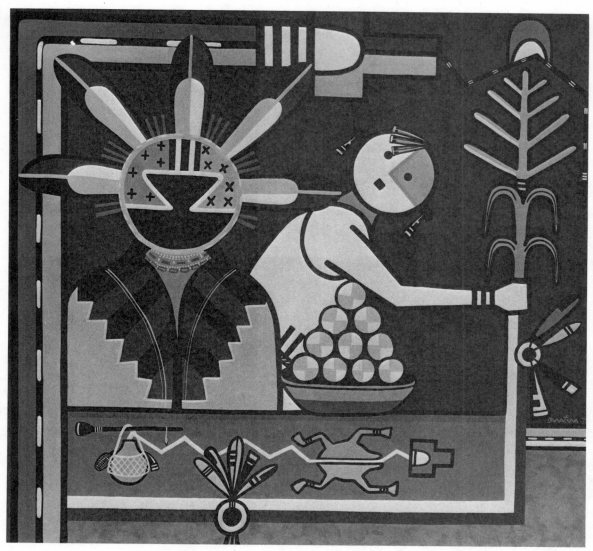

9-4. *Dawakema—Milland Lomakema. Rain and Corn Clan Priests. 1975. 48" x 50".*
Acrylic. Collection: Hopi Cooperative Arts and Crafts Guild.

images, prayer feathers, and symbols of heaven and Earth, as well as petroglyphs and Migration symbols, which represent the past history of the Hopis. Behind Ahula is an outline of the houses of the mesas.

In *Ahula, the Germinator* p. 17 , Neil David, Sr., celebrates the life-giving powers of the sun. The bright colors and bold, radiant forms proclaim the strength of the germinative force in the Hopi world. The background is a fiery red, free of symbol or surface decorations, for nothing must detract from the powers of Ahula. *Giver of Life* p. 45 is a closeup of the mask of Ahula which, like the sun, shines upon the netted gourd and prayer feathers. David uses images of a magnified sun mask and a sacred water vessel to emphasize that sun, water, and prayer are the basic necessities of life in the Hopi world. David explains that the prayer feathers depicted in this work come from the turkey because the turkey was domesticated by the Hopi.

Mike Kabotie, like Neil David, Sr., finds inspiration in the Awatovi image of Ahula. Mike however, combines a representation of the head of the Sun Kachina—which is similar to the image painted on the ancient mural fragments—with a Cubist body. This combination is symbolic of the fusion of past and present and is symbolic of contemporary life, for Mike is conscious of living in a transitional world, and through his paintings he attempts to reconcile the changes that the past three centuries have brought to life on the mesas. In *The Candidate* p. 38 , Ahula campaigns political for office, for today the Hopis are experimenting with democracy after centuries of living under a theocracy; therefore, even a deity who is the righthand man of the Sun must seek popular affirmation.

In *Rain and Corn Clan Priests* (Fig. 9–4), Milland Lomakema turns to the Awatovi murals for his images of Ahula and Eototo. Milland uses Awatovi images to create a simple two-dimensional statement of the yearly cycle of fertility, germination, and harvest. Milland simplifies and stylizes all symbols and design elements and incloses these figures with bands composed of rainbow, cloud, lightning, and corn forms.

Neil David, Sr., in *Murals of the Kachina Society* (Fig. 9–5), paints Awatovi images of Ahula and Eototo above a border of pahoes, frogs, and a netted gourd—a combination frequently used in the Awatovi murals. Whereas Mike Kabotie simplifies and abstracts the Awatovi images in order to give his work connotations of both past and present, David's work adheres to the colors, composition, and iconography of murals in order to force the viewer backward in time to a preindustrial age when all Hopis believed that prayer and the rituals of germination were the key to the survival of the Hopi people. David believes that the Awatovi murals symbolize the powers of endurance and that by painting in the ancient style and using images taken directly from the kiva murals his work will proclaim the strength of the Hopi culture. *Cloud Maidens* p. 164 takes the form of an ancient mural, but in this painting David has invented most of the Awatovi-style images.

Not all of Neil David's Awatovi-style paintings, however, are recreations of ancient murals, for he also experiments with many twentieth-century techniques. *Kiva Murals* (Fig. 9–6) and *Awatovi Murals* (Fig. 9–7) are Cubist paintings based on Awatovi images of Pokanghoya, the Warrior Twin, and Eototo (Fig. 9–8) (quoted by Terrance Talaswaima in *Awatovi*) p. 6 .

Neil David, Sr., frequently utilizes the style of the Awatovi mural to demonstrate the reemergence in modern art of ancient artistic traditions, which is indicative of the regenerative powers of the Hopi culture. *Spider Woman and Muingwa* p. 40 and *Giver of Life* p. 144 both proclaim the all-importance of the germinative force in Hopi life. *Awatovi Eagle Priest* (Fig. 9–9) depicts a guardian of the eagle who is an important intermediary of the

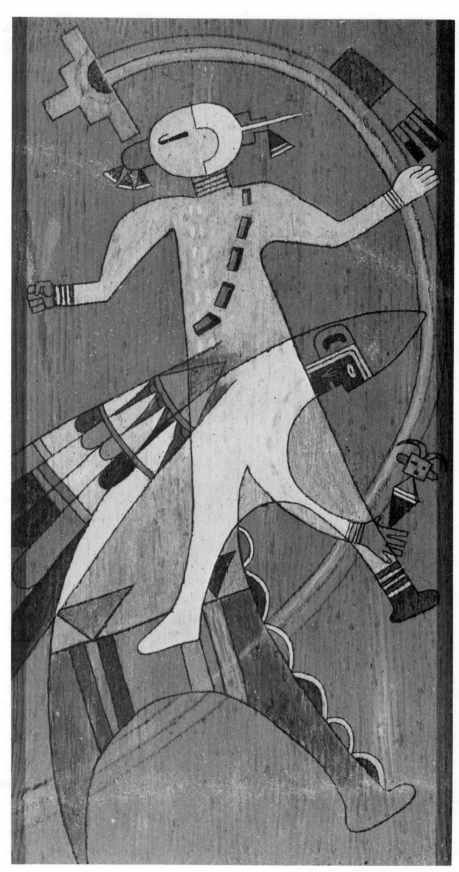

9-6. *Neil David, Sr.*
Kiva Murals. 1973.
30" x 14¹/₂". Acrylic.
Collection: Hopi Coopera-
tive Arts and Crafts Guild.

Hopis in their prayers for rain for their crops. In both *Awatovi Snake Society* p. 147 and in *Snake Society and Prayers with Warrior Maidens* p. 80, David uses the stylized images of the murals to celebrate ceremonies and symbols that have retained their meanings through the centuries.

In many of his paintings, Terrance Talaswaima depicts a highly individual world populated by Corn Spirits and Deities, but occasionally, for example in *Spider Woman and Warrior God* p. 93 , uses figures from the Awatovi murals to express his personal vision of the Hopi world.

Of all the members of the Artist Hopid, Delbridge Honanie paints in a style and evokes a mood closest to that of the Awatovi murals. Unlike Neil David, Sr., who utilizes a tremendous variety of styles in his work, Honanie consistently bases his work on images quoted directly from the Awatovi murals. For example in *Awatovi Women's Ceremony* (Fig. 9–10) he quotes from the mural in order to depict the role of women in the Harvest Ceremonies. In *Flute Player* (Fig. 9–11), he quotes from the fragments to show a mural inside the kiva of the Flute Clan. In *Warriors* p. 72 , Honanie pays homage to the participants in the Snake ritual, and in *Awatovi* (Fig. 9–12), he celebrates the Parrot Clan of the ancient village. In this work he combines both images quoted from the mural and images improvised in the style of ancient Awatovi. In *The Whippers of Old Shungopovi* p. 190 , Honanie paints Sityatki-style mural fragments which can be classified as designs from Layout III, using mural fragments to symbolize the ancient city now in ruins.

The most innovative of Delbridge Honanie's Awatovi-inspired works is *Hopi Ceremony* p. 20 , a composition in earth tones in which Honanie portrays the role of the Bear Clan in Snake rituals (see chapter 4). Against a background of pottery designs and Migration symbols, Honanie paints Awatovi images of Kachinas and of Priests with "cloud blowers" (pipes) .

Milland Lomakema uses the basic symbols of Hopi life as design elements of innovative compositions. In his work he explores the artistic possibilities of line, form, and color using a vocabulary gleaned from the Awatovi murals. Lomakema's work, which is never ideologically complex, reaffirms the focus of the Hopi world—fertility, germination, regeneration, and the survival of the Hopi culture. In *Awatovi Motifs of the Kachina Clan* p. 64 , Lomakema uses the ancient motifs purely as elements of design. He utilizes details from the masks of the Kachina Clan and symbols of the Parrot Clan, using design value as his basic criteria. *Hopi Chief in His Field* p. 70 is close in feeling to the ancient murals. The major stylistic difference is the exaggerated size of the corn stalks which emphasize the role of corn in Hopi life. This exaggeration of proportion, a technique of modern rather than ancient art, is also evident in the *Hopi Ceremonial Calendar* mural, in which towering forms of cornstalks, pahoes and a lightning stick serve as border elements.

In his early work, Mike Kabotie frequently turned to the Awatovi murals for his basic vocabulary of representational forms. *Long Horn with Mana* p. 139 and *Hehe* p. 140 typify Mike's use of Awatovi images to express his vision of the Hopi World. These early paintings, like all of Mike's work, are ideologically complex. Although in recent years Mike has experimented with many styles and artistic devices (see chapter 12), he continues to quote from the Awatovi murals. In *The Candidate* p. 38 , Kabotie's image of Ahula serves as social commentary on Hopi religious and political problems today. At first glance, *Hopi Warrior Spirit* p. 289 is an example of contemporary Pop Art, yet the puma and eagle symbols are taken directly from the Awatovi murals p. 288 . Kabotie describes this work which celebrates Earth and Sky Spirits as "a Hopi macho trip" (see chapter 12).

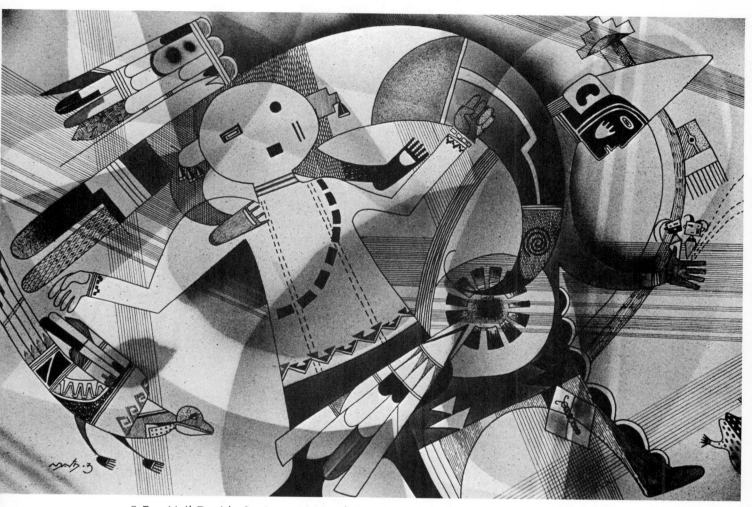

9-7. *Neil David., Sr. Awatovi Murals. 1973. 16" x 23". Ink. Private Collection.*

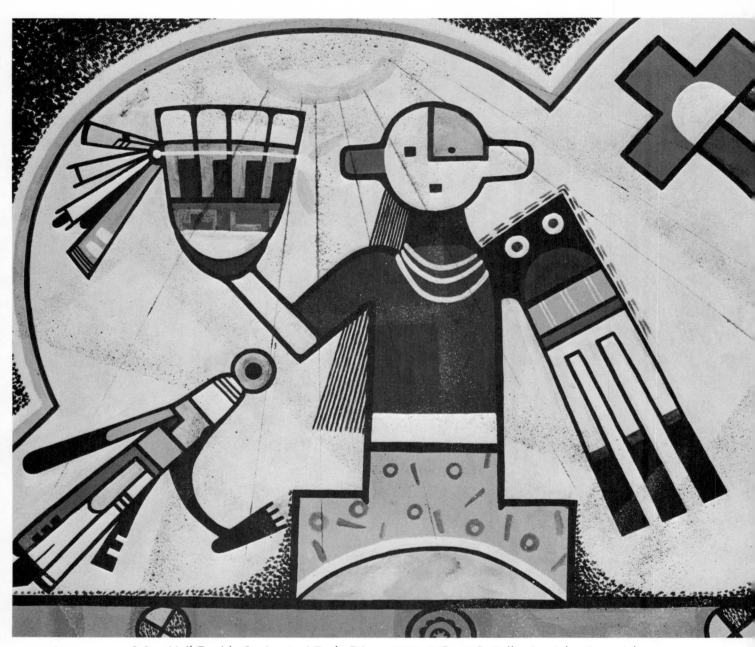

9-9. *Neil David., Sr. Awatovi Eagle Priest. 1975. 21" x 27". Collection:John Cartwright, Santa Fe, N.M.*

9-10. *Coochsiwukioma–Delbridge Honanie. Awatovi Women's Ceremony. 1975. 13¹/₂" x 17¹/₂". Acrylic. Collection:John Cartwright, Santa Fe, N.M.*

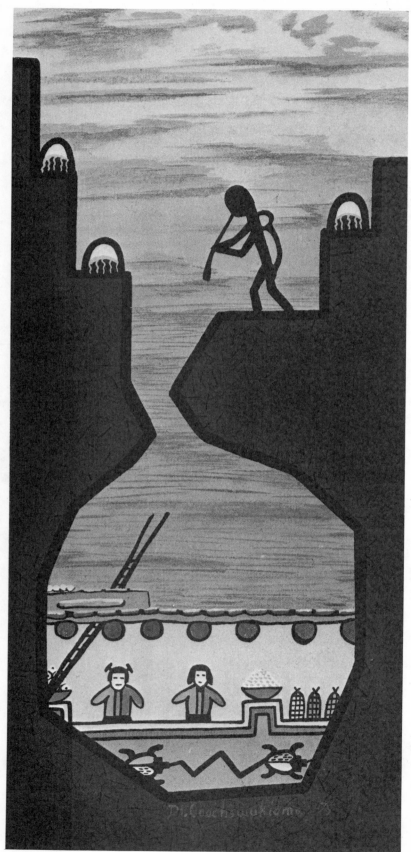

9-11. *Coochsiwukioma–*
Delbridge Honanie. Flute Player.
1975. 19" x 8". Collection:
Hopi Cooperative Arts and Crafts Guild.

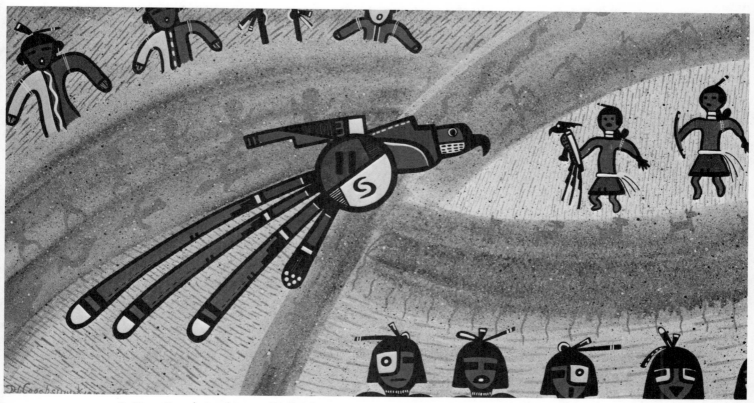

9-12. Coochsiwukioma–Delbridge Honanie. Awatovi. 1975. 14" x 32". Acrylic. Collection: Hopi Cooperative Arts and Crafts Guild.

In surveying the wide range of paintings inspired by the Awatovi murals, it becomes evident that the murals have a tremendous impact on contemporary Hopi painting, for each artist finds a source of inspiration in the murals, which enables him to pursue independent artistic goals. Yet, within this range of individual differences is a central unifying theme, the ability of the Hopi culture to endure. Ceremonies that were the focus of ancient life remain a vital part of the modern Hopi world and symbols of the past retain their meaning today. Anyone who attends the ceremonies of the yearly cycle is able to understand the images of the murals—images of fertility, germination, and regeneration. This especially applies to the Hopi viewer, for the members of the Artist Hopid wish above all to communicate with their own people. When images of the past are painted by artists who have a love, appreciation, and understanding of their own heritage, heightened by twentieth-century vision and a knowledge of contemporary artistic techniques, the viewer can immediately sense a fusion of past and present, the ancient and the modern Hopi worlds. The use of the Awatovi murals in contemporary art thus strengthens the Hopis' identity with their own past. This is the tribal mission of the Artist Hopid.

NOTES

1. Watson Smith, *Kiva Mural Decorations at Awatovi and Kawaika-a with a Survey of Other Wall Paintings in the Pueblo Southwest* (Cambridge, Mass.: Peabody Museum of American Archeology and Ethnology, Harvard University), pp. 319–23.

2. J. L. Brew, Introduction to *Kiva Mural Decorations at Awatovi and Kawaika-a with a Survey of Other Wall Paintings in the Pueblo Southwest*, p. viii.

3. *Ibid.*

4. *Ibid.*, p. ix.

5. Smith, pp. 34–46.

6. *Ibid.*, pp. 47–52.

7. *Ibid.*, p. 19.

8. *Ibid.*, p. 31.

9. Brew, p. x.

10. Smith, p. 55.

11. *Ibid.*, p. 317.

12. *Ibid.*, pp. 106–162.

13. *Ibid.*, p. 317.

14. Harry C. James, *Pages From Hopi History* (Tucson: The University of Arizona Press, 1974), p. 47.

15. *Ibid.*, p. 54.

16. Edward H. Spicer, *Cycles of Conquest* (Tucson: The University of Arizona Press, 1962), p. 197.

17. Mike Kabotie, description written for the Exhibition of the *Hopi Ceremonial Calendar* mural (Second Mesa, Arizona: unpublished July, 1975).

CHAPTER 10

Hopi Pottery Motifs

All forms of Hopi artistic expression have a remarkable continuity of subject, symbol, and design. Today, as in the past, there is an interdependence of the arts which extends to every media. An analysis of Hopi painting reveals design elements and symbols from every art form. In turn, the traditions of Hopi painting have had a critical influence on all other Hopi arts.

For Hopi painters today, the pottery of the mesas has become a basic symbol of Hopi life. In *Hopi Life* p. 37, Delbridge Honanie paints a pottery bowl beneath the circle of the Earth in order to remind the viewer that the Hopis developed their skills in pottery soon after their Emergence into the Fourth World and that the art of pottery continues to thrive in the Hopi world today. In *Hopi Pottery Design* p. 56, Delbridge decorates three circles with geometric patterns based on ancient pottery designs. In the center of each circle is a hole similar to the hole in all "killed" mortuary pottery, and within the hole are three figures, a girl, a boy, and a Warrior, who represent Hopi life.

The clay which the Hopi potter shapes, polishes, and decorates is part of the land upon which the Hopis live, the land chosen for the Hopi people. Hopi pottery, like all Pueblo pottery is made by a coiling technique. The potter first cleans, dries, and tempers the clay with pulverized potsherds in order to attain the proper consistency. She first works the lump of clay by hand, hollowing it out, then places it in a low mold made from a broken pot or saucer. Once the base is formed, the potter builds the walls with hand-rolled coils of clay, which she presses in place with her fingers. The artist must exercise great care that no air spaces remain, for these will cause breakage during firing. All shaping is done from within. When the vessel is thoroughly dry, she moistens the surface and scrapes it to eliminate roughness and to attain the desired thickness.

When the roughness of contour has been corrected, the potter, using a smooth cloth, applies three or four coatings of slip, a solution of fine clay without tempering. Hopi potters use a slip made of the same clay as the paste of the vessel. This clay is light gray prior to firing but turns yellow during firing. While the slip is still damp, the potter rubs the surface with a smooth stone in order to attain the desired degree of polish. Once the polish is completed, the potter paints the design. The design is frequently bordered by a broad band that has a break at one point. This break may correspond to the Sepapu, the point of Emergence.

Most of the artists, regardless of their source of inspiration, paint their designs directly on the vessel. Each strives to create an original design. Many artists are constantly preoccupied with decorative problems and often dream of pottery designs: "One night I dreamed and saw lots of jars and they all had designs on them. I looked at them and got the designs in my head, and next morning I painted them. I often dream about designs, and if I can remember them, I paint them."[1] "I am always thinking about designs, even when I am doing other things, and whenever I close my eyes, I see designs in front of me. I often dream of designs, and whenever I am ready to paint, I close my eyes and then the designs just come to me. I paint them as I see them."[2] The artists pass design traditions to younger generations of the family. A typical Hopi pottery vessel is a small shallow bowl with a curved base and slightly curved-in rims and a small mouth. The traditional Hopi water jar is low and wide-spreading, because this shape is best suited for carrying water for long distances up the rough and steep trails.

Throughout the centuries, Hopi pottery motifs and design elements have been a major influence on the iconography and style of Hopi painters.[3] Comparison of potsherds and petroglyphs reveals the continuity of design in ancient Hopi pottery and painting. Today Hopi painters frequently use pottery motifs as a background which serves as a reminder of cultural continuity. Mike Kabotie explains that the pottery design that appears in the upper part of *Becoming a Spirit* represents Hopi history. Delbridge Honanie, in *The Whippers of Old Shungopovi* p. 190, includes representations of fragments of murals inspired by pottery designs. These fragments are symbols of the spirit of creativity that flourished in the ancient Hopi villages, a spirit which has retained its vitality through the centuries and is a powerful force in the Hopi world today. Honanie utilizes pottery design in the background of *Hopi Ceremony* p. 20 to emphasize the high degree of development of the pottery created in ancient days. He also introduces elements of Hopi pottery design to show that many years ago, in Awatovi, Hopi pottery designs had a strong influence on the kiva mural painters. This influence is confirmed by examination of the mural fragments found in the Awatovi ruins. Mural fragments classified by the Harvard anthropologists as Layout Group III (see chapter 9) were inspired by ancient pottery, particularly the design motifs of the Sikyatki potters.

The Sikyatki pottery, the highest level of development of Hopi pottery, contains highly complex, interwoven designs which include scrolls, stylized forms of human, animal, bird, and reptile life, representations of deities and traditional Hopi symbols. The bird and feather forms are highly stylized and are among the most important elements of Sikyatki design. The execution of these intricate interwoven designs demanded perfect coordination of hand and eye. The artists needed both the special ability to fit the pattern to the surface and a sense of relationship with their materials to create a design appropriate for the form of the vessel.

Most anthropologists believe that Sikyatki was originally inhabited by the Firewood People or Kokop People. An earlier ruin, Kokop or Firehouse, which is northeast of Keam's

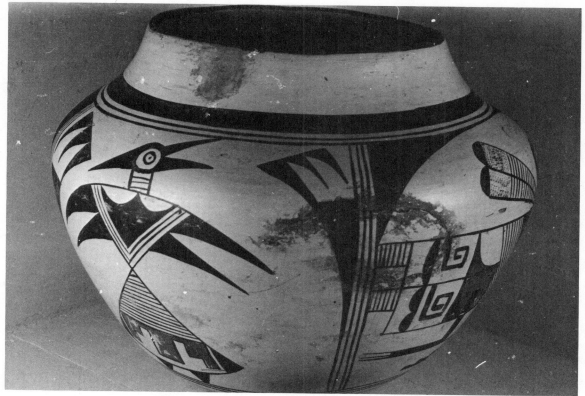

10-1. Nampeyo. Hopi Pottery Jar. c. 1915. H. 10". Geometric and bird designs in black
and red on yellowish cream. Made by Nampeyo and given by her on June 10, 1915, to
her nephew, Philip Dasheno (d. 1963). Gift of Mrs. G. A. Webb to Museum of New
Mexico, Laboratory of Anthropology, Santa Fe.

Canyon, is round in form rather than square like the houses of the mesas. Two round ruins
discovered on the mesa above Sikyatki add credence to the legend that the Firewood Clan
came to the mesas from the Rio Grande Valley. It is told that the Kokop people left Firehouse
because of a conflict with the Bear Clan. They moved west to Sikyatki and were joined by
several other clans.[4] The destruction of Sikyatki, which occurred prior to the arrival of the
Spanish, is attributed to the dispute with the people of Walpi over boundaries or over water
supplies.[5] Anthropologists believe that the surviving Kokop women married men from
Walpi, and that today many of the people of Walpi are descendants of the dwellers of
Sikyatki.[6]

The name *Sikyatki* means yellow house (Sikya—yellow; tki—house).[7] Fewkes esti-
mated the population of Sikyatki to have been between three hundred and five hundred
people.[8] The ruin is about three miles east of Coyote Springs which is near the beginning of
the trail to Hano. The mounds of the ruin are on an elevation about three hundred feet above
the plains.

In 1895, Fewkes headed an expedition devoted to the excavation of the Sikyatki
ruins. Most of the pottery excavated from the ruins was mortuary pottery. Many of the
workmen employed by Fewkes feared reprisal by Massau, the God of Death, for desecration
of his domain. In the course of the excavation, Fewkes employed a workman, Lesou, who
was married to an expert potter, Leah Nampeyo. Nampeyo frequently visited her husband
at the excavation site and was inspired by the designs on the ancient pottery. She began to

Figures of Birds from Sikyatki. *Bureau of American Ethnology* Annual Report 33, fig. 28. Photograph. Collection: Smithsonian Institution, National Anthropological Archives, Bureau of American Ethnology Collection.

Conventionalized Bird Figures. Bureau of American Ethnology Annual Report 33, plate 88. Photograph. Collection: Smithsonian Institution, National Anthropological Archives, Bureau of American Ethnology Collection.

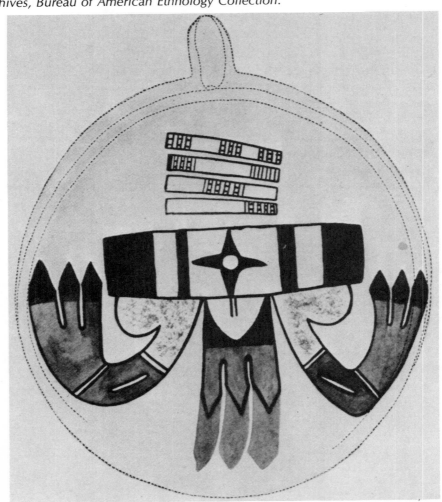

Figures of Bird and Feathers from Sikyatki. *Bureau of American Ethnology* Annual Report 33, *fig. 103. Photograph. Collection: Smithsonian Institution, National Anthropological Archives, Bureau of American Ethnology Collection.*

Bird Figure *(Thunderbird). Bureau of American Ethnology* Annual Report 33. *Photograph. Collection: Smithsonian Institution, National Anthropological Archives, Bureau of American Ethnology Collection.*

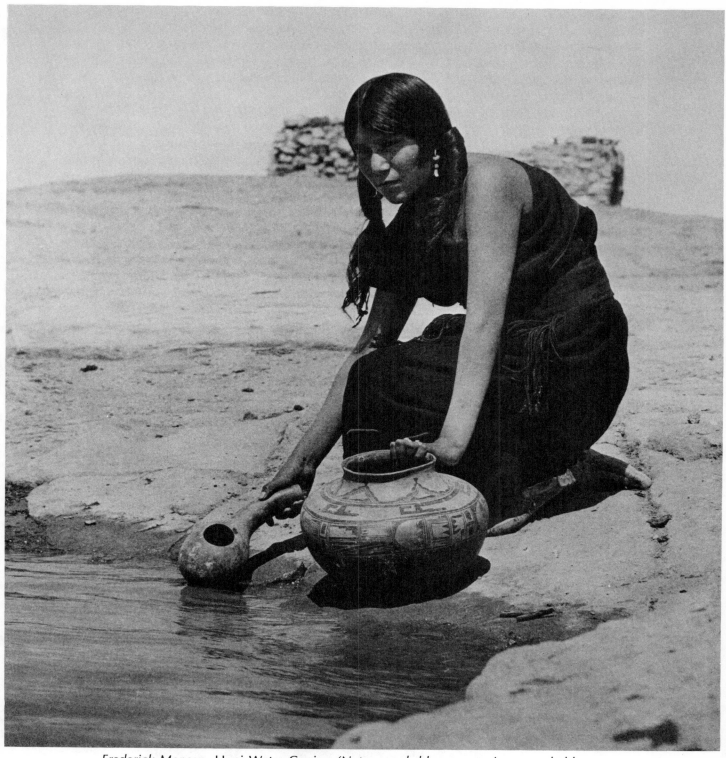

Frederick Monsen. Hopi Water Carrier. (Note squash blossom earrings—probably Navajo.) c. 1903. Photograph. Collection: Southwest Museum, Los Angeles, Calif.

237

adopt the designs into her own work (Fig. 10–1). In the 1920s, Nampeyo recalled: "When I first began to paint, I used to go to the ancient village and pick up pieces of pottery and copy the designs. That is how I learned to paint. But now, I just close my eyes and see the designs and I paint them."[9] Nampeyo's work was a great commercial success and before long her style, which was based on the revival of ancient Sikyatki designs, became the predominant style of Hopi pottery (Fig. 10–2).

Ruth L. Bunzel describes the impact of Nampeyo's pottery: "One of the most important phenomena in this change of style is the fact that Sikyatki type was taken over entirely. The new ware is not a blending of Sikyatki and modern types, but is rather a return to the Sikyatki style. The prehistoric shapes were adopted along with the designs. Even the composition of the ware changed and the soft yellow paste, similar but inferior to the Sikyatki ware, displaced the white slip of the nineteenth-century pottery. It is probable that the two styles existed side by side for some years, some women preferring one type, some the other, but no hybridization resulted from the contact of the two styles."[10]

The Sikyatki-style pottery of Nampeyo is still the dominant style of Hopi pottery. Today her work is the most highly prized, expensive Hopi pottery and is sought by museums and collectors. Fewkes, however, when reporting the results of his excavation, hailed the ancient Sikyatki pottery as the most beautiful and most elaborately decorated prehistoric pottery found in the Southwest, but he looked upon the work of Nampeyo as tourist items

10-2. Hopi Pottery Jar. *1890 to 1910. H. 8½". Red and black conventionalized birds on either side on orange slip. Gift of Nelson Collection to Museum of New Mexico, Laboratory of Anthropology, Santa Fe.*

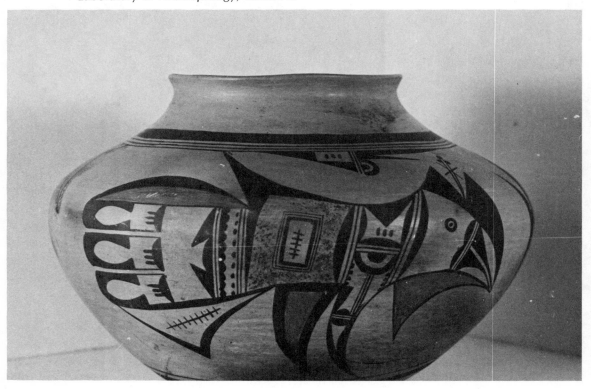

and cautioned the collector against it: "This modified Sikyatki ware, often sold by unscrupulous traders as ancient, is the fourth or present epoch of Hopi ceramics. These clever imitations, however, are not as fine as the productions of the second epoch. There is danger that in a few years some of Nampeyo's imitations will be regarded as ancient Hopi ware of the second epoch, and more or less confusion introduced by the difficulty in distinguishing her work from that obtained in the ruins."[11]

During the first three decades of the twentieth century, the Hopi women received very little payment for their pottery. Ruth Bunzel describes the trading post system of the 1920s: "The method of marketing operates very unfavorably to the potter. The villages are very remote from the market; consequently, the whole output is disposed of to Tom Pavatea, the local trader, in return for credit at the store. A woman will bring in her output of two weeks, consisting of some fifty pieces of various sizes. She has an outstanding debt at the store, and the value of the pottery is used to reduce this debt. The woman has no clear conception of what she receives for her work; and Tom is reticent on this subject. Tom gets for a waterjar by Nampeyo two to five dollars, depending on the size—the five-dollar-size being exceptionally large for any place. A twelve-inch bowl by Nampeyo, seventy-five cents. The work of other potters is cheaper. Small pieces bring from fifteen to fifty cents each. Higher prices prevail on the mesa, potters realizing the extent to which they can fleece the unwary purchaser."[12] Today, examples of Nampeyo pottery bring thousands of dollars at auction. Most contemporary Hopi pottery is sold at the Hopi Cooperative Arts and Crafts Guild, which sets standards for workmanship and assures artists of equitable payment for their work.

Since the excavation of Sikyatki, ancient potsherds and examples of Nampeyo's work are the most important sources of inspiration. The ruins of Sikyatki, which are about two miles northeast of Hano, are easily accessible to the women of First Mesa. From the potsherds, the women study the lines of design. Two potters recall: "Nampeyo was my mother's sister, and she teaches me designs. When I find a piece of old pottery, I save it and get the design in my mind. Once I dreamed and saw a lot of large jars, and they had designs on them. I looked at them and got the designs in my mind and in the morning I remembered them and painted them. I often dream about designs and sometimes I remember them, and then I always use them."[13] And: "I save all the pieces of old pottery and try out the whole design from these scraps. Sometimes I use one of the old designs around the rim of a jar and make the rest of the design out of my head."[14]

Hopi pottery designs of both the historic Sikyatki period and the modern Sikyatki style developed by Nampeyo are both major sources of inspiration for modern Hopi painters. The members of the Artist Hopid are not the first generation of painters to utilize the designs and iconography of pottery in their painting. In the 1930s Kevin Tuvahoema based his painting, *Thunderbird* (Fig. 10–3) p. 220, on the elaborate stylized figure of a bird painted on a vessel recovered in the Sikyatki excavation. Tuvahoema retained the earth colors used in pottery painting and followed the conventions of Sikyatki design in both the form and decorative motif of the Thunderbird. The decorative motif includes conventionalized symbols of rain, clouds, and lightning. It is possible to interpret this design as a composite of three bird forms, one frontal and two side images, rather than as a single image of a Thunderbird with outspread wings. Waldo Mootzka painted stylized pottery birds in *Mythical Bird* (Fig. 10–4) and in *Allegorical Bird in Cloud Hemisphere* (Fig. 10–5). Mootzka's images are closer to the elaborate winged birds found in Nampeyo's pottery (Fig. 10–6) than to the more simplified abstractions of traditional Sikyatki pottery.

239

Various forms of Conventionalized Feathers. *Bureau of American Ethnology* Annual Report 33, *plate 76. Photograph. Collection: Smithsonian Institution, National Anthropological Archives, Bureau of American Ethnology Collection.*

The members of the Artist Hopid not only utilize pottery designs from Sikyatki but those from earlier periods and from neighboring cultures. The antelope figures in Neil David's *Antelope Hunt* (Fig. 10–7) bear a strong resemblance to the stylized images in examples of Mimbres pottery (Fig. 10–8). Long before the arrival of the Spaniards, there was considerable trade among the pueblos. Ancestors of the modern Hopis were familiar with the

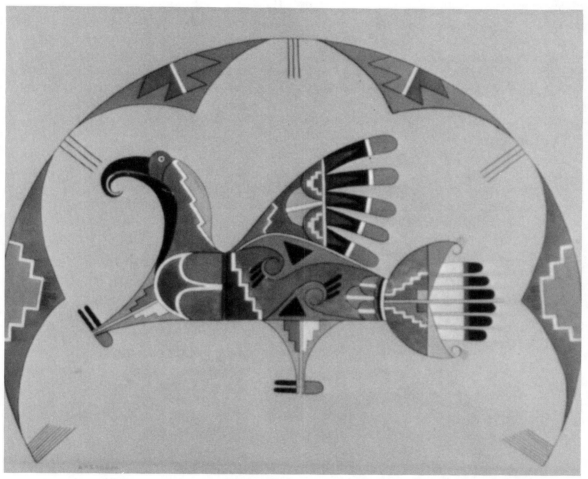

10-4. Waldo Mootzka. Mythical Bird. 1920s. 12" x 15". Watercolor. Collection: James T. Bialac, Scottsdale, Ariz.

pottery from Mimbres and frequently incorporated elements of neighboring pottery designs into their own work. The wing pattern found on a jar from Hawikuh, a village which was occupied until 1680, illustrates the similarity of design of Hopi and Zuni pottery of the same era. Both Hopi and Zuni potters were familiar with the work of their neighbors and each culture had an influence on the art of the other. Terrance Talaswaima explains that in *Pottery*

Design p. 292 and in *Hopi Pottery Elements* (Fig. 10–9) he translates pottery design to a different media; however, he emphasizes that his work is not a copy of the past but a transformation utilizing his artistic heritage.

The stylized profile images of birds which decorate Sikyatki pottery (Fig. 10–10) (Fig. 10–11) are frequently emulated on pottery jars painted between 1890 and the first decade of the twentieth century. Tyler Polelonema's painting *Eagle* (Fig. 10–12), is clearly influenced by this Sikyatki convention. The wing patterns of Nampeyo's jars (Fig. 10–13) have also inspired many two-dimensional wing designs. These stylized wing designs continue to be dominant decorative patterns in modern Hopi painting. Delbridge Honanie explains that *Hopi Pottery Design* (Fig. 10–14) was inspired by many Hopi crafts; however, the central design is a composite of stylized representations of wings and two thunderbird heads. The bird image is painted in yellow and red pottery colors and the color washes of the background evoke a sense of the past and of the ravages of time and weather on pottery found in the ruins. In *Awatovi Pottery Elements,* Mike Kabotie, like Delbridge Honanie, uses washes as symbols of time, a means of reminding the viewer of the ever presence of the past in Hopi art today. Kabotie's images of a rainbird, a hummingbird and a Migration Spirit are similar to those painted on ancient pottery. Kabotie explains that the stylized bird and feather design emphasizes the need for the Hopis to turn to the past for inspiration and that ancient pottery designs are an effective means of contact with the past. Neil David, Sr., in *Swallows* (Fig. 10–15) utilizes conventional designs of birds and wings. In *Pottery Designs* (Fig. 10–16), the roadrunner is in the decorative tradition of bird profiles painted by Nampeyo; however, the abstract image of a bird in the lower half of the painting follows the stylized conventions of ancient pottery.

10-5. *Waldo Mootzka. Allegorical Bird in Cloud Hemisphere. 1930s. 14¹/₂" x 21". Water-color. Collection: The Heard Museum of Anthropology and Primitive Art (Indian Collection), Phoenix, Ariz.*

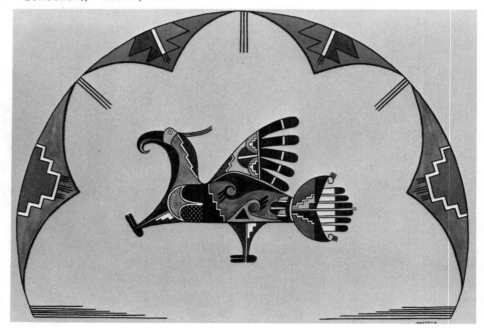

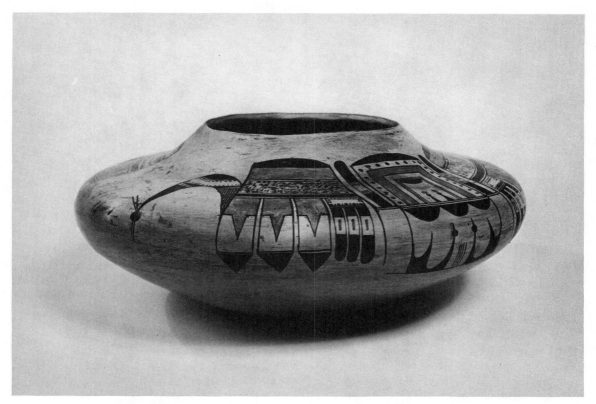

10-6.　Nampeyo Pottery Jar. *c. 1900. H. 6". Yellowware, red and black painted decoration.*
Collection: Museum of the American Indian, Heye Foundation, New York, N.Y.

Milland Lomakema frequently uses pottery elements as the basic source of his designs. For him, design rather than ideology is always the predominant focus. In *Turtle Design* (Fig. 10–17), the body of the turtle is a circular form surrounded by a semicircle of stylized feathers. Within the circle the central design is water waves surrounded by Migration spirals, terraced clouds, and feathers. *Sculpture Maiden* (Fig. 10–18) is Milland Lomakema's imaginative representation of a Hopi maiden created in pottery. The maiden wears the traditional wedding robe, a mask, and a feather in her hair. Milland was inspired by the pottery excavated at Awatovi to paint *Stylized Eagle* p. 293, a Cubist work in which he utilizes pottery designs and traditional Hopi symbols (lightning signs, Migration spirals, Warrior marks, and bird tracks) to proclaim the power of tradition in Hopi life. *Awatovi Motifs of the Kachina Clan* p. 64 is a more complex painting in which Milland Lomakema includes pottery elements in the representation of the parrot. In *The Village Chiefs* p. 266, he includes representations of stylized thunderbirds and in *Snake Society with Warrior Maidens* p. 80, he paints a conventional pottery image of a bird.

Mike Kabotie frequently includes a bee in his work, either as an independent design element or combined with stylized birds. In *Hawk and Bee* (Fig. 10–19), a painting depicting the fight between the two creatures, Kabotie paints the hawk, but not the bee, with a life line that runs from the mouth to the heart. In *Sikyatki Hand with Bee* p. 255, the central image is quoted directly from an example of Sikyatki pottery; however, it is necessary to see the

243

10-7. *Neil David, Sr. Antelope Hunt. 1971. 8" x 15". Mixed media. Collection: Brian Hunter, Phoenix, Ariz.*

10-8. *Mimbres Bowl, 1000 to 1300. New Mexico. D. 11". Painted decoration represents an antelope. Collection: Museum of the American Indian, Heye Foundation, New York, N.Y.*

10-9. *Honvantewa—Terrance Talaswaima. Hopi Pottery Elements. 1973. 35" x 40". Acrylic. Private Collection.*

10-10. *Hopi Pottery Jar. 1890 to 1910. H. 10½". Red and black design on light orange. Two designs on either side. Used as a household utensil. Gift of Nelson Collection to Museum of New Mexico, Laboratory of Anthropology, Santa Fe.*

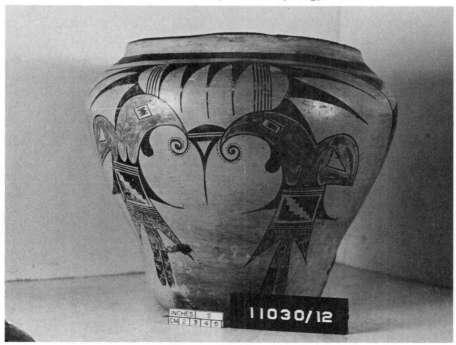

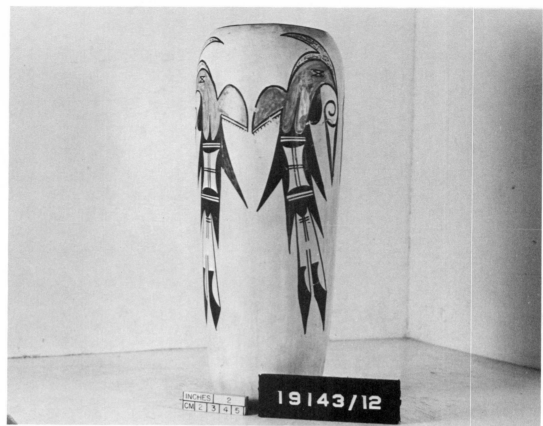

10-11. Hopi Pottery Vase. c. 1900 to 1910. H. 11³/₄". Black and red on cream; bird design; four identical birds. Gift of H. F. Robinson Collection to Museum of New Mexico, Laboratory of Anthropology, Santa Fe.

10-12. Duvehyestewa–Tyler Polelonema. Eagle. 1967. 13¹/₂ x 9¹/₂". Gift of Byron Harvey to The Heard Museum of Anthropology and Primitive Art (Indian Collection), Phoenix, Ariz.

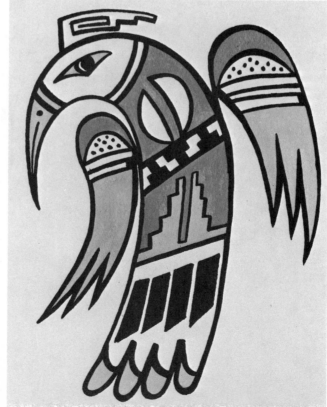

246

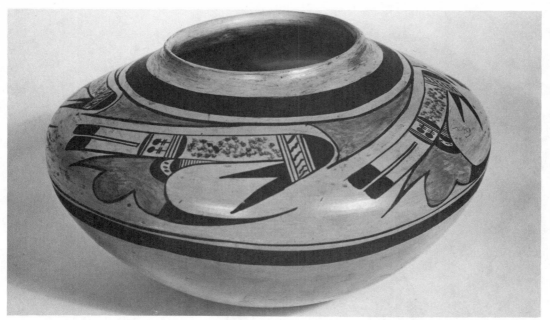

10-13. Nampeyo Pottery Jar. c. 1900. Hano. H. 5¹/₂″. Collection: Museum of the American Indian, Heye Foundation, New York, N.Y.

10-14. Coochsiwukioma–Delbridge Honanie. Hopi Pottery Design. 1975. 48″ x 24″. Acrylic. Collection: Hopi Cooperative Arts and Crafts Guild.

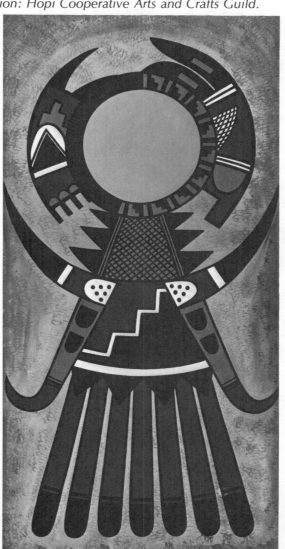

247

10-15. *Neil David, Sr. Swallows. 1968. 11½" x 10". Watercolor. Collection: Judith Rosenstock, Phoenix, Ariz.*

10-16. *Neil David, Sr. Pottery Design. 1975. 20" x 16". Acrylic. Collection: Hopi Coopera-tive Arts and Crafts Guild.*

10-17. Dawakema–Milland Lomakema. *Turtle Design. 1975. 33" x 30½". Acrylic. Collection: Hopi Cooperative Arts and Crafts Guild.*

250

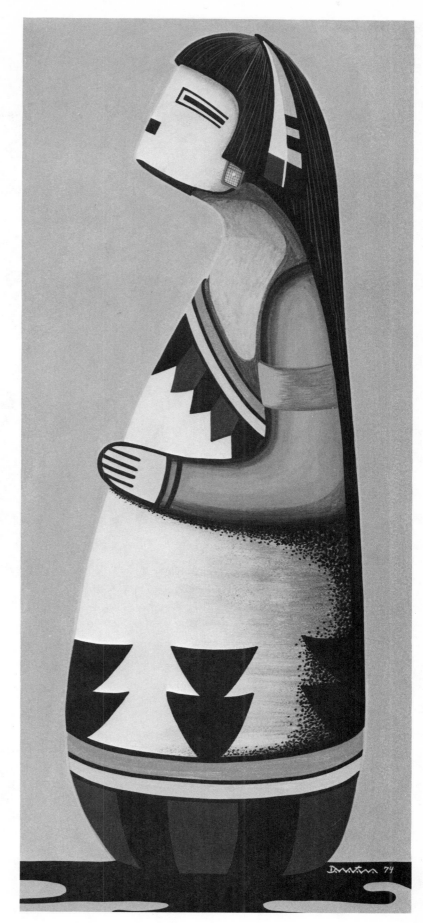

10-18.
Dawakema–Milland Lomakema.
Sculpture Maiden. 1973.
30" x 13". Acrylic. Collection: Hopi
Cooperative Arts and Crafts Guild.

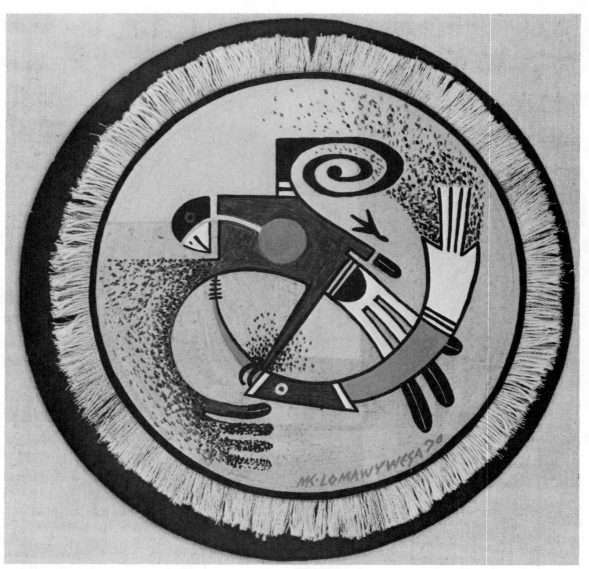

10-19. *Lomawywesa–Mike Kabotie. Hawk and Bee. 1970. D. 8¹/₄″. Mixed media. Collection: Judith Rosenstock, Phoenix, Ariz.*

ancient design to believe that these hard-edge, stylized abstractions were first conceived by an artist many centuries ago.

It is difficult to realize that the stylized forms in many twentieth-century Hopi paintings, which appear to be highly modern abstractions, are based on artistic conventions that are several hundred years old. Centuries ago, ancestors of contemporary Hopi artists decorated pottery with images of birds, utilizing conventions of foreshortened dorsal views, side views, and two-dimensional wing designs. Today these conventions are recognized as sophisticated techniques of abstractions. The images of ancient Hopi pottery and Sikyatki-inspired pottery are not only compatible with the innovations of modern art, but they stand as a vital creative force which testifies to the fusion of the past and the present in the Hopi world.

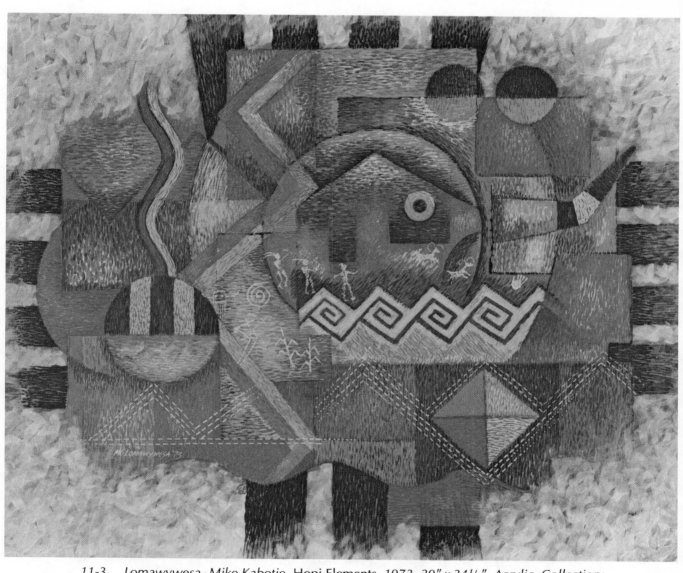

11-3. *Lomawywesa–Mike Kabotie. Hopi Elements. 1973. 29″ x 34¹/₂″. Acrylic. Collection: Hopi Cooperative Arts and Crafts Guild.*

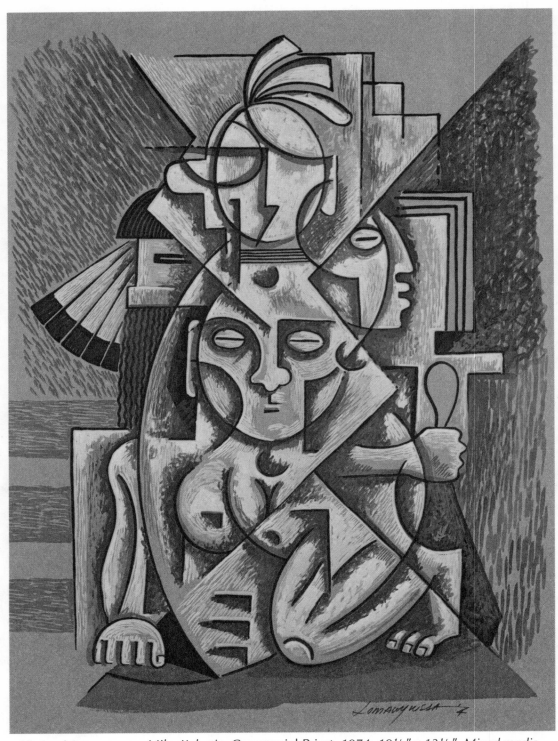

12-4. *Lomawywesa–Mike Kabotie. Ceremonial Priest. 1974. 19¹/₂" x 13¹/₂". Mixed media. Private Collection.*

12-13. *Lomawywesa–Mike Kabotie. Sikyatki Hand with Bee. 1973. 50" x 37". Mixed media.*
Collection: John Cartwright, Santa Fe, New Mexico.

12-6. *Lomawywesa–Mike Kabotie. Dark Dawn Blessing. 1975. 30" x 32". Acrylic. Collection: Hopi Cooperative Arts and Crafts Guild.*

NOTES

1. Ruth L. Bunzel, *The Pueblo Potter: A Study of Creative Imagination in Primitive Art* (New York: Columbia University Press, 1929). Reprint New York: Dover Publications, Inc., 1972), p. 51.

2. *Ibid.*

3. *Ibid.*, pp. 78–80.

 In order to evaluate the influence of both prehistoric and contemporary pottery designs on modern Hopi painters, it is necessary to understand the chronology of Hopi pottery. Ruth Bunzel, in *The Pueblo Potter: A Study of Creative Imagination in Primitive Art,* outlines the developmental sequence of Hopi pottery. Miss Bunzel describes seven basic periods:

 > I. The earliest ware from both of these sites is black on white—the ware which at an early period was made all over the Southwest and which everywhere shows similar technical and artistic features. Found with this in the Hopi ruins is a small amount of orange ware with decorations in red and black (Kayenta polychrome) which is widely distributed in Northeastern Arizona. In both of these wares the decoration is entirely geometrical and largely angular.

 > II. Red with geometric decorations in black. This ware is similar to the earliest Hawikuh wares. The base color in later periods gradually fades out to orange and yellow, giving place slowly to

 > III. "Jeddito Yellow," a ware specialized in Tusayan, a clear yellow base with excellent decorations in brown. Angular geometric patterns predominate with, very rarely, representative forms. This ware takes its name from the numerous ruins in the Jeddito Valley, where it is found on the surface as the dominant ware. The transition is gradual into

 > IV. "Sikyatki." This ware, which takes its name from the ruin on First Mesa which has yielded the most varied and beautiful specimens, is characterized by a clear yellow surface with elaborate decorations in brown and red. The characteristic form is the shallow bowl, in the decoration of which highly conventionalized life forms predominate. This is a late pre-historic period, contemporaneous with the polychrome period of Hawikuh, with which it shares many characteristics of color, form, and the general influence on one another, or both have sprung from a common source. The Sikyatki is the more highly developed style.

 > V. "Mission." This ware, which is found on or near the surface at Awatovi, associated with articles of Spanish manufacture, is inferior to the preceding product of Sikyatki and Awatovi. The vessels are thick and heavy, the paste soft. The ground color is yellow or buff, with decorations in black and red, crudely executed. The beautiful and elaborate designs of the earlier designs have given way to simpler patterns with an increase of geometric forms. Material of this period is very slight in quantity. This was the predominant ware at Awatovi when the town was destroyed in 1700 by a war expedition from Walpi. It is found, however, in the rubbish heaps of Walpi, where it gradually gives way to

 > VI. Modern. This ware which flourished from 1850 to 1900 is well represented in our museums. It has a white or yellowish slip with decorations in black and red.*

 > VII. Contemporary. This is a reversion to type IV, Sikyatki ware, the finest pottery of the Hopi region, and is the result of the efforts of one person.

4. Jesse Walter Fewkes, "Archaeological Expedition to Arizona in 1895," *Bureau of American Ethnology Annual Report* 17 (Washington, D.C.: 1898). Reprint "Sityatki and its Pottery," *Designs on Prehistoric Hopi Pottery* (New York: Dover Publications, Inc., 1973) p. 9.

5. *Ibid.*

6. *Ibid.*, p. 11.

7. *Ibid.*, p. 12.

8. *Ibid.*, p. 13.

9. Bunzel, p. 56.

10. *Ibid.,* p. 81.

11. Jesse Walter Fewkes, "Designs on Prehistoric Hopi Pottery," Bureau of American Ethnology *Annual Report* 33 (Washington, D.C.: 1919), p. 218.

12. Bunzel, p. 5.

13. *Ibid.,* p. 52.

14. *Ibid.*

*There is a great similarity in the images of the Calako-Mana, the Corn Spirit, on this pottery and the Kachina figures in the paintings commissioned by Fewkes.

Hawikuh Jar. *New Mexico. H. 7¹/₂". Cone-shaped orangeware pottery jar with two verticle loop handles. Red and black painted decoration. Collection: Museum of the American Indian, New York, N.Y.*

CHAPTER 11

Hopi Creativity:
Craft Designs in Modern Hopi Painting

It is not possible to separate the fibers of Hopi life. All the components of Hopi life—daily labors, religious rituals, social ceremonies, and artistic creativities—are integral steps along the path to universal progress and harmony. It is equally impossible to isolate the different forms of Hopi art. All Hopi art is a celebration of the powers of creativity and the dominant theme of every form of Hopi artistic expression—painting, pottery, basketry, textiles, and jewelry—is the regeneration of life.

Hopi artists look to their religion and their land as the sources of all artistic inspiration. They identify artistic expression with a creative life force which encompasses the powers of germination and regeneration. In *Homage to Hopi Creativity* (Fig. 11–1), Mike Kabotie has painted a giant Sun Kachina to represent Hopi arts and crafts. The head of the Kachina, a radiant sun mask, represents the life-giving power of Hopi artistic achievement. This stylized sun mask serves as the trademark of the Hopi Arts and Crafts Cooperative Guild. The body of the Kachina is a composite of symbolic representations of Hopi arts and crafts. Beneath the sun mask on the left is the head of a Kachina doll which represents the art of carving. A Migration spiral, a stylized parrot head and sun, cloud, and rain symbols represent jewelry design. Beneath these images are basketry patterns and designs. On the right, beneath the Kachina doll is an example of classic Hopi textile design, and below this design are examples of pottery designs. The Sun Kachina stands on a base which is decorated with stylized mesa forms and a body of water in which tadpoles swim. Water is a basic necessity

A. C. Vroman. Nampeyo Potter of Hano with Some of Her Ware. *1901. Photograph.*
Collection: Southwest Museum, Los Angeles, Calif.

260

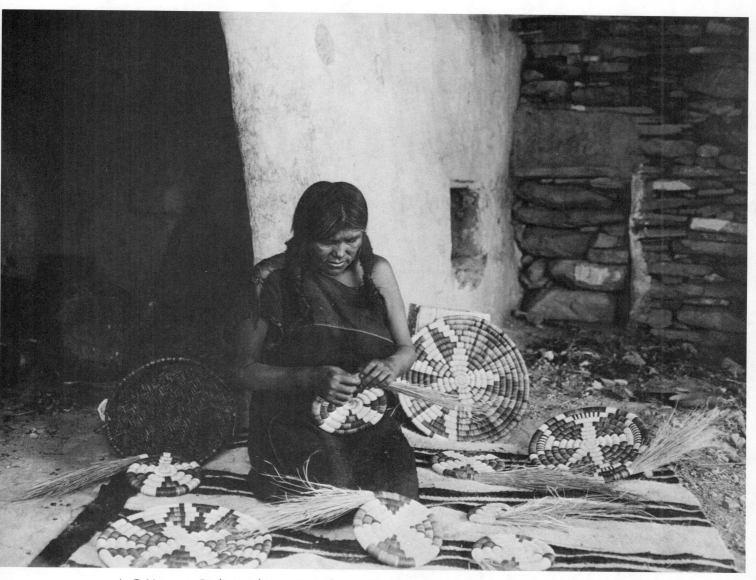

A. C. Vroman. Basket Making. Hopi Plaque. (Coil work—note plaited basket on left). Taken during Gates Expedition, 1901. Photograph. Collection: Southwest Museum, Los Angeles, Calif.

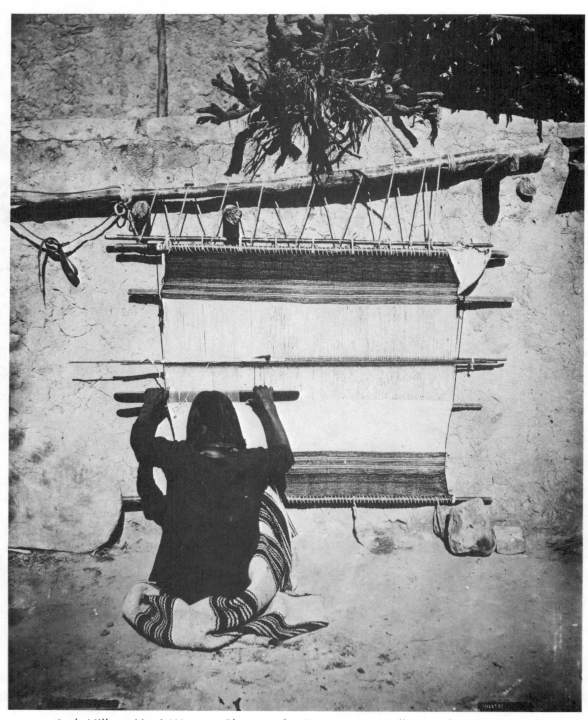

Jack Hillers. Hopi Weaver. Photograph. G. W. James Collection from Bureau of American Ethnology, Southwest Museum, Los Angeles, Calif.

262

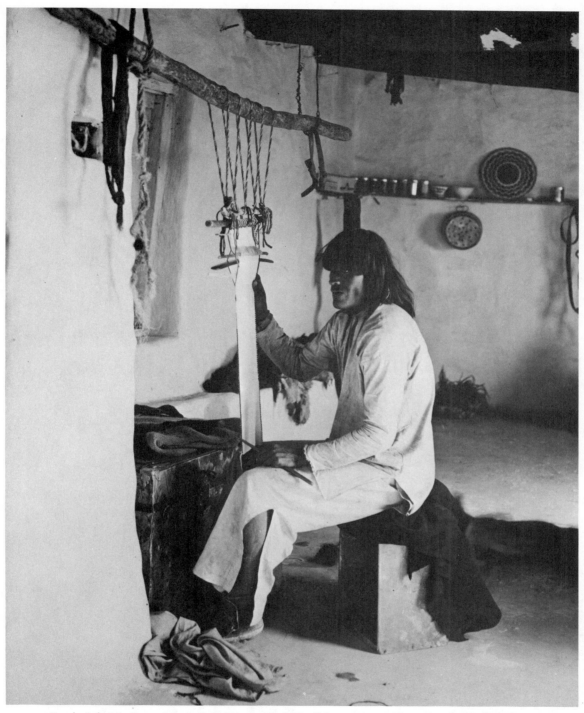

Frederick Monsen. Hopi Belt Weaver of Oraibi. c. 1903. Photograph. Collection: Southwest Museum, Los Angeles, Calif.

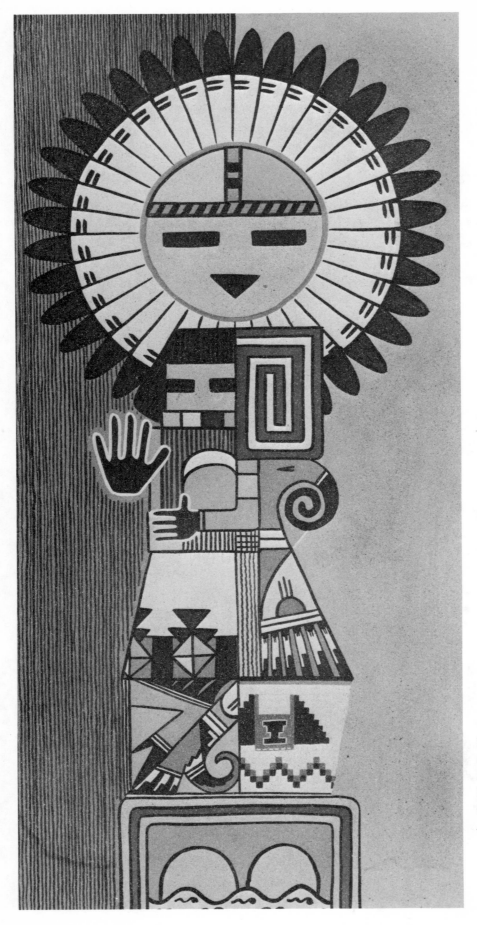

11-1.
Lomawywesa–Mike Kabotie.
Homage to Hopi Creativity.
1967. 39¹/₂" x 19¹/₂". Casein.
Collection: Hopi Cooperative
Arts and Crafts Guild.

for sustaining life, and tadpoles are symbolic of germination and growth. The mesas are the spiritual center of the Hopi universe and Hopi artists derive their spiritual strength and inspiration from their ancestral land.

Historically, the materials of Hopi artistic creation were the basic elements of the land of the mesas and desert. Today as in the past, pottery and basketry are products of the land. The clay from which the pottery vessels are formed is part of the earth upon which the Hopis live, and Hopi baskets are woven from the fibers of native plants. Until the mid-twentieth century, textiles were woven with cotton grown by Hopi farmers and with wool shorn from sheep raised by Hopi herders. The pigments for paint were ground from local minerals, and textile dyes came from plants native to northeastern Arizona.

Basketry is the oldest of Hopi craft arts. Archaeological evidence suggests that basketry was practiced in North America before 7000 B.C.[1] For centuries, artists have hand-manipulated natural plants and grasses to create useful and decorative baskets and plaques. All Southwestern Indians made baskets centuries before the arrival of the Spanish. In ancient days, Hopi men were skilled in basketry; however, today it is purely a woman's craft. Contact with Western civilization introduced utensils of many materials to the Indians, but the Hopis, more than any other Indian people, have maintained their tradition of high quality basket weaving. Today the tremendous interest in native Indian crafts has revitalized the production of baskets throughout the Southwest, and basketry as a craft has continued to flourish in Hopi villages on all three mesas as it has since pre-contact days.

The Hopis are among the most skilled and versatile basket weavers. They are able to achieve harmony of color, form, and design in all three types of basketry: coiling, plaiting, and wicker. Coiled basketry is the oldest form of Anasazi basket weaving. The basket patterns of the Anasazi influenced both the textile and pottery designs of the period. These ancient coiled baskets were decorated with geometric designs and life forms. Modern coiled baskets are decorated with traditional Hopi symbols (clouds, lightning, and rain), animal forms, Kachina figures and masks, and geometric designs.

The Hopis use yucca for the coiled work. The coil is made of slender grass stems which are tightly wrapped with narrow yucca. The coiled basket is made by building coils into the desired form. The most common color for coiled basketry is off-white, which is the color of naturally dried yucca. Coiled baskets are decorated with black, yellow, and dark red strips of yucca that have been colored with mineral and vegetable dyes. The women of the Second Mesa excel in coiled work. Clara Lee Tanner in *Southwest Indian Craft Arts* writes in praise of Hopi coiled work: "Today the Hopis are producing better coiled basketry than ever before. They continue to use baskets to decorate their homes, give them as wedding presents, and use them for ceremonial purposes. These native-use pieces are well made; also a great many baskets made for commercial purposes are perfectly woven and beautifully designed."[2]

In the mid-twentieth century, plaited baskets are still woven on all three mesas. In plaiting, the weaver produces a design by an under and over rhythmic pattern. The designs of ancient plaited baskets were formed by the weave alone. Historic plaited designs include plain weave, diamonds, squares, and zigzags, and these same designs are the basis of contemporary plaited work.

Wicker is the simplest form of basketry. In wicker work, the weaver manipulates flexible fibers under and over radiating stiff twigs or other elements. Ancestors of the Hopis wove wicker baskets as early as A.D. 1200 to 1300.[3] Hopi wicker plaques are decorated with both symmetrical and asymmetrical designs which cover the entire surface of the plaque.

265

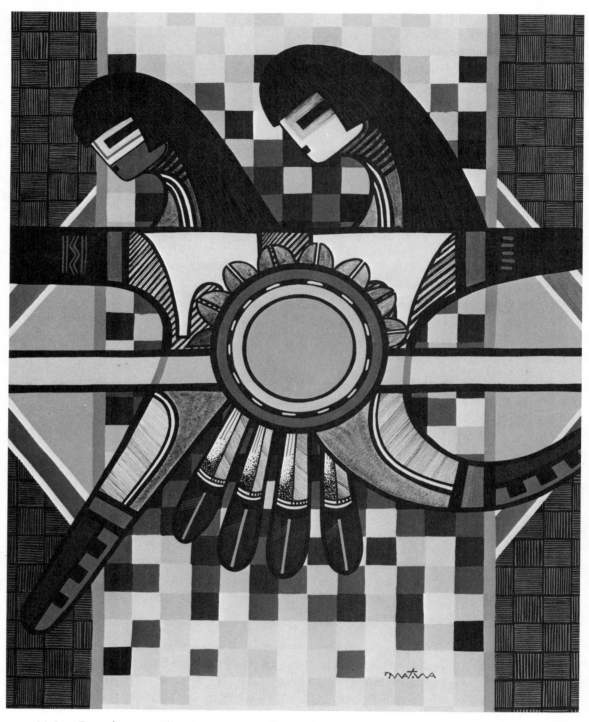

11-2. *Dawakema–Milland Lomakema. The Village Chiefs. 1974. 31" x 25". Acrylic. Collection: John Cartwright, Santa Fe, N.M.*

The weaver tries to achieve a harmony and rhythm of color and design. Today wicker is woven primarily on the Third Mesa; however, women on First Mesa create a small quantity of wicker work. Clara Lee Tanner pays tribute to Hopi wicker: "This tribe has developed the elaboration of design in wicker technique to the highest point of any tribe in the United States".[4]

Hopi basketry and basket designs have an important influence on the iconography of modern Hopi painters. Baskets are used in many Hopi ceremonies (one of the most important of the Women's Harvest Ceremonies is the Basket Dance (see chapter 7), and woven plaques are used to carry ceremonial foods. For generations, all varieties of woven baskets have been used in Hopi homes, and basket weaving has been a traditional household occupation; therefore, Hopi basketry has become a symbol of both Hopi ceremonial and domestic life. In *Hopi Life* p. 37, Delbridge Honanie includes examples of both coiled and wicker baskets to show that the Hopi arts of ancient days still have importance and vitality in the modern world.

The basket-weave motif is used frequently as the background of modern Hopi paintings. Milland Lomakema utilizes a simple plaited motif as the background in *The Village Chiefs* (Fig. 11–2) and in *Dance Maiden* p. 164. In both *Abstract of Whipper* p. 187 and in *Chaquina II* p. 134, the woven design of the background has a dual function. Lomakema explains that basketry not only symbolizes Hopi tradition, but symbolizes the Whippers who use ceremonial whips made from strips of yucca. In *Dance Maiden and Mask* p. 132, plaited basket patterns are part of the background, costume, and mask of the maiden. Neil David, Sr., suggests a basketry pattern in the background of *Giver of Life* p. 45 in order to evoke a sense of tradition, for the art of basketry, like religious ceremonies and dances, retains its meaning and importance in the world of the Hopis today.

In *Hopi Pottery Designs* p. 247 by Delbridge Honanie and in *Awatovi Pottery Elements* p. 270 by Mike Kabotie, simple plaited patterns are incorporated in pottery motifs in order to emphasize the unity of all Hopi arts and crafts. In *Hopi Pottery Elements* p. 245 Terrance Talaswaima introduces a basketry pattern into the figure of a thunderbird. Talaswaima's artistic goal is to create a contemporary design which extols the powers of Hopi art to transcend time and the limitations of a single media. He finds inspiration in four historic Hopi art forms—mural painting, pottery, basketry, and textile weaving. Talaswaima like the Awatovi muralists, follows the conventions of abstraction used to depict birds and feathers on Sikyatki pottery. The thunderbird image is suspended from a woven support, and Talaswaima explains that the stylized symbols of water and clouds at the base of the painting are representative of Hopi textile design.

Hopi textile weaving, like basketry, predates the arrival of the Spanish in the American Southwest. The Anasazi ancestors of the Hopis practiced the craft of weaving almost a thousand years before the arrival of the conquistadors. Pedro de Tovar, upon reaching the mesas in 1542, received gifts of Hopi weaving.[5] Before the arrival of the Spanish, all Hopi cloth was woven from cotton cultivated by the Hopis. When the Spanish established their first Hopi missions in 1629, they brought sheep to graze in the desert land around the mesas. The introduction of sheep and wool to the Hopis was the outstanding contribution of the Spanish to Hopi crafts. Since the sixteenth century, the Hopis have raised sheep of several varieties. The cloth they weave is made from naturally colored black, white, and brown wool. A gray wool is a mixture of natural black and white colors. In 1875, Mormon missionaries built a textile mill in Moencopi, but it was never accepted by the Hopis and it failed.

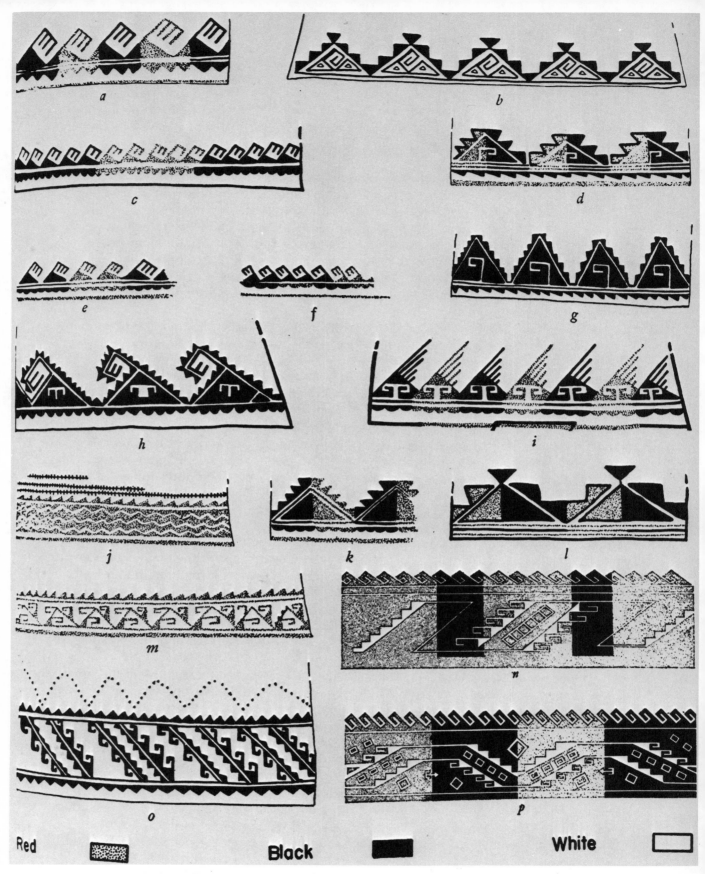

Red Black White

Lower Border Decorations on Kilts Worn by Human Figures in the Jeddito Mural Paintings, *with comparative modern examples. A to M from Awatovi, N and P are modern examples from Acoma, and O from Kawaika-a. Peabody Museum Papers, vol. XXXVII, plate 25. Photograph. Collection: Peabody Museum, Harvard University, Cambridge, Mass.*

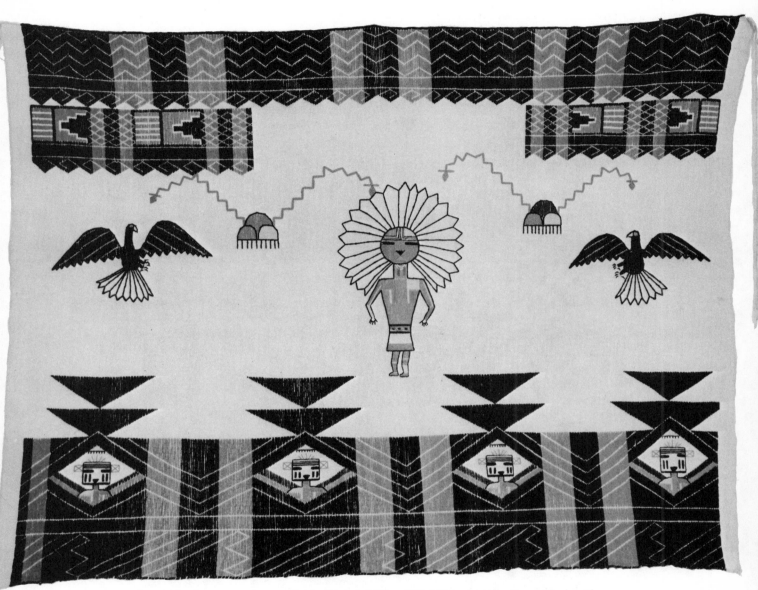

Kachina Blanket. c. 1900 to 1910. Walpi. 72" x 55". White cotton decorated with eagles and Tawa (Sun) Kachina Figure. Worn for ceremonial occasions. Collection: Museum of the American Indian, Heye Foundation, New York, N.Y.

The Hopis use wool of natural colors for basic woolen textiles; however, they embroider these textiles with bright red and green wool. Until the late nineteenth century, the Hopis employed organic or natural dyes, but in the 1870s they began to work with aniline colors. In the late 1920s, the Museum of Northern Arizona instituted a program which succeeded in improving the quality of Hopi dyes and introduced a natural indigo that has remained popular. The woman's everyday dress or *manta* is black wool with an embroidered border of indigo blue.

Although wool is used for blankets and daily clothing, cotton remains the principal ceremonial textile. Frequently, cotton textiles are embroidered or brocaded in wool. For

Lomawywesa–Mike Kabotie. Awatovi Pottery Elements. 1973. 26" x 26". Acrylic. Collection: Hopi Cooperative Arts and Crafts Guild.

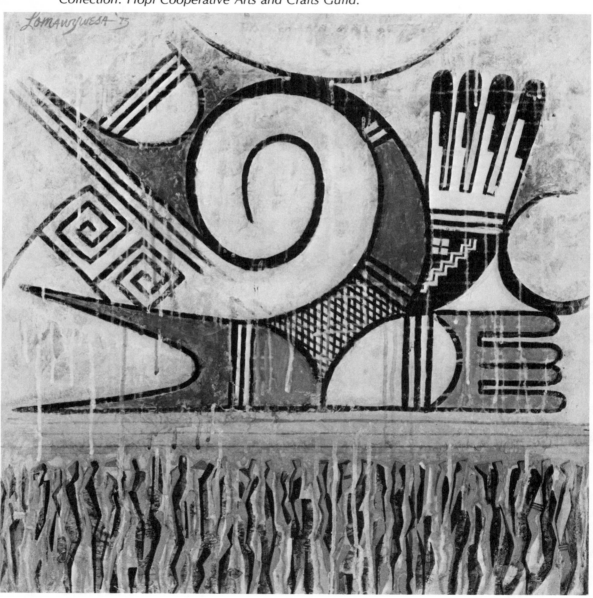

270

many years string was used for the warp, and, today, commercial cotton is standard in most cotton weaving; however, the Hopis persisted in the cultivation of cotton longer than any other Indian tribe of the Southwest. Weaving today, as in prehistoric days, is a craft practiced by the men. The art of weaving is taught from generation to generation and is a treasured Hopi cultural tradition. Most ceremonial cloth is woven in the kivas, but the men also use looms in their homes. They work on a loom which extends from the floor to the ceiling beams.

One of the most sacred woven garments is the wedding dress. At the time of the wedding ceremony, it is woven of plain white cotton; however, in later years it may be embroidered with a wide band at the bottom and a narrow border at the top. The fringe of the sash of the wedding dress symbolizes rain and fertility. Most Hopi women have two wedding dresses. One dress is kept all of a woman's life, for it will be her burial robe and will insure passage to the Underworld, the Spirit World of the Dead. In *Sculpture Maiden* p. 251, Milland Lomakema clothes the imaginative figure in the traditional wedding dress. Another traditional ceremonial garment is the white cotton shawl that is worn by Hopi women. This shawl has bands of black and green wool upon which are embroidered brightly colored symbolic designs. Across the center are embroidered flowers, birds, or Kachina figures.

One of the most important Hopi textile designs is a double triangle which traditionally decorates the wide borders of both wedding dress and prayer shawl. In 1934, Lorenzo Quannie, in *Two Men Praying for Rain* p. 22, included the double triangle as part of the wall design of the ceremonial chamber. Today, both the double triangle and the embroidered pattern of nested chevrons (V-shaped patterns) are basic design elements of modern Hopi painting. These designs have become symbols of Hopi textiles and of Hopi tradition.

In both *Sikyatki Hand and Bee* p. 255 and *Warrior Spirit* p. 289, Mike Kabotie uses the chevron and water scroll of textile embroidery as a symbol of Hopi tradition. In *Hopi Elements* p. 253, the nested chevrons of ceremonial robes represent Hopi textile art. Kabotie explains that he has chosen symbols and elements of Hopi life to decorate a stylized representation of woven cloth. He includes petroglyph-style figures (a Kachina, hunters, and antelopes) and traditional petroglyph symbols (lightning, corn, a hand print, and a Migration symbol) to evoke images of Hopi life of the past. The fibers of the cloth stretch in four directions, as a symbol of the Hopis receiving blessings and inspiration from every direction. The cloudlike mist which surrounds the central design and the scroll beneath the petroglyph images symbolizes the Hopis' dependence upon water. The textile serpent's head and body represent water and fertility. The eye and horn of the Disciplinary Kachina are a reminder of the importance of Kachina ceremonies in Hopi life.

One of the most important Hopi textiles is the ceremonial kilt. The kilt, which is made of plain woven cotton, has a wide embroidered border across the shorter edges and a narrow border along the lower horizontal edge. Geometric patterns are embroidered on the borders with brightly colored wool. Border designs include chevrons, double triangles, terraced clouds, water scrolls, and other rain symbols.[6]

Painted images of kilts can be found on many fragments of the Awatovi murals. The Awatovi figures wear both solid black kilts and white kilts with elaborate border decorations. The kilts depicted in the Awatovi murals have horizontal decorative borders; a discovery which contradicts the belief that vertical borders characterized kilt designs in the past.[7] The borders of many of the kilts in the Awatovi murals consist of rows of isosceles triangles which rise from a base line. These triangles are composed of water scrolls, terraced clouds, and a variety of rain symbols.

Hopi kilts and the designs associated with kilt borders are included in many modern paintings as symbols of Hopi ceremonial life. In the *Hopi Ceremonial Calendar* mural painted by the Artist Hopid, the dancers wear kilts decorated with Awatovi-style isosceles triangles, chevron patterns, double triangles, and terraced-cloud images. In *Awatovi Ceremonials* p. 219 , Neil David, Sr., uses a triangular kilt pattern as a central design element of the painting. Kilt designs are also used in modern paintings to symbolize Kachinas or Kachina Dancers. In *Chief Kachina of Walpi Village* p. 128 , David uses a kilt border as the baseband of the composition, and in *Long Horn with Mana* p. 139 Mike Kabotie paints an Awatovi-style Kachina Maiden attached to a baseband inspired by a kilt border design. In *Impersonation* p. 131 , Terrance Talaswaima uses the diamond design, a typical kilt border pattern, to represent the costume of the Kachina. In an abstract work, *Awatovi Motifs of the Kachina Clan* p. 64 , Milland Lomakema uses textile designs both as symbols of the Kachina Clan and as geometric elements of the composition. In *Salako, the Cloud Spirit* p. 183, the Salako wears representations of all of the Hopi staples. The kilt represents cotton which was domesticated by the Hopis.

Textile designs define the figures of the Sun Kachina, and in Neil David's, Sr. painting Ahula in *Ahula, the Germinator* p. 17. Textile patterns and masks are dominant images of Lomakema's interpretation of the Sun Kachina in a painting also entitled *Ahula, the Germinator* p. 182. Innovative design based on traditional Hopi patterns and symbols is the central focus of Lomakema's work. He describes this painting as "An abstract design of the Germ God—to the left center, circular design with stylized feathers, his costume below in diamond shapes, plants and cloud designs below. Portion of the sun design in the background again cloud designs."[8]

Hopi sashes, like Hopi kilts, have great symbolic importance both in Hopi ceremonies and in modern Hopi paintings. The sashes are woven on a small loom. The men's sash is plain cotton with a design embroidered at the end in colored wool. Tassels which symbolize rain are attached to the ends; however, the entire sash is thought of as a rain sash. In *Spider Woman and Muingwa* p. 40 , David visualizes Muingwa wearing an elaborate kilt and a rain sash, which is clearly symbolic of germination. Traditionally, Hopi women wear a red sash embroidered with geometric rain patterns over their black mantas. In Mike Kabotie's painting *Hopi Mother and Child* p. 193 , the mother wears a manta with a sash decorated with geometric images which symbolize rain and fertility.

The same symbols and geometric patterns, which for centuries have characterized Hopi pottery, basketry, and textile weaving, are today used in Hopi jewelry (Fig. 11–5). Although, historically, Hopis wore decorative jewelry (as evidenced by necklaces in the Awatovi murals), prior to 1900 most Hopi jewelry was acquired in trade for textiles. The jewelry which today is thought of as Hopi silver jewelry is a recent craft. Around 1900, Hopi craftsmen began to work in silver. This early Hopi silverwork was similar in style to Zuni and Navajo work. In 1930, Dr. Harold S. Colton, and his wife, Mary Russell Colton established the annual Hopi Craftsmen Exhibit at the Museum of Northern Arizona in order to provide a place for Hopi crafts to be sold and to encourage high quality crafts. In late 1939, the Coltons began a program aimed at establishing a style of Hopi silver which would distinguish Hopi work from that of other tribes. They encouraged the use of traditional Hopi designs and symbols. World War II interrupted the program and crafts show; however, in 1946 Fred Kabotie and Paul Saufkie organized, as a G.I. training program, an eighteen months course in silversmithing for veterans. When the program began in February, 1947, Saufkie provided the technical instruction and Fred Kabotie lectured on jewelry design.[9]

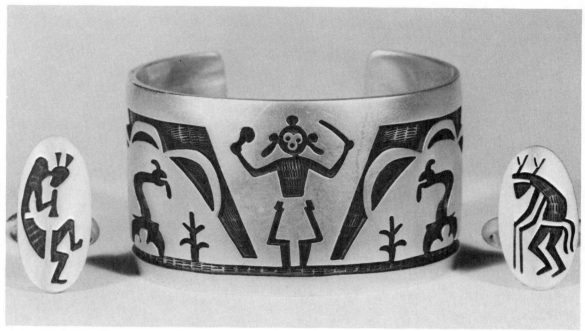

11-5. *Tony Kyasyousie,* Water Serpent and Mudhead Bracelet. *Joe Coochyumptewa,*
Kokopelli. *Patrick Lomawaima,* Deer Dancer Rings. *1970s. W. Bracelet, 1¹/₂". H.
Rings, 1¹/₄". Silver overlay. Private Collection.*

The first major show of the veterans' silver was in December, 1948, at the Indian
Crafts Shop of the Department of the Interior in Washington, D.C. In July, 1949, the overlay
work was exhibited and sold at the Hopi Craftsmen Exhibition at the Museum of Northern
Arizona. In 1949, Fred Kabotie was instrumental in founding the Hopi Silvercraft Guild. The
Guild provides a central workshop and sales outlet and maintains the highest standard of
work. In 1961, Emory and Wayne Sekaquaptewa founded Hopi Craft and hired Peter Shel-
ton, Jr., as the designer. Both the Guild and Hopi Craft insist that all work exhibited repre-
sent excellence in both workmanship and design.

The basic technique of Hopi silver work is called overlay. A design is cut from one
layer of silver and this negative image is then soldered on a base of silver. When the inside of
the design is oxidized, a black pattern appears on the polished silver surface (Fig. 11–6).
Today many examples of overlay jewelry incorporate turquoise, for the Hopis look upon
turquoise as a basic element of their land, part of the legacy of the Hurung Whuti as
illustrated in Terrance Talaswaima's painting, *Deities of Hard Substance* p. 48 .

Modern Hopi silversmiths looked to every era of Hopi history and every art media for
their designs. Images from petroglyphs and mural paintings, ancient and modern pottery
designs, basket and textile patterns, and Kachina masks are transformed into jewelry designs.
In *Turquoise Bird* (Fig. 11–7) Mike Kabotie has created a design which symbolizes Hopi
jewelry. Rocks of turquoise and coral and a Sikyatki-style bird rise from a baseband of heshe.
The precious stones of Hopi jewelry are echoed in the beak of the bird.

In *Homage to Hopi Overlay* (Fig. 11–8), Kabotie compares Hopi overlay to "a new
birth of Hopi." In the center of the design is the Migration symbol and the square is a symbol
of the Sepapu, the opening through which the Hopis emerged into this world. This form is

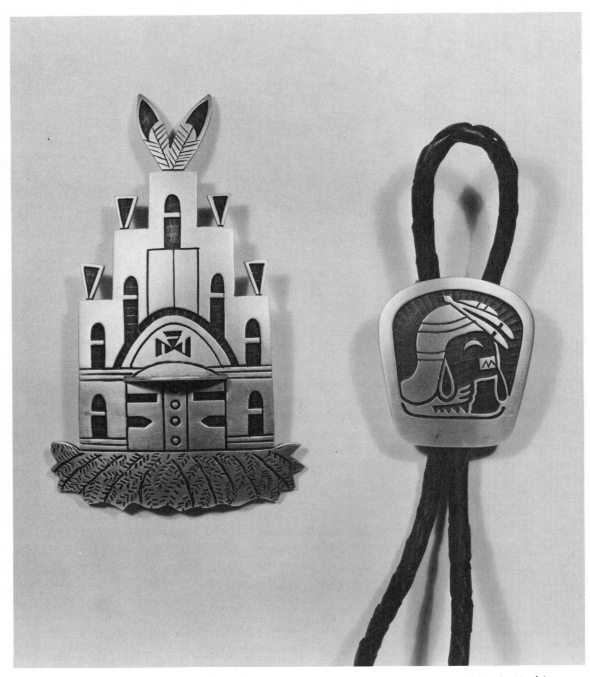

11-6. *Tony Kyasyousie.* Bearded Kachina Bolo. *Eldon Sieweyumptewa,* Hemis Kachina
Pendant. *1970s. H. Bolo, 1⁷/₈". H. Pendant, 4³/₄". Silver overlay. Private Collection.*

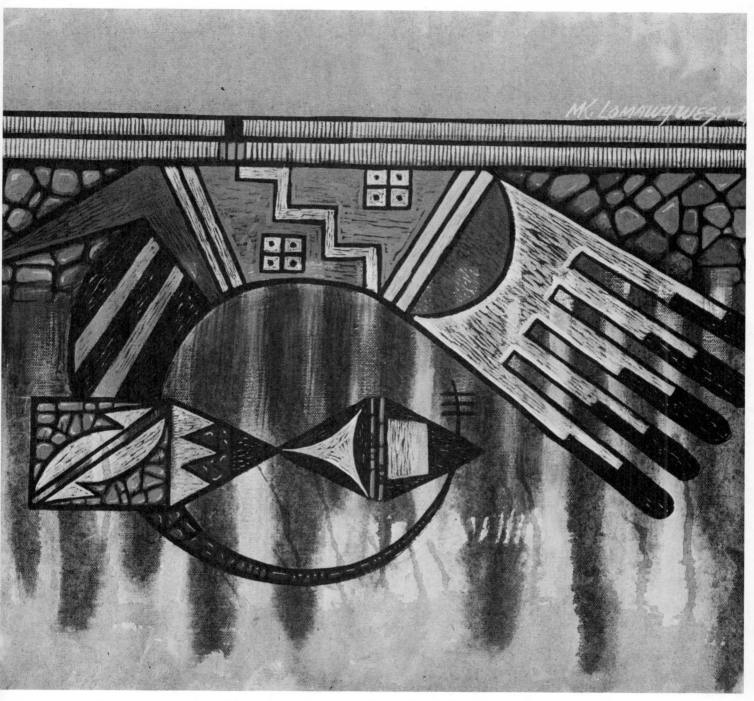

11-7. Lomawywesa–Mike Kabotie. Turquoise Bird. 1974. 16″ x 20″. Acrylic. Collection:
Hopi Cooperative Arts and Crafts Guild.

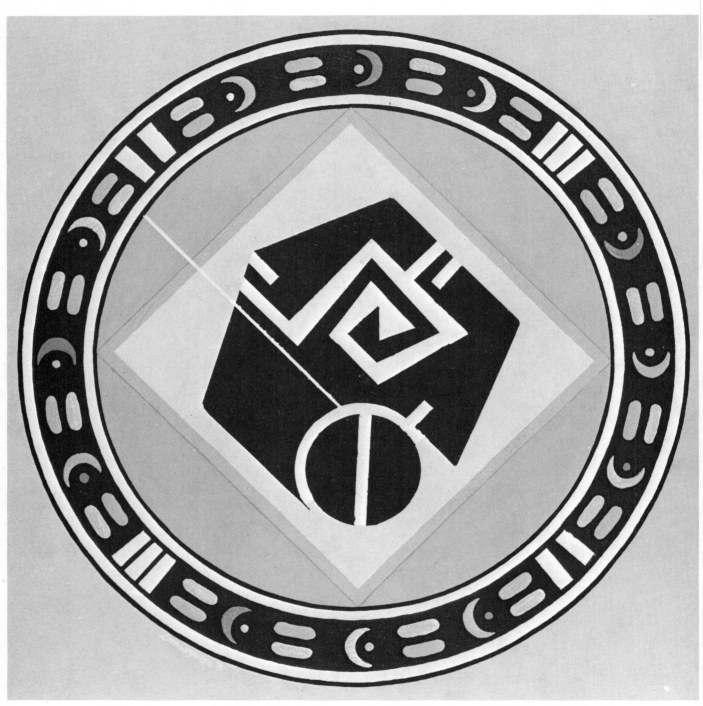

11-8. *Lomawywesa–Mike Kabotie. Homage to Hopi Overlay. 1975. 30" x 30". Acrylic. Collection: Hopi Cooperative Arts and Crafts Guild.*

also symbolic of the kiva which is associated with the womb and is part of the Hopi Emergence concept. A serpent, which represents fertility, surrounds the land, and the short straight lines indicate the four directions.

Kabotie explains that Hopi artists return to elements of their land and use designs which are part of their cultural heritage in order to understand their roots. Only by contact with the past and by incorporating designs of the past into their work can modern Hopis realize their identity in the contemporary world.

Modern Hopi painting is a blend of the ancient and the modern, tradition and innovation; for Hopi art, like Hopi life, is a celebration of endurance and regeneration. Hopi painters, by incorporating images from both the crafts of their ancestors and the newly developed crafts of twentieth century Hopi artisans, give visual testimony to the continuity of Hopi cultural history and to the creative force in Hopi art.

NOTES

1. Clara Lee Tanner, *Southwest Indian Craft Arts* (Tucson: University of Arizona Press, 1968), p. 7.

2. *Ibid.,* p. 20.

3. *Ibid.,* p. 9.

4. *Ibid.,* p. 38.

5. *Ibid.,* p. 54.

6. *Ibid.,* pp. 55–56.

7. Watson Smith, *Kiva Mural Decorations at Awatovi and Kawaika-a with a Survey of Other Wall Paintings in the Pueblo Southwest* (Cambridge, Mass.: Peabody Museum of American Archeology and Ethnology, Harvard University, 1952), pp. 273–76.

8. Margaret Nichelson Wright, *Hopi Silver* (Flagstaff, Ariz.: Northland Press, 1972), pp. 1–34.

9. *Ibid.,* pp. 37–50.

CHAPTER 12

Experiments with Forms of Modern Art

There is a great temptation to romanticize Indian culture and Indian art. Even in the twentieth century, many people think of Indian painting as the naïve visual expression of cultures uncontaminated by contact with the artistic traditions of European civilization. It is doubtful that even in the early twentieth century, Indian painters who lived in Santa Fe or those who, having learned the fundamentals of drawing and painting, returned to their people to work in their native land were able to create truly indigenous works of art. The white man had been present in the Southwest for more than three centuries, and it is undeniable that conquest and domination by Spanish, Anglo, and American cultures had a major influence on Indian art as well as on the Indian way of life.

White civilization brought irreversible changes to the Indian world, and these changes had to be reflected in Indian art. The concept of an artist as a creative individual whose goal is independent achievement is foreign to most Indian cultures. In the traditional Indian world, creativity and artistic expression were an integral part of daily and ceremonial life. Creative work was not recognized as a special achievement and the creator was not rewarded with individual praise and singled out as a special creative personality. All artistic creation was the individual's contribution to the general welfare of the community. Hopi painters, carvers, weavers, and potters were content to be functional members of society, following the Hopi Path of Life.

The concept of twentieth-century Indian painting as either naïve or ethnologically pure is a myth. Kachina painting—readily identifiable individual Kachinas, lines of standing

279

Kachinas, and narratives of Kachina figures which are thought of as traditional Hopi art—had its roots in the Fewkes commission, the teachings of John and Elizabeth DeHuff and the Dorothy Dunn Studio. The inadequacies of stylized naïve art has been recognized by many contemporary Indian artists, and today many Indian painters work within the mainstream of modern art. Schools like the Institute of American Indian Art familiarize Indian painters with the basic techniques and innovations of twentieth-century art. In recent years, several Indian artists have achieved international success by transforming Indian art into a form of racial and political commentary on the problems of the American Indian in the twentieth century. Most of these artists, however, live in the urban centers of the Southwest—Santa Fe, Albuquerque, Phoenix, and Los Angeles—far from their people and their traditions.

The painters of the Artist Hopid are participants in a cohesive society and in their art they express their commitment to the Hopi culture. Their's is not the work of expatriot Indians nostalgically recalling a once-idyllic existence or angrily protesting social injustice in a world to which they no longer belong, a world with which they have little in common. In contrast, these Hopi artists recognize the problems and experience the tensions of the Indian in society today. They recognize that the mid-twentieth century is a transitional period in Hopi history and that the contemporary Hopi world is inextricably tied to the past. Modern Hopi art, like modern Hopi life, is distinguished by a sense of history and cultural continuity.

Thanks to modern communication and transportation, the Hopis no longer live in an isolated world. Hopi civilization is no longer threatened by starvation from crop failure and drought. Electricity, automobiles, highways, supermarkets, and television are part of everyday Hopi life. Commercial food products, clothing, furniture, and household supplies are an accepted part of daily life; and it is a fantasy to think modern industrial civilization has not changed the Hopi world. What distinguishes the Hopi people is that despite technological changes the Hopis continue to reaffirm the tenets and values of their cultural heritage.

The painters of the Artist Hopid are international in outlook but have their roots in their own land. In their quest to give visual expression to the experience of the Indian in modern America, they experiment with all forms of modern art, but the basic commitment of these Hopi artists to their own culture remains firm. They apply the techniques of Cubism, Surrealism, Hard Edge painting and Pop Art to icons and designs that are part of Hopi cultural history. Some of these artistic experiments are more successful than others; nevertheless, they represent the artistic evolution of a people who live in a transitional world.

The techniques and conventions of Cubism have great appeal to modern Hopi artists. Hopi art is basically a representational and didactic art, an art which proclaims and reaffirms the power and strength of the Hopi generative force. Hopi artists are able to unify abstract designs which are based on a Cubist precedent without destroying the recognizability of the form. The fragmenting and reduction of forms into their structural components is a highly effective means of expressing the limitations of man's knowledge of both the physical and the spiritual world. As the Hopi progresses along the Path of Life and through the many stages of initiation, he develops an understanding of his tribal past, of the meaning and direction of present-day Hopi ceremonial life, and of the role of the Dead in the Underworld when life on Earth is completed. No individual, however, possesses total understanding of the Hopi world, for each clan and society guards its own history and secrets. Complete knowledge of the Hopi world is unattainable even by the most respected clan and society leaders. For the non-Hopi it will never be possible to attain more than a fragmentary understanding of the surface of the Hopi world, because knowledge of the Hopi world is passed from generation to generation and the secrets of initiation are inaccessible to those who do not belong to the Hopi world.

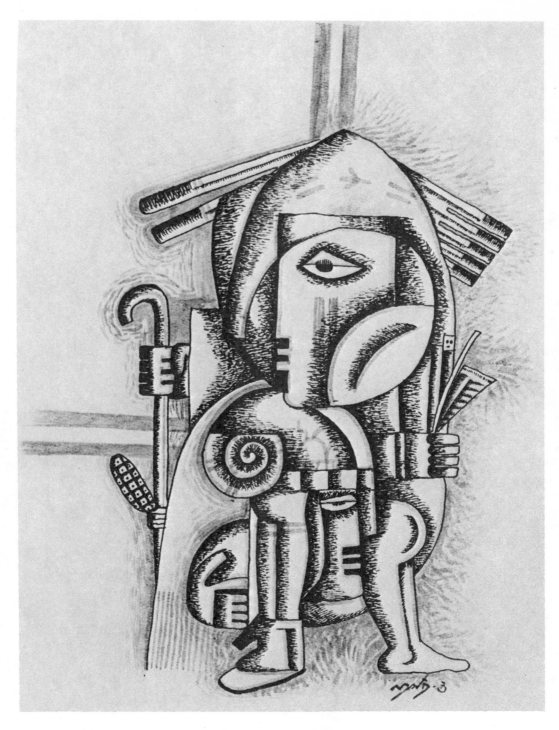

12-1. *Neil David, Sr.* One Horn Priest and Warrior Priest. *1973. 16" x 10". Ink. Private Collection.*

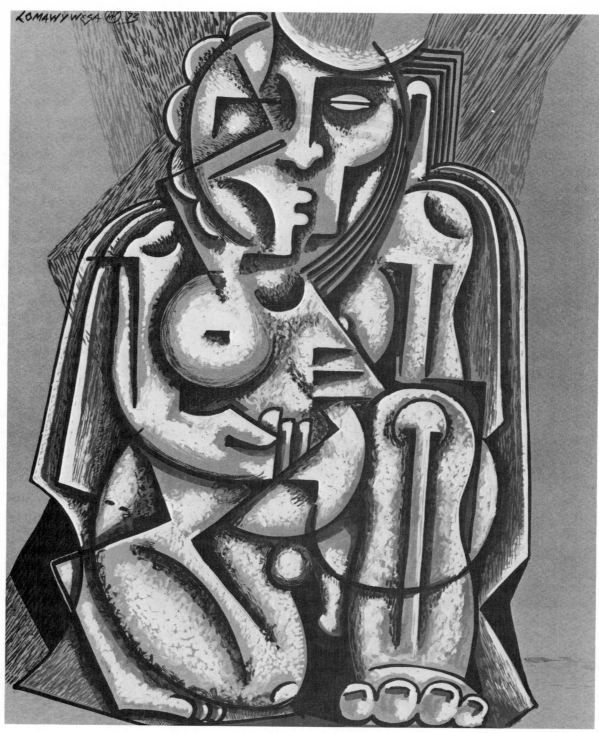

12-2. *Lomawywesa–Mike Kabotie. Hopi Lovers I. 1973. 19¹/₂″ x 13¹/₂″. Mixed media.*
Collection: Ed Comins, Phoenix, Ariz.

282

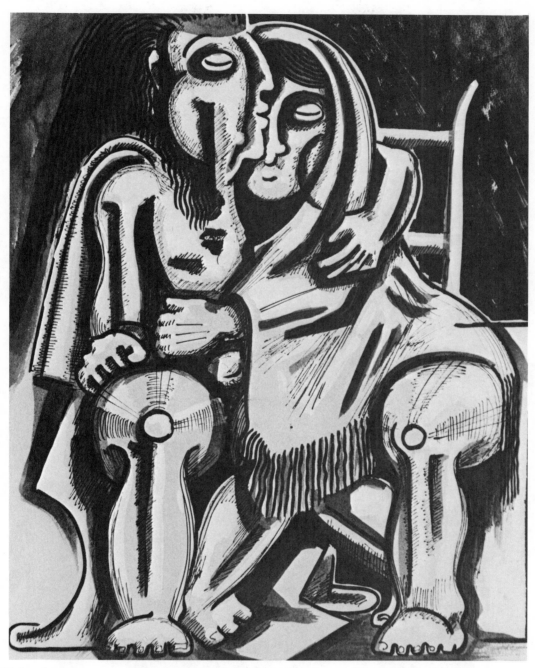

12-3. *Lomawywesa–Mike Kabotie. Hopi Lovers II. 1972. 12″ x 10″. Mixed media. Private Collection.*

Lomawywesa–Mike Kabotie. Deer Dancer, 1969. 19″ x 10¹/₂″. Mixed media. Collection: James T. Bialac, Scottsdale, Ariz.

12-7. *Lomawywesa—Mike Kabotie. Portrait of a Big Horn. 1974. 26" x 18¹/₂". Acrylic. Collection: Hopi Cooperative Arts and Crafts Guild.*

During the past decade, all members of the Artist Hopid have experimented with Cubist techniques in order to convey a sense of the complexity and mystery of the Hopi world. In *Hopi Life* p. 37 , Delbridge Honanie has transformed the left side of the painting into a Cubist composition which stands apart from the clear symbols and representative images of the rest of the work. Honanie explains that the Cubist forms represent the people of all tribes fighting during the days immediately following Emergence into the Fourth World. Because the long years of Migrations followed the Emergence, the Migration spirals and hand and foot prints are all important composition elements. Honanie's complex Cubist images symbolize the confusion of this period when the people were unsure of their identity. Two paintings by Terrance Talaswaima, *Study of Rock #1* and *#2*, are Cubist designs that suggest variations in the forms, colors, and textures of the rocks of the mesa and the spiritual character of these rocks p. 33, p. 34 .

The tremendous complexity on historical, ethnological, and psychological levels of Hopi ceremonial life has inspired many contemporary Cubist paintings. *Symbols of Powamu* p. 168 and *Symbols of Bachavu* p. 170 are a kaleidoscope of petroglyph images, clan symbols, craft designs, and Kachina masks. Design elements from ancient kiva murals, Kachina masks and costumes, textiles, and pottery are the basic components of many Hopi Cubist compositions. In *Awatovi Murals* p. 225 , Neil David, Sr., applies Cubist techniques to bird, butterfly, and Kachina images quoted from the mural fragments excavated from Awatovi. He preserves the image of the Awatovi bird, but transforms the features and decorative images of the Kachina masks and textile patterns into elements of geometric composition. Milland Lomakema in *Awatovi Motifs of the Kachina Clan* p. 64 also turns to the ancient murals for inspiration. In *Symbols of the Dance* p. 109 , Lomakema's vision of Kachina images as industrial forms is reminiscent of the Precisionist work of Charles Demuth who painted the world of industry within a generic Cubist framework. *One Horn Priest and Warrior Priest* (Fig. 12–1), David's Cubist study of two important Hopi ceremonial figures, and *Abstract of Whipper* p. 187 , Milland Lomakema's composition in which a Kachina figure constructed of traditional symbols and designs is integrated into a background of basket-weave patterns and rain symbols, exemplify modern Hopi experiments with Cubism.

Mike Kabotie painted *The Christian Kachina* p. 217, one of his first experiments with Cubism, in 1968, a year after his initiation. Kabotie feels that at this time he began to develop a clear understanding and appreciation of his Hopi heritage and of his identity as a Hopi. He acknowledges his debt to Picasso, whose Cubist influence inspired many of Kabotie's paintings. The strength of Picasso's influence is evident in *Hopi Lovers* I and II (Fig. 12–2) (Fig. 12–3), in *Hopi Mother and Child* p. 193 , and in *Kachina Lovers* p. 135 which explores the human side of a Kachina and his beloved. In *Ceremonial Priest* p. 254 , Kabotie uses Cubist techniques to suggest the complexity and multiple levels of the Kachina tradition. In this work, he reduces to geometric abstractions the images of a Long-Haired Kachina, a Dancer with a rattle, a Priest wearing a prayer feather, and a woman. In the uppermost figure, Kabotie superimposes a profile of a man against a Kachina mask in order to express the dual identity of the Kachina Priest.

The concept of the Kachina world as a world of fleeting colorful images and symbols is frequently translated into Cubist terms. Both *Hopi Study* p. 125 and *Kachina World* p. 123 by Bevins Yuyahoeva, suggest the visual impact of the Kachina Dancers. Milland Lomakema in *Faces of Kachinas* p. 127 and Mike Kabotie in *Kachina Faces* p. 130 abstract elements of Kachina masks to suggest the visual excitement and color of the Kachina cere- monies. Lomakema's masks are reminiscent of those represented in the Awatovi murals,

whereas Kabotie's masks are reduced to their basic geometric elements and traditional designs. These forms are superimposed on a Mayan profile, a symbol of his ancestors. In *Dance Maiden and Mask* p. 132 , Lomakema integrates the geometric components of the face and mask into a background composed of basket-weave and textile designs.

The Hopi artist is, in many ways, a visionary, for manifestations of the Spirit World are an ever-present part of Hopi life. In the Hopi world, animals, plants, clouds, and rainbows, as well as inanimate objects such as rocks, have a spirit of their own. Ancestral spirits carry out their responsibilities in order to assure the prosperity of the Hopis on Earth. Deities, Kachina Spirits, and even Ogres are all part of the spiritual inheritance of the modern Hopi.

Waldo Mootzka was one of the first Hopi artists to paint the visions inspired by Hopi spiritual beliefs. *Fertilization* p. 16 is one of a series of paintings in which a naked man kneels before a row of torch-bearing maidens. All of the figures are suspended above stylized cloud and rainbow forms. These images symbolize the power of germination which is central to Hopi life.

Each member of the Artist Hopid has a distinctive means of communicating his vision of the Spirit World. In *Dreams of Hopi* p. 110 , Bevins Yuyahoeva has painted a seated Kachina who envisions a series of infinite reflections of his ceremonial mask. Some of the dream images are vague shadows, while others are clear, brightly-colored masks. A giant arm holding the ceremonial rattle symbolizes the power of the Kachina. Terrance Talaswaima portrays the ever-present spirits in the Hopi world by means of a personal iconography. *Pathway of Spirits* p. 180 typifies Talaswaima's work, which can frequently be identified by Corn Spirits with mask-like features and prayer feathers at the top of their heads. The pregnant bodies of these fertility spirits are defined by a black outline which terminates in a Migration spiral. Talaswaima's images of Corn Spirits in *Spotted Corn Germination* p. 95 and *Prayer to Corn People* p. 96 are translucent forms through which can be seen the color washes which represent the Hopi world. Talaswaima paints Spirits of the unborn and Spirits of those whose days on Earth are over.

Milland Lomakema, like Terrance Talaswaima, has created a personal Spirit World. Lomakema's Corn Spirits in *Corn Maidens* p. 73 are solid geometric forms which have importance as independent elements of design. *Corn Field* p. 30 is an almost Surrealistic representation of a corn field bordered by mesas and surrounded by clouds and a rainbow. Beams of sunlight streaming from a Sun Forehead symbol give the work the perspective of a Surrealist dream.

In the past decade, Mike Kabotie has experimented with many forms of modern art. In several paintings, he has successfully used Surrealist techniques to portray the multiple levels of Hopi spiritual life. *Deer Dancer* p. 284, painted in 1969, is one of his earliest Surrealist efforts. In recent years, Kabotie has periodically chosen Surrealism to convey his vision of the Hopi Spirit World. *Water Serpent My Father* p. 101, is a Surrealist dramatization of the legend of Palotquopi (see chapter 5). *A Hopi Dream* (Fig. 12–5) is one of Kabotie's most complex Surrealist works. Kabotie explains that the Hopi man is dreaming that he is part of the rocks of the Hopi world. He is within his house, made of the stones of the mesa, and this stony structure represents the security of home and shelter. The bare bones of his body represent the hard times which the Hopi people can overcome with the help of the Dieties and Spirits. The head of a Water Serpent emerges from a pottery jar, a symbol of Hopi cultural history. The body of the snake coils over the Hopi in his shelter. The hawk, which represents the breath of prayer, relates the messages and prayers of the Hopis to all directions and, in turn, these prayers are answered from all directions. The dreamer has dual identities,

Reproduction of Fragment of Awatovi Mural. c. 1700. Room 788, left wall design.
Photograph. Collection: Museum of Northern Arizona, Flagstaff.

12-8. *Lomawywesa—Mike Kabotie. Hopi Warrior Spirits. 1974. 26" x 40". Mixed media. Collection: Hopi Cooperative Arts and Crafts Guild.*

a Hopi man and a One-Horn Kachina. The duality of human and ceremonial roles in the Hopi world is echoed by the profile of a man superimposed on the profile of a deer dancer. Beneath the headdress of clouds and yucca, both the image of the man and the mask have the appearance of a rocklike mosaic. The dual identity of the deer dancer is symbolized by the rocklike legs of man and deer.

Kabotie uses a mosaic of rocks to define the bodies and facial features of the Hopis in *Coming of the Water Serpent* p. 103 , *Dark Dawn Blessing* (Fig.12–6, p. 256) and *Becoming a Spirit* p. 195. The figures in these paintings are reminiscent of Mexican political paintings. In *Dark Dawn Blessing,* one Hopi is deep in meditation while the other stares straight ahead at the vision before him. He sprinkles cornmeal, the symbol of motherhood, with his right hand (right has connotations of good) because, throughout Hopi history, the Hopi people were nurtured by corn. The pottery motif, which appears in the upper part of this painting and in the upper part of *Becoming a Spirit,* is a symbolic of Hopi cultural history. Kabotie explains that *Dark Dawn Blessing* portrays the importance of tradition in Hopi life and the ability of the Hopi people to faithfully follow the Hopi Way. In *Signatures of the Past* p. 59, Kabotie celebrates the impact of Hopi artistic and spiritual history on contemporary Hopi artists. The images of Hopi Spirits and traditional symbols are close in feeling to the Surrealist work of Miró.

Today Hopi artists embrace Pop Art as a means of satiric social commentary. *Portrait of a Big Horn* (Fig. 12–7) is a Pop Art portrait of the dancer from the Rio Grande area. Mike Kabotie once again superimposes the profile of a Hopi on the mask of the dancer. The

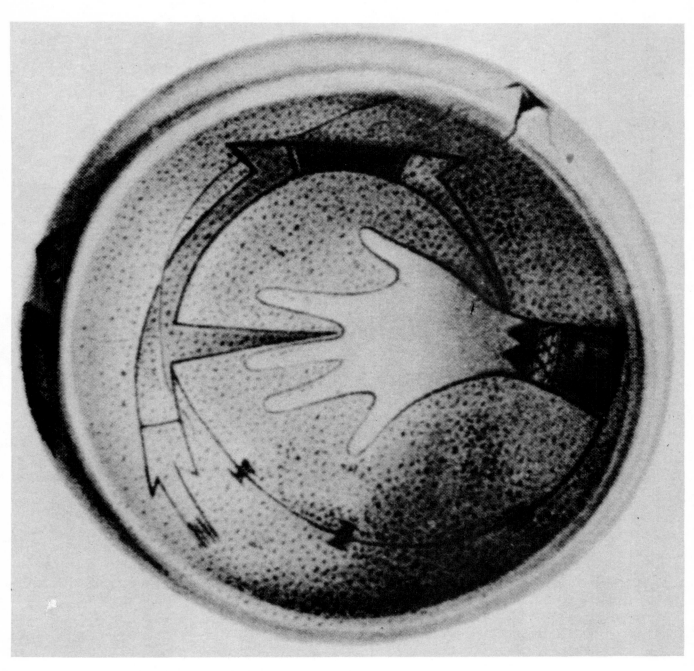

Vessel with Figures of Human Hand from Sikyatki. *Bureau of American Ethnology Annual Report 17., plate 137. Photograph. Collection: Smithsonian Institution, National Anthropological Archives, Bureau of American Ethnology Collection, Washington, D.C.*

rocklike forms of man, mask, headdress, costume, hand, and rattle have a plastic appearance, for Kabotie describes this satiric work as a portrait of a plastic Kachina Dancer who lives in a plastic modern world and performs his dance to influence the atmosphere.

Mike Kabotie occasionally uses cartoon images in his work. In *Warrior and Water Serpent* p. 91, which depicts an incident from an ancient children's story, Kabotie has chosen to paint Spider Woman and her mischievous grandson as cartoon figures. Kabotie describes another Pop Art work, *Hopi Warrior Spirits* (Fig. 12–8), as "a Hopi macho trip." The eagle and the puma represent the powers of sky and earth. The puma, holding a medicine bag, thinks about the Snake Society which performs ceremonial prayers to insure a successful harvest. With the exception of these Snake Priests, all images in this work can be traced to the Awatovi mural fragments. This painting, which appears at first glance to be an example of twentieth-century Pop Art, is composed of images identical to those painted on murals three centuries ago. This Pop Art painting proclaims the same message as the historic messages on the kiva walls: the power of fertility and germination in the Hopi world.

Many modern Hopi paintings can be considered highly successful examples of Hard Edge painting. For centuries Hopi artists have succeeded in understanding the relation of shape, space, and color. The exploration of these relations is the essence of Hard Edge painting. Symbols from Hopi history and legend are rich in design value. In *Sepapu* p. 47, Milland Lomakema, through geometric abstraction, expresses the concepts of Emergence, Four Worlds, and Four Directions. Lomakema, in *Bear and Kachina Migration Patterns* p. 60 created unified designs from clan symbols and traditional cloud, water, and Migration symbols. Many of the most effective Hopi Hard Edge paintings are inspired by ceremonial life. These paintings have great dramatic impact and convey the color and spirit of the Hopi dancers. In *Chaquina II* p. 134, the features of man and mask are abstracted into a geometric design. In *Two Uncle Star Kachinas* p. 112, Delbridge Honanie uses clear acrylic colors on simplified geometric forms as a means of portraying the protagonists in the Mixed Kachina Dance. These images are similar in impact and immediacy of communication to modern commercial art.

These paintings are part of the mainstream of Hopi cultural tradition, rather than isolated attempts to utilize the techniques of modern art. With the exception of a few artists who, early in the twentieth century, attempted to follow the principles of European realism, Hopi artists for centuries have painted two-dimensional designs and images. Two-dimensional representations of Deities, wildlife, water, clouds, lightning, Migration spirals, and hand prints can be found on cave walls throughout the Southwest. Geometric abstraction is fundamental to traditional Hopi pottery, basketry, and textile design. The potters of Sikyatki utilized highly sophisticated abstract geometric patterns, which are the predominant designs of Hopi pottery today, (see chapter 10). Fragments of the kiva murals excavated in Awatovi exhibit flat areas of color defined by sharply marked black, white, and red lines. Milland Lomakema in *Antelope Priest* p. 71, a Hard Edge painting of a Rain Priest of the Antelope Society, observes the conventions of the Awatovi murals. In *Stylized Eagle* (Fig. 12–10), a work inspired by Awatovi pottery designs, Milland Lomakema simplifies and abstracts traditional designs and symbols in order to create an innovative Hard Edge design. In *Women's Society* p. 161 by Delbridge Honanie, a Hard Edge painting based on two symbols of the Women's Ceremony, the border of prayer feathers and the dragonflies, is taken directly from the Awatovi murals.

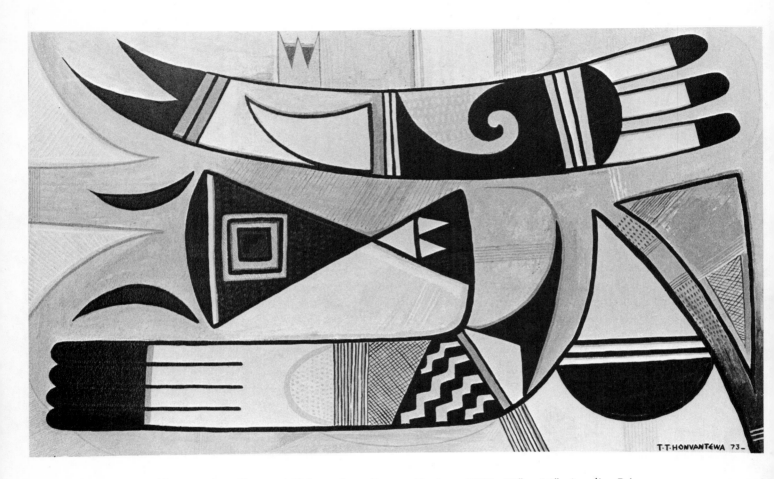

Honvantewa—Terrance Talaswaima. Pottery Design. 1973. 19" x 31". Acrylic. Private Collection.

292

12-10. *Dawakema—Milland Lomakema. Stylized Eagle. 1975. 23" x 25". Acrylic. Collection: Hopi Cooperative Arts and Crafts Guild.*

Mural Fragment from Kawaika—A. *Test 5, Room 1. Left wall design 1. Seated figure on baseband. Note similarity of geometric design of* Futurist Hopi *and sixteenth-century design of kilt. Peabody Museum Papers, vol. XXXVII, fig. 676. Photograph. Collection: Peabody Museum, Harvard University, Cambridge, Mass.*

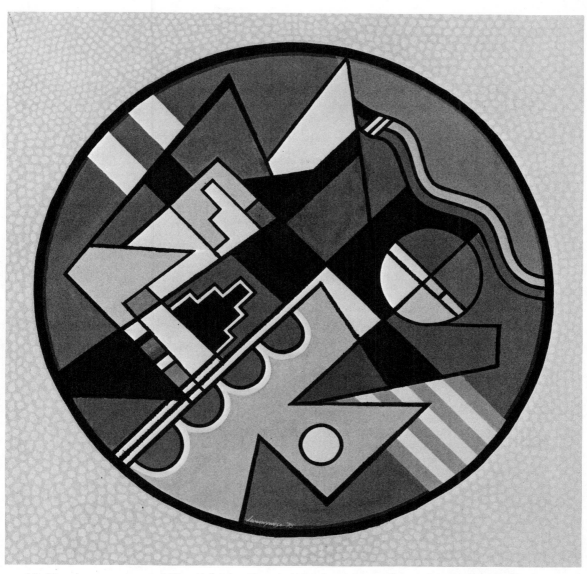

12-11. *Lomawywesa—Mike Kabotie. Futurist Hopi. 1975. 40″ x 40″. Acrylic. Collection: Hopi Cooperative Arts and Crafts Guild.*

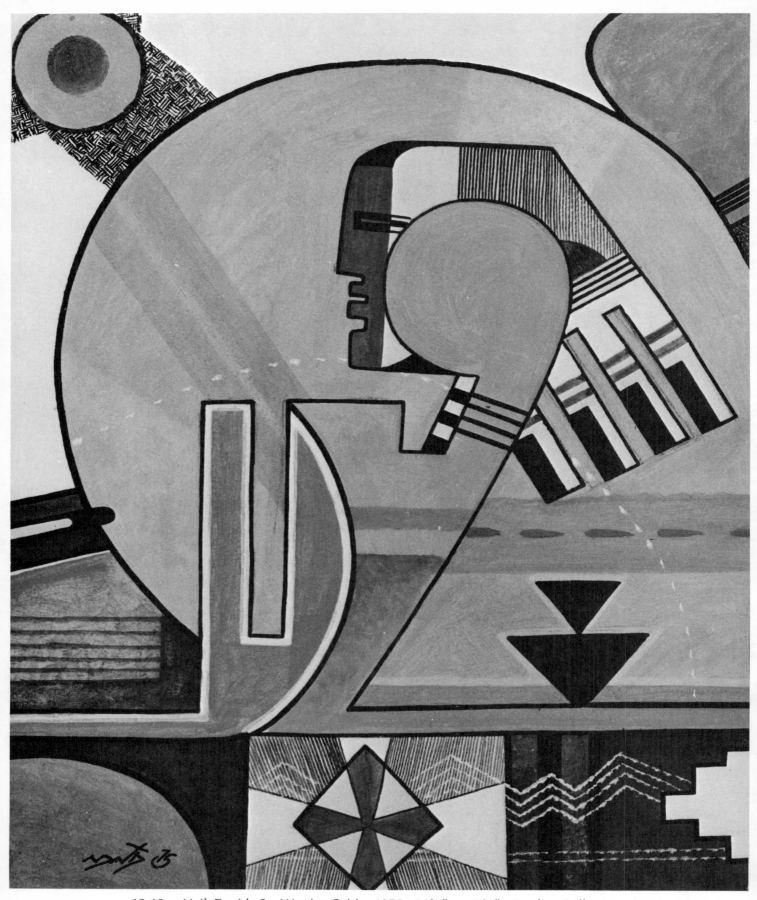

12-12. *Neil David, Sr. Warrior Spirit. 1975. 14¹/₂″ x 11¹/₂″. Acrylic. Collection: Hopi Cooperative Arts and Crafts Guild.*

The Hopi Hard Edge painter adopts pottery patterns (*Pottery Design*, p. 292) to the flat surface of the painting, simplifies the woven patterns of basketry (*Social Dance Maiden*, p. 163, isolates patterns of textile design (*Futurist Hopi*, Fig. 12–11), and simplifies symbols used as jewelry patterns (*Homage to Hopi Overlays*, p. 277) in order to create paintings which initially appear to be experiments with modern techniques but upon analysis are clearly traditional Hopi images. In *Warrior Spirit* (Fig. 12–12), Neil David, Sr., combines a sun image, pottery elements, kilt design, basketry, and a Kachina mask to create a highly effective Hard Edge work. It is hard to realize that the central design of *Sikyatki Hand and Bee* p. 255 is quoted directly from a Sikyatki vessel. In this work Mike Kabotie strives to achieve the most modern effect possible, in order to show that ancient Hopi designs and symbols are all important in modern Hopi art, and that the Hopi culture retains vitality in the twentieth century.

Today Hopi artists continue to search for the most effective visual means of expressing the essence of Hopi creativity. They combine the techniques and stylistic innovations of the twentieth century with the pictorial traditions of the past in order to express their vision of the Hopi world. This vision encompasses the ethnological past, the history, the religious beliefs and legends, and the contemporary problems and goals of the Hopi people. Traditionally, Hopi painting is a ceremonial art and modern Hopi art is part of the mainstream of Hopi culture. For generations, Hopi artists have painted decorative images, symbols, and designs on kiva walls, altars, masks, and ceremonial objects. All Hopi symbols and designs are directly related to Hopi ceremonial life and all Hopi art extols the generative forces in Hopi life. Like their ancestors, the painters of the Artist Hopid are dedicated to celebrating the generative force in the Hopi world. The goal of their painting is to interpret the Hopi Way and the Hopi Spirit—the Hopi Way and the Hopi Spirit of ancient days and the Hopi Way and the Hopi Spirit of the mid-twentieth century.

CHAPTER 13

The Artist Hopid

The Artist Hopid was organized in May 1973, by Mike Kabotie, Terrance Talas-waima, and Neil David, Sr. The founders of the Artist Hopid had five basic objectives: (1) to utilize the artistic talents of the Hopis to instill pride and identity; (2) to educate the Hopi, non-Hopi, and the non-Indian to the aesthetic and cultural values of the Hopi; (3) to experiment and test new ideas and techniques in art, using traditional Hopi designs and concepts; (4) to control their artistic talents and market; (5) to research and document Hopi history and events through the visual arts for posterity.[1] All members of the Artist Hopid live on the mesas and are active participants in all phases of Hopi life.

In 1974 the Artist Hopid held their first annual exhibition on Second Mesa. This exhibition, held in conjunction with the Hopi Arts and Crafts Cooperative Guild on Second Mesa, has become an annual event. In 1974 the Artist Hopid also exhibited as a group at the Heard Museum in Phoenix, at the Tucson Art Center, at Riverside Community College in Riverside, California, and at the Museum of Man in San Diego. In 1975 the Artist Hopid had exhibitions at the Taylor Art Museum in Colorado Springs and at the Flagstaff Art Museum.

The year 1976 was of major importance for the Artist Hopid. The National Endowment for the Arts and the Arizona Commission on the Arts and Humanities provided a joint grant to send thirty-one paintings on a tour across the United States. These paintings were exhibited at the Arizona state capital in Phoenix; Texas A&M; Northern Arizona University; the Desert Caballeros Museum in Wickenburg, Arizona; the Katona Gallery in Katona, New

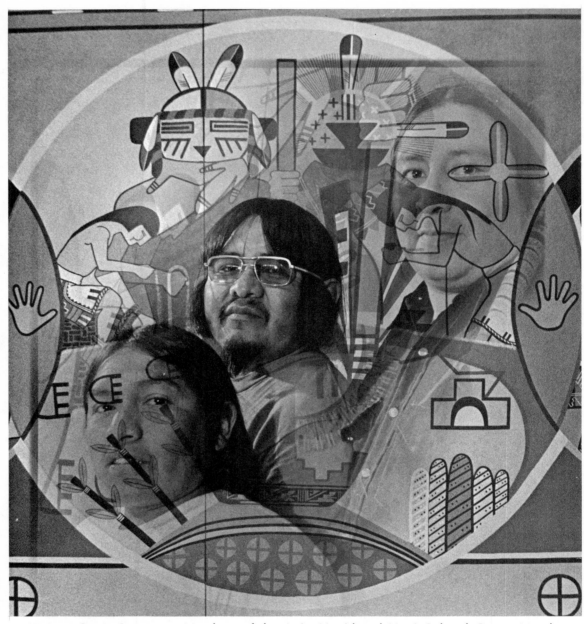

13-1 *Owen Seuptewa. Members of the Artist Hopid and Hopi Cultural Center Mural. 1975. Composite Photograph.*

York; and the Southern Plains Indian Museum and Art Center in Anadarko, Oklahoma. The tour was concluded in 1977 by an exhibition at the Hillsboro County Museum in Tampa, Florida.

In order to give visual evidence of the roots of Hopi iconography and style, these exhibitions included examples of Hopi craft arts and fragments of petroglyphs and ancient kiva murals. The members of the Artist Hopid also gave demonstrations and lectures and occasionally participated in readings of ancient and modern Hopi poetry as a means of broadening the understanding of those who attended the exhibitions.

COOCHSIWUKIOMA—DELBRIDGE HONANIE

Delbridge Honanie was born in January, 1946, in Winslow, Arizona. He received his early education on the Hopi Reservation and in 1968 was graduated from the Phoenix Indian School, a Bureau of Indian Affairs boarding school. While in Phoenix, Honanie studied painting under Winton Coles and upon graduation entered the Institute of American Indian Arts in Santa Fe. At the Institute, Delbridge studied with Otellie Lolma, a well-known Hopi artist and teacher. In 1970, after receiving his diploma from the Institute of American Indian

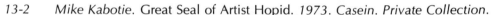

13-2 *Mike Kabotie.* Great Seal of Artist Hopid. *1973. Casein. Private Collection.*

Arts, Honanie returned to Phoenix, where he worked as an arts and crafts instructor at the Phoenix Indian School.

Delbridge Honanie has exhibited his work in museums and galleries throughout the United States and has entered and won many Indian art competitions. In 1968, while studying in Phoenix, he won a student award at the Scottsdale National Indian Art Show. In 1969 he won the "Discover America" poster contest and his winning entry, *Two Shalakos*, was reproduced as a poster. In 1970 Honanie won several awards at the Heard Museum National Art Show, and in 1975 he won the Swazo Memorial Award at the Heard Museum.

In 1972 Honanie returned to the Hopi villages to be initiated into the Men's Society. At this time he received his manhood name, Coochsiwukioma, which means "falling snow." Honanie is a member of the Bear Clan, the spiritual leaders of the Hopi people.

In 1973 Honanie joined the Artist Hopid. In addition to his work on the Hopi Ceremonial Calendar mural, he has painted a mural in the Academic Building on the Institute of American Indian Art campus and a mural in a building on the Arizona State University campus.

DAWAKEMA—MILLAND LOMAKEMA

Milland Lomakema was born in Shungopovi in 1941. He was educated at Hopi Reservation schools, the Navajo Mission in Holbrook, Arizona, and the Hardin Academy in Searcy, Arkansas. He also studied at Magic Valley Christian College in Delco, Idaho. Lomakema is a self-taught artist with no formal training in the arts.

In 1958 Lomakema joined a visual education tour which traveled throughout the east coast of the United States and Canada. He returned to the mesas in 1960 and was initiated into the men's One Horn Society. Milland Lomakema is a member of the Corn-Water Clan, which participates in all Hopi religious activities.

During the mid-1960s, Lomakema worked with a detective agency in Phoenix, and in 1968 he joined the Hopi police force. While employed as a law-enforcement agent, Lomakema devoted much of his time and energy to painting, participating in many local art exhibitions, and entering many competitions. In 1968 his painting *Sea Serpent and Sun* won first place in the Heard Museum's National Indian Art Show. In 1969 he was awarded second and third prizes in the Indian Arts Competition at the Arizona State Fair. In 1970 Lomakema won awards at the Scottsdale National Indian Art Exhibition, the Gallop Inter-Tribal Ceremonial Competition, and the Navajo Tribal Fair.

Today Milland Lomakema's work is in many museums and private collections. In 1973 he joined the Artist Hopid and since this time has worked and toured with the group. In addition to exhibiting his paintings, he frequently lectures on the objectives of the group.

LOMAWYWESA—MICHAEL KABOTIE

Mike Kabotie was one of the three founding members of the Artist Hopid and is the spokesman for the group. Born in Shungopovi in 1942, Mike is the son of Alice Kabotie and Fred Kabotie. (Fred Kabotie was the first Hopi to win individual recognition as an artist. In 1949 he founded the Hopi Cooperative Silvercraft Guild.) Mike Kabotie was educated at the Reservation Day School and studied art with his father. In 1959 Mike entered Haskell Institute in Lawrence, Kansas, and was graduated in 1961. Following graduation, he entered the College of Engineering at the University of Arizona in Tucson but withdrew from the University to devote his full attention to painting.

In 1966 Mike Kabotie had a one-man show at the Heard Museum and, in August of that year, one of his paintings was featured on the cover of *Arizona Highways*. During 1968

and 1969 he won the Merit Awards and first and second place awards at the Gallop Inter-Tribal Ceremonial Competition. In both 1969 and 1970 Mike Kabotie won honorable mention at the Indian Art Competition at the Philbrook Institute in Tulsa. In 1971 he won first place award in the Indian art competitions at both the Museum of Northern Arizona at Flagstaff and at the Heard Museum.

Mike Kabotie is an active participant in all phases of Hopi life. He is a member of the Snow-Water Clan which cosponsors the Flute Ceremony held in Shungopovi on odd-numbered years. (The Snake Ceremony is held on even-numbered years.) In 1967 Mike was initiated into the Wuwuchim, the Hopi Men's Society, and his Godfather gave him his adult name, Lomawywesa which means "walking in harmony."

In January 1970 Mike Kabotie was elected president of the Hopi Arts and Crafts Cooperative Guild, and for three years he devoted the greatest part of his time and energy to this organization. In 1973 he was a founder of the Artist Hopid. Since this time he has directed the activities of the group and organized their exhibition tours. Mike Kabotie has lectured at museums and universities throughout the United States including San Diego State University, Harvard University, Rochester Museum of Science, and Northern Arizona University.

NEIL DAVID, SR.

Neil David, Sr., is the only Tewa in the Artist Hopid. His paternal ancestors, seeking refuge from the Spanish reprisal which followed the great Pueblo Revolt of 1680, settled among the Hopis. He lives in the Tewa-speaking community of Hano on First Mesa and is a member of the influential Kachina Clan. Neil was born in Hano in 1944 of Hopi and Tewa parents.

David attended Polacca Day School and Hopi High School, where he studied art with Fred Kabotie. In 1959 David transferred to the Phoenix Indian School. Today he is recognized as a Kachina carver as well as a painter. Following graduation from the Phoenix Indian School, David entered the armed forces and served in Germany. Since 1968 he has devoted his full energy to painting. In 1973 he became one of the founders of the Artist Hopid.

HONVANTEWA—TERRANCE TALASWAIMA

Terrance Talaswaima was born in 1939 in Shipolovi. He attended primary school at the Toreva Day School, junior high at Oraibi Day School, and Catalina High School in Tucson. Following graduation from high school, Talaswaima studied art education at the University of Arizona for three years, in a program that was part of the Southwest Indian Project.

During the 1960s Talaswaima worked in Tucson in the anthropology department of the University of Arizona, was employed as a draftsman and illustrator for the American Universities for Research in Astronomy, and worked for a blueprint company.

From 1969 to 1973 Talaswaima participated in the Hopi Action Program in Oraibi, a program devoted to incorporating Hopi culture into school curriculum. He was art consultant and cultural-materials developer to this program, which came under the auspices of the Hopi Tribal Council. The program was devoted to research into Hopi folklore, songs (social), and stories. These stories were recorded into Hopi then translated and written in English. As a result of this program, three books, *Birds at Hano Village, Frog and Bird Work in the Cornfield,* and *Hopi Lullaby,* were published and used as supplementary reading in school classes. Talaswaima illustrated *Birds at Hano Village.*

Throughout his career, Talaswaima has been able to combine in his work his interests in both education and art. In 1973 he received a grant to work as a curatorial intern at the Museum of Northern Arizona. In 1975, upon completion of the program, he was appointed curator of the Hopi Cultural Center Museum.

Terrance Talaswaima is an active participant in Hopi community life. He is a councilman on the Hopi Tribal Council, a member of the Second Mesa Day School Advisory Board, and Chairman of the Save-the-Children Foundation in Shipolovi Village.

Talaswaima is a member of the Pumpkin Clan, which is part of the Sand and Snake phratry. He is a member of the Wuwuchim Men's Society and the Gray Flute Society. The Pumpkin Clan was one of the last clans to arrive at the mesas; however, in the course of time they have won a reputation as historians. Talaswaima is keeper of the drum in Shipolovi. His name, Honvantewa, means "bear making tracks."

LOMAQUASTEWA—BEVINS YUYAHOEVA

Bevins Yuyahoeva was born in Shungopovi in 1938. He was educated at Shungopovi Day School and Hopi High School in Oraibi. Yuyahoeva was born into the Bear Strap Clan, and in 1956 he was initiated into the Two Horn Society. His name Lomaquastewa means "eagle sitting." In 1969 he was killed in an automobile accident.

Yuyahoeva was a self-taught painter. In 1959 he participated in a visual educational tour of the eastern United States. In 1967 he won first prize at the Arizona State Fair for *Dreams of Hopis* and second place in the National Indian Art Exhibition at the Heard Museum.

DUVEHYESTEWA—TYLER POLELONEMA

Tyler Polelonema was born in Shungopovi in 1940. He is the son of Otis Polelonema, a well-known traditional Hopi painter.

Tyler, however, is a self-taught painter. He recalls: "My father was an inspiration in the arts. He would often ask me 'Do you want to be an artist?' then answer his own question by saying, 'It is up to you then to catch on.'"[2]

Polelonema was educated at the Shungopovi Day School and the Hopi Junior High School in Oraibi. He then attended the Stewart Indian High School in Stewart, Nevada, and was graduated in 1963.

In 1967 he won first place in the Hopi Craftsmen Show at the Museum of Northern Arizona, and in 1968 he took second place in the competition at the Philbrook Institute.

In 1973, when the Artist Hopid was founded, Tyler Polelonema exhibited with the group. However, he is no longer a member of the Artist Hopid, for he has moved from the mesas to Phoenix, where he works in the Public Health Indian Hospital. Tyler is a member of the Sun Forehead Clan.

NOTES

1. *Profile Artist Hopid* (Second Mesa, Arizona: private printing).

2. Biographical outline written for author, August 1976.

Selected Bibliography

STUDIES OF HOPI LIFE

Beaglehole, Ernest. *Notes on Hopi Economic Life*. New Haven: Yale University Press, 1937.

Bourke, John Gregory. *The Snake Dance of the Moquis of Arizona*. Reprinted from the original 1884 edition. Chicago: Rio Grande Press, 1962.

Crane, Leo. *Indians of the Enchanted Desert*. Boston: Little Brown & Co., 1925.

Cushing, Frank Hamilton. "Contributions to Hopi History, 1: Oraibi in 1883," *American Anthropologist* (n.s.), vol. 24, no. 3. 1922.

Dockstader, Frederick J. *The Kachina and the White Man*. Bloomfield Hills, Mich.: Cranbrook Institute of Science, 1954.

Dorsey, George A., and H. R. Voth. *The Oraibi Soyal Ceremony*. Field Museum of Natural History, Anthropological Series, no. 55. Chicago: 1901.

Dozier, Edward P. *Hano, A Tewa Indian Community in Arizona*. New York: Holt, Rinehart and Winston, 1966.

Dozier, Edward P. *The Pueblo Indians of North America*. New York: Holt, Rinehart and Winston, 1970.

Fewkes, Jesse Walter. "Awatovi, an Archaeological Verification of a Tusayan Legend," *American Anthropologist*, vol. 6, no. 4. 1893.

Fewkes, Jesse Walter. "The Butterfly in Hopi Myth and Ritual," *American Anthropologist* (n.s.), vol. 12, no. 4. 1910.

Fewkes, Jesse Walter. "Contributions to Hopi History, II: Oraibi, 1890," *American Anthropologist* (n.s.), vol. 24, no. 3. 1922.

Fewkes, Jesse Walter. "The Kinship of the Tusayan Villages," *American Anthropologist* (o.s.), vol. 7, no. 4. 1897.

Fewkes, Jesse Walter. "The New Fire Ceremony at Walpi," *American Anthropologist* (n.s.), vol. 2, no. 1. 1900.

Fewkes, Jesse Walter. "The Snake Ceremonials at Walpi," *A Journal of American Ethnology and Archeology*, vol. IV. 1894.

Fewkes, Jesse Walter. "Two Summers' Work in Pueblo Ruins," U.S. Bureau of American Ethnology, *Annual Report 22*, part 2. 1904.

Forrest, Earle R. *The Snake Dance of the Hopi Indians*. Los Angeles: Westernlore Press, 1961.

Hack, John T. *The Changing Physical Environment of the Hopi Indians of Arizona*. Papers of the Peabody Museum, vol. 35, no. 1. Cambridge, Mass., 1942.

Hargrave, Lyndon L. "First Mesa," *Museum Notes* (Museum of Northern Arizona), vol. 3. 1931.

Hargrave, Lyndon L. "The Jeddito Valley and the First Pueblo Towns in Arizona," *Museum Notes* (Museum of Northern Arizona), vol. 8. 1935.

Hargrave, Lyndon L. "Oraibi," *Museum Notes* (Museum of Northern Arizona), vol. 4. 1932.

Hargrave, Lyndon L. "Shungopovi," *Museum Notes* (Museum of Northern Arizona), vol. 2. 1930.

Hopi Hearings. U.S. Department of the Interior. Bureau of Indian Affairs, Hopi Agency. Keams Canyon, Arizona: 1955.

Hough, Walter. *The Moki Snake Dance*. Chicago: The Henry O. Shepard Co., 1899.

James, Harry C. *Pages from Hopi History*. Tucson: University of Arizona Press, 1974.

Lowie, Robert H. "Notes on Hopi Clans," *Anthropological Papers*, American Museum of Natural History, vol. xxx, part 5. New York: 1929.

Lummis, Charles F. *Bullying the Moqui*. Reprinted from *Out West*, April and October 1903. Prescott, Arizona: Prescott College Press, 1968.

Mindeleff, Victor. "A Study of Pueblo Architecture: Tusayan and Cibola," Bureau of American Ethnology *Annual Report 8*. Washington, D.C.: 1891.

O'Kane, Walter Collins. *The Hopis: Portrait of a Desert People*. Norman, Okla.: University of Oklahoma Press, 1953.

O'Kane, Walter Collins. *Sun in the Sky*. Norman, Okla.: University of Oklahoma Press, 1950.

Parsons, Elsie Clews. "Contributions to Hopi History, III: Oraibi," *American Anthropologist* (n.s.), vol. 24, no. 3. 1920.

Parsons, Elsie Clews. "Contributions to Hopi History, IV: Shungopovi," *American Anthropologist* (n.s.), vol. 24, no. 4. 1920.

Parsons, Elsie Clews. *Pueblo Indian Religion*, 2 vols. Chicago: University of Chicago Press, 1939.

Powell, John Wesley. "The Hopi Villages: The Ancient Province of Tusayan," *Schribner's Monthly*, vol. XI. Oct., 1875. Reprinted. Palmer Lake, Colorado: Filter Press, 1972.

Smith, Watson, and J. O. Brew. *Franciscan Awatovi: The Excavation and Conjectural Reconstruction of a 17th-Century Spanish Mission Established at a Hopi Town in Northeastern Arizona.* Papers of the Peabody Museum, vol. XXXVI, no. 1. Cambridge, Mass., 1949.

Stephen, Alexander M. *Hopi Journal*, Elsie Clews Parsons, ed. *Columbia University Contributions to Anthropology*, vol. XXIII, 2 parts. New York: Columbia University Press, 1936.

Stephen, Alexander M. "Hopi Journal," Elsie Clews Parsons, ed. *Journal of American Folklore*, vol. 42, no. 163. 1929.

Thompson, Laura. *Culture in Crisis: A Study of the Hopi Indian.* New York: Harper & Brothers, 1950.

Thompson, Laura, and Alice Joseph. *The Hopi Way.* Chicago: University of Chicago Press, 1944.

Titiev, Mischa. *The Hopi Indians of Old Oraibi, Change and Continuity.* Ann Arbor: The University of Michigan Press, 1972.

Titiev, Mischa. *Old Oraibi.* Peabody Museum Papers, vol. 22, no. 1. Cambridge, Mass.: 1944.

Voth, Heinrich R. *The Mishonguovi Ceremonies of the Snake and Flute Fraternities.* Field Museum of Natural History, Anthropological Series, no. 66. Chicago: 1901.

Voth, Heinrich R. *The Oraibi Powamu Ceremony.* Field Museum of Natural History, Anthropological Series no. 61. Chicago: 1901.

Voth, Heinrich R. *The Oraibi Summer Snake Ceremony.* Field Museum of Natural History, Anthropological Series no. 83. Chicago: 1903.

Voth, Heinrich R. *The Traditions of the Hopi.* Field Museum of Natural History, Anthropological Series no. 96. Chicago: 1905.

Whiting, Alfred F. *Ethnobotany of the Hopi.* Museum of Northern Arizona Bulletin no. 15. Flagstaff: 1939.

POST-CONTACT HOPI HISTORY

Bancroft, Hubert Howe. *History of Arizona and New Mexico. 1530–1888.* San Francisco: The History Co., 1889.

Bartlett, Katherine. "The Navajo Wars, 1823–1870," *Museum Notes* (Museum of Northern Arizona), vol. 8. 1934.

Bartlett, Katherine. "Spanish Contacts with the Hopi, 1540–1823," *Museum Notes* (Museum of Northern Arizona), vol. 6. 1934.

Bolton, Herbert E. *Coronado, Knight of Pueblos and Plains.* New York and Albuquerque: Whittlesley House and University of New Mexico Press, 1949.

Bolton, Herbert E., ed. *Spanish Exploration in the Southwest, 1541–1706.* New York: Charles Scribner's Sons, 1916.

Colton, Harold S. "A Brief Survey of the Early Expeditions into Northern Arizona," *Museum Notes* (Museum of Northern Arizona), vol. 2. 1930.

Hackett, Charles Wilson. *The Revolt of the Pueblo Indians of New Mexico and Otermin's Attempted Reconquest, 1680–1682,* 2 vols. Albuquerque: University of New Mexico Press, 1942.

Hammond, George P., and Agapito Rey. *The Rediscovery of New Mexico, 1580–1594.* Albuquerque: University of New Mexico Press, 1966.

McClinton, James H. *Mormon Settlement in Arizona.* Published by the author. Phoenix, Ariz.: 1921.

Spicer, Edward H. *Cycles of Conquest: The Impact of Spain, Mexico, and the United States on the Indians of the Southwest, 1533–1960.* Tucson: University of Arizona Press, 1962.

Winship, George Parker, trans. "The Narrative of the Expedition of Coronado by Castaneda," Bureau of American Ethnology *Annual Report 14*, part 1. Washington, D.C.: 1896.

HOPI LEGENDS

Courlander, Harold. *The Fourth World of the Hopis.* New York: Crown Publishers, 1971.

Cushing, Frank H. "Origin Myth from Oraibi," *Journal of American Folk-lore,* vol. XXXVI, no. 139. 1923.

Nequatewa, Edmund. *Truth of a Hopi.* Originally published as Museum of Northern Arizona Bulletin no. 8. Flagstaff, Ariz.: 1936. Flagstaff, Ariz.: Northern Arizona Society of Science and Art, 1947.

Stephen, A. M. "Hopi Tales," *Journal of American Folk-lore,* vol. XLII, no. 163. 1929.

Tyler, Hamilton A. *Pueblo Gods and Myths.* Norman, Okla.: University of Oklahoma Press, 1964.

Wallis, Wilson D. "Folk Tales from Shumopovi, Second Mesa," *Journal of American Folk-lore,* vol. 49, nos. 191–192. 1936.

HOPI BIOGRAPHIES

Qoyawayma, Polingaysi (Elizabeth White). *No Turning Back.* Albuquerque: University of New Mexico Press, 1964.

Talayesva, Don C. *Sun Chief: The Autobiography of a Hopi Indian.* Leon W. Simmons, ed. New Haven, Conn.: Yale University Press, 1963.

Udall, Louise. *Me and Mine: The Life Story of Helen Sekaquaptewa.* Tucson: University of Arizona Press, 1969.

STORIES OF HOPI LIFE

James, Harry C. *Red Man—White Man.* San Antonio, Texas: 1958.

Nelson, John Louw. *Rhythm for Rain.* Boston, Mass.: Houghton, Mifflin, 1937.

PHOTOGRAPHS OF HOPI LIFE

Edward S. Curtis: *Portraits from North American Indian Life.* Introductions by A. D. Coleman and T. C. McLuhan. New York: Promentory Press, 1972.

Mahood, Ruth I. *Photographer of the Southwest: Adam Clark Vroman, 1856–1916.* Los Angeles: The Ward Ritchie Press, 1961.

Webb, William, and Robert A. Weinstein. *Dwellers at the Source: Southwestern Indian Photographs of A. C. Vroman 1895–1904.* New York: Grossman Publishers, 1973.

INDIAN ART

Appleton, L. H. *Indian Art of the Americas.* New York: Charles Scribner's Sons, 1950.

Dockstader, Frederick J., ed. *Directions in Indian Art.* The report of a conference held at the University of

Arizona, March 20–21, 1956. Tucson: University of Arizona Press, 1959.

Dockstader, Frederick J. *Indian Art in America.* Greenwich, Conn.: New York Graphic Society, 1961.

Douglas, Frederic H., and Rene d'Harnoncourt. *Indian Art of the United States.* New York: Museum of Modern Art, 1941.

Feder, Norman. *American Indian Art.* New York: Harry N. Abrams, Inc., 1971.

New Lloyd Kiva. *Future Directions in Native American Art.* Santa Fe: Institute of American Indian Arts, 1972.

Sides, Dorothy Smith. *Decorative Art of the Southwest Indians.* New York: Dover Publications, 1961.

Warner, John Anton. *The Life and Art of the North American Indian.* Feltham, Middlesex, England: Astronaut House, 1974.

Vaillant, George C. *Indian Arts in North America.* New York: Harper & Brothers, 1939.

INDIAN PAINTING

Brody, J. J. *Indian Painters and White Patrons.* Albuquerque: University of New Mexico Press, 1971.

Dawdy, Doris O., comp. *Annotated Bibliography of American Indian Painting,* vol. 21, part 2. Contributions from the Museum of the American Indian. Heye Foundation. New York: Heye Foundation, 1968.

Dunn, Dorothy. "A Documented Chronology of Modern American Indian Painting of the Southwest," *Plateau* (Museum of Northern Arizona), vol. 44. 1972.

Dunn, Dorothy. *American Indian Painting of the Southwest and Plains Areas.* Albuquerque: University of New Mexico Press, 1968.

Dunn, Dorothy. "The Studio of Painting, Santa Fe Indian School," *El Palacio* (Museum of New Mexico), vol. 67, no. 1. 1960.

Dunn, Dorothy. "The Development of Modern American Indian Painting in the Southwest and Plains Areas," *El Palacio* (Museum of New Mexico), vol. 58, no. 11. 1951.

Harvey, Byron, III. *Ritual in Pueblo Art: Hopi Life in Hopi Painting.* New York: Museum of the American Indian, Heye Foundation, 1970.

Snodgrass, Jeanne O., comp. *American Indian Painters, A. Biographical Directory.* New York: Museum of the American Indian, Heye Foundation, 1968.

Tanner, Clara Lee. "Fred Kabotie—Hopi Indian Artist," *Arizona Highways.* July 1951.

Tanner, Clara Lee. *Southwest Indian Painting: A Changing Art.* Tucson: University of Arizona Press, 1957.

PICTOGRAPHS AND PETROGLYPHS

Brewer, J., and S. Brewer. "Wupatki Petroglyphs," *U.S. National Park Service Southwestern Monuments Monthly Report.* August 1935.

Colton, Harold S. *Black Sand—Prehistory in Northern Arizona.* Albuquerque: University of New Mexico Press, 1960.

Colton, Mary Russell F., and Harold J. Colton. "Petroglyphs, the Record of a Great Adventure," *American Anthropologist,* vol. XXX, no. 1. 1931.

Fewkes, Jesse Walter. "A Few Tusayan Pictographs," *American Anthropologist* (o.s.), vol. V, no. 1. 1892.

Fewkes, Jesse Walter. "Tusayan Totemic Signatures," *American Anthropologist* (o.s.), vol. V, no. 1. 1897.

Fewkes, Jesse Walter. Tusayan Migration Traditions," Bureau of American Ethnology, *Annual Report 19.* Washington, D.C.: 1900.

Fossnock, A. "Pictographs and Murals in the Southwest," *El Palacio* (Museum of New Mexico), vol. XXXIX, nos. 16 to 18. 1935.

Mallery, Garrick. "Pictographs of the North American Indians," U.S. Bureau of American Ethnology, *Annual Report 4.* Washington, D.C.: 1886.

Mallery, Garrick. "Picture Writing of the American Indians," U.S. Bureau of American Ethnology, *Annual Report 10.* Washington, D.C.: 1893.

Kidder, Alfred Vincent, and Samuel J. Guernsey. "Archaeological Explorations in Northeastern Arizona," Bureau of American Ethnology, *Bulletin 65.* Washington, D.C.: 1919.

Schaafsma, Polly. *Southwest Indian Pictographs and Petroglyphs.* Santa Fe: Museum of New Mexico Press, 1965.

Wetherill, M. A. "Pictographs at Betatakin Ruin," *U.S. National Park Service Southwestern Monument Monthly Report.* May 1935.

Young, J. V. "The Peregrinations of Kokopelli," *Westways,* vol. LVII, no. 9. 1965.

KIVA MURAL PAINTING

Smith, Watson. *Kiva Mural Decorations at Awatovi and Kawaika-a.* Papers of the Peabody Museum, vol. XXXVII. Cambridge, Mass.: 1952.

Dutton, Bertha P. *Sun Father's Way—The Kiva Murals of Kuaua.* Albuquerque: University of New Mexico Press, 1963.

HOPI KACHINAS

Arizona Highways (Special Hopi Kachina Issue). June 1971.

Boelter, Homer H. *Portfolio of Hopi Kachinas.* Hollywood, Calif.: Homer H. Boelter Lithography, 1969.

Colton, Harold S. *Hopi Kachina Dolls, With a Key to Their Identification.* Albuquerque: University of New Mexico Press, 1949; new ed., 1959.

Fewkes, Jesse Walter. "Hopi Kachinas, Drawn by Native Artists," U.S. Bureau of American Ethnology, *Annual Report 21.* Washington, D.C.: 1903.

Fewkes, Jesse Walter. "Tusayan Kachinas," Bureau of American Ethnology, *Annual Report 15,* Washington, D.C.: 1897.

Wright, Barton. *Kachinas, A. Hopi Artist's Documentary.* Flagstaff Ariz.: Northland Press, 1973.

Wright, Barton, and Evelyn Roat. *This is a Hopi Kachina.* Flagstaff Ariz.: Museum of Northern Arizona, 1970.

INDIAN CRAFTS

Bartlett, Katherine. "Notes on the Indian Crafts of Northern Arizona," *Museum Notes* (Museum of Northern Arizona), vol. 10. 1938.

Colton, Harold S. "Exhibitions of Indian Arts and Crafts," *Plateau* (Museum of Northern Arizona), vol. 12. 1940.

Colton, Mary Russell F. "The Arts and Crafts of the Hopi Indians," *Museum Notes* (Museum of Northern Arizona), vol. 11. 1938.

Colton, Mary Russell F. "The Hopi Craftsman," *Museum Notes* (Museum of Northern Arizona), vol. 3. 1931.

Colton, Mary Russell F. "Technique of the Major Hopi Crafts," *Museum Notes* (Museum of Northern Arizona), vol. 3. 1931.

Tanner, Clara Lee. *Southwest Indian Craft Arts.* Tucson: University of Arizona Press, 1968.

Underhill, Ruth. *Pueblo Crafts,* Washington, D.C.: U.S. Dept. of the Interior, Bureau of Indian Affairs. 1944.

Whiting, Alfred F. *Hopi Arts and Crafts Survey for the Indian Arts and Crafts Board,* 4 vols. Flagstaff, Ariz.: Museum of Northern Arizona Archives, 1942.

Stevenson, James. "Illustrated Catalogue of the Collections Obtained from the Pueblos of Zuni, New Mexico, and Walpi, Arizona, in 1881,"Bureau of American Ethnology, *Annual Report 3*. Washington, D.C.: 1884.

Stevenson, James. "Illustrated Catalogue of the Collections Obtained from the Indians of New Mexico and Arizona in 1879," Bureau of American Ethnology, *Annual Report 2*. Washington, D.C.: 1883.

INDIAN POTTERY

Arizona Highways (Special Prehistoric Indian Pottery Issue). February 1974.

Arizona Highways (Special Pueblo Pottery Issue). May 1974.

Bunzel, Ruth C. *The Pueblo Potter*. New York: Columbia University Press, 1929; new edition, New York: Dover Publications Inc., 1972.

Chapman, Kenneth. "Pueblo Feather Designs," *El Palacio* (Museum of New Mexico), vol. XXIII, no. 1. 1927.

Colton, Mary Russell F., and Harold S. Colton. "An Appreciation of the Art of Nampeyo and Her Influence on Hopi Pottery," *Plateau* (Museum of Northern Arizona), vol. XV. 1943.

Fewkes, Jesse Walter. "Archeological Expedition to Arizona in 1895," U.S. Bureau of American Ethnology, *Annual Report 17,* part 2. 1898.

Fewkes, Jesse Walter. "Designs in Prehistoric Hopi Pottery," U.S. Bureau of American Ethnology, *Annual Report 33*. Washington, D.C., 1919.

Harlow, Francis H., and John V. Young, *Contemporary Pueblo Indian Pottery*. Santa Fe: Museum of New Mexico Press, 1965.

Jeancon, Jean, and Frederic H. Douglas. *Hopi Indian Pottery* (leaflet 47). Denver: Denver Art Museum, 1932.

Kabotie, Fred. *Designs from the Ancient Mimbrenos with a Hopi Interpretation,* San Francisco: The Grabhorn Press, 1949.

Martin, Paul S., and Elizabeth S. Willis. *Anasazi Painted Pottery in Field Museum of Natural History*. Field Museum Anthropology Memoirs, vol. 5. Chicago, 1940.

Mera, Henry P. *The Rain Bird: A Study in Pueblo Design*. Memoirs of the Laboratory of Anthropology, vol. 11. Santa Fe, 1938. New York: Dover Press, new edition, 1970.

Mera, Harry P. *Style Trends of Pueblo Pottery in the Rio Grande and Little Colorado Cultural Areas from the 16th to the 19th Century*. Memoirs of the Laboratory of Anthropology, vol. III. 1939.

Ward, Bob, comp. "Pueblo Pottery," *New Mexico Magazine,* May to June 1974.

INDIAN BASKETRY

Arizona Highways (Special Indian Basketry Issue), July 1975.

Dedera, Don. "Basket Making in Arizona," *Arizona Highways,* June 1973.

Douglas, Frederic H. *Basketry Construction Techniques* (leaflet 67). Denver: Denver Art Museum, 1935.

Douglas, Frederic H. *Southwestern Twined, Wicker and Plaited Basketry* (leaflets 99 to 100). Denver: Denver Art Museum, 1940.

Douglas, Frederick H. *Types of Southwestern Coiled Basketry* (leaflet 88). Denver: Denver Art Museum, 1939.

Jeancon, Jean, and Frederic H. Douglas. *Hopi Indian Basketry* (leaflet 17). Denver: Denver Art Museum, 1930.

Mason, Otis T. "Aboriginal American Basketry," *Annual Report,* U.S. National Museum, 1902.
Weltfisch, Gene. "Prehistoric North American Basketry Techniques and Modern Distributions," *American Anthropologist,* vol. 32, no. 3. 1934.

INDIAN TEXTILES

Amsden, Charles Avery. "The Loom and Its Prototypes" *American Anthropologist* (n.s.), vol. 34, no. 2. 1932.
Douglas, Frederic H. "Notes in Hopi Brocading," *Museum Notes* (Museum of Northern Arizona), vol. II. 1938.
Jacka, Jerry D. "Hopi Weaving," *Arizona Highways.* July 1974.
Jeancon, Jean Allard, and F. H. Douglas. *Hopi Indian Weaving* (leaflet 18). Denver: Denver Art Museum, 1931.
Douglas, Frederic H. *Main Types of Pueblo Cotton Textiles* (leaflets 92 to 93). Denver: Denver Art Museum, 1940.
Douglas, Frederic H. *Main Types of Pueblo Woolen Textiles* (leaflets 94 to 95). Denver: Denver Art Museum, 1940.
Kent, Kate Peck. "The Braiding of a Hopi Wedding Sash," *Plateau* (Museum of Northern Arizona), vol. 13. 1940.
MacLeish, Kenneth. "Notes on Hopi Belt Weaving in Moenkopi," *American Anthropologist,* vol. XLII, no. 2. 1940.

SILVERWORK

Adair, John. *The Navajo and Pueblo Silversmith,* Norman, Okla.: University of Oklahoma Press, 1946.
Arizona Highways (Special Indian Jewelry Issue), no. 1. August 1974.
Arizona Highways (Special Indian Jewelry Issue), no. 2. March 1975.
Colton, Mary, and Russell F. Colton. "Hopi Silversmithing—Its Background and Future," *Plateau* (Museum of Northern Arizona), vol. 12. 1939.
Hodge, F. W. "How Old is Southwestern Indian Silverwork?" *El Palacio* (Museum of New Mexico), vol. 25. 1928.
Kabotie, Fred. *Hopi Silver* (mimeographed catalogue). Oraibi, Ariz.: Hopi Silvercraft Guild, 1950.
McGibbeny, J. H. "Hopi Jewelry," *Arizona Highways.* July 1950.
Mera, Harry P. *Indian Silverwork of the Southwest,* vol. I. Globe, Ariz.: Dale Stuart King, 1959.
Mori, John, and Joyce Mori. *Hopi Silversmithing* (leaflet 35). Los Angeles: Southwest Museum, 1971.
Ritzenthaler, Robert E. "Hopi Indian Silverwork," *Lore* (Milwaukee Public Museum), vol. 16. 1966.
Tanner, Clara Lee. "Contemporary Southwest Indian Silver," *The Kiva* (Arizona State Museum), vol. 25, no. 3. 1960.
Wright, Margaret Nichelson. *Hopi Silver.* Flagstaff, Arizona: Northland Press, 1972.

Index